EATING BEAUTY

EATING BEAUTY

THE EUCHARIST AND THE
SPIRITUAL ARTS OF THE MIDDLE AGES

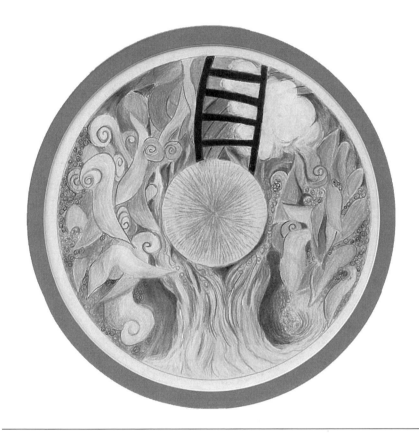

ANN W. ASTELL

Cornell University Press Ithaca & London

Publication of this book was made possible,
in part, by a grant from Purdue University.

First published 2006 by Cornell University Press
Printed in the United States of America

Library of Congress Cataloging-in-Publication Data

Astell, Ann W.
 Eating beauty : the Eucharist and the spiritual arts of the Middle Ages
/ Ann W. Astell.
 p. cm.
 Includes bibliographical references and index.
 ISBN-13: 978-0-8014-4466-1 (cloth : alk. paper)
 ISBN-10: 0-8014-4466-7 (cloth : alk. paper)
 1. Lord's Supper— Catholic Church—History of doctrines—Middle
Ages, 600–1500. 2. Lord's Supper—Catholic Church—History of
doctrines—16th century. 3. Aesthetics—Religious aspects—Catholic
Church. 4. Food—Religious aspects—Catholic Church. 5. Spiritual
life—Catholic Church—History of doctrines—Middle Ages, 600–1500.
6. Spiritual life—Catholic Church—History of doctrines—16th
century. I. Title.
BV823.A77 2006
248.09′02—dc22

 2006006245

Cornell University Press strives to use environmentally responsible suppliers
and materials to the fullest extent possible in the publishing of its books.
Such materials include vegetable-based, low-VOC inks and acid-free papers
that are recycled, totally chlorine-free, or partly composed of nonwood
fibers. For further information, visit our website at
www.cornellpress.cornell.edu.

Cloth printing 10 9 8 7 6 5 4 3 2 1

In Memoriam

Tom Andrews, Poet

(1961–2001)

Brother, I speak these words

to your sleep. Your mouth is watched.

—Tom Andrews, "The Brother's Country"

'God teaches

by inconvenience'

(the Middle Ages

listening)

—Tom Andrews, "Triptych: Augustine of Hippo"

CONTENTS

ILLUSTRATIONS

ACKNOWLEDGMENTS

When one begins to think, really to think, something rapturous happens. An event of wonderment (OE *wundor*) occurs—often traumatically, in the form of a wound (OE *wund*)—and one begins a quest, even as one is carried off by it. The old cliché of the "train of thought" comes alive when one realizes that one has been transported in this way, from station to station, toward an unforeseen destination that was somehow always already there in the beginning, implicit in the question itself. When one comes home, one has been altered by the journey, so that the arrival back is different from the setting out. True thought for this reason can never really be circular, but the image of the circle can nonetheless be an icon—a mandala—for a thought that leads beyond itself.

Most of this book was written in Washington, DC, in the academic year 2001–2002. During that same year, the manuscript of *Joan of Arc and Sacrificial Authorship* (2003) went into press. Both books deal, albeit in different ways, with the combined topics of religious experience, especially as represented in the lives of saints, and artistic production—the holy and the beautiful.

Those readers familiar with my *Song of Songs in the Middle Ages* (1990) will be struck by a similarity in structure between that book and this one, finished fifteen years later. In that first book I showed how the biblical figure of the Solomonic Bride had four different faces in medieval commentaries—faces that corresponded to the spiritual ideals of the exegetes who identified themselves with her. In *Eating Beauty* a single scriptural story—that of the Fall in Genesis—stands as the basis for four different interpretations of the first sin, each of them entailing the discovery of an appropriate remedy, a virtuous way back to an original beauty. In this book the Eucharist itself is seen as both the living source of those remedial virtues and the artistic image of the perfection to which they lead.

The books written in the interim between my first book and this one—*Job, Boethius, and Epic Truth* (1994), *Chaucer and the Universe of Learning* (1996), and *Political Allegory in Late Medieval England* (1999)—all concerned themselves in one way or another with the sophisticated allegorical modes of reading and writing that derived from scriptural exegesis and flourished in the literature of the High Middle Ages. My inclination has been to oppose a static, dualistic understanding of allegory, which divorces literal meaning from spiritual significance. My fascination has been not with what divided the different levels of meaning synchronically from one another, but with what connected them diachronically, even across wide gaps, in the minds of medieval readers and writers. I have tended

to see *allegoresis* as a process of thought that allows for a dynamic extension of literal meaning into allegorical discovery. These studies, too, have prepared me for *Eating Beauty,* because the theology of the Eucharist distinguishes between the outward sign and the inner reality of the sacrament, in a manner analogous to the literal and spiritual meanings of an inspired allegory, such as the *Song of Songs.*

The year I spent in Washington writing this book was an extended retreat for me. Thanks to a John Simon Guggenheim Memorial Fellowship and the kind invitation of Peter Casarella, then chair of the Program in Medieval and Byzantine Studies, and Ernest Suarez, chair of the Department of English, I was able to live and work on the campus of the Catholic University of America as a visiting scholar. I tried to live as simply as possible, spending the year in an undergraduate dorm. The horrible events of September 11, which occurred during my first month in the nation's capital, heightened the spiritual intensity of even the most ordinary actions. Every morning I arose early, walked to Mass, had my meditation in the National Shrine of the Immaculate Conception—a basilica of great beauty—and then went to the library to spend the day there, reading, thinking, and writing. Sometimes I took the subway to the Library of Congress, to the Folger Shakespeare Library, or to the National Gallery of Art.

I remember the experience of that year, during which I learned so much, with great gratitude. Members of the Department of English—especially Ernest Suarez, Christopher Wheatley, Anca and Virgil Nemoianu, Michael Mack, and Sr. Anne O'Donnell, S.N.D.—showed me warm hospitality. Maria and Peter Casarella and Thérèse-Anne Druart, who succeeded Peter as chair of Medieval and Byzantine Studies, became wonderful friends. Peter, in particular, was a God-sent "conversation partner" for me—knowledgeable, generous, and encouraging. I cannot thank him enough for the interest he showed in my work and the many ways in which he helped to shape it.

There have been many other conversation partners to whom I wish to express heartfelt gratitude. Caroline Walker Bynum, to whom I owe a great intellectual debt, corresponded generously with me at the very beginning of this project, when my thoughts were only beginning to take form. Thomas Bestul, Robert Boenig, Warren Ginsberg, and Barbara Newman warmly supported the writing of this book with their letters of recommendation. Martin Winkler and Katharine Goodland visited me in Washington. Bonnie Wheeler and Jeremy duQuesnay Adams graciously welcomed me into their home in May 2002, for a wonderful week of working together on Joan of Arc and talking about *Eating Beauty.*

The following summer I spent a month in Cambridge, England, where I did most of the research for chapter 3 of this book. I recall gratefully my days at the Margaret Beaufort Institute, where I found a home away from home, and at

Cambridge University Library, where I had memorable conversations with Rita Copeland, David Wallace, Jill Mann, and James Simpson. Paul White and Paula Leverage—dear friends and colleagues—walked the streets of Cambridge and Norwich with me, to ease the loneliness that comes with foreign travel and a long, intellectual labor.

Purdue University, my home institution, made possible the extended leave that allowed me to write most of *Eating Beauty*. I wish to thank Margaret Moane Rowe, who was dean of the School of Liberal Arts at the time I received the Guggenheim Fellowship and when I was selected as a University Faculty Scholar; Toby Parcel, who succeeded her as dean; and Thomas Adler and Irwin Weiser, who have served as head of the Department of English in recent years, for their support. To my fellow medievalists in English—Shaun Hughes, Thomas Ohlgren, and Dorsey Armstrong—I owe a particular debt of gratitude, for the work they shouldered in my absence and for their constant encouragement.

Among the wonderful conversation partners I have here at Purdue, I wish to mention gratefully some of those who have contributed in small and great ways to this book: Ingeborg Hinderschiedt, Wendy and David Flory, Adele and Roberto Colella, Tom and Winnie Adler, Marianne Boruch, Charles Ross, Peggy Rowe, Geri Friedman, Holly Schrank, and Felix and Selma Stefanile. I quote two good friends, Sandor Goodhart and Thomas Ryba, in these pages, but that is only a tiny indication of the ways their thoughts and interests have enriched and expanded mine.

Sincere thanks are also owed to the graduate students who took my seminar Medieval Women Mystics in the spring and summer of 2000, and to those who participated in the seminar on Edith Stein, Simone Weil, and Hannah Arendt in the spring of 2004, which Tom Ryba and I team-taught. From these students and courses I learned a great deal.

Thanks to Martin Beck Matustik, I presented a version of chapter 7 as a paper in the Illuminations Lecture Series here at Purdue University in the fall of 2002. In the spring of 2004, at the invitation of Raymond-Jean Frontain, I gave the Nolte-Behrens Lecture at the University of Central Arkansas, drawing on the introduction. That same spring I presented papers both at the meeting in Seattle, Washington, of the Medieval Academy of America and at the meeting of the Illinois Medieval Association at Northwestern University, based on sections of chapters 2 and 3, respectively. For these occasions and for the encouraging responses I received, I wish also to express gratitude.

Virgil Nemoianu and Michael Mack read an early version of chapter 7 and suggested revisions. Peter Casarella read first drafts of chapters 4, 5, and 6. Margaret R. Miles and Stephanie Paulsell read the manuscript for Cornell University Press.

Jean Frisk also read and commented on the complete manuscript. For the responses and written reports of these readers I am greatly indebted. Without them *Eating Beauty* would be much less beautiful.

I gratefully acknowledge the permissions granted by Paulist Press to quote from Ewert Cousins's translation of the writings of St. Bonaventure; the permission given by Yale University Press to quote from James Saslow's translation of *The Poetry of Michelangelo;* and the permissions given by Cistercian Publications to quote from Kilian Walsh and Irene Edmonds's translations of St. Bernard's *Sermons on the Song of Songs* and from M. Ambrose Conway's translation of St. Bernard's *Steps of Humility and Pride.* Permissions granted for the use of the illustrations in this book are noted on a separate page. I thank Annalisa Innocenti of the Opera di Santa Maria del Fiore, Dr. Edith Schipper of the Bayerische Staatsbibliothek, Tricia Buckingham of the Bodleian Library, Teodoro Hampe Martínez, Jeffrey Gore, Señora María Luisa Ugarte, Frank Graziano, Barbara Newman, Barbara Goldstein Wood of the National Gallery of Art, and Mary A. Zore for their generous assistance in obtaining these images and the permissions necessary for their use.

The debts to people at Cornell University Press are enormous. Bernhard Kendler, who has played a vital part in my whole scholarly career, followed the development of the book with great interest, sending me occasional letters to check on my progress. He received the finished manuscript in fall 2004 and saw it through the review process, but he retired from the Press shortly before the board approved the book's publication in spring 2005. The news of Bernie's retirement came to me as a shock, because I owe so much to him. I hope he will regard *Eating Beauty* as one of "his" books.

To John Ackerman, director of Cornell University Press, I owe a long-standing and frequently renewed debt of gratitude. It was into John's hands that Bernie entrusted the fate of this project. To Marta Steele, who copyedited the manuscript with great care, I also wish to express sincere thanks.

I cannot end these acknowledgments without remembering with special affection my parents, grandparents, and brothers and sisters. I grew up in a family with many artistic talents, literary interests, a love for nature, and a deep religious faith. All of my siblings are, in fact, artists of one sort or another—potters, photographers, calligraphers, woodworkers, painters, writers, musicians, gardeners, seamstresses, archers, and athletes. My sister Mary's painting, *The Bread of Angels Mandala,* is among the Eucharistic artworks included here. It would not be an exaggeration to say that this book began in my childhood home in Jefferson, Wisconsin, and in the parish church where I received my first Holy Communion.

I count it as a sign of special providence that the acceptance of *Eating Beauty* came in 2004–2005, a year proclaimed by Pope John Paul II as a Year of the Eu-

charist. To my fellow Schoenstatt Sisters of Mary, I can only say, "Thank you for your love of the Eucharist, which has helped mine to grow in depth and beauty."

This book is dedicated to the memory of Tom Andrews, a talented young poet who belonged for several years to the faculty of the Department of English at Purdue, where I knew him as a colleague. Tom had been awarded a John Simon Guggenheim Memorial Fellowship for 2001–2002, and his name was listed immediately above mine in the roster announcing the fellows for that year. Before he could begin the period of his fellowship, however, he fell suddenly ill in Greece and died shortly thereafter. I consciously began work on *Eating Beauty*, therefore, in Tom's memory. Knowing his love for St. Francis of Assisi and for St. Augustine, I am sure that Tom would be pleased about the dedication, as his parents are. The poems that form an appendix to this book are mine—one poet's offering to the memory of another: "Brother, I speak these words to your sleep."

ABBREVIATIONS

AASS

Acta Sanctorum. Edited by Johannes Bolland, Godefridus Henschenius, and Daniel van Papenbroeck. First published in Antwerp: Joannem Mevrsium, 1643. Revised edition by Jean Baptist Carnandet. Paris: V. Palmé, 1863. Supplemented by Analecta bollandiana, 1885–1983. 67 vols.

CCSL

Corpus Christianorum, Series Latina

EETS

Early English Text Society

PG

Patrologiae Cursus Completus, Series Graeca. Edited by J. P. Migne. 162 vols., with Latin translation. Paris, 1857–66.

PL

Patrologiae Cursus Completus, Series Latina. Edited by J. P. Migne. 221 vols. Paris, 1844–64.

SC

Sources Chrétiennes

The Eating of Beauty

Human beings can only say "good to eat" when they mean "beautiful."
—Virginia Woolf

The great trouble in human life is that looking and eating are two different operations.
—Simone Weil

Smell, taste, and touch are excluded from the enjoyment of art.
—G. W. F. Hegel

E ating beauty. The title of this book is intentionally ambiguous. It carries, on the one hand, a sinister meaning, for the eating of beauty denotes its frightening, mythic consumption, whether by cunning serpents, monstrous beasts, cannibals, or machines. It recalls the vicious abuse of food and drink and the concomitant destruction of health and humanity, emblematically represented in the gaping glutton and the drunkard sprawled on the sidewalk. Finally it evokes the devouring mouth of the grave, the sepulcher that swallows every beautiful person and thing (in Latin, *pulcher*), and the horrific mouth of Hell. On the other hand, the title *Eating Beauty* awakens an almost magical hope. What wonders would occur if beauty could be eaten, beauty imbibed, beauty absorbed, without ever ceasing to be beauty! How beautiful we would be and become! Are we not, after all, what we eat?

The title is ambiguous in its very grammar. Is *eating* adjectival? That is to say, does it describe Beauty as a subject—"Eating Beauty" (like "Sleeping Beauty")? If so, who is this Beauty who eats, and what does Beauty eat? Or is *eating* verbal, with *beauty* as its object? Who or what, then, eats beauty, and why and how is beauty to be eaten? In considering *Eating Beauty,* are we to think of "beauty and the feast" instead of "Beauty and the Beast," or is the topic closely tied to such tales of threatened, monstrous consumption, which end (perhaps) with the transformation of beasts into handsome princes?

And yet eating, it would seem, is an enemy to beauty, whether natural or artistic. Nicholas of Cusa (1401–1464), that great herald of modern science and learned student of Albertus Magnus and Pseudo-Dionysius the Areopagite, gives voice to a long aesthetic tradition, traceable back to the *Enneads* of Plotinus (AD 205–270) and forward to the lectures of Hegel (1770–1831), which defines the theoretical

opposition between the two. In a sermon delivered in 1456 on the Feast of Mary's Nativity, Cusanus honors the beautiful Virgin ("Tota pulchra es") with a series of reflections on pulchritude. He first defines the beautiful through etymology, explaining that what is beautiful (*kallos,* in Greek; *formosus,* in Latin) is so because it *calls* and attracts us to the good, and because it has a visible *form,* a definable, proportionate, and pleasing shape. He continues:

> And if we pay attention, making use of the more spiritual senses (since it is through these that doctrines are grasped), then we understand by that very means what is beautiful. For we say that color and shape have beauty and, similarly, voice, song, and speech; thus vision and hearing in different ways comprehend the beautiful. *We do not call a scent beautiful, nor a taste, nor anything that we touch, because those senses* [smell, taste, touch] *are not so near the rational spirit; for they are purely bestial or animal.* For all properly human senses are nobler than those of brutes, by reason of union with the intellectual spirit.[1]

Beauty, then, must be seen or heard, because only the senses of sight and hearing can apprehend form, which appears from a contemplative distance. It cannot be eaten, for if it is eaten, Nicholas implies, it is thereby destroyed by the beasts or bestial people who consume it. What is eaten is too close, too immediate to a purely physical appetite, and thus lacking a spiritually apprehensible form. Humans do not eat beauty, insofar as they are truly human.

The "coincidence of opposites" that patterns the thought of Cusanus allows, however, for an important counterstatement. Beauty may and must be eaten in the Eucharist. In a vernacular homily on the Lord's Prayer, Nicholas explains that "Christ is our bread" and a "spiritual food for our soul" in his agile, glorified, resurrected body, which shines under the form of bread with an "incomprehensible spiritual splendor," the *claritas* or brightness of unchanging Beauty.[2] We should beg daily for this bread, Nicholas says, "for it is necessary daily," if we are to go on

1. Emphasis mine. Nicolas of Cusa, "Tota pulchra es, amica mea, et macula non est in te" (*Sermo* 243), in Nicolas of Cusa, *Opera omnia,* vol. 29, fasc. 3, *Sermones IV (1455–63),* ed. Walter Andreas Euler and Harald Schwaetzer (Hamburg: Felix Meiner, 2002), 254–55: "Et si attendimus, tunc sensibus spiritualioribus, cum quibus doctrinas venamur, attingimus suo modo pulchrum. Dicimus enim colorem et figuram habere pulchritudinem et similiter vocem, cantilenam et sermonem. Sic visus et auditus pulchritudinem aliqualiter attingunt. Non dicimus odorem pulchrum, nec saporem, nec quae tactui subsunt, quia illi sensus spiritui rationali non sunt ita vicini; sunt enim pure brutales seu animales. Omnes enim hominis sensus ex unione ad intellectualem spiritum sunt nobiliores quam sint in brutis." I thank Karsten Harries for calling my attention to this little-known sermon of Cusanus, and Peter Casarella for helping me to find the source. Unless otherwise indicated, all translations are my own.

2. I quote with permission from Frank Tobin's unpublished translation of Nicolas of Cusa's "Vernacular Sermon on the *Pater Noster.*" For the complete sermon in the original language, see Nicolas of Cusa, *Sermones 1 (1430–41),* ed. Rudolf Haubst et al. (Hamburg: Felix Meiner, 1991), 384–431.

living the life of grace and thus to attain eternal life in Heaven, where our bodies, joined to our souls, will also be beautiful, well-formed, and radiant.[3]

Nicholas expresses here the familiar, orthodox teaching and belief of the medieval church. But how are we to understand this eucharistic eating? Is the eating of the Eucharist a wonderful, unique exception that only proves the rule that beauty should not be eaten, or does it practically undermine that prohibition?

The medieval practice of spiritual Communion confirms the association of sight with the apprehension of beauty. A devout, intent gazing upon the conse-crated Host at its elevation during Mass was often regarded as a substitute for the sacramental consumption of the Eucharist. Even to begin to answer the question "why" is, however, already to deconstruct the simple, aesthetic binary that separates looking from eating; the higher senses of sight and hearing from the lower, bestial senses of touch, taste, and smell. Understood in the context of medieval popular visual theory and piety, to see the Host was to touch it. One could eat it, touch it, taste it, with one's eyes. Gazing upon the Host in adoration meant a real, physical contact with it, a touch, as light rays emanating from the Host beamed into the eye of the adorer; and vice versa, as rays from the beholder's eye extended themselves in a line of vision to the Host.[4] Touch (in Latin, *tangere, tactum*), the basic sense of contact with the world, was held to be the "common term or *proportion*" of the other senses, Thomas Ryba explains, "making them all a species of touch."[5] As a form of touch, "vision was thus the strongest possible access to [the] object of devotion," Margaret R. Miles asserts. "[It] was considered a fully satisfactory way of communicating, so that people frequently left the church after the elevation."[6]

But seeing the Host was not merely a physical act; it simultaneously involved all the spiritual senses, which take as their proper objects spiritual realities.[7] To see the consecrated Host for what it was—Christ—was to see it with the eyes of faith; to hear, to smell, to taste, and ultimately to touch Christ and to be touched by Him. At the base of all the physical senses, touch was paradoxically at the pin-

3. Tobin, trans., "Vernacular Sermon." I thank Peter Casarella for introducing me to Frank Tobin and to this sermon by Cusanus.

4. On the visual ray theory, see David Chidester, *Word and Light: Seeing, Hearing, and Religious Discourse* (Urbana: University of Illinois Press, 1992), 1–24.

5. Thomas Ryba, "Truth and the Sensuous in Theology: Newman, Milbank and Pickstock on the Perception of God," forthcoming in a collection of essays on John Henry Cardinal Newman, ed. Ian Ker and Terrence Merrigan. I quote with Dr. Ryba's kind permission from a typescript of his essay.

6. Margaret R. Miles, *Image as Insight: Visual Understanding in Western Christianity and Secular Culture* (Boston: Beacon Press, 1985), 96–97.

7. For a magisterial essay on this topic, see Karl Rahner, S.J., "The Doctrine of the 'Spiritual Senses' in the Middle Ages," trans. David Morland, O.S.B., in *Theological Investigations*, vol. 16, *Experience of the Spirit: Source of Theology* (New York: Crossroad, 1983), 104–34.

nacle of the spiritual senses in the view of medieval mystics like St. Bonaventure (1221–1274), who associated it with the dark, imageless state of contemplative union, "a knowing and intimacy without mediation" that marked and effected what Ryba calls "a complete transformation of the will in love," its beautification and beatification.[8]

[Through a complex interaction of the physical and spiritual senses, eucharistic eating suggested to mystics like Bonaventure that the exercise of the spiritual senses could in fact alter the physical ones, increasing one's power to apprehend the hidden beauty, visible and invisible, in all things. But how? With their different objects, the spiritual and physical senses would seem to be parallel powers—analogous to rather than continuous with one another. From the time of Origen, dualistic theologies have in fact tended to keep the two sets of senses separate, whereas mystical experience, sacramental reception,[9] liturgical practice, and the doctrine of the resurrection of the body have worked to confirm a mystical continuity between the senses of body and soul,[10] as well as their power to affect one another.[11] If the soul in glory is to effect a transfiguration of the body joined to it, thus allowing for its participation in the four qualities of Christ's resurrected body—*claritas, subtilitas, agilitas,* and *impassibilitas*—then, theologians reasoned, the spiritual and physical senses must somehow be connected. Christ's glorified body and soul, received in the Eucharist, were believed to nourish this human capacity for transfiguration and to guarantee its fulfillment in the life to come.]

The mysterious relationship between the physical and spiritual senses—a connection intrinsically linked to the perception of the literal and spiritual meanings ("senses") of the sacred scriptures—determines, however, that the eucharistic beauty that is eaten and that eats cannot be identified exclusively with Christ's divinity, nor with the properties of Christ's glorified, human body. It must extend to the outward signs of the sacrament; to the plain letter of the scriptures; to the simple forms of bread and wine; to the ritual actions of eating and drinking; to

8. Ryba, "Truth and the Sensuous in Theology," note 2.

9. See Georgia Frank, "'Taste and See': The Eucharist and the Eyes of Faith in the Fourth Century," *Church History* 70.4 (2001): 619–43.

10. See Margaret R. Miles, "Vision: The Eye of the Body and the Eye of the Mind in Augustine's *De Trinitate* and Other Works," *Journal of Religion* (April 1983): 125–42.

11. Ryba draws a comparison to the phenomenon of synaesthesia and coins the term *transaesthesia* to designate "a *thinking* of the relations between sensations" mediated by a *sensus communis* that "must have access to all of these senses," spiritual and physical. Again I quote from a typescript of his forthcoming essay. Chidester also invokes synaesthesia in his treatment of sensory images in mystical theology. See his *Word and Light,* 14–24, 69–72. For an artist's classic commentary on the linkage of the senses, see Wassily Kandinsky, *Concerning the Spiritual in Art,* trans. Michael Sadlier, rev. Francis Golffing, Michael Harrison, and Ferdinand Ostertag (New York: Wittenborn, Schultz, 1947); first published in 1912 as *Über das Geistige in der Kunst.*

the remembrance of Christ's torture, deformity, and death; and thus to the absolute disappearance of beauty. But is this not a contradiction in terms? If beauty must appear, be visible, in order to be beauty (in Latin, *species*), then beauty cannot disappear, cannot be deformed and hidden, cannot be eaten.

The Eucharist seems indeed to have been a source of tension within medieval aesthetics. Umberto Eco, who has taught us so much about the aesthetics of St. Thomas Aquinas (1225–1274),[12] implicitly associates the aesthetic decline of the late Middle Ages not only with the "havoc" wreaked by "late Scholasticism . . . upon the metaphysics of beauty," but also with an excess of eucharistic cult and a crisis in mysticism: "The Victorine aesthetic [had been] a fruitful and forceful one. But how can anyone contemplate the *tranquilitas ordinis,* the beauty of the universe, the harmony of the divine attributes, if God is seen as a fire, an abyss, a food offered to an insatiable appetite?"[13]

As if in answer to Eco, the mystic and philosopher Simone Weil (1909–1943) describes "the beauty of the world" as the "mouth of a labyrinth," at the center of which "God is waiting to eat" the lovers of beauty, but only to transform them: "[They] will have become different, after being eaten and digested by God."[14] God's eating of us and our eating of Him in the Eucharist are not destructive of beauty, she insists, but rather a way to participate in Beauty itself, the same Beauty that expresses itself in obedience to God's law of charity. (*Charis* in Greek, like *gratia* in Latin, connotes what is graceful, pleasing, and seemly; it belongs, as the medieval exegetes understood, to the very meaning of Eu*char*ist.)

There are two ways to eat beauty, according to Weil. One way destroys the beauty of the world and the beloved; the other preserves and enhances it. "The great trouble in human life is that looking and eating are two different operations," she muses.[15] Alluding to Adam and Eve's devouring of the forbidden fruit, she observes, "Vice, depravity, and crime are nearly always, or perhaps always, in their essence, attempts to eat beauty, to eat what we should only look at."[16] "Only

12. Umberto Eco presents Thomistic aesthetics as the high point of scholastic reflection on the metaphysics of beauty, but he makes no mention in that context of the important place of the Eucharist in St. Thomas's theology and spirituality. The word *Eucharist* does not appear in the index to Eco's magisterial book, *The Aesthetics of Thomas Aquinas,* trans. Hugh Bredin, 2nd ed. (Cambridge, MA: Harvard University Press, 1988).

13. Umberto Eco, *Art and Beauty in the Middle Ages,* trans. Hugh Bredin (New Haven: Yale University Press, 1986), 90.

14. Simone Weil, *Waiting for God,* trans. Emma Craufurd (New York: Putnam's, 1951), 164: *Attente de Dieu,* ed. J. M. Perrin (Paris: Fayard, 1966), 153: "La beauté du monde est l'orifice du labyrinthe. . . . Dieu l'attend pour le manger. Plus tard il ressortira, mais changé, devenu autre, ayant été mangé et digéré par Dieu."

15. Weil, *Waiting for God,* 166; *Attente de Dieu,* 156: "La grande douleur de la vie humaine, c'est que regarder et manger soient deux opérations différentes."

16. Weil, *Waiting for God,* 166; *Attente de Dieu,* 156: "Peut-être les vices, les dépravations et les

in the sky, in the country inhabited by God," she writes, "are [looking and eating] one and the same operation."[17] Weil found in the Eucharist a sacramental fore- taste of, and guarantee for, that heavenly looking and eating. It was, she thought, a means properly available to Christians at a certain height of spirituality. Find- ing herself inadequate to its sacramental reception,[18] she feasted on the Host ar- dently with her eyes in adoration, practicing as a paradoxically non-Christian Christian what medieval believers called spiritual Communion and daily draw- ing "transcendent energy" from it.[19]

The Eucharist, Eating, and Art

The enigmatic link between the natural and artistic beauty that is to be contem- plated but not eaten, on the one hand, and the eucharistic beauty that is both seen (with the eyes of faith) and eaten, on the other, intrigues me and inspires this book. One cannot ask theo-aesthetic questions about the Eucharist without engaging fundamental questions about the relationship between beauty, art (broadly defined), and eating. The "anthropocentric analysis" of the Eucharist "ought not to be overlooked," theologian Hans Urs von Balthasar rightly insists, because Christ's Last Supper "is the consummation of all sacral and cultic meals of mankind, which has always realized the naturally mysterious character of eat- ing and drinking . . . and has consequently assigned a cultic form to this sign."[20]

A painting (ca. 1535) by Lucas Cranach the Elder (plate 1) illustrates some of the anthropological issues.[21] Titled *Madonna and Child*, it represents Mary and Jesus without halos. The young mother holds in her left hand a cluster of grapes before her breast, pressing her child's rounded chest with her right hand, to sup-

crimes sont-ils presque toujours ou même toujours dans leur essence des tentatives pour manger la beauté, manger ce qu'il faut seulement regarder."

17. Weil, *Waiting for God,* 166; *Attente de Dieu,* 156: "De l'autre côté du ciel seulement, dans le pays habité par Dieu, c'est une seule et même operation."

18. Simone Weil was, in fact, never baptized with water. She does link her spiritual Commu- nion to the baptism of desire, however, when she tells Fr. Perrin that she has a vocation to remain "on the threshold of the Church, without moving, quite still," while her heart is "transported, for- ever, . . . to the Blessed Sacrament exposed on the altar" (*Waiting for God,* 76): "seulement main- tenant mon Coeur a été transporté, pour toujours, . . . dans le Saint Sacrement exposé sur l'autel" (*Attente de Dieu,* 54).

19. Weil, *Waiting for God,* 221; *Attente de Dieu,* 221: "[I]l est une énergie transcendante. . . ."

20. Hans Urs von Balthasar, *The Glory of the Lord: A Theological Aesthetics,* trans. Erasmo Leiva-Merikakis and ed. Joseph Fessio, S.J., and John Riches, vol. 1, *Seeing the Form* (New York: Crossroad; San Francisco: Ignatius, 1983), 575, 571.

21. I thank the curator of the National Gallery of Art in Washington, D. C., for permission to reproduce this painting.

port him as he stands, naked, before her, one of his feet resting on a tabletop. The child holds a grape to his mouth with his left hand, while his right rests on an apple, which sits upon his plump knee, at the side of his navel and penis, exposed frontally as traditional emblems of Christ's humanity.[22] The mirroring, bodily gestures of mother and child and their similar facial features evoke not only the close physical connection between them, but also the specific nourishing function that makes the mother's body food for the child, the grapes at her breast recalling an earlier breastfeeding with milk. A glass of water and a second apple on the altar-like table recall simultaneously the eucharistic chalice and Host and the Edenic fruit. Even as Adam once ate the fruit presented to him by Eve, now the Christ eats the fruit given him by Mary, assuming human flesh from her, the New Eve. The child himself, however, also resembles food, his plump body like the rounded apple (and the circular Host). Holding him up in a gentle elevation, the priestly mother presents the child to view. Withdrawn from the world of consumables, the food of the painting represents at once a beauty to be seen and not eaten, and a beauty to be received in Communion.

A number of major theorists have associated the very origins of human art with eating. In his lectures on aesthetics, delivered in Berlin in the 1820s, Georg Wilhelm Friedrich Hegel imagined a prehistoric age when human beings were merely sensuous creatures, who desired and consumed the objects within their reach. The emergence of artwork coincided with the development of the human spirit, as humankind contemplated and represented in painting, sculpture, and words what it had previously only eaten. The greater the distance (spatial, temporal, and conceptual) that separated human eaters from the edible objects of their physical desire, the more *homo sapiens* became capable of savoring its own thoughts, drawing spiritual nourishment from its own ideas.[23] Sensuous in its origins as a representation of the edible, art continues to appeal to the physical senses, but only to the higher, theoretical senses of sight and hearing, which distinguish humans from other animals. According to Hegel, "Smell, taste, and touch [*Geruch, Geschmack, und Gefühl*] remain excluded from the enjoyment of art."[24]

Hegel's emphasis on the enjoyment of art, rather than its ritual use-value,

22. See Leo Steinberg, *The Sexuality of Christ in Renaissance Art and in Modern Oblivion*, 2nd ed. (Chicago: University of Chicago Press, 1997).

23. This artistic and reflective distance built on and extended other, natural distances in the human mode of procuring food. Leon Kass emphasizes: "Unlike simple organisms and plants, . . . higher animals (including all vertebrates and the higher invertebrates, like bees, spiders, and squids) live and meet their needs over greater distances. . . . In the realm of awareness, powers of distance, perception and locomotion disclose more of the world" (*The Hungry Soul: Eating and the Perfecting of Our Nature* [New York: Free Press, 1994], 51, 53).

24. Georg Wilhelm Friedrich Hegel, *Aesthetics: Lectures on Fine Art,* trans. T. M. Knox (Oxford: Clarendon Press, 1991), 1:38; *Ästhetik* (Frankfurt: Europäische Verlagsanstalt, 1966), 1:48.

has inspired trenchant criticism. "Artistic production begins," Walter Benjamin (1892–1940) writes, "with ceremonial objects designed to serve in a cult,"[25] which often included sensory experiences of taste, touch, and smell. These objects possessed "aura," according to Benjamin, for a number of related reasons. They possessed "distance," because they had been consecrated and set aside for a ritual use. They were "unique" and "permanent," because they were original, hand-crafted objects that could not be exactly copied. They were, moreover, located in a specific time, place, and community, and "imbedded in the fabric of tradition."[26] This "aura" decays, Benjamin argues, when art becomes detached from its cultic context, is used for exhibition purposes, and begins to be mechanically reproduced (through printing, photography, film). Exhibition and mechanical reproduction free art from a "parasitic" attachment to religion and grant it a supposed autonomy ("art for art's sake"), but they also put art covertly at the service of politics, either as an illusory screen for the economic interests of the elite classes, or as a didactic means (in accord with Bertolt Brecht's "epic theatre") for a Marxian revolution.[27]

Benjamin illustrates the transition from one kind of art to another by pointing to Raphael's *Sistine Madonna,* which was "originally . . . painted for exhibition" at the obsequy of Pope Sixtus.[28] Contrary to the usual practice and indeed in violation of church law, the painting was later used as an altarpiece. The law, Benjamin explains, effectively "devalued Raphael's painting" and other artworks produced for exhibition, reserving the highest honor for those originally intended for ritual use.[29] Although Benjamin does not explicitly refer to the Eucharist, his example of the altarpiece suggests the centrality of the sacrament and of the Mass to the artworks of the Middle Ages.[30]

In an endnote to this essay, Benjamin calls attention to his departure from

25. Walter Benjamin, "The Work of Art in the Age of Its Mechanical Reproduction," in *Illuminations,* trans. Harry Zohn, ed. Hannah Arendt (New York: Schocken, 1969), 224.

26. Ibid., 223.

27. For helpful treatments of Benjamin's essay, see Joel Snyder, "Benjamin on Reproducibility and Aura: A Reading of 'The Work of Art in the Age of Its Technical Reproducibility," in *Benjamin: Philosophy, History, and Aesthetics,* ed. Gary Smith (Chicago: University of Chicago Press, 1989), 158–74; Sándor Radnóti, "Benjamin's Dialectic of Art and Society," ibid., 126–57; Yvonne Sherrat, "Aura: The Aesthetic of Redemption?" *Philosophy and Social Criticism* 24.1 (1998): 25–41.

28. Benjamin, "Work of Art," in *Illuminations,* 223.

29. Ibid.

30. Benjamin's basic distinction between the arts of religious devotion and of exhibition has found an echo among art historians. See, for example, Hans Belting, *Likeness and Presence: A History of the Image before the Era of Art,* trans. Edmund Jephcott (Chicago: University of Chicago Press, 1994). On the functionality of the altarpiece in particular, see Beth Williamson, "Altarpieces, Liturgy and Devotion," *Speculum* 79.2 (2004): 341–406. Williamson argues that "altarpieces can and did function . . . as foci for devotional prayer and activity as well as liturgical ritual" (404).

Hegel. Hegel's "idea of beauty," he observes, comprises "these polar opposites [of cult and exhibition value] without differentiating between them."[31] The "aesthetics of [Kantian] Idealism" simply could not recognize the fundamental differences in use-value that separate premodern from modern art, and yet, Benjamin concedes, Hegel had a limited awareness of "this polarity."[32] In support of this claim, Benjamin cites a passage from Hegel's *Philosophy of History* where Hegel acknowledges the existence from earliest times of sacred objects used in worship and distinguishes them from the (necessarily beautiful) works of fine art. As a second proof, Benjamin quotes the following sentence from Hegel's *Aesthetics:* "We are beyond the stage of reverence for works of art as divine and objects deserving our worship."[33] In this way, Rainer Rochlitz observes, "Benjamin traces the awareness of a crisis in the aura back to Hegel."[34]

Whereas Benjamin worries concerning Hegel's thesis about the decline and imminent end of art, others have been troubled by Hegel's account of its beginning. Hegel's idealist account of the historical development from eaters to artists raises the troubling question of what exactly was being eaten to occasion such a transition. Sigmund Freud (1856–1930) did not hesitate to place an act of cannibalism—the eating of the Father by the primal horde of his sons—at the start of human civilization.[35] Revising Freud's psychoanalytic thesis and correcting the structuralist account of Claude Lévi-Strauss, René Girard has argued that ancient societies secured their communal survival through the operation of the so-called victimage mechanism, whereby the expulsion or murder of a human scapegoat served to reunite competing groups, whose members then expressed and secured their restored unity through an often cannibalistic feast. Girard observes: "The eating of sacrificial flesh, whether animal or human, can be seen in the light of mimetic desire as a veritable cannibalism of the human spirit in which the violence of others is ritually devoured. . . . [T]he victim is eaten only after he has been killed, after the maleficent violence has been completely transformed into a beneficent substance, a source of peace, strength, and fecundity."[36]

The various art forms—dance, drama, music, poetry, scene painting, sculp-

31. Benjamin, "Work of Art," in *Illuminations*, 244n8.

32. Ibid.

33. Ibid., 245; cf. Hegel, *Aesthetics*, 1:10; *Ästhetik*, 1:21.

34. Rainer Rochlitz, *The Disenchantment of Art: The Philosophy of Walter Benjamin*, trans. Jane Marie Todd (New York: Guilford , 1996), 149.

35. See Sigmund Freud, "Civilization and Its Discontents," in *Civilization, War, and Death*, ed. John Rickman, Psycho-analytical Epitomes 4 (1929; London: Hogarth, 1968), 26–81; *Totem and Taboo: Resemblances between the Psychic Lives of Savages and Neurotics*, trans. A. A. Brill (1913; New York: Random, 1946).

36. René Girard, *Violence and the Sacred*, trans. Patrick Gregory (Baltimore: Johns Hopkins University Press, 1979), 277.

ture, architecture—are closely tied in their origins to religious feasts of sacrifice, according to Girard, because artistic mimesis is structurally adequate to other forms of mimesis (educative, acquisitive, competitive, contagious). Art provides the community with a means, first, to free itself from guilt by displacing it through a mythic narrative onto the polluted victim; then, to harmonize the conflict of doubles in symmetrical representations (including the mirror-like movements of dance); and thus to ward off, by means of a ritualized reenactment and surrogate victim, the actual repetition of the real violence that is regularly precipitated by a mimetic crisis.[37]

Anthropologists affirm both the historical reality of cannibalism and its cultural extension (via projection) in the form of persecutory charges against any minority group that is perceived by the dominant society to be threatening.[38] Whereas Girard proposes his adaptable, mimetic theory as a single explanation for different forms of cannibalism, other theorists seek to delineate a range of possible causes that take into account what Peggy Reeves Sanday, in her study of 156 societies, calls "the diversity in the cultural content of cannibal practice."[39] Drawing upon Paul Ricoeur's *The Symbolism of Evil*, Sanday does not hesitate, however, to reduce this "cultural content" to a "dichotomous variable."[40] Distinguishing between the "exocannibalism (the cannibalism of enemies, slaves, or victims captured in warfare)" and "endocannibalism (the cannibalism of relatives)," Sanday "conceptualizes cannibalism as a cultural system, that is, a system of symbols and ritual acts that provides models of and for behavior."[41] Predicated upon a "dialectal opposition" between self and other, cannibalism seeks to resolve that opposition "either by synthesizing the other as part of the self [endocannibalism] or by negating the other in the self [exocannibalism]."[42] To practice eucharistic Communion rather than cannibalism, Sanday suggests, is to provide a different model for human behavior and civilization, one based on reciprocity, paradox, and mediation.[43]

37. Ibid., 290–97. On the anti-mimetic taboo and the imperative mimesis of ritual, see René Girard, *Things Hidden since the Foundation of the World*, trans. Stephen Bann and Michael Metteer (Stanford: Stanford University Press, 1987), 10–23.

38. See Peggy Reeves Sanday, *Divine Hunger: Cannibalism as a Cultural System* (Cambridge: Cambridge University Press, 1986), 51.

39. Ibid., 7.

40. Ibid., 8.

41. Ibid., 7, 31.

42. Ibid., 33, 36.

43. Sanday writes: "Postulates that construct biological reality in terms of metaphysical entities or in terms of a reciprocal relationship between subject and object are not likely to be associated with cannibalism, as cannibalism in these cases would not be appropriate for social and individual regeneration. Additionally, an ethos that emphasizes accommodation and integration

Tracing the many metaphors of incorporation, Maggie Kilgour has shown that countless artists have used images of eating, chewing, digestion, cooking, and alchemical sublimation to describe "the material base . . . of [their] artistic creation" in its relationship to the world of nature.[44] Her constant theme is that such images, like "actual eating," undermine the binary distinction between things "inside me *or* outside me" and thus between self and other.[45] Such "dualisms," she argues, "depend on a promise of a false transcendence or sublimation, the end of all opposition, which is in fact achieved through the cannibalistic subsumption of one term by the other."[46] Eating becomes a way of absorbing everything greedily and defensively into oneself. While Kilgour acknowledges that "there is a potential for cannibalism in the sacrament of the Eucharist," she emphasizes that "communion sets up a more complicated system of relation in which it becomes difficult to say precisely *who* is eating *whom*."[47] As an act of "reciprocal incorporation," Communion provides "the beginnings of a model for relations that go beyond the binaries that lead to cannibalism."[48] Unfortunately, Kilgour concludes, in the historical "struggle . . . between communion and cannibalism, cannibalism has usually won," one product of that victory being "the identity of the modern subject or individual who desires to eat without in turn being eaten."[49]

Whereas cannibalism aims at the loss of the Other (either through the Other's absolute destruction or through his absorption into the eater), Communion aims at the loss of the "I" in either the "you" or the "we." Commenting on this inversion of cannibalism, Karl F. Morrison emphasizes the mimetic element in the Eucharist, wherein the human communicant eats God, and God eats him or her to achieve a mutual in-one-anotherness, which is the precondition for empathetic understanding.[50] Such a sacramental assimilation, Morrison writes, was "of primary importance to the biological paradigm" of empathy, but it also con-

with cosmic or social forces, as opposed to the domination or control of those forces, finds in cannibalism a ready symbol of evil" (*Divine Hunger,* 55).

44. Maggie Kilgour, *From Communion to Cannibalism: An Anatomy of Metaphors of Incorporation* (Princeton: Princeton University Press, 1990), 102.

45. Ibid., 239.

46. Ibid., 238–39.

47. Ibid., 15. As evidence of the potential for cannibalism in eucharistic practice, Kilgour points to historical instances of cannibalistic libel that actually reflect the cannibalism of the accusor: "To accuse a minority that resists assimilation into the body politic of that body's own desire for total incorporation is a recurring tactic: during the Middle Ages the Jews were accused of cannibalism, after the Reformation the Catholics were, and Christ has continually been accused of being the head of a Jewish cannibal sect" (5).

48. Kilgour, *From Communion to Cannibalism,* 15.

49. Ibid., 7.

50. Karl F. Morrison, *"I am You": The Hermeneutics of Empathy in Western Literature, Theology, and Art* (Princeton: Princeton University Press, 1988), 9–10.

tributed to "esthetic paradigms of assimilation," involving either "the wholeness of a single composition" or "the bonding through feelings of a viewer with something in the work of art."[51] Derived from the "primordial distinction between body and soul, and between the two corresponding ways of giving form—procreation and composition," the "paradigms drawn from biology and art converged" repeatedly, Morrison writes, in the historical discussions of topics like the Eucharist, where things seen and unseen, physical and spiritual, are conjoined.[52] Thus the "biological and esthetic facts of human existence were woven into broad theories about the cognitive evolution of society through struggle, and indeed, into the movement of that evolution itself."[53]

Philosopher Leon Kass also links eating and art with evolutionary patterns in human history. Defining the human being as *Omniverosus erectus*, he charts the close connection of eating with the spiraling forms of human civilization—hunting and agriculture; the ethics involved in distributive justice and especially in hospitality toward the stranger-guest (the inverse of which is cannibalism);[54] table etiquette; the arts of conversation, including philosophical symposia; and religious feasts and fasts. Kass argues that the human eating of bread, rather than Edenic fruit or the meat of hunters (neither of which require extensive preparation), is coincident with an evolutionary moment when the human becomes an artist in the full sense of that word: "A transformer of nature, a practitioner of art, a restrainer of his own appetites, a settled social creature soon with laws and rules of justice, poised proudly, yet apprehensively between the earth and the cosmic powers—man becomes human with the eating of bread."[55] Kass regards this artistic development as a proof that the Fall—Adam and Eve's eating of the forbidden fruit—was indeed fortunate: "The expulsion from the garden is coupled with a shift from fruit to bread [cf. Genesis 3:19], *the* distinctly human food, and marks the next step toward humanization through civilization."[56] The making of bread from grain, after all, is a complex process in many stages that requires an "artistic transformation" of raw materials.[57] The same community that works together to produce bread is strengthened, in turn, through meal-sharing and companionship on life's journey.

51. Ibid., 8, xxiv.

52. Ibid., xxv.

53. Ibid.

54. In a chapter entitled "Host and Cannibal," Kass terms cannibalism the inverse of hospitality. See *The Hungry Soul,* 99–103. Although Kass does not explicitly compare the god disguised in the needy stranger to Christ in the "least" of His "brethren" (Matt. 25:40), nor to Christ hidden in the eucharistic Host, the comparison is apt.

55. Kass, *The Hungry Soul,* 122.

56. Ibid., 211.

57. Ibid.

In a concluding chapter, Kass shows the formative power of the biblical dietary rules in Leviticus in the life of observant Jews and elucidates their proper meaning in restoring the created order described in Genesis.[58] Their observance, he writes, affects the total form of Jewish communal life and "push[es] back in the direction of the 'original' 'vegetarianism' of the pristine and innocent Garden of Eden."[59] Kass's identification of bread as the distinctively *human* food in the postlapsarian order neatly corroborates the patristic and medieval Christian opposition of the Eucharist and the apple, discussed in chapter 2 of this book. Fittingly chosen by Christ as a sign of human art, the bread becomes through consecration the appearance of Beauty itself, the sacramental form of Christ, the Word through whom God the Father created all things (cf. John 1:1–3).

For a human society normed by the Eucharist, therefore, cannibalism stands as a particularly horrible symbol of evil. Reay Tannahill insists that Christians have viewed "human sacrifice and cannibalism in fundamentally disproportionate horror," due to the spiritual importance of the human body in Christian thought and the doctrine of bodily resurrection.[60] Geraldine Heng, for her part, emphasizes that medieval Christian culture as a whole found its "apotheosis" in the Eucharist, which unified its members in the one church, fostered their personal and communal salvation, and provided a means for their actual divinization "through union with godhead."[61] European Christendom therefore suffered an unspeakable cultural trauma, she asserts, when Christian soldiers in 1098 reverted to cannibalism at Ma'arra, Syria, during the First Crusade, eating the decayed bodies of the Saracen dead and thereby becoming identical with the monstrous Other. This historical trauma, triggered by a horror unspeakable in itself, gave rise, in turn, to artistic forms—romance as a genre, the legends of the Grail, the imagery of courtly love—all of which, Heng argues, gave the cannibalistic experience of the Crusades a displaced expression and a means of redress: "For romance does not repress or evade the historical—as has sometimes been claimed—but *surfaces* the historical, which it transforms and safely memorializes in an advantageous form, as fantasy."[62] In the chivalric rescue of beautiful maidens from flesh-devouring monsters and their ilk, according to Heng, one

58. For a fascinating study of the "hidden" reasons behind the Jewish dietary laws, see Herbert Weiner, "On the Mystery of Eating: Thoughts Suggested by the Writings of Rav Abraham Isaac Kuk," in *Standing before God: Studies on Prayer in Scriptures and in Tradition, with Essays in Honor of John M. Oesterreicher,* ed. Asher Finkel and Lawrence Frizzell (New York: Ktav, 1981), 329–38.

59. Kass, *The Hungry Soul,* 223.

60. Reay Tannahill, *Flesh and Blood: A History of the Cannibal Complex* (London: Abacus, 1996), 32.

61. Geraldine Heng, *Empire of Magic: Medieval Romance and the Politics of Cultural Fantasy* (New York: Columbia University Press, 2003), 26.

62. Ibid., 46.

finds the allegorical, metaphoric transformation of a cultural memory of dehumanizing cannibalism, pollution, and cross-cultural contamination.[63]

Whereas Heng finds a eucharistic narrative displaced and embedded in the exoticism of romance, I find a more wondrous romance in the medieval lives of the saints (*legenda*), which were often explicitly eucharistic in content, recounting miracles and visions associated with the Host in the larger context of narratives of personal and communal conversion. These stories, in turn, became part of the eucharistic celebration as they were retold in homilies on the saints' feasts and depicted in painted icons, stained-glass windows, reliquaries, and statues in churches. The moral and spiritual miracles of changed lives were thus linked metonymically to transformative meditation on the scriptures (traditionally imaged as a chewing and savoring of the text), to the transubstantiation of bread and wine, to sacramental Communion, and to artistic production, including the writing of *legenda*.

What the chivalric romances and the eucharistic *legenda* share is the tale of a quest or a journey, which can be a "way" of holiness. Alasdair MacIntyre has taught us that "every particular view of the virtues is linked to some particular notion of the narrative structure or structures of human life."[64] This book argues that the Eucharist established for the people of the Middle Ages distinctive schools of sanctity, whose members were united by the scriptural Word and the eucharistic sacrament that they received as the strengthening food of wayfarers (*viaticum*). Their narratives of these distinct "ways" begin with different interpretations of the first sin and thus of the virtues necessary for beauty's restoration. The particular paths of holiness they pursued were marked, first, by the unique images of Christ they followed, which were embodied for them in the Eucharist; and second, by the corresponding virtues, received in the Eucharist, which were necessary for the journey's continuation and completion. Eating the Eucharist was thus simultaneously to "see" Christ and to "touch" this vision, to reach out for it, and to embody it virtuously. More basically it was to be seen and eaten by Christ, drawn to Him, and incorporated into Him as "the way, the truth, and the life" (John 14:6). Eating the Eucharist was, in short, productive of an entire "way" of life, a virtuous life-form, an artwork, with Christ Himself as the principal artist.

63. In her *Consuming Passions: The Uses of Cannibalism in Late Medieval and Early Modern Europe* (New York: Routledge, 2003), Merral Llewelyn Price also documents the popular fascination with exotic narratives of cannibalism. She argues that medieval Christians were anxious about a cannibalistic potential in their own eucharistic reception and therefore projected cannibalistic fantasies onto various Others. See also Liz Herbert McAvoy and Teresa Walters, eds., *Consuming Narratives: Gender and Monstrous Appetites in the Middle Ages and Renaissance* (Cardiff: University of Wales Press, 2002).

64. Alasdair MacIntyre, *After Virtue: A Study in Moral Theory*, 2nd ed. (Notre Dame, IN: University of Notre Dame Press, 1984), 174.

Caroline Walker Bynum's important *Holy Feast and Holy Fast,* to which this book offers a delayed response, gives no account of the crucial, rich, theo-aesthetic discourse of the virtues in medieval eucharistic piety. Inspired in part by the work of anthropologist Victor Turner, Bynum has argued that medieval women, because of their societal role as food preparers, and also because of their bodily identification with food as mothers and nurses, identified closely with Christ in the Eucharist. This identification expressed itself metaphorically in their almsgiving, fasting, and religious writings; in the works of visual art that were inspired by their eucharistic piety; and in their visionary encounters with Christ.[65] They "gloried in the pain, the exudings, the somatic distortions that made their bodies parallel to the consecrated wafer on the altar and the man of the cross."[66] Bynum finds "beauty and hope" in this embodiment,[67] and she illustrates *Holy Feast and Holy Fast* with many reproductions of medieval artwork, but she does not speak of beauty per se, nor does she emphasize the aesthetic dimension of the formal parallels she observes. Her thesis of a feminine, eucharistic identification does not, moreover, manifest itself in the same way or to the same degree in all women saints and mystics, as she herself acknowledges. Recovering the discourse of the virtues allows us to differentiate among the various eucharistic receptions according to the life-forms of distinct spiritualities.

Spiritual Arts and Life-Forms

In the epilogue to *Holy Feast and Holy Fast,* Bynum quotes the words of Simone Weil about the temptation "to eat beauty," highlighting the resonant phrase that inspired the title of this book. Like Weil, I take my bearings from two ways of eating beauty. The first, manifestly destructive way is represented in the Judeo-Christian tradition in the biblical story of the Fall of Adam and Eve, who ate the forbidden fruit and suffered the loss of Eden, the loss of paradisiacal beauty, as a consequence. As I show in chapter 2, medieval exegetes interpreted this first sin

65. Critical of Bynum's sympathetic thesis, some cultural historians have stressed that a piety centered on the Passion of Jesus has yielded not only saintly works of mercy, but also religious persecution. See Thomas H. Bestul, *Texts of the Passion: Latin Devotional Literature and Medieval Society* (Philadelphia: University of Pennsylvania Press, 1996); David Aers and Lynn Staley, *The Powers of the Holy: Religion, Politics, and Gender in Late Medieval Culture* (University Park: Pennsylvania State University Press, 1996); Kathleen Biddick, "Genders, Bodies, Borders: Technologies of the Visible," *Speculum* 68 (1993): 389–418.

66. Caroline Walker Bynum, *Holy Feast and Holy Fast: The Religious Significance of Food to Medieval Women* (Berkeley: University of California Press, 1987), 296.

67. Ibid., 300.

in different ways: as pride, avarice, gluttony, and disobedience. The Eucharist, identified with Christ as the Tree of Life, was understood to be mystically present already in Paradise; that same life-giving food—sacramentally present in the scriptural Word of God and in the eucharistic Host—was received by Christian wayfarers, exiled from Eden, as an antidote for the poisonous effects of the apple. To eat the Eucharist was, therefore, to implant in the very ground of one's soul the seed of the Tree of Life, the embryonic beginning in Christ of all personal virtue, and the actual potential through Him for a new, everlasting Paradise. Medieval saints, such as St. Catherine of Siena (1347–1380), saw this new Paradise blossoming within themselves through visions of beautiful orchards, filled with trees of life and virtue, on which they fed and from which they plucked luscious fruit for others.

Given the remedial and restorative quality of the Eucharist, Christ was received in the sacrament under the aspect of different root virtues, depending on the interpretation of the first sin: humility (to counteract pride), poverty (to eradicate avarice), preaching and abstinence (to atone for gluttony), and obedience (to conquer disobedience). Thus the one Christ took *form* (the essential quality of the beautiful) through divine grace and human striving in four different "ways" of holiness during the Middle Ages, each of them aimed at the artistic restoration of God's likeness in humanity: (1) the monastic way of humility and self-knowledge, exemplified in this study by the Cistercians; (2) the Franciscan way of poverty; (3) the Dominican way of fasting and preaching; and, at the very end of the Middle Ages, the Ignatian way of Christlike obedience.

These four medieval spiritualities—Cistercian, Franciscan, Dominican, and Ignatian—differ in their respective, eucharistic answers to the related questions, "What was the first sin, and how may its effects be reversed?" The four spiritualities have, of course, often been studied individually. They have never, however, been grouped together as an array of possible answers to the single question of the first sin, nor have they been interrogated from the perspective of their distinctive understandings of beauty, insofar as an ideal of beauty is inseparable from the ardent pursuit of holiness. Assembling them, as I do, allows for a comparative treatment of them as forms of Christian life, as distinctive ways of eating beauty.

My approach throughout this book may be described as theo-aesthetic, in keeping with Richard Viladesau's broad understanding that "theological aesthetics . . . comprises both an 'aesthetic theology' that interprets the objects of theology . . . through the methods of aesthetic studies, and a more narrowly defined 'theological aesthetics' that interprets the objects of aesthetics—sensation, the beautiful, and art—from the properly theological starting point of religious con-

version."[68] It thus participates in a growing movement of scholarship that, building upon the theoretical insights of Karl Barth, Gerardus van der Leeuw, and Hans Urs von Balthasar, seeks not only to redress the neglect of the category of the beautiful within theology itself, but also to bridge the gap between philosophical aesthetics, theology, ethics, and practical art criticism.[69]

My concern is to see the four aforementioned spiritualities (Cistercian, Franciscan, Dominican, and Ignatian), as they are realized in the lives of particular saints, as distinctive life-forms or (to echo the title of Richard Rolle's medieval treatise on contemplative prayer and asceticism) "forms of living"[70] that allow us to grasp "the incarnation of God's glory, and the consequent elevation of man to participate in that glory."[71] Connecting such life-forms in their sensuous concreteness with Beauty itself, Balthasar asks, "What is a person without a life-form, that is to say, without a form which he has chosen for his life, a form into which and through which to pour out his life, so that his life becomes the soul of the form, and the form becomes the expression of his soul? . . . To be a Christian is precisely such a form," a conformity with Christ, and an imitation of him.[72]

Given the indispensable importance of particular saints to the forging of the different ways of holiness studied in this book, I discuss the various spiritualities (for the most part) not in accord with their abstract presentation in the Rules and Constitutions of the respective Orders, but rather from the lives (biographical and autobiographical) of the charismatic men and women who gave these "ways" a living form through their eucharistic eating. If these *legenda* are themselves artwork (as indeed they are), so that all the saints' lives are always already interpreted and mediated for us, this artwork fittingly reverences, responds to, and thereby bears witness to a perceived, historical beauty in the saints themselves, art answering to art.

68. Richard Viladesau, *Theological Aesthetics: God in Imagination, Beauty, and Art* (New York: Oxford University Press, 1999), 23.

69. See Gerardus van der Leeuw, *Sacred and Profane Beauty: The Holy in Art,* trans. David E. Green (New York: Holt, Rinehart, and Winston, 1963); F. David Martin, *Art and the Religious Experience: The 'Language' of the Sacred* (Lewisburg: Bucknell University Press, 1972); Frank Burch Brown, *Religious Aesthetics: A Theological Study of Making and Meaning* (London: Macmillan, 1990); James Alfred Martin Jr., *Beauty and Holiness: The Dialogue between Aesthetics and Religion* (Princeton: Princeton University Press, 1990); Karl Rahner, "Art Against the Horizon of Theology and Piety," *Theological Investigations* 23 (*Final Writings*), trans. Joseph Donceel, S.J., and Hugh M. Riley (London: Darton, Longman, and Todd, 1992), 162–68; Karl Barth, *The Doctrine of God,* in *Church Dogmatics,* ed. G. W. Bromiley and T. F. Torrance, trans. T. H. L. Parker, W. B. Johnston, Harold Knight, and J. L. M. Haire (Edinburgh: T. and T. Clark, 1957), vol. 2, part 1, 650–77.

70. See "The Form of Living," in *Richard Rolle: Prose and Verse,* ed. Sarah Ogilvie-Thomson, EETS, old series, 293 (London: Oxford University Press, 1988), 1–25.

71. Balthasar, *Glory of the Lord,* 1:125.

72. Ibid., 1:24, 28.

The saints, upon whose lives I reflect in this book, frequently seem to have been conscious of themselves as artists at work to carve, polish, and refine their very selves through an imitable asceticism into the particular *forma* of Christ to which they were drawn through the Eucharist. St. Francis of Assisi (ca. 1182–1226), for example, went out into the winter cold one night and, laughing, fashioned snow-men in order to cool his desires.[73] St. Rose of Lima (1586–1617) designed her own instruments of penance, which cut into her flesh, and she saw herself in vision as a sculptor in an artist's studio, weeping as she carved.[74] The frequency, moreover, with which sacramental works of art—icons, statues, crucifixes—both mediated the religious experience of the saints and recorded them for others not only confirms a metaphoric analogy between the saint's life, on the one hand, and the aesthetic object, on the other, but also suggests a metonymic relationship between them, whereby the artwork actually participates instrumentally in the theo-aesthetic work of saintly formation.

Noting the modern "survival of asceticism in art and criticism," Geoffrey Galt Harpham has called attention to a close connection between asceticism and aesthetics.[75] Whereas Harpham emphasizes the ascetic's own creative efforts, however, in order to argue for asceticism as a "historical constant" rather than a "transcendental event,"[76] I call attention to the virtuous activity of Christ Himself, present in the Eucharist as a work of aesthetic re-creation aimed at beautifying the communicant, the community, and indeed the cosmos. If Stephen Greenblatt is correct in noting "in the sixteenth century . . . an increased self-consciousness about the fashioning of human identity as a manipulable, artful process," that increase in "self-fashioning" may reflect, in fact, a reduced faith in the formative, artistic power of the Eucharist.[77] The reciprocal relationships of mutual indwelling and co-operation established by eucharistic reception allow for both human and divine activity and complicate the analogies between the ascetic and the artist to which Harpham points, because the artists (divine and human) in this theo-aesthetic, sacramental scheme are also artworks, even as the eaters are simultaneously eaten. Structures of difference (subject/object) and discontinuity become structures of mutual identification, participation, and continuity.

73. St. Bonaventure relates this episode in chapter 5 of his *Long Life of Saint Francis,* which is discussed in chapter 4 of this book.

74. On this topic see chapter 5 of this book.

75. Geoffrey Galt Harpham, "Asceticism and the Compensation of Art," in *Asceticism,* ed. Vincent L. Wimbush and Richard Valantasis (New York: Oxford University Press, 1995), 368, 357. See also Geoffrey Galt Harpham, *The Ascetic Imperative in Culture and Criticism* (Chicago: University of Chicago Press, 1987).

76. Harpham, "Asceticism," 368.

77. Stephen Greenblatt, *Renaissance Self-Fashioning from More to Shakespeare* (Chicago: University of Chicago Press, 1980), 2.

The words of the first canon of the Fourth Lateran Council (1215) give dogmatic expression to this mysterious reciprocity, emphatically linking Christ's incarnation to His death and resurrection, to eucharistic transubstantiation, and ecclesial Communion: "[In] this church, Jesus Christ is himself both priest and sacrifice, and his body and blood are really contained in the sacrament of the altar under the species of bread and wine, the bread being transubstantiated into the body and the wine into the blood by the power of God, *so that to carry out the mystery of unity we ourselves receive from Him the body He himself receives from us.*"[78]

Medieval formulations of eucharistic doctrine are, I hope to show, strikingly aesthetic, expressed in a paradoxical vocabulary that both echoes and revises classical notions of the beautiful. Chapters 2 and 7 provide a theo-aesthetic frame, medieval and modern, for chapters 3 through 6, which deal with the four spiritual "ways" and their respective, virtuous "arts" of humility, poverty, preaching, and obedience. In these framing chapters I address aesthetic questions and interests specifically as they arise in doctrinal contexts, in an attempt to grasp the perceived, theoretical relationship between beauty and the sacrament.

The Beauty of the Eucharistic Christ:
Form and Deformity

Because the whole Christ (*totus Christus*) was understood by orthodox medieval Christians to be present in the Host, the questions concerning eucharistic beauty are inevitably Christological and ecclesial. They address the beauty of Christ in His divinity as the Son of the Father and the preexistent Logos, through whom "all things were made" (John 1:3) and are refashioned. They meditate on Christ's beauty in His humanity—born of Mary, morally just, cruelly crucified, and radiantly risen. They consider the beauty of the Lord in His salvific, spousal relationship to the church and to the individual soul. Finally they regard the beauty of the sacrament itself as an artwork instituted by Christ and enacted by the church through consecration, adoration, Communion, and charitable service.

Although these reflections on eucharistic beauty show a definite development during the Middle Ages, reaching a certain climax in the thirteenth century with the institution of the feast of Corpus Christi, they all refer back in various ways

78. Decrees of the Fourth Lateran Council, canon 1 (ed. Henry Denzinger, in *Enchiridion symbolorum: Definitionum et declarationum de rebus fidei et morum,* ed. Adolfus Schönmetzer, 34th ed. [Barcelona: Herder, 1967], document 802, p. 260), trans. in Bynum, *Holy Feast,* 50. Emphasis mine.

to the Augustinian question (discussed in chapter 2) of the *Christus deformis*. Like
Hegel after him, St. Augustine, who was well versed in neo-Platonic aesthetics and
Ciceronian stylistics, recognized that Christian revelation challenged classical
notions of the beautiful. Expressed in biblical terms, how was Christ as the proph-
esied Suffering Servant of Isaiah 53:2, in whom there is "no beauty," to be recon-
ciled with Christ as the messianic prince of Psalm 44:3, who is "fairer in beauty
. . . than the sons of men"?[79] How was the beautiful form of Christ's divine na-
ture to be reconciled with the crucified form of a human slave (cf. Phil. 2:5–8)?
How was the verdant Tree of Life to be identified with the bloody wood of the
cross? How, in short, could a manifest deformity—the wounds of Christ and the
loss of *integritas* (inviolate wholeness) they represent—be beautiful (as indeed
they must be, since the God-Man never ceases to be God, who is eternal Beauty)?
What about the apparent deformity of the biblical plain style, which is so inade-
quate to the beauty of the revealed truth it conveys?[80] And what of the deformity
whereby the God-Man takes the form, the appearance, of the Host?

Although Augustine and others offer various answers to these questions, the
fundamental response, reiterated in various ways, involves a reciprocal relation-
ship between the *Christus deformis* of the Eucharist and the reform of the human
person, created in the "image and likeness" of God (Gen. 1:26): "The deformity of
Christ forms you, for had he not willed to be deformed, you would not have re-
gained the form which you had lost."[81] Interpreting the Fall in various ways and
seeking its remedy through the infusion and practice of correspondent virtues,
received in the sacrament, the four different spiritualities surveyed in this book
each gave a different response to the theo-aesthetic problem that occupied
Augustine.

For the Cistercians the body of the crucified Christ—like the figurative, car-
nal language of scripture and the outward, sensible signs of bread and wine in the
Eucharist—is both a veil to cover, and a revelation of, the divine love that seeks

79. Throughout this book, unless otherwise indicated, I use the Douay-Challoner version of
the Holy Bible, ed. John P. O'Connell (Chicago: Catholic Press, 1950), because of its similarity to
the Latin Vulgate.

80. St. Augustine's reflections on the problem of the *Christus deformis* are remarkably similar
to his comments on the plain style of the Bible, which did not appeal to his classically trained
sense of eloquence. The story of his conversion, as related in his *Confessions*, narrates a shift from
a youthful disdain of the scriptures (3.5: "for my inflated pride shunned their style") to an ad-
miring appreciation of their "profound significance," communicated through "the great plainness
of its language and lowliness of its style" (4.5). On this topic, see Erich Auerbach, "*Sermo humilis*,"
in *Literary Language and Its Public in Late Latin Antiquity and in the Middle Ages*, trans. Ralph
Manheim (London: Routledge and Kegan Paul, 1965), 27–66.

81. St. Augustine, *Sermo XXVII*, PL 38, col. 181: "Deformitas Christi te format. Ille enim si de-
formis esse noluisset, tu formam quam perdidisti non recepisses."

as its match and spouse the "black but beautiful" bride of the Song of Songs (1:4), identified as the Christian soul. Through the mystical marriage of divine and human natures by which Christ knows His bride even in her suffering and sin, she comes to know herself as she truly is, and her dissimilarity to Christ is overcome. The similitude of bride and bridegroom, realized through a supreme art of humility, is thus the beauty of the *Christus deformis et gloriosus.*

In chapter 3 I focus on the writings and lives of Saints Bernard of Clairvaux (1090–1153) and Gertrude of Helfta (ca. 1256–1301) as exemplars of this Cistercian way of holiness.[82] Aspiring after humility (true self-knowledge), Bernard practiced the monastic *lectio divina* as an artform, ruminating, feasting, digesting, and expounding on the scriptures. Renouncing the curious, decorative images of visual art as a superficial distraction for monks, Bernard practiced instead an "aesthetics of mneme" (to use Mary Carruthers's apt phrase),[83] filling the soul's house of memory with vivid, biblical images, artistically arranged and combined in accord with his personal experience. These memorial images, in turn, effected, expressed, and safeguarded for Bernard and his monks the restoration of the soul's likeness to the *imago Dei* (image of God) in which it was created—a heavenly *imago* beyond all earthly *imagines.*

Following St. Bernard's example and invoking his authority to confirm her practices, St. Gertrude likewise sought to know herself in relation to God and others. Whereas Bernard read and chewed the scriptures as if they were the Eucharist, however, Gertrude "read" the Eucharist as if it were a text, as her reception of the sacrament occasioned vision after vision. For Gertrude the plainness of the eucharistic Host, like the unadorned walls of the Cistercian church, was the paradoxically imageless trigger of visionary experience, the memorial site par excellence for the whole imaginary of salvation, self-discovery, and divine revelation. The differences between Gertrude and Bernard's attitudes toward visionary experience and visual art have been exaggerated, I argue, by scholars who have compared writings composed in dissimilar genres. These Cistercian saints are remarkable for their joint theo-aesthetic extension of the Augustinian problem of the *Christus deformis* into an entire anthropology of desire and redemption. In

82. There is, in fact, some scholarly disagreement about whether Gertrude of Helfta was a Cistercian or a Benedictine nun. Even if Helfta was technically a Benedictine abbey (and this is doubtful), it was so thoroughly influenced by Cistercian spirituality that one can refer to Gertrude as Cistercian. Frank Tobin refers unhesitatingly to "the Cistercian community at Helfta" in his introduction to Mechthild of Magdeburg, *The Flowing Light of the Godhead,* trans. Frank Tobin (New York: Paulist Press, 1998), 5.

83. Mary J. Carruthers, *The Craft of Thought: Meditation, Rhetoric, and the Making of Images, 400–1200,* Cambridge Studies in Medieval Literature 34 (Cambridge: Cambridge University Press, 2000), 86.

the "black but beautiful" bride of the Song of Songs, who is wounded by love, they discover the *Christiana deformis* as a self-image to match the divine bridegroom's.

For the Franciscans the beauty of the *Christus deformis* is revealed in the poverty and the wounds of St. Francis of Assisi, stigmatized on Mount la Verna in 1224. His wounds, pierced by a seraph, become the quintessential revelation of a kenotic love that breaks into the world, pouring itself forth in a ceaseless, self-emptying stream of light and radiance. Blurring the differences between relic, icon, and sacrament, painted scenes from the life of the saint served in the Middle Ages as altarpieces, representing the life of Christ in that of Francis, Christ's perfect *imitatio* and work of art.

In Chapter 4 I examine St. Bonaventure's patterned, artistic *Legenda maior* (*Long Life*) of St. Francis as a sustained meditation on the beauty of that saint's life as a eucharistic beauty, characterized by outward poverty of appearance and revealed in a seraphic piercing of Francis's body, analogous to the breaking of bread. In Bonaventure's telling, the life of Francis becomes the story of a new creation, which restores a paradise lost through avarice. Drawing on the same neo-Platonic and Augustinian legacy that inspired St. Bernard, Bonaventure (1221–1274) develops its aesthetic vocabulary and the mystical doctrine of the spiritual senses, putting them at the service of an incarnate and sacramental beauty. Strongly under the impression of the love-worthy, physical wounds of Francis, Bonaventure gives voice to an all-inclusive aesthetic that discovers beauty (to echo Balthasar) in "even the Cross and everything else which a worldly aesthetics (even of a realistic kind) discards as no longer bearable."[84]

Whereas the medieval Cistercians and Franciscans focused on the individual person as the image of God and of Christ, the Dominicans and Jesuits confronted the problem of the *Christus deformis* in the members of the church, His mystical body, torn apart by schism and leprous with sin—the *ecclesia deformis*. This corporate focus, I argue, broadened the already-expansive concept of Christian beauty, to make it inclusive of ugliness to an unprecedented degree. Rather than regarding ugliness as the absence of beauty, on the one hand, or redefining ugliness as the only true beauty (because of its undeceiving historical truth and mundane realism), on the other, the theological aesthetics of the later Middle Ages endeavored to understand both beautiful and ugly things as participatory in a transcendent, cosmic beauty, which inheres and unfolds in everything that is. In the "integrated sensibility" of the medieval period, Eco avers, "even ugliness found its place."[85]

For the Dominicans of the fourteenth century, not the visible stigmata of St.

84. Balthasar, *Glory of the Lord,* 1:124.
85. Eco, *Art and Beauty,* 80, 35.

Francis but the invisible wounds of St. Catherine of Siena became the symbolic focal point for reflection on the *Christus deformis*. In the fasting, ascetic women of the Dominican tradition—Catherine of Siena, Catherine of Genoa (1447–1510), and Rose of Lima (1586–1617)—Dominican preachers found anew the image of Christ crucified, but in a feminized form that mirrored the sufferings of the church, Christ's mystical body and bride and the mother of all Christians. For the Dominican preachers the wounded, feminine body of the church, torn by heresy, schism, and sociopolitical division, renewed the problem of the *Christus deformis* as an archetype of beauty. The ascetic appearance of these women saints thus represented with a prophetic force the ecclesial pulchritude that the Dominicans sought to perfect through the rhetorical art of their preaching and the dispensation of the Eucharist.

In chapter 5 I show how the invisible stigmata, extreme fasting, and frequent Communion received by St. Catherine of Siena brought a new, gendered, ecclesiastical, and performative dimension to the eating of beauty. As a rhetorical artform Dominican preaching sought to heal division and restore a paradisiacal order lost originally through a gluttonous misuse of the mouth and related sins of the tongue. Limited in their access to the pulpit, Dominican women placed emphasis on fasting, eucharistic reception, and gestural artforms that mirrored societal distress, atoned for sin, and witnessed publicly to the unseen presence of Christ in His suffering people. Consciously imitating Catherine of Siena in the New World context of Peru, the ascetic, Creole saint, Rose of Lima, shows in her life the apostolic force of such cross-cultural, double-coded images.

Confronted not merely by a schism, precipitated by rival claims to the papacy, but by the rejection of papal authority itself, the Catholic reformers at the end of the Middle Ages and the beginning of modernity understood the theo-aesthetic problem of the *Christus deformis* to concern the unity of the church, as Christ's body, with its visible head, the pope who served as Christ's vicar. They sought to discover anew and to represent the beauty of God's people through sustained meditation on the whole providential plan revealed in the scriptures. Formulating his *Spiritual Exercises* on the basis of his own conversion experience, St. Ignatius of Loyola (1491–1556) gathered his followers into the "Company of Jesus," an eschatological troop united in the Word, the Eucharist, and obedience to the pope as Vicar of Christ. Meditating on the same scriptural stories that Ignatius taught his disciples to visualize, Michelangelo (1475–1564) sculpted altarpieces, painted the walls and ceiling of the Sistine Chapel, composed poetry, and designed capacious works of architecture (including St. Peter's Basilica in Rome). For Ignatius and Michelangelo alike, the Eucharist symbolized and effectively sealed the unity and beauty of the church in Christ. Viewed in this light, Michelangelo's multifigured, Florentine *Pietà*, intended as an altarpiece and as his last

testament, stands as a damaged sign of the artist's heroic, imaginative attempt to hold together many members in a single Petrine Communion, carved out of one stone.⌉

Chapter 6 thus brings the lifework of two artistic figures of the Catholic Reform—St. Ignatius Loyola and Michelangelo—into dialogue. Exemplars of obedience, they sought by the radical power of that virtue, effective in meditative practice, to restore the beauty of an earthly paradise lost through disobedience. Drawing systematic parallels between the *Autobiography* of St. Ignatius and the four weeks of his *Spiritual Exercises,* on the one hand, and the different periods and works of Michelangelo's art, on the other, I show the remarkable spiritual kinship that led Ignatius to choose Michelangelo as the architect of the Church of the Gesú, the mother-church of the Jesuits in Rome. For Ignatius and Michelangelo alike, sacramental Communion was inseparable from commitment to the one church—a commitment that entailed a personal decision for Christ in the Eucharist and anticipated a final judgment by Him. Viewed in its Sistine context as an altarpiece, Michelangelo's *Last Judgment* (1536–41) fittingly centers attention on the eucharistic tabernacle, imaged as the tomb of the Risen Christ and (by extension) as the site of the resurrection of the dead to judgment.⌉

Drawing upon the work of Karl F. Morrison, Rachel Fulton has wonderfully described the devotion to Christ and Mary in the years 800 to 1200 as a movement "from judgment to passion" (to echo the title of her book), from self-knowledge before the Divine Judge to empathy before the Crucified Savior.[86] Whereas Fulton's detailed, historical study of the devotional expressions of the early Middle Ages begins with judgment and ends with passion, however, my theo-aesthetic study focuses on the later Middle Ages; it begins with the passion Fulton describes and ends (albeit on a different note) with a return to the theme of judgment with which she begins.

⌈The theological controversies of the sixteenth century, which defined the eucharistic presence in different ways and divided the very body of the church, inevitably awakened a renewed fear of judgment, since a failure to recognize the Lord, to know what one was eating—bread or God—brought with it condemnation, either for idolatry or for irreverence. In either case the classical expression of Gezo of Tortona (AD 984), echoing 1 Corinthians 11:27, applies: "The altar is the tribunal of Christ, . . . and his body with his blood judges those who approach it unworthily."[87]⌉

The loss of a common eucharistic understanding and unifying, sacramental

86. Rachel Fulton, *From Judgment to Passion: Devotion to Christ and the Virgin Mary, 800–1200* (New York: Columbia University Press, 2002).

87. Gezo of Tortona, *De corpore,* PL 137, col. 391; quoted in Fulton, *From Judgment to Passion,* 56.

practice in the early modern period had enormous and very evident, historical consequences for artistic thought and expression among Christians. As Lee Palmer Wandel has shown, to those Christians who accounted eucharistic worship idolatrous, the Host itself and all the artifacts surrounding it appeared as consuming, voracious idols, "stealing food and heat from needy human beings, the 'true images of God.'"[88] Iconoclastic violence erupted in many places, leading to the destruction of "altars, altar retables, crucifixes, carved and painted triptychs and diptychs, panel paintings, architectural and free-standing sculptures, chalices, patens, candlesticks, and oil lamps."[89]

This violent ending of art in parts of sixteenth-century Europe is not unrelated to contemporary discussions about aesthetic decline. Chapter 7, as an excursus and a closing frame, follows the study of the Ignatian "art of obedience" with a consideration of modern theological aesthetics, Catholic and Protestant. It compares and contrasts the eucharistic theologies of Simone Weil and Georg W. F. Hegel, to show how their divergent sacramental understandings lead to opposed aesthetic theories. For both philosophers the understanding of beauty, natural and artistic, derives from and depends on their notion of the Eucharist. Hegel views the Eucharist as a symbol of Christ's love and vehemently rejects the Catholic dogma of transubstantiation. For Hegel the heartrending gap between what the Eucharist promises (God) and what it actually gives (bread) is so unbridgeable that it signals the end of art itself, the inadequacy of anything sensual to express the spirit. For Weil, by contrast, the gap, the distance, between the sacrament's substance (Christ) and its appearance (bread) is a manifestation of the perfection of art, both divine and human. Blending a Catholic, theological understanding of the Eucharist with a post-Kantian aesthetics and associating transubstantiation with what she calls "decreation," Weil understands the Eucharist to be the generative source of all natural and artistic beauty, its beginning rather than its end.

Together chapters 2 and 7 thus provide a theoretical framework within which to contextualize the four medieval spiritualities and their practical arts of holiness, discussed in the intervening chapters. Chapter 2 emphasizes different theories of the Fall, linking the Eucharist to the Edenic apple as its remedy and as a virtuous means to the instauration of humanity, which is recreated in the crucified and glorified Christ. Chapter 7 stresses different concepts of the Eucharist, which link the Host to modern aesthetics and artistic production, including (as Weil understood) the making of saints. The idea that God continues His creative

88. Lee Palmer Wandel, *Voracious Idols and Violent Hands: Iconoclasm in Reformation Zurich, Strasbourg, and Basel* (Cambridge: Cambridge University Press, 1995), 190.
89. Ibid., 3–4.

work in and through the Eucharist (as Artist and Artifact), effecting the forma-
tion of saints and directing and sustaining their action in the world, is central to
the theological aesthetics explored throughout this book. If God is glorified in
His saints—so the medieval church reasoned—that glory, that aura, is also the
virtuous radiance of eternal Beauty, eaten and eating in the Host. What imagin-
able feast could be more beautiful and beautifying?

As a brief conclusion, chapter 8 is intentionally in-conclusive, looking back at
the preceding chapters only to suggest ways in which the present work opens
the way for studies of other spiritual arts, medieval and modern, such as the
Carmelite art of prayer. In keeping with Jean-Luc Marion's dictum that there are
and must be "an infinity of Eucharists, celebrated by an infinity of communi-
ties,"[90] eating beauty can never really end.

90. Jean-Luc Marion, *God without Being: Hors-Texte*, trans. Thomas A. Carlson (Chicago:
University of Chicago Press, 1991), 157.

2 : THE APPLE AND THE EUCHARIST

Foods for a Theological Aesthetics

Like trees of spice his servants stand
There planted by his mighty hand;
By Eden's gracious streams, that flow
To feed their beauty where they grow.
—Robert Bridges

It may be that vice, depravity and crime are nearly always . . . attempts
to eat beauty, to eat what we should only look at. Eve began it.
—Simone Weil

The tree of life my soul hath seen,
Laden with fruit and always green.
The trees of nature fruitless be
Compared with Christ the apple tree.
—Joshua Smith

When the beauty of the world as one knows it is lost through some personal or communal catastrophe, be it a crippling accident, the death of a loved one, betrayal by a trusted and idealized friend, or some more far reaching disturbance—a terrorist attack that ends in mass destruction, an epidemic, a genocidal uprising, a world war—the ancient question arises anew: How is this possible? What went wrong in the beginning to allow this to happen? How can the beauty that was lost be restored?

In the Judeo-Christian tradition, the question concerning what went wrong is always answered with a narrative, the biblical story of the Fall of Adam and Eve in Genesis. The story itself, however, is richly evocative and mysterious. It gives rise to further questions and multiple interpretations, suggesting more than one answer to the question, What exactly was the first sin of the first humans, the original cause of the loss of paradisiacal beauty?

Since it was generally agreed that Lucifer, the most splendid of the angels, fell from Heaven because of self-worshiping, idolatrous pride (cf. Isa. 14:12–15), medieval theologians, following the lead of St. Augustine, typically named pride the sin of Adam and Eve as well (cf. Sirach 10:14–15),[1] thus making the first human

1. See St. Augustine, *The Literal Meaning of Genesis,* trans. John Hammond Taylor, S.J., Ancient Christian Writers 42 (New York: Newman, 1982), 11.15, in 2:146.

sin an offense against the first commandment: "I am the Lord thy God. . . . Thou shalt not have strange gods before me" (Exod. 20:2–3; Deut. 5:6–7).[2] The serpent, after all, promised Eve that if they ate the fruit of the forbidden tree, they would be "as gods, knowing good and evil" (Gen. 3:5). Their curiosity about such tantalizing knowledge distracted them from their self-knowledge as lowly creatures of God; as a species of pride, their curiosity thus opposed humility. The Lord God, however, punished the couple not for the sin of pride, but for their act of disobedience in breaking the specific precept he had given them (Gen. 3:11). St. Paul, moreover, terms disobedience, not pride, the first sin in Romans 5:19: "For just as by the disobedience of the one man the many were constituted sinners, so also by the obedience of the one, the many shall be made just."

In seeming contrast, 1 Timothy 6:10 designates avarice "the root of all evils," a judgment that correlates the first sin with the tenth and last of the commandments: "Thou shalt not covet . . ." (Deut. 5:21).[3] Adam and Eve did not covet money, to be sure, but they greedily desired other things: the knowledge of good and evil and a divine status for themselves that would allow them to rival God. Their unbridled curiosity about a knowledge withheld from them was, some argued, a form of concupiscence, as was their avaricious lust for preeminence.

Inordinate desire expressed itself in a sensual appetite when "the woman saw that the tree was good to eat, and fair to the eyes, and delightful to behold" (Gen. 3:6); when she was "seduced" by its beauty (1 Tim. 2:14) and ate the fruit. Since the forbidden act was eating (albeit not eating in general, but from that particular tree), theologians as early as Tertullian (AD 230) and Nilus (AD 430) argued for gluttony as the first sin.[4] That argument gained strength from the comparison of Adam and Eve's temptation in the garden to that of Jesus in the desert, when he fasted for forty days, experienced hunger, and yet withstood the devil's urging to turn a stone into bread to eat (Luke 4:1–4). Christ's first temptation suggested, by analogy, the priority of gluttony. Invoking the authority of Gregory the Great (AD 604), the Middle English *Stanzaic Life of Christ* asserts that even as the devil tempted Adam with three sins—gluttony, vainglory, and avarice—and "the first of hom was glotery,"[5] so too Christ was first tempted to eat bread. Ja-

2. I use the Douay-Challoner version of the Holy Bible, ed. John P. O'Connell (Chicago: Catholic Press, 1950).

3. On avarice see Richard Newhauser, *The Early History of Greed: The Sin of Avarice in Early Medieval Thought and Literature,* Cambridge Studies in Medieval Literature 41 (Cambridge: Cambridge University Press, 2000).

4. See Tertullian, *De ieiunio adversus psychicos,* chap. 3, PL 2, col. 958. According to Nilus, "It was the desire of food that spawned disobedience; it was the pleasure of taste that drove us from Paradise" (quoted by Caroline Walker Bynum in *Holy Feast and Holy Fast: The Religious Significance of Food to Medieval Women* [Berkeley: University of California Press, 1987], 36).

5. *A Stanzaic Life of Christ, Compiled from Higden's "Polychronicon" and the "Legenda Aurea,"* ed. Francis A. Foster, EETS 166 (1926; New York: Kraus Reprint, 1971), 177, line 5265.

cob's Well, which Morton W. Bloomfield calls "the last great medieval English popular compendium" of "theological knowledge,"[6] declares: "[Be] glotonye deth entryd into all mankynde. It is gate of synnes, be þe whiche alle oþere synnes entryn in-to man. Þis gate of glotonye speryd Adam out of paradys, & othere also þat usyn þat synne."[7] Similarly Chaucer's Pardoner exclaims in apostrophe: "Corrupt was al this world for glotonye."[8]

Although additional interpretations of the Edenic offense were and are possible,[9] medieval writers most frequently named these four sins—pride (subsuming idolatry, vainglory, and a distractive curiosity), disobedience, avarice, and gluttony—whether alone or in combination, as the reason for Adam and Eve's loss of intimacy with God, their expulsion from Paradise, and all the earthly woes that followed as a consequence and curse—chief among them, death. In his treatise on the *Sentences*, for example, Hugh of St. Victor (AD 1141) writes that Adam and Eve were tempted in three ways: through gluttony, vainglory, and avarice.[10] St. Bonaventure (AD 1274) states similarly that Eve's embryonic (*inchoatum*) sin began in pride, progressed into avarice, and reached its fulfillment in gluttony and disobedience in the act of eating.[11] In his *Summa theologiae,* St. Thomas Aquinas (AD 1274) argues for an idolatrous pride as the first human sin, after carefully weighing and refuting the counterarguments for disobedience, gluttony, avari-

6. Morton W. Bloomfield, *The Seven Deadly Sins: An Introduction to the History of a Religious Concept, with Special Reference to Medieval English Literature* (Lansing: Michigan State University Press, 1967), 223.

7. *Jacob's Well, an English Treatise on the Cleansing of Man's Conscience,* ed. Arthur Brandeis, EETS 115 (London: Kegan Paul, Trench, Trübner, 1900), 145.

8. Geoffrey Chaucer, *The Canterbury Tales,* in *The Riverside Chaucer,* ed. Larry D. Benson, 3rd ed. (Boston: Houghton Mifflin, 1987), VI, line 504. Chaucer's Parson makes a similar assertion: "This synne corrumped al this world" (X, line 818). Chaucer's friend, John Gower, apostrophizes Gluttony as the "cause of all evils" and the "origin of all our ills" in his *Mirour de l'omme,* trans. William Burton Wilson, rev. Nancy Wilson Van Baak (East Lansing, MI: Colleagues, 1992), 118, lines 8569–80.

9. The Manichees, for instance, against whom St. Augustine argued, interpreted the story of the Fall as an allegory that used the forbidden fruit to encode illicit sex. See St. Augustine, *The Literal Meaning of Genesis,* book 11.41, in 2:174. On the basis of the letter of Genesis, some medieval theologians (Alger of Liège, among them) argued for unbelief as the first sin, because Adam and Even failed to believe God when He told them not to eat lest they die. In Milton's *Paradise Lost,* the first sin has its inchoate origin in the disordered marriage of Adam and Eve and the lack of a proper unity between them. The Cathars of the Middle Ages practiced a heretical spirituality that arguably took as its starting point a Manichaean interpretation of the Fall.

10. Hugh of St. Victor, *Summa sententiarum,* tract. 3, PL 176, col. 96: "Per tria tentavit: per gulam cum dixit: *comedite;* per vanam gloriam, cum dixit: *Eritis sicut dii;* per avaritiam, cum dixit: *Scientes bonum et malum.*"

11. St. Bonaventure, *2 Sent.,* dist. 22, art. 1, q. 1, in *Doctoris Seraphici S. Bonaventurae opera omnia* (Quaracchi: Collegium S. Bonaventurae, 1882–1902), 2:517a: "peccatum mulieris inchoatum fuit in superbia, progressum habuit in avaritia, consummatum habuit in gula et inobedientia in actu comestionis." See also dist. 33. "Dubia," in *Doctoris Seraphici S. Bonaventurae opera omnia,* 2:798b.

cious curiosity, and unbelief—sins he traces back, one by one, to an underlying pride.[12]

Depending on one's answer to the question, "What went wrong in the beginning?" on one's diagnosis of the human condition, different remedies have been and are prescribed as appropriate ways to heal humanity's root ailment, restore its original integrity, and regain the beauty of paradise. I argue in this book that the chief spiritualities of the Christian Middle Ages and Catholic Reformation each responded differently to the question of the first sin and prescribed a different form of remediation that was embodied for them in the Eucharist. For the monastics the diagnosis of pride gave rise to a spirituality that cultivates humility as its chief virtue. For the Franciscans poverty was the foundation of evangelical perfection, the powerful virtue to cure the underlying vice of covetousness in all its forms. For the Dominicans the savoring of Wisdom (*Sapientia*) and the practice of preaching restored what was lost through gluttony, a sin of the mouth and the gateway to Hell. Dominican women—notably Saints Catherine of Siena (AD 1380), Catherine of Genoa (AD 1510), and Rose of Lima (AD 1617)—answered in particular to the gluttony of Eve by intense fasting and by an ardent feeding on what St. Catherine of Siena called the food of souls. Finally, for St. Ignatius of Loyola (AD 1556) and the Jesuits, a radical obedience was the way back to the paradise lost through disobedience.

The evident charisms of the saints who founded and lived these spiritualities point, moreover, to the radical, formative virtues mentioned above—humility, poverty, abstinence, and obedience—as an array of divinely infused powers of soul, not merely abilities acquired or developed through habitual practice and meritorious cooperation with actual grace. At issue in each case is not a semi-Pelagian "self-fashioning" (to borrow a phrase made famous by Stephen Greenblatt),[13] but rather a redemptive work of divine artistry in which the saint collaborates. Taking into themselves the living Word of the scriptures and of the Eucharist, the saints literally eat the Beauty that is the source of their own progressive beatification and beautification. Christ Himself, swallowed in the Host, is the antidote for the Edenic apple. Indeed the Eucharist is effective in them even when they feast on it only with their eyes and in their thoughts, for (as G. J. C. Snoek acknowledges) "the Host [is] not just an 'object' of veneration and adoration but also a 'subject', a *virtus* of mercy, of spiritual and material favours."[14]

12. St. Thomas Aquinas, *Summa theologiae* (New York: Benziger, 1947), part 2-2, q. 163, art. 1, 2:1862–63. I use this English translation throughout.

13. Stephen Greenblatt, *Renaissance Self-Fashioning: From More to Shakespeare* (Chicago: University of Chicago Press, 1980).

14. G. J. C. Snoek, *Medieval Piety from Relics to the Eucharist: A Process of Mutual Interaction* (Leiden: Brill, 1995), 372.

[In keeping with the specific form (*forma*) of life generated by a given spirituality, Christ reveals Himself, and is received in the Eucharist, under a different, beautiful aspect or appearance (*species*). The eucharistic *species* of bread and wine as the outward signs of the sacrament are not the *species* that is proper to Christ, but only provide a sacramental veil for Christ's real presence. The outward, sacramental *species* thus stand in a unique way for *Species* itself, that is, for Christ, the Beauty and perfect Image of God the Father.[15] (In Latin the nouns *forma* and *species* are virtually synonymous, as are the adjectives *formosus* and *speciosus,* both meaning "beautiful.") That Beauty (*Species*), moreover, communicates itself by definition to each one according to its kind (*species*). In the words of Hans Urs von Balthasar, "Being inevitably includes being of a certain kind (*species*) or, what comes to the same thing, a form (*forma*), two words which imply both 'essence' and 'beauty.'"[16]

The very blankness of the bread makes the Host, as it were, a pure mirror (*speculum*), capable of reflecting different images and forms of Christ's beauty into the world. The monks, therefore, receive Christ in the Eucharist as the one who is "meek and humble of heart" (Matt. 11:29). The Franciscans beg for the Bread of Angels and eat the Christ of poverty. The Dominicans taste and savor the Eucharistic Word that they proclaim with their lips. The Jesuits maintain company with the obedient Jesus through their reception of him in Communion.

Before we examine these spiritualities individually in the chapters that follow, however, it is necessary to address four basic issues that are crucial to the theo-aesthetic argument of this book. How exactly is the Eucharist, as a vital source of beauty, to be related to the apple of Eden through which the loveliness of Paradise was lost? In what sense can we speak of the beauty of Christ's historical and sacramental Body, given the function of the Eucharist as a memorial of the Passion? How are we to consider the beauty of Christ's glorified Body, present in the Host? Finally, how is Christ's beauty in the Eucharist communicated to others?

These four questions concern different, eucharistic forms of Christ: first the sacramental form of food; second the historical form of the man Jesus, who was crucified and thus deformed (*Christus deformis*); third the form of Christ in His glorified Body, invisibly present in the Eucharist; and fourth the Marian form of the individual communicants who receive and embody Christ, and thus the Christ-bearing, Marian form of the Mystical Body of Christ as a whole. The implicit, narrative diachrony in the succession of these forms is biblical, beginning

15. See St. Augustine, *The Trinity,* trans. Stephen McKenna, C.SS.R. The Fathers of the Church 2 (Washington, DC: Catholic University of America Press, 1963),6.10, pp. 212–15.

16. Hans Urs von Balthasar, *The Glory of the Lord: A Theological Aesthetitcs,* trans. Erasmo Leiva-Merikakis and ed. Joseph Fessio, S.J., and John Riches (New York: Crossroad; San Francisco: Ignatius, 1983), 2:115.

with Christ's sacramental presence in the Edenic Tree of Life, leading through the Gospels, and ending with the eucharistic accounts in the Acts of the Apostles, the Pauline epistles, and the Revelation. Tracing these forms of Christ in the theological reflection of the early and medieval church serves a double function: it provides a traditional background for Simone Weil's modern, eucharistic aesthetics, as discussed in chapter 7 of this book,[17] and it sets the stage for chapters 3 through 6, where Christ is seen to appear in the saintly forms of specific, medieval spiritualities.

The Apple and the Eucharist

The Christians of the early church and the Middle Ages recognized the two trees named in Genesis—the proscribed Tree of the Knowledge of Good and Evil and the Tree of Life (Gen. 2:9)—to be sources of alternative fruits, the one poisonous and mortifying, the other vivifying and immortalizing. St. Augustine explains that the fruit of the Tree of Knowledge of Good and Evil was not, of course, poisonous in itself (because all the trees in Paradise were created good by God), but only in its deadly effect when eaten in disobedience.[18] Disorder, disease, death, and the whole ugliness of sin resulted from the evil of disobedience, not from the apple per se. The tree was meant to stand untouched in Paradise as an outward sign of the humans' free obedience to God and ordinate relationship to Him.

Whereas the Tree of Knowledge was a sign, the Tree of Life was a sacrament. That is to say, the Tree of Life both pointed to a divine reality and actually mediated God's grace. In the words of St. Augustine (AD 430), "God did not want man to live in Paradise without the mysteries of spiritual things made present in material things. Man, then, had food in the other trees, but in the Tree of Life there was a sacrament."[19] The Tree of Life "both existed as a real material tree and at

17. Of particular interest in Weil's writings is her frequent use of the imagery of seeds and trees. In a haunting parable with eucharistic overtones, she describes God's coming to plant within the soul a seed, which grows into a tree of virtues. When this tree is struck by the hammer blow of affliction that inaugurs passive purification, it becomes a cross on which the soul hangs in union with Christ in His abandonment. This deepest of all possible unions becomes the means and occasion for the crossing of an infinite distance by the divine love between the Father and the Son, a love that fills the soul united with Christ with the lightness and grace of glory. See Simone Weil, *Waiting for God*, trans. Emma Craufurd (New York: Putnam's, 1951), 133–36; *Attente de Dieu* (Paris: Fayard, 1966), 117–21.

18. See St. Augustine, *The Literal Meaning of Genesis*, 8.13, in 2:52; *De Genesi ad litteram*, PL 34, col. 383.

19. St. Augustine, *Literal Meaning*, 8.4, in 2:38; *De Genesi ad litteram*, PL 34, col. 375: "Nec sine mysteriis rerum spiritualium corporaliter praesentatis voluit hominem Deus in paradiso vivere. Erat ei ergo in lignis caeteris alimentum, in illo autem sacramentum."

the same time symbolized Wisdom," that is, Christ.[20] It also operated out of it-self. Comparing its fruit to the sacramental bread that sustained Elijah for forty days (3 Kings 19:5–8), Augustine writes, "The fruit of the Tree of Life was mate-rial food, and yet it had the power to give lasting health and vigor to man's body, not in the manner of other foods but by a mysterious communication of vital-ity."[21] Indeed, precisely because the Tree of Life was operative as a "visible sacra-ment of invisible wisdom" (*sacramentum visibile invisibilis sapientiae*) that was also a source of "invisible power" (*virtute invisibilii*) for the body, Adam and Eve had to be physically separated from it after the Fall in a sort of excommunication, just as "people are sometimes excluded from the visible sacrament of the altar by ecclesiastical discipline."[22] God in His mercy expelled Adam and Eve from Par-adise lest they, destined to die, prolonged their earthly suffering by receiving the sacrament of eternal life unworthily, to their own greater harm.

The fruit of the Edenic Tree of Life was not intended by God in the order of creation to be a direct antidote for the fruit of the Tree of Knowledge of Good and Evil. It was clearly understood by medieval theologians, however, to fore-shadow the eucharistic sacrament, the Bread of Life (John 6:35, 48), which does have a remedial effect in the order of redemption. In *De Eucharistia* St. Albert the Great (AD 1280) applies Proverbs 11:30, "The fruit of the righteous is a tree of life," to Christ. Albert's explanation succinctly sums up the tradition of associations: "For even as man, if he had not sinned, would have lived immortally from the Tree of Life, so the Lord, in order to restore what we had lost, gave to us his fruit in the sacrament, the very taste of life immortal (Rev. 2:7)."[23] Jacques de Vitry (AD 1240) expresses the same doctrine in a popular adage: "Just as by Adam's tasting we all died, thus by tasting Christ we all recover life."[24]

Following Augustine's lead, medieval writers and artists gave rich and varied

20. St. Augustine, *Literal Meaning*, 8.5, in 2:41; *De Genesi ad litteram*, PL 34, col. 377: "Etiam vere aliquod lignum fuisse, et tamen sapientiam figurasse."

21. St. Augustine, *Literal Meaning*, 8.5, in 2:41; *De Genesi ad litteram*, PL 34, col. 377: "Illud quoque addo, quanquam corporalem cibum, talem tamen illam arborem praestitisse, quo corpus hominis sanitate stabili firmaretur, non sicut ex alio cibo, sed nonnulla inspiratione salubritatis occulta."

22. St. Augustine, *Literal Meaning*, 11.40, in 2:173; *De Genesi ad litteram*, PL 34, col. 451: "Sicut etiam in hoc paradiso, id est Ecclesia, solent a Sacramentis altaris visibilibus homines disciplina ecclesiastica removeri."

23. St. Albert the Great, *De Eucharistia*, dist. 3, tract. 1.5, in *Opera omnia*, ed. August and Emile Borgnet (Paris: Ludovicus Vivès, 1899), 38:255: "Sicut enim homo si non peccasset, de ligno vitae immortaliter vixisset, ita Dominus ad restitutionem ejus quod perdidimus, fructum nobis dedit in sacramento, gustum scilicet vitae immortalis."

24. Jacques de Voragine, *De sacramentis*, in *The "Historia occidentalis" of Jacques de Vitry: A Critical Edition*, ed. John Frederick Hinnebusch (Freiberg: University Press, 1972), 208; quoted in Miri Rubin, *Corpus Christi: The Eucharist in Late Medieval Culture* (Cambridge: Cambridge Uni-versity Press, 1991), 27.

expression to the Christological symbolism of the Tree of Life. Mystics such as Saints Hildegard of Bingen (AD 1179) and Catherine of Siena contemplated Christ as a life-giving tree in their visions.[25] Apocryphal legends, like that of Seth's visit to Eden, recorded in the Middle English *Cursor Mundi,* described the Christ Child in the branches of the paradisiacal tree,[26] even as communicants reported seeing the Child in the elevated Host during Mass.[27] The Arthurian *Quest for the Sacred Grail* tells how Eve, expelled from the Garden, took with her the branch on which the apple had hung and planted it in the ground, where it sprouted roots and grew into a tree of changing colors, from the wood of which bed-spindles were carved to adorn King Solomon's ship, the vessel predestined for Sir Galahad's eucharistic journey.[28] Visual artists, supported by patterns of biblical concordance, blended the iconography of the Tree of Life, the Tree of Jesse (depicting the genealogy of Jesus), the Tree of Virtues, and the Tree of the Cross.[29]

A colorful illustration (plate 2), painted by Berthold Furtmeyr and found in the third volume of a five-volume missal (ca. 1481) commissioned by Bernhard

25. See Hildegard of Bingen, *Scivias,* trans. Mother Columba Hart and Jane Bishop (New York: Paulist Press, 1990), 3.8, 425–48. In Hildegard's vision a tower becomes a ladder, which in turn becomes a tree of seven virtues. Hildegard's tree recalls the Tree of Jesse (Isa. 11:1–3) and the apple tree of Song of Songs 2:3, both of which are identified explicitly with Christ, "the most beautiful fruit of the most beautiful tree [i.e., the Virgin Mary]," Who satisfies the hungry: "And thus He excels all the trees of the woods" (440). For St. Catherine's vision see *The Orcherd of Syon,* ed. Phyllis Hodgson and Gabriel M. Liegey, EETS 258 (London: Oxford University Press, 1966), 103.

26. See *Cursor Mundi,* ed. Richard Morris, EETS 57 (London: N. Trübner, 1874), part 1, lines 1339–47, pp. 85, 87.

27. Blessed Angela of Foligno saw Christ as "a child of twelve" in the elevated Host. See her *Memorial,* in Angela of Foligno, *Complete Works,* trans. Paul LaChance, O.F.M., Classics of Western Spirituality (New York: Paulist Press, 1993), 147. Such miracles were not uncommon. See Snoek, *Relics to Eucharist,* 59; Peter Browe, S.J., *Die Verehrung der Eucharistie im Mittelalter* (Munich: Max Hueber, 1933), 26–69.

28. See *The Works of Sir Thomas Malory,* ed. Eugène Vinaver, 2nd ed. (Oxford: Clarendon Press, 1967), 2:990–93. The Quest is full of eucharistic miracles. Notable is the vision of a Mass, celebrated by Joseph of Arimathea and witnessed by Sirs Galahad, Bors, and Perceval. At the elevation of the Host, they see the Christ Child: "At the lyftyng up there cam a viguore in lyknesse of a chylde" (2:1029). Shortly thereafter Christ Himself appears as the Man of Sorrows out of the chalice to give them Communion: "Than loked they and saw a man com oute of the holy vessel that had all the sygnes of the Passion of Jesu Cryste, bledynge all opynly" (2:1030).

29. The scholarship on this topic is vast. See Arthur Watson, "The *Speculum Virginum* with Special Reference to the Tree of Jesse," *Speculum* 3 (1928): 445–69; Arthur Watson, *The Early Iconography of the Tree of Jesse* (London: Oxford University Press, H. Milford, 1934); Jennifer O'Reilly, *Studies in the Iconography of the Virtues and Vices in the Middle Ages* (New York: Garland, 1988); Aidan Meehan, *Celtic Design: The Tree of Life* (New York: Thames and Hudson, 1995). See also Edwin Oliver James, *The Tree of Life* (Leiden: E. J. Brill, 1966); Gordon V. Boudreau, *The Roots of Walden and the Tree of Life* (Nashville: Vanderbilt University Press, 1990); Jean Magne, *From Christianity to Gnosis and from Gnosis to Christianity: An Itinerary through the Texts to and from the Tree of Paradise,* trans. A. F. W. Armstrong, Brown Judaic Studies 286 (Atlanta, GA: Scholars Press, 1993).

von Rohr, Archbishop of Salzburg, vividly depicts both the juxtaposition and the coalescence of these arboreal images.[30] Entitled *Eva und Maria,* it shows a single, central tree, which can easily be identified as the Tree of Knowledge of Good and Evil by the serpent curled around its trunk. Eve, standing naked to the left of the tree, distributes its apples to sinners, who approach her, as it were, in a Communion line, at the end of which looms a skeletal Death-figure. The same tree, however, doubles as the Tree of Life, for eucharistic Hosts flourish in its branches like white blossoms, intermingled with the fruit. A crucifix hangs on the right side of the tree, to associate the wood of the cross with the tree's branches and trunk. Christ's body on the cross parallels in its position a skull that appears opposite it, on the tree's left side. Taken together, the cross and the skull signal the saving power of the Hosts and the mortifying effect of the apples. Mary, dressed in blue and wearing a crown on her haloed head, distributes Hosts to a line of saintly communicants who approach her at the right side of the tree. Mary's action thus mirrors Eve's at the left. Adam sits, dazed, below the tree, the trunk of which arises phallic-like in front of his loins, to indicate his generation of two kinds of offspring, good and evil. Adam's naked body, symbolically joined to the tree trunk against which he rests his head and around which he reaches his arm, points to Jesus' body above, stripped and nailed to the cross, and thus to Christ, the Son of Man, as a New Adam. Adam's apparent, apple-induced sleepiness recalls Christ's death as a sleep before His resurrection, but also God's fashioning of Eve from a rib taken from Adam's side, while Adam slept. By extension Mary appears at Adam's right as the New Eve, the sinless, bridal fruit of the New Adam's atoning sacrifice.

The iconography in this late-medieval illustration gives summary expression to a long-standing pattern of exegetical thought. Biblical commentators and theologians in the Augustinian tradition followed an artistic, formal impulse in their discovery of a wealth of symmetrical correspondences between and among these trees and their fruits. Among these theologians, Alger of Liège (AD 1130) is of particular interest, because it was at Liège that the Feast of Corpus Christi was first introduced in 1246 by Bishop Robert of Turotte, at the instigation of Juliana van Cornillon (AD 1258), and from which its observance spread to the universal church in 1264, under the auspices of Pope Urban IV, the former cardinal-legate of Liège. Alger's treatise on the Eucharist, written in response to the heresy of Berengar of Tours (1000–1088),[31] provides an important twelfth-century back-

30. I thank Dr. Edith Schipper of the Bayerische Staatsbibliothek in Munich, Germany, for permission to reproduce this illustration (Clm. 15710, fol. 60v). I thank Barbara Newman for bringing it to my attention.

31. Developing the Augustinian distinction between the "thing" (*res*) of the sacrament and its outward sign, Berengar denied a substantial change in the elements of bread and wine. Alger of

ground to the eucharistic devotion that flourished with particular intensity in thirteenth-century Liège among laity and clerics alike.

In his treatise Alger highlights a series of correspondences between the account in Genesis and Christ's words about the Eucharist in the sixth chapter of St. John's Gospel. God had warned Adam not to eat of the forbidden fruit lest he die, but obedience required faith on Adam's part, for the apple, which was "beautiful to behold and sweet to eat" (*pomum visu decorum et suave ad comedendum*), appeared to be a food of life (*cibus vitalis*) rather than of death.[32] By contrast Jesus promised eternal life to those who ate His flesh and blood (John 6:55). Obeying Him required an even greater faith on the part of His disciples, because the food He offered seemed to be "the food of our mortality" (*cibus mortalitatis nostrae*), when in fact it yields everlasting life.[33]

Adam and Eve believed not God, but the deceitful serpent, who had promised them that they would be "as gods" (Gen. 3:5). Christ, however, truly satisfies the human longing for deiformity through His Incarnation and sacramental presence.[34] Whereas the serpent hid the painful reality of death from Adam and Eve and displayed instead the savory fruit, Christ veiled the reality of His divinity, displaying instead His mortal body on the cross, the tree of obedience, as a visible sacrament of invisible grace.[35] Thus, Alger writes, true faith in Christ, wholly present in the Eucharist, may fittingly atone for the false faith, once unjustly credited to the devil's lies, by which the world perished: "Quia videlicet falsa fide mundus periit."[36]

That true faith allows Christ to plant in human beings through the consecrated

Liège's lengthy response in three books was esteemed as an important statement of orthodox teaching. See A. J. McDonald, *Berengar and the Reform of Sacramental Doctrine* (1930; Merrick, NY: Richwood, 1977), esp. 379–88; R. P. Redmond, *Berengar and the Development of Eucharistic Doctrine* (Newcastle upon Tyne: Doig, 1934).

32. Alger of Liège, *De sacramento corporis et sanguinis Dominici,* PL 180, col. 821.

33. Ibid.

34. Ibid., col. 824.

35. Ibid., col. 821: "Sicut ergo diabolus non umbram in ligno inobedientiae, sed ipsum verum et visibilem fructum exhibens, promisit id quod non videbatur, scilicet, *eritis sicut dii* (Gen. III.5), sic et Deus non umbram, sed ipsum qui in ligno pependit obedientiae, in suo visibili sacramento exhibens, promittit vitam aeternam quae non videtur, ut dum ea re plus ei modo creditur quam Hosti, ut dignum est, sanetur hac vera fide illa perdida fides, qua olim plus diabolo quam sibi injuste creditum est." (Therefore, even as the devil, not showing the shadow in the wood of disobedience but rather the true and visible fruit, promised that which was not being shown, namely, "You will be like Gods" [Gen. 3:5], so too God, showing in His own visible sacrament not the shadow but Himself who hung on the tree of obedience, promises eternal life, which is not visible, so that when the latter in the mode of the Host is believed more than the former, as is fitting, that deadly faith which once unjustly credited more to the devil than to God Himself, might be healed by this true faith.)

36. Alger of Liège, "De sacramento corporis et sanguinis Dominici," PL 180, col. 821.

Host the seed of heavenly grace and virtues (*gratia coelestis virtutum germina*) that grows into the Tree of Life, which is Christ himself (Gen. 2:9; Rev. 2:11).[37] "Even as the Tree of Life, by which man might live eternally in body, was placed in paradise," Alger concludes, "so Christ has placed himself as the Tree of Life in the Church, that he might be eternal life for those believing in him."[38]

Hugh of Fouilloy (AD 1172–73) identifies the Tree of Justice, which grows in the cloister of the soul, with the Tree of Life in Paradise (Rev. 2:11). The human form of this tree, he writes, is Christ in the midst of the church; its fruit is the Eucharistic Body and Blood of Christ on which the faithful feed.[39] Received as a germinating seed of grace into the soul, the eucharistic Christ grows there in the form of a mystic tree. "Planted in the soil of good will, rooted in depth of humility," this tree "grows through desire, spreads out its branches, bears the fruit of good work through example, and feeds the hungry with the sweetness of contemplation."[40] The fruit of this Tree of Justice satiates the soul with its virtues (*anima cum suis virtutibus satiatur*), transforming it and empowering it to do what is right and good.[41]

Emphasizing the efficacy of the seven infused virtues to oppose the seven vices or capital sins,[42] Hugh of St. Victor (AD 1141) points to their origin in the seven gifts of the Holy Spirit (Isa. 11:2).[43] The gifts of the Spirit are, he writes, "initial movements in the heart, the seeds, as it were, of virtues sown on the ground of the heart from which the virtues sprout like plants."[44] Possessing the perfection

37. Ibid., col. 824.

38. Ibid., col. 822: "Sicut enim lignum vitae in paradiso positum est, quo aeternaliter homo in corpore viveret, sic Christus in Ecclesia lignum vitae seipsum posuit, ut in se credentibus vita aeterna esset."

39. Hugh of Fouilloy, *De claustro animae*, PL 176, col. 1174: "Fructus hujus arboris est caro Christi et sanguis."

40. Hugh of Fouilloy, *De claustro animae*, PL 176, col. 1173: "Plantatur autem arbor justitiae in terra bonae voluntatis, radicatur in profundo humilitatis, crescit per desiderium, expandit ramos; per exemplum dat fructum boni operis, cibat esurientem dulcedine contemplationis."

41. Hugh of Fouilloy, *De claustro animae*, PL 176, col. 1174.

42. In his commentary on the *Sentences*, Hugh uses the Gregorian list of the seven capital sins: "superbia, invidia, ira, acidia vel tristia, avaritia, gula, luxuria" ("pride, envy, wrath, slothful sadness, avarice, gluttony, lechery"). See *Summa sententiarum*, tract. 3, PL 176, col. 113. In "De fructibus carnis et spiritus," however, he gives a variant listing. See PL 176, cols. 997–1010. For a study of the variant patristic and medieval listings, see Bloomfield, *Seven Deadly Sins*.

43. The seven gifts listed in Isaiah 11:2 are wisdom, understanding, counsel, knowledge, fortitude, piety, and the fear of the Lord. In *De fructibus carnis et spiritus*, Hugh sets this biblical list parallel to another list of seven virtues: the three theological virtues (faith, hope, and charity) plus the four cardinal virtues of classical philosophy (temperance, fortitude, prudence, and justice). See PL 176, cols. 1007–10.

44. Hugh of St. Victor, *Summa sententiarum*, tract. 3, PL 176, col. 114: "Inter dona autem et virtutes haec est differentia quod dona sunt primi motus in corde, quasi quaedam semina virtutum iactata super terram cordis nostri; virtutes quasi seges quae ex ipsis consurgunt."

of the gifts and virtues, Christ himself is the Tree of Life from which these spiritual seeds originate. Glossing the word *Eucharist* as *bona gratia* (good grace), Hugh traces the physical movement of this seed from the mouth to the heart: "Christus de ore ad cor transit."[45] Quoting from St. Augustine's *Confessions* 7.10, Hugh explains that, unlike other kinds of food, which are incorporated into the body of the one who eats, the Body of Christ is eaten in the sacrament in order that we might be incorporated into Him: "He comes to you that he might be eaten, not consumed. He comes that he might be tasted, not incorporated. Augustine heard a voice from heaven, because this could not be said or replied by any earthly person: 'I am the food of grown-ups. Grow that you might feed on me; not that you might turn me into you, like the food of your body, but that you might be changed into me.'"[46]

Hugh of St. Victor's *De fructibus carnis et spiritus* images the eucharistic Christ, the New Adam, schematically as the Tree of Virtues (*Arbor virtutum*).[47] Following Hugh's lead, St. Bonaventure (AD 1274) tells the story of Christ's life in the form of a meditation on the Tree of Life, each evangelical scene illustrating a different virtue on the tree's twelve branches.[48] Bonaventure's extraordinary combination in *Lignum vitae* of a vertical, static image—the twelve-branched Tree of Life—with the three-part chronological narrative of Christ's life, passion and death, and glorification had great appeal for medieval readers. It made the twelve fruits of the tree emphatically Christ's own, expressed in His earthly life and yet available to others through the Eucharist: "This fruit [Christ] is offered to God's servants to be tasted so that when they eat it, they may always be satisfied, yet never grow weary of its taste."[49] The series of meditations ends with a prayer for the seven gifts of the Holy Spirit through the seven petitions of the *Pater Noster,*

45. Hugh of St. Victor, *De sacramento corporis et sanguinis Christi,* PL 176, cols. 467, 471.

46. Hugh of St. Victor, *De sacramento corporis et sanguinis Christi,* PL 176, col. 471: "Venit ad te ut comedatur, non ut consumatur. Venit ut gustetur, non ut incorporetur. Augustinus vocem de coelo audivit, quia hoc a terrenis illi dici aut responderi non potuit. 'Cibus sum grandium, cresce et manducabis me; non ut me mutes in te, sicut cibum carnis tuae, sed tu mutaberis in me.'"

47. The Migne edition includes a sketch, showing the various branches and fruits. Hugh places pride at the root of the Old Adam's Tree, humility at the root of the New Adam's. He opposes faith to gluttony (*ventris ingluvies*), hope to avarice, charity to lechery, temperance to slothful sadness (*tristitia*), fortitude to wrath, prudence to envy, justice to vainglory. See PL 176, cols. 1007–10.

48. The Quaracchi edition includes a drawing of the Tree, on which the body of the Crucified is hung. That drawing approximates an illustration that accompanied the original work in manuscript, to which Bonaventure's text refers. See St. Bonaventure, *Lignum vitae, Opera omnia,* vol. 8, where the drawing appears between pages 68 and 69.

49. *Bonaventure: The Soul's Journey into God, The Tree of Life, The Life of Francis,* trans. Ewert Cousins (New York: Paulist Press, 1978), 120–21; *Lignum vitae,* in *Opera omnia,* 8:69a. I use Cousins's translation throughout.

the fourth and central petition of which is the request for the "daily bread" of the Eucharist (Matt. 6:11).[50]

Countering the subtle serpent, who made the forbidden fruit seductively attractive, the seraphic doctor appeals at the beginning to the senses of sight, hearing, smell, touch, and taste: "Imagine that the leaves are a most effective medicine. . . . Let the flowers be beautiful with the radiance of every color and perfumed with the sweetness of every fragrance. . . . Imagine that there are twelve fruits, *having every delight and the sweetness of every taste* (Wisdom 16:20)."[51] The meditations on the individual scenes from Christ's life are similarly imagistic and deliberately evocative of an emotive response as Bonaventure attempts to depict in words the Incarnate Word from whom the Wisdom of God "shines forth, . . . as in a mirror containing the beauty of all forms and lights and as in a book in which all things are written."[52]

The wisdom of God, however, is not an earthly wisdom, but rather the foolishness of the cross (cf. 1 Cor. 1:17–31). No one can avoid the error of Adam "who preferred the *tree of the knowledge of good and evil* (Gen. 2:17) to the tree of life," St. Bonaventure writes, if he does not prefer "the sacred cross of Christ to all carnal feeling of wisdom of the flesh."[53] For Bonaventure, the cross is the mysterious new Tree of Life on which hung the life-giving fruit of Christ's eucharistic body: "This is the fruit that took its origin from the virgin's womb and reached its savory maturity on the tree of the cross."[54] By drinking the vinegar and gall on the cross, Christ the New Adam atoned for the first Adam's disobedient eating of "the sweetness of the forbidden tree."[55]

In his description of the glorified body of Christ, Bonaventure accomplishes a return to the opening imagery of the Tree of Life and its colorful flowers, so that the two effectively become one. Praising the "extraordinary beauty" of the risen Jesus, Bonaventure writes: "This most beautiful *flower of the root of Jesse* (Isa. 11:1), which had blossomed in the incarnation and withered in the passion, thus blossomed again in the resurrection so as to become the beauty of all. For that most glorious body—subtle, agile, and immortal—was clothed in glory so as to be

50. The petition for daily bread was regularly interpreted to mean not only bodily sustenance but also spiritual nourishment through the Eucharist, whether or not one actually received it sacramentally. On the question of the frequency of sacramental reception during the Middle Ages, see Peter Browe, S.J., *Die häufige Kommunion im Mittelalter* (Münster: Regensbergsche Verlagsbuchhandlung, 1938). I discuss the practice of spiritual Communion in chapters 3 and 5.

51. *Bonaventure: The Tree of Life*, 120; *Lignum vitae*, *Opera omnia*, 8:69a.

52. *Bonaventure: The Tree of Life*, 170; *Lignum vitae*, *Opera omnia*, 8:85a.

53. *Bonaventure: The Tree of Life*, 122; *Lignum vitae*, *Opera omnia*, 8:69b.

54. *Bonaventure: The Tree of Life*, 121; *Lignum vitae*, *Opera omnia*, 8:69a.

55. *Bonaventure: The Tree of Life*, 151, *Lignum vitae*, *Opera omnia*, 8:78b.

truly more radiant than the sun."[56] The splendor of Christ's person, which is mysteriously variegated in color due to the combination in Him of humanity and divinity, emanates from His risen body to illuminate His mystical body of the church in its various members, so that in the end "Christ will be clothed with all the beauty of the elect as if *with a many-colored tunic* [Gen. 37:3] in which He will shine forth richly adorned."[57]

The Beauty of Christ as God and Man

Christ, crucified and risen, is for Bonaventure the source of the beauty of all the saints, whose beauty in turn mirrors and magnifies His. Does it follow, then, that to eat Christ in the Eucharist is actually to eat Beauty, a beauty that is not destroyed by that consumption, but rather enhanced by it?

The historical work of Caroline Walker Bynum on the resurrection of the body highlights the faith that the early Christian martyrs placed in the Host as a viaticum, a life-giving source of immortality and glory—the heavenly splendor that theologians identify with God's transcendental beauty. In the age of Roman persecution, when Christians were being libeled with cannibalism and literally fed to the lions, martyrs like St. Ignatius of Antioch explicitly identified their own bodies with the Lord's in the Eucharist. In his letter to the Smyrnaeans, Ignatius complains about the Docetists that their lack of belief in the Incarnation and in Christ's Real Presence in the Host leads them also to ignore the poor and suffering, in whom Christ's beauty is disguised: "They have no regard for charity, none for the widow, the orphan, the oppressed, none for the man in prison, the hungry or the thirsty. They abstain from the Eucharist and from prayer because they do not admit that the Eucharist is the flesh of our Savior Jesus Christ, the flesh which suffered for our sins, and which the Father, in His graciousness, raised from the dead."[58] Later, writing to his fellow Christians in Rome from his place of imprisonment, Ignatius claims an aesthetic, eucharistic form for himself: "I am God's wheat; I am ground by the teeth of the wild beasts that I may end as the pure bread of Christ."[59] Urging the saints not to lament his death, Ignatius expresses the desire that his mortal body be hidden in his martyrdom, disappearing from view as the food of beasts, even as Christ's glorified Body is veiled in the

56. *Bonaventure: The Tree of Life,* 160; *Lignum vitae, Opera omnia,* 8:81b.

57. *Bonaventure: The Tree of Life,* 168; *Lignum vitae, Opera omnia,* 8:84a.

58. St. Ignatius of Antioch, *The Letters,* in *The Apostolic Fathers,* trans. Gerald G. Walsh, S.J. (New York: Christian Heritage, 1948), 121.

59. Ibid., 109.

Eucharist, and that his self-emptying might extend in Jesus to the depths of Christ's own *kenosis:* "If anything, coax the beasts on to become my sepulcher. . . . I shall be really a disciple of Jesus Christ if and when the world can no longer see so much as my body."[60]

Those who celebrated the Eucharist on the altar of the martyrs' tombs similarly expressed their faith in the resurrection of the dead, a faith grounded in Christ's own resurrected and glorified body present in the Host. For them, Bynum writes, "the Eucharist [was] a guarantee that the risen body we shall all become cannot be consumed. . . . Eating God causes us to bear within our members while still on earth the incorruptible body we shall be after the trumpet sounds."[61] The translucent, almost bodiless body of the risen Christ and of the glorified saint was understood to correspond to the earthly body of the martyr, which has been literally given up for God and others, and to the bodiless body of Christ in the Eucharist, whose outward appearance is not a body, but bread—a bodily disappearance.

By the high Middle Ages, that incorruptible body was generally understood to possess the four qualities highlighted by St. Bonaventure in his depiction of Christ's glorified body in *Lignum vitae: subtilitas* (the ability to walk through walls), *agilitas* (the ability to move quickly or lightly from place to place and to levitate), *claritas* (the brightness of light and color), and *impassibilitas* (freedom from suffering).[62] In her discussion of these four endowments (*dotes*) of the glorified body, Bynum occasionally translates *claritas* as "beauty," perhaps because both Christian and neo-Platonic aesthetics emphasize light and color as constitutive of the beautiful.[63] Clarity is a point of obvious overlap and continuity between the two traditions. To translate *claritas* as "beauty," however, has the effect of making beauty one gift beside the others. It obscures the truly remarkable tendency of Christian theological aesthetics to make beauty an attribute of all sensory experience to the extent that the grace-filled soul affects the body as a whole. *Subtilitas, agilitas, impassibilitas,* and *claritas* all manifest lightness, albeit in different forms; they all result, as the scholastics taught, from the overflow of the soul's light and beauty into the body and its senses and thus into the entire form of a blessed life.

In the twentieth century the explosion of the atomic bomb on August 6, 1945, "sent a seismic shock" through the Catholic painter Salvador Dalí, who rediscov-

60. Ibid.

61. Caroline Walker Bynum, *The Resurrection of the Body in Western Christianity, 200–1336* (New York: Columbia University Press, 1995), 56, 80.

62. On the origin and development of this standard list of four *dotes* (endowments), see Bynum, *Resurrection of the Body,* esp. 131, 172n61, 235, 269, and 302n89.

63. See, for example, Bynum, *Resurrection of the Body,* 302n89.

ered these four properties of lightness in the very make-up of matter, which "'contains and radiates'" energy.[64] Turning to the resources of Spanish mysticism, he sought to use his art "'to demonstrate the unity of the universe, by showing the spirituality of all substance.'"[65] That unity he found symbolized above all in the Eucharist. The breaking of the eucharistic bread was, for Dalí, a creative explosion of energy and beauty into the world more powerful than that produced by atomic fission, because it "penetrate[s] to the core of reality,"[66] revealing what Dalí's close contemporary, the mystic Jesuit theologian and scientist Pierre Teilhard de Chardin (1881–1955) named the Cosmic Christ.[67] In painting after painting—notably, *Basket of Bread* (1926), *Christ of St. John of the Cross* (1951), *Eucharistic Still Life* (1952), and *The Sacrament of the Last Supper* (1955)—Dalí sought to represent "'the metaphysical beauty of the Christ-God. . . . My principal preoccupation was that my Christ would be beautiful as the God that He is.'"[68]

Dalí's magnificent *Sacrament of the Last Supper* (plate 3) shows all four properties of the glorified body of Christ, present in the Eucharist.[69] A radiant light (*claritas*) burst forth from Christ, seated at the center, to open the very walls of the upper room, which appear in the painting as window panes open to a seascape, glorious at dawn or sunset. The transparency (*subtilitas*) of Christ's body at the waist—its center of gravity—makes it the point of mediation between table and fishing boat, inside and outside, matter and light, wine and waves of water. Around the table the apostles kneel, heads bowed in adoration, as if overcome by the force of a beauty too great to look upon. Christ's left hand points to his own breast, while his right hand and upraised glance gestures above, to another body of Christ—his own torso—which is ascending to heaven, arms outstretched in a gesture that recalls the cross, but also wings.[70] This tri-location of Christ's body—in the glowing, broken, eucharistic bread on the table; in the fig-

64. Robert Descharmes and Gilles Néret, *Salvador Dalí, 1904–1989: The Paintings* (Cologne: Taschen, 2000), 407. Descharmes and Néret quote from Dalí's *Mystical Manifesto* (1951).

65. Ibid., 407.

66. Ibid.

67. See Pierre Teilhard de Chardin, *The Divine Milieu* (New York: Harper, 1960) and *Hymn of the Universe* (New York: Harper, 1970).

68. Quoted in Descharmes and Néret, *Salvador Dalí*, 441–42.

69. I thank the Curator of the National Gallery of Art in Washington, DC, for permission to reproduce this painting.

70. In "Salvador Dalí's *Sacrament of the Last Supper*: A Theological Reassessment," a paper given at the Epiphanies of Beauty conference at the University of Notre Dame (Notre Dame, IN) in November 2004, Michael Anthony Novak argued that the upper torso represents God the Father, to whom Christ points (cf. John 14:5–9). This point of disagreement aside, we concur that the significance of the painting resides not in its depiction of the historical Last Supper, as many have supposed, but in its powerful representation of the Eucharist as sacrament. I thank Mr. Novak for permission to cite his work.

ure of Christ seated at the table; and in his arms and torso ascending above—symbolizes his *agilitas,* rapidity and ease of movement, to the point of levitation. The extended arms of Christ cross the wooden beams above; his down-turned hands bear only the shadowy hint of wounds, to show that his limbs are now beyond suffering, impassible, free from pain. Set into motion through Christ's breaking of bread, the cenacle has become a church-like ship, with the resurrected Christ Himself at its helm and masthead. The painting itself (*peint*) almost dematerializes in its spiritualization of matter, becoming bread (*pain*) a food for souls.[71]

What makes possible such a marriage of body and soul is, for Christians—from Ignatius of Antioch to Salvador Dalí—not a neo-Platonic emanation of forms, but rather the assumption of a created human nature by the Son of God; His death and resurrection; and the reception of the whole Christ—Body, Blood, Soul, and Divinity—in the Eucharist. St. Augustine (AD 430) accepted from Plotinus's doctrine of beauty whatever the scriptures confirmed to be true, but Augustine's biblical reading, doctrinal reflection, and sacramental practice led him (and the doctors following him) to redefine and augment the classical properties of the beautiful (form, proportion, integrity, light, and color) in order to develop a theological aesthetics commensurate with the beauty of Christ. Doing so meant reconsidering the very meaning of beauty not only in relation to the Second Person of the Trinity; to the Incarnation of the Son of God; and to the life, death, and resurrection of the historical Jesus; but also in connection with Christ, hidden but wholly present in the Eucharist under the appearance (*species*) of bread and wine.

Among the ancient philosophers Plotinus (AD 270) wrote most extensively on the topic of beauty. His neo-Platonic doctrine influenced St. Augustine and pseudo-Dionysius, and through their mediation, the whole Christian Middle Ages.[72] Regarded by his disciples as a saint, Plotinus was said to exemplify in his own life the beauty about which he taught. According to Porphyry, "When [Plotinus] spoke, his mind was manifest even in his countenance, which radiated light; lovely as he was to see, he was then especially beautiful to the sight."[73]

In the *Enneads* Plotinus distinguishes among the physical beauty perceived by the senses, the moral beauty recognized in and by virtuous souls, and the divine Beauty from which all the forms emanate. As Margaret R. Miles explains, how-

71. Descharmes and Néret ascribe this pun to Salvador Dalí himself, who jokes that his complete paintings (*l'oeuvre peint complet*) is "the complete bread" (*l'oeuvre pain complet*) (*Salvador Dalí,* 7).

72. On Augustine's reading of Plotinus, see Carol Harrison, *Beauty and Revelation in the Thought of Saint Augustine,* Oxford Theological Monographs (Oxford: Clarendon Press, 1992), 5–8, 13, 36–37, 80, 98, 132, 237.

73. *Neoplatonic Saints: The Lives of Plotinus and Proclus by their Students,* trans. Mark Edwards, Translated Texts for Historians 35 (Liverpool: Liverpool University Press, 2000), 23.

ever, this hierarchy of forms in Plotinus's thought is not a discontinuous sequence, but rather a way of describing and envisioning "the continuous circulation of being through all living beings" in an interconnected chain.[74] Form itself is what all things have in common, albeit to different degrees, and thus the act of seeing beauty in anything "produces awareness of the interconnectedness of the universe."[75] Seeing beauty is for Plotinus a contemplative, "spiritual discipline" that recognizes in each entity a beauty that is "supplied by the great Beauty," which is the One.[76]

Summarizing the general consensus of opinion about physical beauty, Plotinus asserts: "Beauty is mostly in sight, but it is to be found also in the things we hear. . . . Nearly everyone says that it is good proportion of the parts to each other and to the whole, with addition of good colour, which produces visible beauty."[77] Commenting on the idea of arrangement and proportion, Plotinus decries the ugliness of shapeless things and insists, "The things in this world are beautiful by participating in form."[78] Light "is incorporeal and formative power and form," according to Plotinus, and it produces "the simple beauty of colour" through its "presence" in matter.[79]

Even as matter gains in beauty through being shaped and formed—for example, into a statue—so too the soul is beautified through a formative process that is, however, both passive and active. The soul is passively transformed through the assimilating power of love: "No eye ever saw the sun without becoming sun-like, nor can a soul see beauty without becoming beautiful."[80] When a person consciously aims at realizing an ideal form of life that he or she has recognized from seeing good examples, the soul is also actively transformed through the self-disciplined rejection of vice and the practice of virtue.

This combination of (mystical) passivity and (ascetical) activity likens the person not only to a work of art, but also to an artist who realizes in material his or her artistic conception. Plotinus uses a striking, aesthetic image that reappears again and again in the writings and experience of Christian saints: "Go back into yourself and look; and if you do not yet see yourself beautiful, then, just as someone making a statue which has to be beautiful cuts away here and polishes there and makes one part smooth and clears another till he has given his statue a beau-

74. Margaret R. Miles, *Plotinus on Body and Beauty: Society, Philosophy, and Religion in Third-Century Rome* (Oxford: Blackwell, 1999), 35.

75. Ibid., 37.

76. Ibid., 42.

77. Plotinus, *Enneads*, trans. A. H. Armstrong, Loeb Classical Library (Cambridge, MA: Harvard University Press, 1989), 1.6.1, 1:233, 235.

78. Ibid., 1.6.2, 1:239.

79. Ibid., 1.6.3, 1:241.

80. Ibid., 1.6.9, 1:261.

tiful face, so you too must cut away excess and straighten the crooked and clear
the dark and make it bright and never stop 'working on your statue.'"[81]

In the early Christian understanding of things, the uncreated Son of God, who
became incarnate in Jesus Christ, is the divine Logos through whom God made
all things (John 1:3). Humankind, created in the image and likeness of God (Gen.
1:26), was fashioned especially in the likeness of Christ, who as God's only begot-
ten Son is the perfect Image, expressed Likeness, Beauty (*Species*), Word, and "Art"
of the Father.[82] Deformed through original and actual sin, humans are reformed
and transformed through Christ's grace.[83] The Incarnate Son is the beautiful ex-
emplar, the form of life, the original model or paradigm according to which every
saint carves and polishes the "statue" of his or her being in the process of con-
version and transformation. Christ is also the perfect fulfillment of each one's
unique being, the end or purpose toward which each one aims and gravitates.

Patristic exegetes found the (unacknowledged, misunderstood, and misap-
propriated) source for neo-Platonic aesthetics and indeed for all of Greek wis-
dom in the Hebrew scriptures, which, they argued, antedated Plato.[84] In the book
of Wisdom, in particular, they discovered an image of God whose beauty in the
work of creation possesses all the qualities praised by Plotinus, and more. God's
Wisdom is described as an "artful worker . . . of those things that are" (Wisdom
8:6). Possessing perfect proportion in Himself, God the Creator "ordered all
things in measure, and number, and weight" (Wisdom 11:21). Since beauty is de-
fined by formal proportion and integrity, and justice similarly renders to each one
what is due, God's beauty is inseparable from His justice. Indeed God beautifies
the souls of His children, teaching them the cardinal virtues, "temperance, and
prudence, and justice and fortitude" (Wisdom 8:7). If light and color are also es-
sential aspects of the beautiful, they belong par excellence to God's Wisdom, for
"she is the brightness of eternal light, and the unspotted mirror of God's majesty"
(Wisdom 7:26). Comparable to created light, but "more beautiful than the sun"
(Wisdom 7:29), God's Wisdom is also agile, active, and subtle, penetrating all
things and reaching everywhere (Wisdom 7:22–25).

In His divinity as God's Word and Wisdom—the Logos through whom all
things were created—Christ was understood to possess a beauty that is certain
by definition. Invoking the authority of St. Augustine and quoting from his fifth-

81. Ibid., 1.6.9, 1:259.
82. See St. Augustine, *De Trinitate*, ed. W. J. Mountain and Fr. Glorie, CCSL 50 (Turnhout: Bre-
pols, 1968), 6.10, 241–43.
83. See Gerhart B. Ladner, *The Idea of Reform: Its Impact on Christian Thought and Action in
the Age of the Fathers* (Cambridge, MA: Harvard University Press, 1959).
84. On this "fundamental theory about the nature of the liberal arts that . . . goes back to
Clement of Alexandria," see James O'Donnell, *Cassiodorus* (Berkeley: University of California
Press, 1979), 158–59.

century treatise on the Trinity, St. Thomas Aquinas elaborates on this point in his *Summa theologiae*. In answer to the question whether St. Hilary was correct in attributing Beauty (*Species*) to the Second Person of the Trinity, St. Thomas affirms it as a quality especially appropriate to Him as the Father's Son, Image, and Word. "Beauty," Thomas explains, "includes three conditions: *integrity* or *perfection,* since those things which are impaired are by that very fact ugly; *due proportion* or *harmony;* and lastly, *brightness* or *clarity,* whence things are called beautiful which have a bright color."[85] All three conditions are perfectly met in the Second Person. First He possesses *integritas* as the Son "inasmuch as He . . . has in Himself truly and perfectly the nature of the Father."[86] Second He is proportionate to the Father as His "express Image."[87] Third He possesses *claritas* as the Word, because He is, as St. John Damascene names Him, "'the Light and Splendor of the Eternal Mind'" and, as Augustine writes, "'the Art of the omnipotent God.'"[88]

Beautiful as God, Christ is also beautiful as a human being. The wonder of the Incarnation is a theo-aesthetic challenge, because it posits in Jesus a human nature so perfectly proportioned to God in body and soul that it could fittingly and adequately accommodate a harmonious joining (*convenientia*) with the divine nature in the hypostatic union. The divine beauty of Christ is necessarily always veiled from mortal eyes in His humanity and hidden in the eucharistic Host, but even His beauty as "true man" is excessive. Seeking to describe the beauty of Christ's human body, born of the sinless Virgin, medieval Christians turned most often to the Old Testament, where they found the Lord Jesus foreshadowed in the handsome bridegroom of the Song of Songs and in the messianic king of David's forty-fourth psalm. In the Gospels the locus classicus is the account of the Transfiguration on Mount Tabor (Luke 9:28–36, Matt. 17:1–9, Mark 9:1–8).

The scriptures, however, also bore witness to the ugliness of Christ. St. Augustine's biblical reading challenged him to reconcile Isaiah's prophecy of the lep-

85. St. Thomas Aquinas, *Summa theologiae,* part 1, q. 39, art. 8, 1:201; *Summa theologiae,* cura et studio instituti studiorum medievalium Ottaviensis (Ottawa, Canada: Garden City Press, 1941): "Nam ad pulchritudinem tria requiruntur. Primo quidem integritas sive perfectio; quae enim diminuta sunt, hoc ipso turpia sunt. Et debita proportio sive consonantia. Et iterum claritas; unde quae habent colorem nitidum, pulchra esse dicuntur" (1:248b). I use this edition of the Latin text (*ST*) throughout, giving volume and column numbers parenthetically.

86. *Summa theologiae,* part 1, q. 39, art. 8, 1:201; *ST:* "inquantum est Filius habens in se vere et perfecte naturam Patris" (1:248b).

87. *Summa theologiae,* part 1, q. 39, art. 8, 1:201; *ST: imago expressa Patris* (1:248a–249b). Forging a link between Thomas's Trinitarian theology and the aesthetic value of works of art, Umberto Eco observes: "It is in this connection that the beauty of the Son of God . . . is most significant. For it has to do with the Image par excellence, and so with all images" (*The Aesthetics of Thomas Aquinas,* trans. Hugh Bredin [Cambridge, MA: Harvard University Press, 1988], 124).

88. St. Thomas Aquinas, *Summa Theologiae,* part 1, q. 39, art. 8, 1:201; *ST:* "'lux est et splendor intellectus' . . . 'ars quaedam omnipotentis Dei'" (1:249a).

rous, Suffering Servant (Isa. 53:2) with David's prophecy of the comely king (Ps. 44:3). Carol Harrison observes, "Augustine often quotes Philippians 2:6–8 in this context."[89] That Pauline passage presents Christ in two forms: the divine form (*forma Dei*) of equality with God, to which He did not cling, and the human form of a servant and slave (*forma servi*), which He embraced. What St. Paul presents as a diachronic history of descent and self-emptying, St. Augustine sees as an aesthetic, synchronic, coincidence of opposites. Whatever has a form must be beautiful in some way, even the form of a slave, and all the more so since Christ remained God, even when His divinity was most hidden, most obscured. Thus Christ's "beauty and deformity are held together *in forma servi* and *in forma Dei*" for Augustine; similarly "wisdom, justice or righteousness, and beauty" are "brought together in his descriptions of the beauty radiant in the face of a wrinkled old person or in the body of a disfigured martyr."[90]

But how? St. Augustine, that great lover of beauty and student of Plotinus, confronted the issue of the *Christus deformis* head on and at considerable length. Commenting on the Pauline verse, "We walk by faith and not by sight [*per speciem*]" (2 Cor. 5:7), Augustine asks, "What is it that we shall see *per speciem* in Heaven?" Playing upon the double meaning of the word *species* as "sight" and "beauty" (that is, "good looking" in appearance), he answers with the words of Psalm 44:3: "We shall see Christ who is 'beautiful [*speciosus forma*] above the sons of men.'"[91] Christ's beauty in outward appearance (*species*) will be shown or manifested when Christ reveals himself in glory.

Augustine often defines Christ's beauty as His justice—that is, His perfect conformity to God's law as God's Incarnate Word and His readiness as man to give to God what belongs to God, to Caesar what belongs to Caesar (Luke 20:25). Commenting on the beauty of the king's son in Psalm 44:3, Augustine writes, "Highest and true beauty is justice."[92] Elsewhere he prophesies, "There [in heaven] you will see the justice, the equity [*aequitatem*] of God, there you will read without a book in the Word," in the Son who is "equal" to God the Father as His Word and perfect self-expression.[93] This divine equality is for Augustine (as for Saints Bonaventure and Thomas Aquinas) the consummate expression of the beauty of proportion and harmony that he likes to name *aequalitas numerosa*.[94]

89. Harrison, *Beauty and Revelation,* 236.

90. Ibid., 236–37.

91. St. Augustine, *Sermo XXVII*, PL 38, col. 181.

92. St. Augustine, *Enarrationes in Psalmos, 1–50,* ed. D. Eligius Dekkers, O.S.B., and John Fraipont, CCSL 38 (Turnhout: Brepols, 1956), 44.3, 496: "Summa et vera pulchritudo iustitia est."

93. St. Augustine, *Sermo XXVII*, PL 38, col. 181: "Ibi aequitatem Dei videbis, ibi sine codice in Verbo leges."

94. See St. Augustine, *De musica* 6.10, PL 32, cols. 1177–79.

In his commentary on the sixth chapter of the Gospel of St. John, Augustine makes explicit the connection between this beauty that is justice, on the one hand, and the eucharistic sacrament, on the other. Augustine applies Matthew 5:6: "Blessed are they who hunger and thirst for justice, for they shall be satisfied" to the word of Christ: "I am the bread of life. He who comes to me shall not hunger, and he who believes in me shall never thirst" (John 6:35). Since "Christ . . . has become for us God-given wisdom and justice" (1 Cor. 1:30), Augustine explains, "whoever hungers for this bread, hungers for justice, but that justice that descends from heaven, the justice that God gives, which no human can fashion for himself."[95]

The beautiful, ontological, and ethical justice of the Incarnate Son reveals the ugly injustice of humankind, the disproportion in its scale of values, its covetous copying of others, and the disorder in its love. If, as Elaine Scarry insists, "beauty . . . assists us in addressing injustice,"[96] this is especially true of Christ's beauty. St. Augustine's characterization of Christ's beauty as justice *and truth* includes the notion that Christ's example sets a standard according to which we may measure ourselves rightly. Christ's humility helps us to see ourselves truthfully and humbly as we are and as we are called to be. The Son's descent from the realm of pure Spirit to become man, to die ignominiously on the cross, and even to assume the appearance [*species*] of bread is for Augustine a medicinal act of profound humility by the divine physician (*medicus*) to cure the root cause of all diseases, pride.[97] In the embryonic smallness and vulnerability of the Host, Christ can literally descend so far as to get to the bottom of things, lay a new foundation, and fashion there a new creature, building up from the very ground (*humus*) in the work of recreation (cf. Gen. 2:7).

The humility of Christ makes His divine beauty and justice invisible except to the eyes of faith. Judging by ordinary sight, we see Christ crucified as one out-

95. St. Augustine, *In Johannis Evangelium,* ed. D. Radbodus Willems, O.S.B., CCSL 36 (Turnhout: Brepols, 1954), tract. 26, 259–60: "Iustitiam vero nobis esse Christum Paulus apostolus dicit (I Corinth. 1:30). Ac per hoc qui esurit hunc panem, esuriat iustitiam, sed iustitiam quae de caelo descendit, iustitiam quam dat Deus, non quam sibi facit homo."

96. Elaine Scarry, *On Beauty and Being Just* (Princeton: Princeton University Press, 1999), 62. Scarry emphasizes the analogy between distributive justice and artistic symmetry and proportion, noting that "the pressure toward the distributional is an unusual feature of beautiful things and persons" (67). "A single word, 'fairness,' is used," she observes, "both in referring to the loveliness of countenance and in referring to the ethical requirement for 'being fair,' 'playing fair,' and 'fair distribution'" (91). This is not, according to Scarry, a mere linguistic accident. Rather beauty teaches us the meaning of justice and invites the perceiver of beauty into a covenantal relationship with everything that partakes of beauty: "Beautiful things give rise to the notion of distribution, to a life-saving reciprocity, to fairness not just in the sense of loveliness of aspect but in the sense of 'a symmetry of everyone's relation to one another'" (95).

97. St. Augustine, *In Johannis Evangelium,* tract. 25.16, 256–57.

wardly deformed and leprous, condemned as a criminal with felons, utterly lacking in justice and beauty: "non habebat speciem neque decorum" (Isa. 53:2). Only with the eyes of faith (a "spiritual sense") can we see the hidden, spiritual beauty of the Lord who remains just even as He is condemned; who remains divine, even as He dies a man.[98] Indeed His inner beauty actually increases during His Passion as He exercises His virtues, undergoes a prophet's fate, forgives His enemies, learns obedience through suffering (Heb. 5:8), and freely lays down His life for his friends (John 15:13). Thus the "veil" of His humility becomes also the "revelation" (as Carol Harrison observes) of the beauty of Christ's love, a love that becomes visible precisely through His deformity.[99]

The all-surpassing spiritual beauty of Christ's divine nature and human soul not only compensates for His physical ugliness on the cross, but also incorporates and transfigures that ugliness, which serves as a means for, and an expression of, God's boundless charity. Such an ecstatic recognition of Christ's beauty requires, however, the use of spiritual senses, especially the eyes and ears of faith: "In your mind [*intellectum*] hear the song, and do not let the weakness of the flesh divert your eyes from the splendor of his beauty."[100]

Because Christ never ceases to be beautiful as God and righteous as a man, He is always beautiful. Meditating on the life, death, and resurrection of Christ, Augustine breaks out into a hymn of praise:

> Therefore now to us believers, the Bridegroom appears beautiful wherever we encounter Him. Beautiful as God, as the Word with God; beautiful in the virgin's womb, where He assumed humanity without losing divinity; beautiful born as the infant Word. . . . Beautiful therefore in heaven, beautiful on earth; beautiful in the womb, beautiful in the arms of His parents; beautiful in miracles, beautiful in being flogged; beautiful inviting to life, beautiful not fearing death; beautiful giving up His soul, beautiful receiving it back; beautiful on the cross, beautiful in the sepulcher, beautiful in heaven.[101]

98. The ancient doctrine of the "spiritual senses," first elaborated by Origen, maintained that the soul possesses faculties analogous to the five physical senses—sight, hearing, smell, taste, and touch—whereby it comprehends spiritual objects, even as the body takes in physical impressions. See Karl Rahner, S.J., "The 'Spiritual Senses' according to Origen," in *Theological Investigations*, trans. David Morland, O.S.B. (New York: Crossroad, 1979), 16:81–103.

99. Harrison, *Beauty and Revelation*, 216, 237.

100. St. Augustine, *Enarrationes in Psalmos*, 44.3, 496: "In intellectum audite canticum, neque oculos vestros a splendore pulchritudinis illius avertat carnis infirmitas."

101. Ibid.: "Nobis ergo credentibus, ubique sponsus pulcher occurrat. Pulcher Deus, Verbum apud Deum; pulcher in utero virginis, ubi non amisit divinitatem, et sumsit humanitatem; pulcher natus infans Verbum. . . . Pulcher ergo in caelo, pulcher in terra; pulcher in utero, pulcher in manibus parentum; pulcher in miraculis, pulcher in flagellis; pulcher invitans ad vitam, pulcher non curans mortem; pulcher deponens animam, pulcher recipiens; pulcher in ligno, pulcher in sepulcro, pulcher in caelo."

St. Thomas Aquinas quotes St. Augustine's anaphoric praises of Christ's beauty in his own commentary on Psalm 44:3. Applying the verse to Christ, Thomas discovers a fourfold beauty in the Lord Jesus: the beauty of His divinity; the beauty of His justice and truth as the Father's Son and Image; the beauty of His moral virtues as a man; and finally, the beauty of His body.[102] "But was Jesus indeed beautiful physically?" Thomas wonders. Does not Isaiah 53:2 explicitly state, "There is no beauty [*species*] in Him, nor comeliness?" Christ chose poverty for Himself, moreover, in order to teach us to despise worldly wealth. Would He not also have chosen, then, to be ugly in appearance, in affirmation of Proverbs 31:30: "Beauty is vain"?[103]

To these objections Thomas responds that beauty is a matter of proportion and coloring, and therefore each entity's beauty is unique: "alia pulchritudo unius, alia alterius."[104] Christ's physical beauty was precisely that beauty that was most fitting to His nature as God and man. He did not, therefore, have a physical beauty (for example, ruddy cheeks and flowing hair) that outshone and detracted from the greater beauty of His soul and divinity, but rather a bodily appearance that led beyond itself and inspired reverence in His followers: "A certain divine quality was radiant in his face."[105] Isaiah's prophecy, Thomas explains, applies only to the Passion, when Christ's beautiful body was maltreated and abused. Properly understood, the verse from Proverbs means that "riches and beauty are to be despised" to the extent that we use them wrongly: "quibus male utamur."[106]

St. Augustine's ecstatic, paratactic, anaphoric hymn in praise of Christ's beauty becomes a scholastic *distinctio* of beauty in St. Thomas's *Expositio in Psalmos*. St. Bonaventure, however, follows Augustine yet more closely, expressing in mystical juxtapositions the fluid joining of opposite forms of beauty and ugliness. In Bonaventure's *Vitis mystica* the Davidic image of the royal bridegroom merges with that of the king crowned with thorns: "Your bridegroom, excelling in beauty the sons of men, woos you; and such a spouse comes forth today crowned not with gold, not with gems, but with thorns."[107]

102. St. Thomas Aquinas, *Expositio in Psalmos David, in Opera omnia* (Parma, 1863; photographic repr., New York: Musurgia, 1949), vol. 14, col. 320a.

103. Ibid. In listing these objections, St. Thomas rehearses an ancient debate that divided the fathers of the church. As Harrison notes (*Beauty and Revelation*, 323n267), John Chrysostom and Jerome upheld Christ's physical beauty on the basis of Psalm 44:3, whereas Justin Martyr, Clement of Alexandria, Tertullian, and Ambrose denied it.

104. St. Thomas Aquinas, *In Psalmos, in Opera omnia*, vol. 14, col. 320b.

105. Ibid.: "Ita quod quoddam divinum radiabat in vultu ejus."

106. St. Thomas Aquinas, *In Psalmos, in Opera omnia*, vol. 14, col. 320b. Thomas A. Ryan discusses this Thomistic commentary on Psalm 44 in *Thomas Aquinas as Reader of the Psalms*, Studies in Spirituality and Theology 6 (Notre Dame, IN: University of Notre Dame Press, 2001), 135, 139–42.

107. St. Bonaventure, *Vitis mystica, in Opera omnia* 8:167a: "Sponsus tuus *speciosus forma prae*

In Augustine's understanding (and that of the medieval doctors after him), the beauty of anything is proportionate to its purpose or end. The theo-aesthetic problem of Christ's deformity on the cross must, therefore, take into account the beautifying effect of that heart-melting deformity on others. "The deformity of Christ forms you," Augustine declares, "for had He not willed to be deformed, you would not have regained the form which you had lost. Therefore He hung deformed on the cross. But His deformity was our beauty."[108] In His complete self-emptying on the cross, Christ accomplished a divine *kenosis* through which He released, as it were, the infinity of gifts, forms, and virtues whereby the whole world might be recreated in His image and likeness. In the order of redemption, that recreation requires conformity also to the crucified Christ, whose wounds, still visible in His glorified body (John 20:25–29), are the gates of return to paradisiacal beauty.[109] "Let us cling in this life," Augustine urges, "to the deformed Christ," glorying in His cross, whereby the world is crucified to us, and we to the world (cf. Gal. 6:14); "Let us hold to this path, that we may also arrive *ad speciem*"—that is, at the sight (*species*) of Christ's glory in heaven in the *visio beata*, but also at beauty itself (*species*), our own and God's.[110]

The *Christus Deformis* of the Eucharist

These Augustinian reflections on Christ's beauty and ugliness, which find multiple echoes in the writings of the medieval doctors and mystics, bear directly on the medieval understanding of the Eucharist. Indeed the problem of the *Christus deformis* is a specifically eucharistic problem in at least three ways. First of all the outward appearance (*species*) of bread and wine does not accord with the actual substance of the sacrament, which is Christ Himself in His entirety—body, blood, soul, and divinity.[111] Even as Christ's divinity is concealed by His suffering humanity and requires faith for recognition, so too His sacramental presence is a stumbling block to unbelievers.

filiis hominum subarrhavit te; et ipse tanquam sponsus hodie processit coronatus non auro, non gemis, sed spinis."

108. St. Augustine, *Sermo XXVII*, PL 38, col. 181: "Deformitas Christi te format. Ille enim si deformis esse noluisset, tu formam quam perdidisti non recepisses. Pendebat ergo in cruce deformis: sed deformitas illius pulchritudo nostra erat."

109. St. Augustine taught that the bodies of the martyrs must somehow retain their scars in heaven as adornments that enhance, rather than detract from, this beauty. See Bynum, *Resurrection of the Body*, 98.

110. St. Augustine, *Sermo XXVII*, PL 38, col. 181: "In hac ergo vita deformem Christum teneamus. . . . Hanc viam teneamus, et ad speciem perveniemus."

111. See St. Thomas Aquinas, *Summa theologiae*, part 3, q. 76, art. 1, 2:2455.

Second the sacrament can be received unworthily or with malicious intent, as it was by Judas at the Last Supper, with the result that it is deformed in its effect. Good and lifegiving in itself, it can be eaten in an evil way by the wicked (*male malus*), as St. Augustine observes.[112] Such persons, according to St. Paul, eat and drink a judgment against themselves and die (1 Cor. 11:29), because they are not properly disposed. "How many," Augustine wonders, "receive from the altar and by receiving die?"[113]

Third the sacrament represents Christ's Passion, making it "present" and daily effective in its fruitfulness. St. Thomas Aquinas explains that even as Christ's "blood was separated from his body" in the Passion, so too "in the sacrament, which is the memorial of Christ's Passion, the bread is received apart as the sacrament of the body, and the wine as the sacrament of the blood,"[114] even though the whole Christ is contained under each species. "The altar," he writes, "is representative of the cross itself, upon which Christ was sacrificed in His proper species,"[115] while the altar stone recalls the sepulcher, and the altar linen, the shroud in which Christ's body was wrapped.[116]

Although orthodox doctrine and tradition maintained that the whole of the paschal mystery—Christ's Passion, death, and resurrection—is rendered present through the Mass in a diachronic unfolding, and that communicants receive the risen Christ in the Host, the definition of the sacrament as a memorial of the Passion associated the eucharistic Christ in a special way with the Man of Sorrows, the *Christus deformis*.[117] The elevation of the Host recalled the raising of Christ's body on the cross; the lowering of the Host, the deposition and burial. Eucharistic miracles—many of which occurred as proofs of the Real Presence in answer to doubts about transubstantiation—often involved bleeding Hosts, disturbingly bloody signs of the mystery the Mass represented in an unbloody way.[118] These

112. St. Augustine, *In Johannis evangelium*, tract. 25, 265.

113. Ibid.: "Quam multi de altari accipiunt et moriuntur, et accipiendo moriuntur?" On this topic see St. Thomas Aquinas, *Summa theologiae*, part 3, q. 79, art. 3, 2:2481–82.

114. St. Thomas Aquinas, *Summa theologiae*, part 3, q. 74, art. 1, 2:2439; *ST*: "Secundo, quantum ad passionem Christi, in qua sanguis est a corpore separatus. Et ideo in hoc sacramento, quod est memoriale Dominicae passionis, seorsum sumitur panis ut sacramentum corporis, et vinum ut sacramentum sanguinis" (4:2929a).

115. *Summa theologiae*, part 3, q. 83, art. 1, 2:2512; *ST*: "Ita altare est repraesentativum crucis ipsius, in qua Christus in propria specie immolatus est" (4:3024a).

116. See *Summa theologiae*, part 3, q. 83, art. 3, 2:2517; *ST*, 4:3029b–3030a.

117. Jonathan Bishop finds an "implicit contradiction between the idea that each Eucharist was a reenactment of the passion . . . and the equally important belief that the body present in the species must be that of the risen Jesus" (*Some Bodies: The Eucharist and Its Implications* [Macon, GA: Mercer University Press, 1992], 8). That apparent contradiction rests, however, on a synchronic, instead of a diachronic, interpretation of the eucharistic celebration in the Mass.

118. See P. Eugène Couet, *Les miracles historiques du Saint Sacrement* (Brussels: Chaussée de Wavre, 1906).

miracles, moreover, became more frequent in the late Middle Ages, when artists, departing from earlier practice, began to depict the Passion of the Lord graphically and realistically in altarpieces.

Such an apparition, according to St. Thomas Aquinas, is not deceptive, because it is "divinely formed in the eye in order to represent some truth, namely, for the purpose of showing that Christ's body is truly under this sacrament."[119] Properly speaking, however, "Christ's body, according to the mode of being which it has in the sacrament, is perceptible neither by the sense nor by the imagination, but only by the intellect, which is called the spiritual eye."[120]

After the Resurrection, the Body of Christ received in the sacrament is the glorified body of Christ, medieval theologians reasoned, for that is the body He has. But what of His suffering body, which the Mass memorializes and which visionaries saw in the Host? Important in this context are the theological disagreements concerning which body of Christ—the passible or the impassible—was received at the Last Supper, when the sacrament was instituted. Hugh of St. Victor maintained, as St. Thomas Aquinas reports in his *Summa theologiae,* that the body Christ gave to His apostles that night was His glorified body, given in anticipation of the resurrection. Already during His earthly life, Hugh argued, Christ's body occasionally manifested the four qualities proper to the glorified body: subtlety, agility, clarity, and impassibility. His body exhibited *subtilitas* at His birth, when He passed from the womb of His mother Mary without violation of her virginity. It showed *agilitas* when He walked on the water. In the Transfiguration, it radiated forth in *claritas.* Finally at the Last Supper it possessed *impassibilitas,* for the apostles ate His body and blood in a manner completely painless to Christ.[121]

In the *Summa* St. Thomas refutes Hugh's position, arguing that Christ could only give the body that He possessed at the time of the Last Supper. That body, "as seen in its own species . . . was not impassible; nay more, it was ready for the Passion."[122] Therefore Christ "gave a passible and mortal body to the disciples,"

119. St. Thomas Aquinas, *Summa theologiae,* part 3, q. 76, art. 8, 2:2461; *ST:* "quia talis species divinitus formatur in oculo ad aliquam veritatem figurandam, ad hoc scilicet quod manifestetur vere corpus Christi esse sub hoc sacramento" (4:2957b).

120. *Summa theologiae,* part 3, q. 76, art. 7, 2:2460; *ST:* "Et ideo proprie loquendo, corpus Christi secundum modum essendi quem habet in hoc sacramento, neque sensu neque imaginatione perceptibile est, sed solo intellectu, qui dicitur oculus spiritualis" (4:2956b). St. Thomas's reference to the "spiritual eye" refers in shorthand to the ancient doctrine of the "spiritual senses." See note 98 above.

121. *Summa theologiae* (*ST*), part 3, q. 81, art. 3, 2:2502. See also *Summa theologiae,* part 3, q. 28, art. 2, 2:2172. There Thomas argues that Christ walked on the water and was born of a virgin miraculously by divine power, not through "an overflow of the soul's glory on to the body."

122. *Summa theologiae,* part 3, q. 81, art. 3, 2:2502; *ST:* "Non autem erat impassibile secundum quod in propria specie videbatur; quinimmo erat passioni paratum" (4:3011a).

but "that which was possible of itself" was nonetheless "present in the sacrament in an impassible way, . . . just as that was there invisibly which of itself was visible."[123] The conclusion that Christ gave a mortal body capable of suffering to His apostles forces St. Thomas to admit the frightening possibility that "had this sacrament been celebrated during those three days when He was dead, the soul of Christ would not have been there."[124] Had a portion of the bread that Christ consecrated in the upper room been preserved in a pyx, moreover, the Body of Christ would have died there, at the same moment when he died on Calvary.[125]

St. Albert the Great (AD 1280), Thomas's teacher, finds the question of the *passibilitas* of Christ's eucharistic body so important that he devotes three full columns of text to its discussion in *De Eucharistia*. Refuting the nightmarish suggestion that Christ would have suffered torture in His eucharistic body contained in the pyx ("videtur quod in pyxide flagellabatur, conspuebatur, et crucifigebatur"),[126] Albert argues that one must distinguish among the different forms of Christ's presence and the attributes proper to each. Christ has assumed various forms (*plures formas assumpsit*), appearing in many different visions to the prophets. As proof, Albert cites Hosea 12:10: "I have multiplied visions."[127] Of the many faces of Christ ("Christus est multarum facierum"), three forms are basic: those according to His divinity, to His humanity, and to His sacramental form.[128] Since the eucharistic form is that of bread and wine, attributes improper to that form are excluded. The sacrament in the form of food is meant to be eaten as a true nourishment for body and soul ("verum ad animae et corporis refectionem"), whereas no one eats a man's body in its corporeal form: "nemo comederet hominem in statura corporis humani."[129]

The *Christus Gloriosus* of the Eucharist

Christ's glorified Body, received in Communion after the resurrection and in the form of bread, is an indestructible and impassible means to a share in His glory.

123. *Summa theologiae*, part 3, q. 81, art. 3, 2:2502; *ST*: "Ergo corpus passibile et mortale discipulis dedit. . . . Impassibili tamen modo erat sub specie sacramenti quod in se erat passibile, sicut invisibiliter quod in se erat visibile" (4:3011a).
124. *Summa theologiae*, part 3, q. 76, art 1, 2:2455; *ST*: "Et ideo si in illo triduo mortis fuisset hoc sacramentum celebratum, non fuisset ibi anima Christi" (4:2950a).
125. *Summa theologiae*, part 3, q. 81, art. 4, 2:2503; *ST*: 4:3012a.
126. St. Albert the Great, *De Eucharistia, Opera omnia*, dist. 3, tract. 1.7, 38:263b.
127. Ibid., 264a.
128. Ibid.
129. Ibid., 264b.

In a vernacular, fifteenth-century sermon on the *Pater Noster,* Nicholas of Cusa (AD 1464) declares: "Christ is our bread as we make our way toward him. . . . Christ, who is immortal and, since His resurrection, invisible to mortal eyes because of His most agile and incomprehensible spiritual splendor."[130] "Since *Christ rising from the dead dieth no more* (Romans 6:9), His soul is always really united with His body," St. Thomas Aquinas asserts in the *Summa theologiae,*[131] and the latter, received in the Eucharist, possesses the four *dotes* (endowments) of clarity, subtlety, agility, and impassibility. This glory corresponds to one of the effects of the sacrament, namely, "the attainment of eternal life."[132] Although the sacrament "does not at once admit us to glory," it "bestows on us the power of coming unto glory," to the extent that we as wayfarers are willing to "*suffer with Him in order that we may also be glorified afterward with Him* (Rom. 8:17)."[133] To some extent, however, even in this earthly life the Body of Christ may affect our bodies, St. Thomas admits, albeit indirectly: "Although the body is not the immediate subject of grace, still the effect of grace flows into the body while in the present life we present *our* (Vulgate, *your*) *members as instruments of justice unto God* (Rom. 6:13), and in the life to come our body will share in the incorruption and the glory of the soul."[134]

St. Thomas Aquinas celebrates the beauty of the Eucharist in his eucharistic theology, prayers, and hymns[135] but, as John Saward notes, "among the Dominican Doctors, it is especially St. Albert who develops a theological aesthetic of the Eucharist."[136] The very name of the sacrament, Albert suggests, has aesthetic connotations, for "Eucharistia" means "good grace," and *grace* (in Greek, *charis;* in

130. Nicolas of Cusa, "Vernacular Sermon on the *Pater Noster.*" I quote with permission from an unpublished translation by Frank Tobin. For the original text of the sermon, see Nicolas of Cusa, *Sermones I* (1430–41), ed. Rudolf Haubst et al. (Hamburg: Felix Meiner, 1991), 384–431.

131. St. Thomas Aquinas, *Summa theologiae,* part 3, q. 76, art. 1, 2:2455; *ST:* "Sed quia 'Christus resurgens ex mortuis iam non moritur,' ut dicitur *Rom.* VI, anima eius semper est realiter corpori eius unita" (4:2950a).

132. *Summa theologiae,* part 3, q. 79, art. 2, 2:2481; *ST: adeptionem vitae aeternae* (4:2982b).

133. *Summa theologiae,* part 3, q. 79, art. 2, 2:2481; *ST:* "sed dat nobis virtutem perveniendi ad gloriam non, tamen ita quod statim per ipsam introducamur in gloriam sed oportet ut prius 'simil compatiamur,' ut postea 'simul glorificemur,' sicut dicitur *Rom.* VIII" (4:2982b).

134. *Summa theologiae,* part 3, q. 79, art. 1, 2:2480; *ST:* "Et licet corpus non sit immediatum subiectum gratiae, ex anima tamen redundat effectus gratiae ad corpus; dum in praesenti 'membra nostra exhibemus arma iustitiae Deo,' ut habetur *Rom.* VI; et in futuro corpus nostrum sortietur incorruptionem et gloriam animae" (4:2982a).

135. At the request of Pope Urban IV, St. Thomas wrote four hymns to mark the occasion of the institution of the Feast of Corpus Christi in 1264: *Lauda, Sion, salvatorum; Pange, lingua, gloriosi; Sacris solemniis juncta sint gaudia; Verbum supernum prodiens.* See *The Hymns of the Breviary and Missal,* ed. Dom Matthew Britt, O.S.B. (New York: Benziger, 1948), 188–91.

136. John Saward, *The Beauty of Holiness and the Holiness of Beauty: Art, Sanctity, and the Truth of Catholicism* (San Francisco: Ignatius, 1996), 107.

Latin, *gratia*) is a word that, whatever its specific denotation, never ceases to con-
note "beauty," "comeliness," "a charming or attractive endowment," "seemliness,"
and "propriety."[137] Albert characterizes the Eucharist as the sacrament of sacra-
ments, containing every possible grace within its grace. Through the sacrament
of the altar, the faithful receive, first of all, the grace of Communion with their
fellow Christians; second the grace of expiation by which their souls are cleansed
through infused, purgative virtues; third the grace of redemption; fourth that of
transformation or vivification; fifth that of eternal beatitude.[138] Whereas the first
four eucharistic graces stem from Christ's humanity, the fifth stems specifically
from His divinity, for "God is Light" (1 John 1:5): "For the brightness [*claritas*] that
the Father gives in perfection to the Son is the glory [*claritas*] by which He shines
in all the members of the mystical body of Christ."[139] In eternity this brightness
of soul will be so great that it will shine through the glorified bodies of the saints
more brightly than natural light shines in gold or through glass.[140]

Comparing the beauty of the Eucharist to that of the crocus, a flower that he
describes as possessing a penetrating power (*subtilitas*), fragrance (akin to *agili-
tas*), and colorful brightness (*claritas*), Albert indicates that these same qualities
reside in the Eucharist, "which *penetrates* to the height of the deity, *flows* with the
fragrant odor of virtues, and induces spiritual beauty by the *splendor* of the full-
ness of grace by which [the faithful] are assimilated to the most beautiful king
and font of graces."[141] It is no accident that the qualities that Albert discovers in
the crocus and in the sacrament are three of the four qualities generally attrib-
uted to the glorified body of the risen Christ.

Because these graces and qualities are given in the Eucharist in the useful form
of a *gift,* God in His graciousness observes the due proportion that is a funda-
mental aspect of the beautiful. The gift is fitting for the Giver (*habet conformi-
tatem ad donantem*), because Christ gives Himself totally and finds in that total
giving an apt expression for His affection for humankind.[142] The gift is also "ap-
propriate [*conveniens*] and proportionate [*proportionatum*] to the recipients,"

137. Albert the Great, "De Eucharistia," dist. 1.1, in *Opera omnia*, 38:192. The aesthetic mean-
ings I list for *grace* appear in *Webster's Third New International Dictionary of the English Language,
Unabridged*. That Bonaventure was aware of the aesthetic connotations of *charis* becomes clear
in his meditation on the title "Maria charissima" in *De laudibus beatae Mariae virginis*, book 6,
chap. 3, in *Opera omnia*, 36:331.

138. Albert the Great, "De Eucharistia," dist. 1.5, in *Opera omnia*, 38:208–12.

139. Ibid., 211: "Claritas enim quam Pater perficiendam dedit Filio est claritas qua claret in om-
nibus membris corporis mystici."

140. Ibid., 212.

141. Ibid., dist. 1.3, 205: "Quae sublimitate deitatis penetrat, odore virtutum flagrat, et splen-
dore plenae gratiae pulchritudinem inducit spiritualem, qua pulcherrimo regi et fonti gratiarum
assimilantur." Emphasis mine.

142. Albert the Great, "De Eucharistia," dist. 2, tract. 2.4, *Opera omnia*, 38:223.

because "each one finds in it what he seeks," according to their individual capacities.[143]

Because the Eucharist is a kind of food, it allows for and effects, moreover, constant changes in the recipients' capacity to receive Christ, as they grow in the life of grace. The Eucharist acts as an antidote, as "medicine in the pyx of the sacrament,"[144] to counter the poison of the seven sins by "purging the cause of infirmity, repairing lost health, and conserving repaired health."[145] The seed of Christ, consumed in the Eucharist, "germinates," St. Albert says;[146] it sprouts, grows, and gradually matures in the garden of the soul. This organic growth in virtue alters and increases, in turn, the proportionate relationship between the communicant's receptivity and Christ's gift of Himself. The more Christlike people become, the worthier their disposition to receive the Host, the more Christ incorporates them into Himself as they eat the sacrament.

In support of this doctrine, Albert quotes Augustine: "For thus, as Augustine says, we are fashioned and refashioned [reformamur] according to that image, and thus refashioned, we are assimilated to the Son of God, who is our food in the sacrament. . . . So, therefore, by imitating the Son of God, one is made into His likeness and made worthy to eat His body."[147] The more similar two things are to each other in nature, St. Albert explains, the easier the one can be changed into the other. Therefore, "those possessing similitude to our Lord Jesus Christ are easily transmuted into His body and His members,"[148] becoming, as it were, "flesh of His flesh" (Gen. 2:23).

This harmonious relationship of likeness (congruitas or convenientia) demonstrates, in Albert's understanding, yet another way in which the Eucharist is beautiful and beautifying, for the one bread unites the different members of the church in a common feast: "We are, moreover, conformed, having congruity due

143. Ibid., dist. 2, tract. 3.2, 228.

144. Ibid., dist. 3, tract. 1.4, 250.

145. Ibid., 247: "causam infirmitatis expurgando, sanitatem perditam reparando, et sanitatem reparatam conservando."

146. Ibid., dist. 1.6, 213: "totus in agro suae humanitatis germinavit." See also dist. 3, tract. 1.4, 249, where Albert considers how the blessed, who "hunger and thirst" for justice, receive the Eucharist as the "seed of justice," which they then plant in the fields through abundant good works, in the harvest of which grows the grain of the bread of the body of Christ: "et ibi semine justitiae seminaverunt agros et augendo seu agendo dictos, in quibus crescit frumentum panis corporis Christi."

147. Ibid., dist. 3, tract. 1.6, 260–61: "Sic enim ut dicit Augustinus ad eandem imaginem facti sumus, et reformamur et sic reformati assimilamur Filio Dei, qui est cibus noster in sacramento. . . . Sic igitur imitando Filium Dei, ad similitudinem illius efficitur et dignus efficitur ut corpore ejus cibetur."

148. Ibid., 261: "similtudinem habentes ad Dominum nostrum Jesum Christum facile transmutantur in ipsius corpus et in ipsius membra."

to the beauty of spiritual exchange [*ex conversationis pulchritudinem*], because they [i.e., Christ and the individual souls] are conformed to each other in the beauty of virtue [*in virtutis pulchritudine*]. And out of this congruity we come very closely together, through sharing divine food."[149]

According to Albert the assimilating and unifying power of the Eucharist in the work of *convenientia* is progressive, unfolding in five stages. First there is a relationship of connaturality, which makes it possible for us to unite in Communion with the Son in whose Image we were created. Second there develops a likeness in virtue. Third a heart-melting charity brings about the concord of a sincere and beautiful (*et sincera et pulchra*) love for God and neighbor. Fourth comes the illuminative stage (*illustratio contemplativa*), at which we are conformed to Christ in knowledge (*in cognitio conformes*). At the fifth stage a spiritual Communion with Christ present in the sacrament (whether or not the Host is actually eaten) becomes identical with the closest possible mystical union (*unio devota*) with Him and inseparability from Him: "nos ab ipso indistantes."[150]

<hr />

"Tota Pulchra es": Mary and the Mystical Body of Christ

For St. Albert the closest possible figural expression of this mystical Communion of the faithful soul with Christ is the spousal relationship between Mary and her Son. Indeed Albert's Mariology illustrates what Hans Urs von Balthasar writes concerning the "form" of Mary: "In the instance of Mary, virgin and mother . . . two things become visible: first, that here is to be found the archetype of a Church that conforms to Christ, and, second, that Christian sanctity is 'Christ-bearing', 'Christophorous' in essence and actualization."[151]

Both *De Eucharistia* and his twelve-book, encyclopedic praise of Mary are filled with quotations from the Song of Songs. Albert devotes the fifth book of his *De laudibus beatae Mariae Virginis* to Mary's pulchritude in body and soul. Mary's four beauties—chastity of body, purity in conscience, charity in outward works and in divine contemplation—are congruent to Christ's four manifestations of beauty and derived, as it were (*quasi derivantur*), from Him as her spouse.[152] Beautiful in His mortal body, in His Transfiguration, in His Resurrection, and in

<hr />

149. Ibid., dist. 3, tract. 1.7, 261–62: "Sumus autem conformes congruitatem habentes ex conversationis pulchrudine quia conformantur sibi in virtutis pulchrudine et ex hac congruitate maxime conveniemus cum cibo divino."

150. Ibid., dist. 3, tract. 1.8, 271.

151. Balthasar, *Glory of the Lord,* 1:562.

152. St. Albert the Great, *De laudibus beatae Mariae Virginis,* in *Opera omnia,* 36:278.

his divinity, Christ was "'beautiful above the sons of men'" (Ps. 44:3: *speciosus forma prae filiis hominum*), and therefore it is fitting to believe that Mary, His virginal mother, was the fairest of women: *prae filiabus hominum speciosam.*[153] Indeed Mary must have been *tota pulchra* (Song of Sol. 4:7), perfectly beautiful in body and soul, for she conceived and gave birth to the divine Word, who is the "Splendor of the Father's glory" (*splendor paternae gloriae*).[154] She was prefigured by beautiful women of the Old Testament: Sarah, Rachel, Ruth, Esther, Susannah, and Judith. She was destined, moreover, to be the model for the church and the mother of all Christians, who are her children in Christ. Therefore she must have been beautiful, Albert argues, as a fitting sign and symbol of the church's mystical and moral beauty.[155]

Even as the comely Christ was deformed on the cross, so too Mary's splendrous beauty was discolored. "Mary's life," Balthasar writes, "stands in the *chiaroscuro* of grace and faith."[156] Albert, for his part, emphasizes the shadows of grief and shame. Parallel to the prophecy of the Suffering Servant in Isaiah 53:2–4, Albert sets a verse from the Song of Songs: "I am black but beautiful" (1:4), applying it to Mary, who was misjudged and defamed in her pregnancy.[157] She was also discolored, Albert writes, in the darkness of her dolorous compassion for her Son, when a sword of sorrow pierced her heart (cf. Luke 2:35) on Calvary. Solomon's dark-skinned (*fusca*), sun-tanned bride thus speaks prophetically concerning Mary in her relationship to the Son: "Fusca sum, quia decoloravit me sol" (Song 1:5).[158] Even as Christ's beauty was restored and indeed increased in the Resurrection, the pallid Mary regained her color in the joy of Jesus' rising from the dead and in the preaching of the apostles, who proclaimed her blessed in her Son (Luke 1:48–49).[159]

St. Albert's meditation on the *Ave Maria* considers the paradisiacal qualities of the fruit of Mary's womb, Jesus. Mary, the daughter of Eve (*Hevae filia*), restored what the first Eve lost.[160] Therefore the faithful Christian can reverse the complaint of Adam (Gen. 3:12) and speak words of eucharistic praise, not blame, saying, "'Lord, the woman whom you have given me, gave me to eat from the Tree of Life, and I ate: and it has become sweeter than honey in my mouth, because you have vivified me through that very fruit.'"[161]

153. Ibid., 279.
154. Ibid., 275.
155. Ibid., 280.
156. Balthasar, *Glory of the Lord*, 1:565.
157. St. Albert, *De laudibus beatae Mariae*, in *Opera omnia*, 36:291.
158. Ibid., 292. The verse can be translated, "I am brown, because the sun has discolored me."
159. Ibid., 293.
160. Ibid., 7.
161. Ibid., 8: "'Domine, mulier quam dedisti mihi, dedit mihi de ligno vitae, et comedi: et dulce

In her magisterial study of the Annunciation in the dogmatic understanding of the medieval church, Maria Gössmann calls attention to the parallels that were frequently drawn in writings and visual art not only between Mary's fruit, Jesus, and Eve's forbidden fruit, but also between the Incarnation in Mary's womb and the eucharistic reception of Christ's Body by the faithful: "Mary received the Ave [the angel's greeting] and with it Christ; the faithful receive in the Host the Body of Christ."[162] In her *Scivias,* for example, Hildegard von Bingen records God's words to her, likening the coming of Christ's Body upon the altar at the priest's words of consecration to the Incarnation accomplished in Mary's womb at her spoken *Fiat:* "Let it be done to me" (Luke 1:38): "'quemadmodum corpus Filii mei in utero Virginis surrexit, sic etiam et nunc caro eiusdem Unigeniti mei in sanctificatione altaris ascendit.'"[163] St. Francis of Assisi draws exactly the same parallel between the Incarnation and the eucharistic consecration in his *Admonitions:* "Everyday [Christ] humbles himself just as he did when he came from his *heavenly throne* (Wisdom 18:15) into the Virgin's womb; everyday he comes to us . . . when he descends from the bosom of the Father into the hands of the priest at the altar."[164] In his "Letter to All the Faithful," Francis writes on a related theme: "We are mothers to [Jesus] when we enthrone him in our hearts and souls by love with a pure conscience, and give him birth by doing good."[165]

Receiving Christ in Communion, Christians become Marian Christ-bearers and bringers. The Christ Child is almost always depicted in art with His mother's physical features, in witness to the Virgin-Birth, but like Christ, Mary has many faces, assumes many forms, appears in manifold visions. As mother she gives "matter" to Christ, even as each Christian offers the bread to be consecrated through the priest's hands. But she receives her form through her conformity to Christ. The Marian, Christian communicant is what she eats, a mirror image of the Christ she consumes, He who turns her into Himself.

In this book I focus on four of these mirrored, eucharistic *species:* the face of the humble Christ of the monastics; of the poor Christ of the Franciscans; of the preaching and fasting Christ of the Dominicans; and finally that of the obedient

factum est super mel ori meo, quia in ipso vivificasti me.'" St. Albert is quoting St. Bernard of Clairvaux's second homily on Luke 1:26–38.

162. Maria Elisabeth Gössmann, *Die Verkündigung an Maria im dogmatischen Verständnis des Mittelalters* (Munich: Max Hueber, 1957), 270. Translation mine.

163. "For, as the body of My Son came about in the womb of the Virgin, so now the body of My Only-Begotten arises from the sanctification of the altar" (Hildegard von Bingen, *Scivias,* 2:14, PL 197, col. 516; qtd. Gössmann, *Die Verkündigung an Maria,* 113; trans. Mother Columba Hart and Jane Bishop [New York: Paulist Press, 1990], 245).

164. *The Writings of St. Francis of Assisi,* trans. Benen Fahy, O.F.M., ed. Placid Hermann, O.F.M. (Chicago: Franciscan Herald Press, 1976), 79.

165. Ibid., 96.

Christ of the Jesuits. Each is beautiful and a way to Beauty for the saints who fol-
low Christ in the singular manner in which He has appeared to them. Each is
restorative of a paradise lost, an approach to a heaven to come. Each way of
beauty, each spirituality, proves the truth of the words of Hans Urs von Balthasar:
"These commissions of charism can be important as a kind of 'inner form' of a
great theology . . . , the 'form' here emphasizing the aesthetic side of a personal
calling as it breaks in from the self-revealing God through the Church to the heart
and mind of the individual."[166] To each one is given a Host—to Bernard of Clair-
vaux, to Hildegard von Bingen, to Gertrude of Helfta; to Francis of Assisi, to
Bonaventure, to Angela of Foligno; to Albertus Magnus, to Thomas Aquinas, to
Catherine of Siena, to Catherine of Genoa, and to Rose of Lima; to Ignatius of
Loyola, to Vittoria Colonna, and to Michelangelo. Out of these and countless
other individual Communions, spiritual and sacramental, the Communion of
saints is fashioned as a great *convenientia*.

166. Balthasar, *Glory of the Lord*, 2:28.

3 : "HIDDEN MANNA"

Bernard of Clairvaux, Gertrude of Helfta, and the Monastic Art of Humility

My one hope is your table. ✓
—St. Bernard of Clairvaux

St. Bernard compared this Sacrament with the human processes of eating. . . .
To some people this will seem crude, but let such refined people beware of pride,
which comes from the devil; a humble spirit will not take offense at simple things.
—John Tauler

I n his continuation of William of St. Thierry's unfinished Life of St. Bernard, Arnold of Bonnevaux so vividly describes the scene of Pope Innocent II's visit to Clairvaux that it invites (and has received) pictorial representation:[1]

Returning from Liège, the Pope now wished to see for himself what Bernard's famed monastery at Clairvaux was really like. And there he met the poor of Christ coming out to meet him, not with gilded Gospels and purple robes, but all of them ragged men, bearing a rough cross, and greeting him with the quietest and most affectionate of voices, instead of high flown speeches and loud acclaim. The bishops and the Pope himself were moved to tears. All wondered at the gravity of the community, who, on such a solemn and joyful occasion as this, still kept their eyes humbly downcast. They seemed to see no one, and to be without the slightest curiosity. In their church there was nothing that any man might covet, nothing to arouse sufficient interest to make one look twice, nothing in the chapel but the bare walls. It was their way of life, and that alone, that left the visitors gaping in astonishment.[2]

1. See Adriaan H. Bedero, *Bernard of Clairvaux: Between Cult and History* (Edinburgh: T. and T. Clark, 1996), 6.
2. *St. Bernard of Clairvaux: The Story of his Life as recorded in the Vita Prima Bernardi by certain of his contemporaries, William of St. Thierry, Arnold of Bonnevaux, Geoffrey and Philip of Clairvaux, and Odo of Deuil,* trans. Geoffrey Webb and Adrian Walker (Westminster, MD: Newman Press, 1960), 79; *Vita prima,* PL 185, col. 272: "Rediens autem Leodio, Claram-Vallem dominus Papa per se ipsum voluit visitare: ubi a pauperibus Christi, non purpura et bysso ornatis, ne cum deauratis Evangeliis occurrentibus, sed pannosis agminibus scopulosam bajulantibus crucem, non tumultuantium classicorum tonitruo, non clamosa jubilatione, sed suppressa modulatione affectuosissime susceptus est. Flebant episcopi, flebat ipse summus Pontifex: et omnes mirabantur congregationis illius gravitatem, quod in tam solemni gaudio oculi omnium humi defixi,

The scene, as Arnold narrates it, is full of contrasts that make the vignette itself a colorful work of art. Although the rich accoutrements of the pope and bishops are not described, they are evoked by the explicit reference to the poor monks' lack of "gilded Gospels and purple robes." The marveling gaze of the visiting dignitaries and the pope's curiosity ("He wished to see for himself. . . .") stand in sharp contrast to the monks' downcast eyes, which "seemed to see no one," and to their apparently complete lack of curiosity.[3] What strikes the visitors is the remarkable absence within the monastic retreat of familiar kinds of art: ceremonial speeches, religious carvings and paintings, and so on. Perceiving "nothing . . . but the bare walls," "nothing . . . to make one look twice," the high-ranking churchmen nonetheless "gape in astonishment" at what they do not see, because it reveals a marvel, a singular work of beauty to rival all others; namely, the monks' "way of life."

In Arnold of Bonnevaux's description of Pope Innocent's visit to Clairvaux, the bare-walled church stands in a metonymic relationship to the ill-clad monks themselves, whose "way of life" inspires an astonished sense of awe in the beholders, an aesthetic response to a perceived beauty. Commenting on the modern architectural ideal of "the complete building" (as exemplified in Walter Gropius's *Bauhaus* of 1925), Karsten Harries writes about its erasure of "the boundaries between aesthetic, ethical, and technological considerations," its attempt to "shape the space and time of everyday experience in such a way that individuals are recalled from . . . dispersal . . . to an order in which they can recognize their place and vocation."[4] Harries associates this modernist impulse with the medieval Gothic cathedral, but his words apply equally well to the Cistercian church in its monastic setting. "The architectural theory of the abbot of Clairvaux, like his aesthetics in general, appears to have its source," M. Kilian Hufgard affirms, "in his idea of man . . . as a body-soul. Man is an architect who must build two homes—an earthly one, in the image of himself, serving both his body and soul; a spiritual one, in the image of man's Creator, capable of containing Him. . . . The Cistercian church . . . is the image of the monk."[5] Standing inside

nusquam vagabunda curiositate circumferrentur; sed complosis palpebris ipsi neminem viderent, et ab omnibus viderentur. Nihil in ecclesia illa vidit Romanus quod cuperet, nulla ibi supellex eorum sollicitavit aspectum; nihil in oratorio nisi nudos viderunt parietes. Solis moribus poterat inhiare ambitio."

3. The pope's curiosity may be what Mary Carruthers calls "holy curiosity." She notes, "Like other vices, *curiositas*, properly directed, can be a virtue" (*The Craft of Thought: Meditation, Rhetoric, and the Making of Images, 400–1200*, Cambridge Studies in Medieval Literature 34 [Cambridge: Cambridge University Press, 2000], 99).

4. Karsten Harries, *The Ethical Function of Architecture* (Cambridge, MA: MIT Press, 1997), 330.

5. M. Kilian Hufgard, O.S.U., *Saint Bernard of Clairvaux: A Theory of Art Formulated from His Writings and Illustrated through Twelfth-century Works of Art*, Medieval Studies 2 (Lewiston, NY:

the church, the monk always already contains the church (in potential, if not yet in reality) within himself.

The bare-walled building in which St. Bernard of Clairvaux (1090–1153) and his monks prayed—an architectural enclosure that determines what may fittingly be contained within it—suggests an "architectural aesthetic" but, as Conrad Rudolph insists, one that arises out of a vigorously anti-aesthetic asceticism. In the church at Clairvaux, "there were no painted windows, no decorated pavements, no high quality masonry, mystical proportions, or effects at light symbolism."[6] Indeed Bernard's famous *Apologia ad Guillelmum Abbatem* (ca. 1125), written in support of Cluniac reformers, levels a systematic criticism of monastic excess in artistic display.[7] In it Bernard condemns (in Rudolph's summary) "the monastic manipulation of excessive art as an overall sensory saturation in regard to the reception of the laypersons in the monastery, the precedence given to this process and art in general over the well-being of the poor, and the monastic use of distractive, non-religious imagery."[8] "The only image that is permitted in a Cistercian church," Hufgard reminds us, "is the painted wooden crucifix at the altar."[9]

In her magisterial work on monastic mnemotechnic, Mary Carruthers combines, in effect, the emphases of Rudolph and Hufgard. With Rudolph she affirms that St. Bernard's apparent "iconoclasm" must be understood within a specifically monastic milieu, where works of art can be dangerous distractions for curious monks. Comparing the abbot of Clairvaux to parents who forbid their children to watch television "lest their imagination and attention remain undeveloped," she writes: "[Bernard] excoriates lazy monks who rely on other people's images (those of painters and sculptors) and thus get distracted from the interior prayer which they should be continually constructing. Lay people and clerics who are not part of a contemplative order . . . may need such aids and props, but not Cistercian monks."[10]

Like Hufgard, however, she emphasizes that St. Bernard did indeed possess an

Mellen, 1989), 86. John R. Sommerfeldt similarly claims, "The key to understanding the spirituality of Bernard of Clairvaux . . . is anthropology" (*The Spiritual Teachings of Bernard of Clairvaux: An Intellectual History of the Early Cistercian Order,* Cistercian Studies Series 125 [Kalamazoo, MI: Cistercian Publications, 1991], 3).

6. Conrad Rudolph, *The "Things of Greater Importance": Bernard of Clairvaux's Apologia and the Medieval Attitude toward Art* (Philadelphia: University of Pennsylvania Press, 1990), 200.

7. See Bedero, *Bernard of Clairvaux: Between Cult and History,* 218–27; Viladesau, *Theological Aesthetics: God in Imagination, Beauty, and Art* (New York: Oxford University Press, 1999), 203; Rudolph, *"Things of Greater Importance."*

8. Rudolph, *"Things of Greater Importance,"* 201.

9. Hufgard, *Saint Bernard of Clairvaux: A Theory of Art,* 86.

10. Carruthers, *Craft of Thought,* 87, 84.

"architectural aesthetic," which was grounded in his anthropological under-standing and oriented both to the physical plainness of the Cistercian buildings and to the ornate richness of the spiritual mansions the monks constructed within themselves, individually and communally, through meditative practice and constructive memory work: "The goal of meditation . . . is to build oneself into a 'templum spiritualis.' . . . What Bernard counsels is lavish decoration of one's own making within the 'temple' of one's soul, fiction-making which is 'sup-ported' by the plain surfaces and clear articulation of the unadorned church and cloister."[11] Through what she calls a monastic "aesthetics of mneme," Carruthers thus addresses what has been a mystery to many scholars—namely, the apparent contradiction between Bernard's outcry against visual ornamentation, on the one hand, and his wonderfully imagistic, eloquent, and polished sermons, on the other.[12] The former guards against *curiositas*, which feeds the imagination but "neglects to pay attention to thinking as a process of *building*";[13] the latter pro-motes a true self-knowledge and growth in charity.

The specific form of the monks' living, as revealed in Arnold of Bonnevaux's memorable tale of the encounter between the pope and the poor men of Clair-vaux, arises from their cultivation of a single, root virtue, humility, in opposition to an ever-eradicated vice, curiosity. For Bernard, as for the monastic saints be-fore and after him, the first and root sin was pride, especially in the form of a cu-riosity that distracts the soul from the deep self-knowledge that is true humility. Only on the firm ground of humility (a word derived from the Latin *humus*, meaning "earth") can one build a proper home for oneself in the universe ac-cording to the original blueprint of the *imago Dei*, edifying (literally "building up") others in the process. "Look over the earth," Bernard counsels his monks, "that you might know yourself. It speaks to you of yourself because 'Dust you are and unto dust you shall return' [Gen. 3:19]."[14] Was it not, after all, out of soil that God, that great "artist," originally fashioned Adam as a combination of body and soul?[15]

11. Ibid., 86–87.

12. On St. Bernard's stylistic revisions of his sermons and manifest "concern for beauty," see Jean Leclercq, "The Making of a Masterpiece," in St. Bernard of Clairvaux, *On the Song of Songs IV*, trans. Irene Edmonds, in *The Works of Bernard of Clairvaux*, Cistercian Fathers Series 40 (Kala-mazoo, MI: Cistercian Publications, 1980), 6:ix–xxiv.

13. Carruthers, *Craft of Thought*, 84.

14. St. Bernard of Clairvaux, *The Steps of Humility and Pride*, in *The Works of Bernard of Clair-vaux*, vol. 5, *Treatises II*, trans. M. Ambrose Conway, O.C.S.O., Cistercian Fathers Series 13 (Wash-ington, DC: Cistercian Publications, Consortium Press, 1974), 10.28, 57; *De gradibus humilitatis et superbiae*, in *Opera Sancti Bernardi*, vol. 3, *Tractatus et Opuscula*, ed. J. Leclercq and H. M. Rochais, Cistercian Fathers Series 7 (Rome: Cistercian Editions, 1963), 38: "Terram intuere, ut cognoscas te ipsum. Ipsa te tibi repraesentabit, quia terra es et in terram ibis."

15. St. Bernard of Clairvaux, "Sermo in Nativitate Domini," in *Sancti Bernardi Opera*, vol. 4,

A complex of themes resonates in this chapter from a central, monastic association of buildings with bodies and mental spaces; of architecture with eating; of containers with meditation, memorial imagery, and Communion. Noting that the Latin words for a "room, building, or edifice" (*aedes, aedificium*) resemble the word meaning "edible" (from *edere*, "to eat"), Isidore of Seville provides an etymology that was, no doubt, familiar to Bernard of Clairvaux: "Hince et *aedificium*, eo quod fuerit prius ad *edendum* factum" (Hence also *edifice*, because it was first made for what is to be *eaten*).[16] According to the deeper logic of this linguistic observation, how one eats (an act by which one gives spiritual and physical food a home in oneself) determines where and how one lives, the larger home in which one dwells. It is by eating (*edendo*) that one builds not only the house of one's body and soul, but also the larger house, the domicile, the social and spiritual order within which one finds one's place. The sacred scriptures and the eucharistic Host are for Bernard and his Cistercian followers the twinned houses where Christ the Incarnate Word abides humbly in hiding, beneath a veil, behind a wall, in order that He might be transferred into other dwellings, taken into one's heart and soul as nourishing food. Christ's humility increases one's own, a "humility" that is, Bernard says, "a loveliness": "Decor animae humilitas est."[17]

I trace this pattern of associations in three movements. First I examine St. Bernard's analysis of the first sin, *curiositas*, in relation to its prescribed remedy, humility, as a way of life restorative of lost beauty. Second I show how Bernard's anthropology—in particular, his understanding of *amor carnalis*, and of humankind as created in God's image and likeness (Gen. 1:26)—leads him to a new formulation of the Augustinian problem of the *Christus deformis*, whose features appear, transposed, in the "black but beautiful" bride of the Song of Songs 1:4

Sermones, ed. J. Leclercq and H. M. Rochais (Rome: Cistercian Editions, 1966), 252: "Qualis artifex, qualis unitor rerum, ad cuius nutum sic conglutinantur sibi limus terrae et spiritus vitae!" ("What an artist, what a combiner of things, at whose nod the slime of the earth and the spirit of life are joined to one another!"). Bernard's use of the word *artist* (*artifex*) rather than *creator* here is significant. It shows his sensitivity to a distinction found in the *Confessions* 11.5, where St. Augustine distinguishes between the Creator, who creates out of nothing, and the artist, who "imprints a form on something already existing and having power to be, such as earth, stone, wood, or gold, or something of that sort" (*The Confessions of St. Augustine*, trans. John K. Ryan [New York: Doubleday, 1960], 281).

16. Isidore of Seville, *Etymologiae*, 15.3, PL 82, col. 541. Isidore notes that the ancient derivation of *aedem* ("room, hall, temple") from edendo ("eating") may have been inspired by a line from Plautus: "Si vocassem vos in aedem ad prandium" ("If I had invited you into the house for breakfast")(Poemulus 529). I thank Martin Winkler for this reference.

17. St. Bernard of Clairvaux, *On the Song of Songs, II*, trans. Kilian Walsh, O.C.S.O., in *The Works of Bernard of Clairvaux*, vol. 3, *Tractatus et Opuscula*, Cistercian Fathers Series 7 (Kalamazoo, MI: Cistercian Publications, 1976), Sermon 45, 1.2, 232–33; *Sermones super Cantica Canticorum*, in *Sancti Bernardi Opera*, ed. J. Leclercq, C. H. Talbot, and H. M. Rochais (Rome: Cistercian Editions, 1958), 2:50.

("Nigra sum sed formosa"). From this bridal image I turn to a consideration of St. Bernard's visionary, Cistercian disciple, St. Gertrude of Helfta (ca. 1256–1301), whose spirituality goes beyond Bernard's in its use of religious artwork to facilitate a life of prayer, but whose emphasis on a humble self-knowledge, nourished by *lectio divina* and the Eucharist, accords well with his.

St. Bernard's insistence on the imageless quality of contemplative union with God, coupled with his strident criticism of art in the *Apologia,* has led scholars to posit a fundamental distance and disagreement between the abbot of Clairvaux and St. Gertrude about the value of visionary experience and of religious artwork. A comparison of works composed in the same hagiographic genre, however— namely, the *Vita prima sancti Bernardi* (*The First Life of St. Bernard*), composed by Bernard's friends and close contemporaries, and the *Legatus memorialis abundantiae divinae pietatis* (*The Herald of Divine Love*), written by St. Gertrude and her companions—calls attention to the important place of visions in both lives. Gertrude herself, moreover, quotes extensively from St. Bernard's writings in support of her ascetical practice and mystical experiences. Following the brilliant lead of Amy Hollywood, who has effectively closed the putative gap between the apophatic mysticism of Meister Eckhart (ca. 1260–1327) and the cataphatic way of the beguine Mechtild of Magdeburg (ca. 1207–1282),[18] and in the wake of the important work of Jeffrey Hamburger on the use of images within convent culture, I argue that Gertrude did not in fact misread Bernard; rather she complements him, bringing to the fore what he kept in the background. Whereas Bernard eats the sacred scriptures as if they were the Eucharist, Gertrude reads the Eucharist as if it were a text. She thus provides us with an *imitatio Bernardi* that forces us to reconsider a series of learned assumptions about Bernard's supposedly "imageless" mysticism and theological aesthetics.

The Curiosity That Consumes, the Humility That Feeds

For St. Bernard the starting point is always the reality of the fallen human condition, which is characterized by an ingrained *curiositas* and *concupiscentia*, defects that are two sides, as it were, of a single coin. Both constitute a disordered relationship to the other person, whom we are called to know and to love. *Curiositas,* an undue preoccupation with the affairs of others, constitutes a defective *aspec-*

18. Amy Hollywood, *The Soul as Virgin-Wife: Mechthild of Magdeburg, Marguerite Porete, and Meister Eckhart,* Studies in Spirituality and Theology 1 (Notre Dame, IN: University of Notre Dame Press, 1995).

tus (attitude of mind or regard). *Concupiscentia,* a distorted *affectus* (emotion, passion, drive) of longing, desires the other inordinately and craves what belongs to the other.[19] *Curiositas* is *cura* (care or concern) gone wrong; *cupiditas* is the misdirection of love that results from it, a faulty *affectus* following from a myopic *aspectus* and reinforcing it. Charity, which combines responsibility (*cura*) with compassion, rights both of these wrongs, restoring humanity's likeness to the divine image in which it was created. St. Bernard's two most popular treatises, *The Steps of Humility and Pride* (*De gradibus humilitatis et superbiae*) (1125) and *On Loving God* (*De diligendo Deo*) (ca. 1127) address the problems of *curiositas* and *concupiscentia,* respectively. Individually and together, they anticipate the great *summa* of Cistercian spirituality, St. Bernard's *Sermons on the Song of Songs* (*Sermones super Cantica Canticorum*) (AD 1135–53).

In *The Steps of Humility and Pride,* the first of his published treatises, St. Bernard begins at the beginning, with an acute analysis of the first sin, *curiositas,* and its remedy, humility. Whereas Carruthers associates mnemotechnic *curiositas* primarily with a mental laziness and superficiality, a lack of attentiveness and concentration (and rightly so, since as a form of the root sin, *curiositas* participates in all the vices), St. Bernard links curiosity principally not with laziness, but with pride: "The first step of pride is curiosity."[20] Reversing (for pastoral reasons) the emphasis of St. Benedict, who delineates the ascending twelve steps of humility in chapter 7 of his *Rule,* St. Bernard demarcates the twelve descending steps of pride, reasoning that what goes down can also come up and by means of the rungs of the same ladder.[21] Indeed, precisely through the moral humiliation of sin, painfully recognized as such, one can acquire humility, thus turning a miserable defeat in one's striving for holiness into a marvelous victory. For this reason the steps in Bernard's ladder are simultaneously steps "of humility *and* pride."[22]

19. Sometimes medieval theologians distinguish *concupiscentia,* understood as an involuntary disorder of the life of the emotions resulting from each one's conception through sexual union, from *cupiditas,* which is willful lust, a sin arising from concupiscence. Sometimes *concupiscentia* is used as a synonym for *cupiditas. Concupiscentia* can have a positive or neutral connotation, however, depending on the object of desire.

20. St. Bernard of Clairvaux, *The Steps of Humility and Pride,* 10.28, in *Treatises II,* 57; *De gradibus humilitatis et superbiae,* in *Sancti Bernardi Opera,* 3:38: "Primus itaque superbiae gradus est curiositas."

21. The scriptural basis for this image, of course, is that of the ladder on which Jacob saw angels descending and ascending (Genesis 28:2).

22. To those who objected that his title was misleading, since he apparently speaks of pride rather than humility, St. Bernard responded in an appended *Retractio* that "they must not have understood . . . my note at the end" (*Steps of Humility and Pride,* in *Treatises II,* 25). In that concluding note, Bernard observes humbly that he has written about the steps of pride because "I can only tell you what I know myself, the downward path" (*Steps of Humility and Pride,* 22.57, in *Treatises II,* 82).

With consummate skills St. Bernard turns the description of the twelve steps of pride into a mirror for his audience. Recognizing the danger that his auditors will see in the lively portraits of prideful monks everyone besides themselves, Bernard catches himself and them in curiosity immediately at the first step: "The first step of pride is curiosity. But how does it show itself? You see one who up to this time had every appearance of being an excellent monk. Now you begin to notice that wherever he is, standing, walking, or sitting, his eyes are wandering, his glance darts right and left, his ears are cocked. Some change has taken place in him; every movement shows it."[23] The rhetorical trick is this: If they have seen such a curious monk, they have been curious themselves. They have "seen" him, they have begun "to notice" his actions, they have judged him; their "eyes and . . . other senses" have attended "to what is not [their] concern."[24]

Lest his auditors miss his point, Bernard suddenly shifts from a third-person description of the busybody monk, who "used to watch over his own conduct," but whose "watchfulness" is now entirely "for others," to a second-person address: "My man! If you gave yourself the attention you ought, I do not think you would have much time to look after others."[25] Is this an apostrophe to the imaginary monk, or an address to a real monk in his audience? The ambiguity is intentional. Bernard proceeds apparently to cease altogether to address his monastic auditors, apostrophizing instead three great biblical exempla of *curiositas*: Dinah ("Ah! Dinah! You were anxious to see the foreign woman?"), Eve ("What about you, Eve?"), and Lucifer ("And you, Satan!").[26] For Bernard, there is, as it were, no one else present. He looks at his monks, but he sees before him only Dinah, Eve, and Lucifer. Bernard thus leaves the listening monks no escape; they must identify with these examples of curiosity, owning their sins, if they are to remain Bernard's audience, the ones to whom Bernard speaks.

Bernard himself also models this imaginative identification, questioning Dinah, Eve, and Lucifer, and voicing their responses. In his dramatic, fictional dialogue with Lucifer, he probes relentlessly the psychology of the apostate angel, so that the monks in effect overhear a kind of *ethopoeia*, the internal dialogue of

23. St. Bernard of Clairvaux, *The Steps of Humility and Pride*, 10.28, in *Treatises II*, 57; *De gradibus humilitatis et superbiae*, in *Opera*, 3:38: "Primum itaque superbiae gradus est curiositas. Hanc autem talibus indiciis deprehendes: si videris monachum, de quo prius bene confidebas, ubicumque stat, ambulat, sedet, oculis incipientem vagari, caput erectum, aures portare suspensas, e motibus exterioris hominis interiorem immutatum agnoscas."

24. St. Bernard of Clairvaux, *The Steps of Humility and Pride*, Chart of Steps, in *Treatises II*, 27.

25. St. Bernard of Clairvaux, *The Steps of Humility and Pride*, 10.28, in *Treatises II*, 57; *De gradibus humilitatis et superbiae*, in *Opera*, 3:38: "Et vere si te vigilater, homo, attendas, mirum est si ad aliud umquam intendas."

26. St. Bernard of Clairvaux, *The Steps of Humility and Pride*, 10.29–36, in *Treatises II*, 58–65; *De gradibus humilitatis et superbiae*, in *Opera*, 3:39–44.

Bernard with the Luciferian side of himself: "I am curious, O Envious One, to know more about the course of your curiosity."[27] Thus, through introspection and self-examination, a sinful *curiositas* is transformed into a holy one, a deep self-knowledge. The apparent digression (10.37–38) from the topic of *curiositas* to that of revelations is no accident, therefore; it marks the Luciferian temptation to which contemplatives—Joseph, Paul, Zachary (and Bernard himself)—are most prone.

St. Bernard's treatment of *curiositas* is, Basil Pennington notes, "as long as his treatment of the other eleven [steps] put together."[28] Pennington speculates that Bernard may have "thought this was where most of his monastic hearers were or were in greatest danger of being."[29] What is certain is that if Bernard's listeners truly recognized the "first sin" of Eve and Lucifer as being their own, it would have been relatively easy for them to see themselves, not others, in the brief, satirical portraits of proud monks that follow. Even as the sin of Adam and Eve resulted in the loss of Paradise, and Lucifer's in the loss of Heaven, so too, the curiosity of monks can destroy both the spiritual paradise that is built within each one through meditative prayer and also the little paradise, the *paradisus claustralis,* of the closed, monastic community, where so much depends on respecting the solitude of the other.

Of the three portraits of curious sinners on the first step of pride, Lucifer's is by far the longest. Observing that its length balances that of Bernard's "long excursus on the knowledge of Christ found in the first part" of the treatise, Pennington wonders whether one can find here "a bit of subtle artistry which we do not readily perceive or appreciate."[30] My answer to that question is a theo-aesthetic one. St. Bernard clearly wants to call attention to a contrast between the two descents—that of Lucifer, who fell through pride, and that of the Son, who "was not led by curiosity, . . . but by a wondrous charity" to assume human nature, through which "He would experience for Himself what [humans] suffered for their disobedience."[31] The limitation of the Son's divine knowledge by His humanity and His learning of mercy by suffering—both of them freely accepted by Him—contrast with Lucifer's craving of divine foreknowledge, his *curiositas.*

These two (Luciferian and Christological) descents stand as alternative mod-

27. St. Bernard of Clairvaux, *The Steps of Humility and Pride,* 10.36, in *Treatises II,* 64; *De gradibus humilitatis et superbiae,* in *Opera,* 3:43: "Velim tamen curiosius, O curiose, intentionem tuae curiositatis inquirere."

28. M. Basil Pennington, O.C.S.O., introduction, to St. Bernard of Clairvaux, *The Steps of Humility and Pride,* in *Treatises II,* 13.

29. Ibid., 13–14.

30. Ibid., 14.

31. St. Bernard of Clairvaux, *The Steps of Humility and Pride,* 3.12, in *Treatises II,* 40; *De gradibus humilitatis et superbiae,* in *Opera,* 3:25: "Voluit experiri in se, quod illi faciendo contra se merito paterentur, non simili quidem curiositate, sed mirabilis caritate."

els for the monks who are about to accomplish an imaginative descent down the twelve steps of pride, identifying themselves with and as sinners in their meditation. Christ, the Man of Sorrows of Isaiah 53:2, is the one who shows how the responsible assumption of the guilt of others as one's own produces humility and mercy: "Of all His virtues, and He possessed them all, Christ especially commends one to us, humility. 'Learn of me for I am meek and humble of heart' [Matt. 11:29]."[32] "You will never have real mercy for the failings of another," Bernard insists, "until you know and realize that you have the same failings in your soul."[33]

The choice between the patterns of Christ and Lucifer is a choice between two kinds of knowledge and of beauty. Lucifer was "perfect in beauty [*perfectus decore*]," but his "insatiable curiosity," which drove him to pry into God's affairs and to vie with the Most High for knowledge, led the so-called Light-bearer to forget himself, who he really was.[34] Having a false image of God, turning away from the very source of all beauty, and lacking the self-knowledge that is humility, Lucifer also lost his home, his place in an ordered cosmos: "You are thrown out of heaven and there is no place for you on earth."[35]

By contrast the humble person, who continually grows in self-knowledge by following Christ, the incarnate *Logos* of God, becomes more and more beautiful. Bernard explains this process in a set of sermons on true humility that gloss Song of Songs 1:7: "If you do not know [yourself], O fairest among women, go forth. . . ." ("Si ignoras te, O pulchra inter mulieres, egredere. . . ."). Self-knowledge is, first of all, a matter of order and utility and thus of a constructive aesthetics: "Right order, since what we are is our first concern; and usefulness, because this knowledge gives humility rather than self-importance, it provides a basis on which to build."[36] "Facing up to one's real self without flinching and turning aside,"[37] one recognizes one's weakness; one then turns to God for help,

32. St. Bernard of Clairvaux, *The Steps of Humility and Pride*, 9.25, in *Treatises II*, 54; *De gradibus humilitatis et superbiae*, in *Opera*, 3:36: "Sed cum omnes habuerit, prae omnibus tamen unam, id est humilitatem, nobis in se commendavit, cum ait: DISCITE A ME, QUIA MITIS SUM ET HUMILIS CORDE."

33. St. Bernard of Clairvaux, *The Steps of Humility and Pride* 3.6, in *Treatises II*, 35; *De gradibus humilitatis et superbiae*, in *Opera*, 3:21: "Sed ut ob alienam miseriam cor miserum habeas, oportet tuam prius agnoscas, ut proximi mentem in tua invenias."

34. St. Bernard of Clairvaux, *The Steps of Humility and Pride* 10.31, in *Treatises II*, 60; *De gradibus humilitatis et superbiae*, in *Opera*, 3:40–41.

35. St. Bernard of Clairvaux, *The Steps of Humility and Pride* 10.34, in *Treatises II*, 63; *De gradibus humilitatis et superbiae*, in *Opera*, 3:43: "E caelo pulsus, in terris remanere non potes."

36. St. Bernard of Clairvaux, *On the Song of Songs II*, Sermon 36, 4.5, 177; *Sermones super Cantica Canticorum*, in *Opera*, 2:7: "Et ordinis quidem, quoniam quod nos sumus primum est nobis; utilitatis vero, quia talis scientia non inflat, sed humiliat, et est quaedam praeparatio ad aedificandum."

37. St. Bernard of Clairvaux, *On the Song of Songs II*, Sermon 36, 4.5, 177–78; *Sermones super Cantica Canticorum*, in *Opera*, 2:7: "Statuat se ante faciem suam, nec se a se avertere abducatur."

and begins "to seek His face continually."[38] "In this way," Bernard explains, "your self-knowledge will be a step to the knowledge of God; He will become visible to you as His image is being renewed within you. And you, gazing confidently on the glory of the Lord with unveiled face, will be transformed into that same image with ever increasing brightness, by the work of the Spirit of the Lord."[39]

This image-making, this humble, transformative facing of oneself and God, is at the heart of Cistercian theological aesthetics. For Bernard the beauty of the soul, the Bride, can only be perfected in Heaven, when her knowledge of God in the *visio beata* is complete. To her, therefore, the Bridegroom speaks,: "The time will come when I shall reveal myself, and your beauty will be complete, just as my beauty is complete; you will be so like me that you will see me as I am [1 John 3:2]. Then you will be told: 'You are all fair, my love, there is no flaw in you' [Song of Sol. 4:7]."[40] Here on earth, flaws remain, but the meditative gaze into the mirror of the scriptures, the examination of conscience, the practice of virtue, and the ardent, contemplative facing of God in prayer cause the soul more and more to resemble the God in whose image it was created.

For a Cistercian monk, such a restoration of the divine likeness in the soul depends on the mediation of scriptural images, which reveal God's truth and provide an undeceiving mirror for oneself, a way of remembering and of interpreting one's experience, of placing each part within a larger whole. To reflect the glory of God's Eternal Word, one must reflect on the scriptural Word. Thus the meditative fashioning of biblical concordances in integral, architectonic schemes resonant with the pattern of one's own remembered experience is a literal means of self-fashioning.

Such imagistic schemes can be complex works of mental architecture. Before turning to his treatment of the twelve steps of humility and pride, St. Bernard, for example, first reminds his auditors of the heavenly goal that makes the journey about to be taken eminently worthwhile. He charts the full course of the spiritual itinerary, of which the twelve steps of humility and pride (themselves divisible into three) comprise only the first part of a three-part journey. As Carruthers has amply demonstrated in her treatment of similar texts, such steps along the way—

38. St. Bernard of Clairvaux, *On the Song of Songs II*, Sermon 35, 1.1, 165; *Sermones super Cantica Canticorum*, in *Opera*, 1:249: "Quaerere faciem eius semper."

39. St. Bernard of Clairvaux, *On the Song of Songs II*, Sermon 36, 4.6, 179; *Sermones super Cantica Canticorum*, in *Opera*, 2:8: "Atque hoc modo erit gradus ad notitiam Dei, tui cognitio, et ex imagine sua, quae in te renovatur, ipse videbitur, dum tu quidem revelata facie gloriam Domini cum fiducia speculando, in eamdem imaginem transformaris de claritate in claritatem, tamquam a Domini Spiritu."

40. St. Bernard of Clairvaux, *On the Song of Songs II*, Sermon 38, 3.5, 191; *Sermones de Cantica Canticorum*, in *Opera*, 2:17: "Erit, cum apparuero, quod tota pulchra eris, sicut ego sum pulcher totus; et simillima mihi, videbis me sicuti sum. Tunc audies: TOTA PULCHRA ES, AMICA MEA, ET MACULA NON EST IN TE."

whether imaged as the rungs of Jacob's ladder, the branches of the Tree of Life, the compartments of Noah's ark, or the rooms of a temple or palace—serve as mental nodes that give structure and significance to what is stored in the one's memory, enabling recall and association through patterned arrangement and adding a dimension of depth to one's lived experience.[41] What is impressive about St. Bernard is his ability to present a series of separate, relatively abstract, threefold distinctions and then to combine all of them in a single narrative movement, rich in imagistic appeal, which supports their retention. Consider this climactic summary, in which St. Bernard narrates the soul's three-part journey:

> "The King has led me into His chamber" [Song 1:3, 3:4]. She had become worthy of this when she learned humility in the school of the Son, listening to His warning: "If you do not know yourself, go forth and pasture your herds" [Song 1:7]. She is twice worthy, since she was led by the Holy Spirit from the school of humility to the storehouse of charity [Song 1:3], for this is what is meant by guarding the flocks of the neighbors. She was brought there by love. Once there she is cushioned by flowers, stayed up with apples [Song 2:5], that is, by good morals and holy virtues, and finally, led into the chamber of the King for whose love she languishes. There for a short time, just one half-hour, while there is silence in heaven [Rev. 8:1], she sleeps in that desired embrace. She sleeps, but her heart watches [Song 5:2] and is fed with the secrets of truth on which later, when she comes back to herself, her memory can dwell.[42]

The image of the King's chamber at the beginning and end of the passage creates an envelope-pattern for the romance. It suggests that the three locations—the Son's school of humility, the Spirit's storehouse of charity, and the Father's room of rapture—represent different aspects of the one house of God, which is nonetheless epitomized in the final room of rest. The narrative, which pieces together scriptural verses from the Song of Songs and the book of Revelation to tell a continuous, mellifluous story, correlates the three places with the three persons of the Trinity (Son, Spirit, Father), the three virtues (humility, charity, and passivity),

41. See Mary J. Carruthers, *The Book of Memory: A Study of Memory in Medieval Culture,* Cambridge Studies in Medieval Literature (Cambridge: Cambridge University Press, 1990), 27, 37, 43, 160, 250, 253, 254.

42. St. Bernard of Clairvaux, *The Steps of Humility and Pride,* 7.21, in *Treatises II,* 49–50.; *De gradibus humilitatis et superbiae,* in *Opera,* 3:32–33: "INTRODUXITME ME REX IN CUBICULUM SUUM. Digna certe, quae de schola humilitatis, in qua primum sub magistro Filio ad seipsam intrare didicit, iuxta comminationem ad se factam: SI IGNORAS TE, EGREDERE ET PASCA HAEDOS TUOS, digna ergo quae de schola illa humilitatis, duce Spiritu Sancto, in cellaria caritatis—quae nimirum proximorum pectora intelligenda sunt—per affectionem introduceretur, unde suffulta floribus ac stipata malis, bonoroum scilicet moribus et virtutibus sanctis, ad Regis demum cubiculum, cuius amore languet, admitteretur. Ibi modicum, hora videlicet quasi dimidia, silentio facto in caelo, inter desideratos amplexus suaviter quiescens ipsa quidem dormit, sed cor eius vigilat, quo utique interim veritatis arcane rimatur, quorum postmodum memoria statim ad se reditura pascatur."

the three knowledges (of self, of others, of God), the three stages (purgative, illuminative, unitive), the three lives (penitential, active, contemplative), and the three faculties (reason, will, memory). Commenting on this extraordinary "doctrinal synthesis," Étienne Gilson remarks that it "would seem to have presented itself to St. Bernard as a personal discovery of his own."[43]

This marvelously constructed passage comes at the end of St. Bernard's introduction to the twelve steps of pride. It mirrors a passage near the beginning where Bernard traces the same three-part journey using not the images of successive rooms, but those of different courses of food. Unifying the passage is the trope of a banquet, to which a personified Humility contributes "the bread of sorrow [Ps. 126:2] and the wine of compunction [Ps. 59:5]."[44] Contemplation, at the opposite end of the table, provides the bread of wisdom and the inebriating wine that is a "foretaste of the feast of glory."[45] Charity, in the middle, gives "love's milk instead of bread, and oil instead of wine."[46]

The correlation of these two summary passages at the beginning and the end of Bernard's introduction is not accidental. It suggests that the room in which one finds oneself depends on how one assimilates scriptural revelation, drawing nourishment from it. Carruthers has called attention to the frequent use in monastic literature of the "eating the book" metaphor,[47] which gives expression to a life regulated by the sacramental practice of *lectio divina,* the daily recitation of the Divine Office and the silent rumination of its scriptural passages throughout the day. For medieval monks the Bible was truly what St. Bernard called it: "the book of our experience."[48] Not only did they experience it daily in an oral, aural, tactile, and visual way, but its words directed and described their inner experience and provided a standard for their actions. The greater the conformity between the two, the greater the inner beauty of the person.

The distinction between inner and outer beauty—the beauty of the soul and of the body, of the spiritual and physical senses, of the divine and the human—

43. Étienne Gilson, *The Mystical Theology of Saint Bernard,* trans. A. H. C. Downes (London: Sheed and Ward, 1955), 106.

44. St. Bernard of Clairvaux, *The Steps of Humility and Pride,* 2.4, in *Treatises II,* 32; *De gradibus humilitatis et superbiae,* in *Opera,* 3:19: "panem scilicet doloris et vinum compunctionis."

45. St. Bernard of Clairvaux, *The Steps of Humility and Pride,* 2.4, in *Treatises II,* 32–33; *De gradibus humilitatis et superbiae,* in *Opera,* 3:19: "epulari ab introitu gloriae gloriosus."

46. St. Bernard of Clairvaux, *The Steps of Humility and Pride,* 2.4, in *Treatises II,* 33; *De gradibus humilitatis et superbiae,* in *Opera,* 3:19: "lacte interim caritatis pro pane, oleo pro vino."

47. Carruthers, *The Book of Memory,* 44, 161, 167. For a study of the scriptural source of this metaphor, see Ellen F. Davis, *Swallowing the Scroll: Textuality and the Dynamics of Discourse in Ezechiel's Prophecy* (Sheffield, England: Almond, 1989).

48. St. Bernard of Clairvaux, *On the Song of Songs I,* Sermon 3, 1.1, 16; *Sermones super Cantica Canticorum,* in *Opera* 1:14: "Hodie legimus in libro experientiae." See also Sermon 1, 5.9, in *Opera,* 1:6: "Certerum vos, si vestram experientiam advertatis" ("Furthermore, if you look back on your own experience").

corresponds to the difference between the meditative depth of experience and its sensory surface, between the significance of the scriptures and their literal meaning. To derive the *sensus spiritualis,* the scriptural passage in question must be divided into its constituent parts—word by word, phrase by phrase—through close reading, chewed, savored, and digested; only then can the nourishment of the scriptures be converted into energy for life and action. The scriptural images fire the imagination, stimulate meditation, enrich the memory, provide passionate strength for the will to do good and to avoid evil. St. Bernard graphically describes this process of *lectio divina,* using alimentary images:

> As food is sweet to the palate, so does a Psalm delight the heart. But the soul that is sincere and wise will not fail to chew the psalm with the teeth as it were of the mind, because if he swallows it in a lump, without proper mastication, the palate will be cheated of the delicious flavor, sweeter even than honey that drips from the comb [Ps. 18:11]. Let us with the Apostles offer a honey comb at the table of the Lord in the heavenly banquet [Lk. 24:42]. As honey flows from the comb, so should devotion flow from the words; otherwise if one attempts to assimilate them without the ointment of the Spirit "the written letters bring death" [2 Cor. 3:6].[49]

Commenting on the frequent use of such "metaphors of tasting and devouring" in St. Bernard's commentary on the Song of Songs, Caroline Walker Bynum has argued that language like this prepared the way for the heightened eucharistic devotion of the later Middle Ages.[50] Indeed it is often impossible to distinguish Bernard's references to the scriptures from those to the Eucharist, since he, following Saints Augustine and Jerome,[51] represents the Word of God as feeding his disciples in both forms: "He is the good householder, who provides for his family, . . . feeding them with the bread of life. . . . But as he feeds them, he is himself also fed, and fed with the food he takes most gladly, that is our progress."[52]

49. St. Bernard of Clairvaux, *On the Song of Songs I,* Sermon 7, 4.5, 41–42; *Sermones super Cantica Canticorum,* in *Opera,* 1:34: "Cibus in ore, psalmus in corde sapit. Tantum illum terere non negligat fidelis et prudens anima quibusdam dentibus intelligentiae suae, ne si forte integrum glutiat, et non mansum, frustretur palatum sapore desiderabili, et dulciori super mel et favum. Offeramus cum Apostolis in caelesti convivio et dominica mensa favum mellis. Mel in cera, devotio in littera est. Alioquin littera occidit, si absque spiritus condimento glutieris."

50. Caroline Walker Bynum, *Holy Feast and Holy Fast: The Religious Significance of Food to Medieval Women* (Berkeley: University of California Press, 1987), 94.

51. See, for example, St. Jerome, *Commentarius in Ecclesiasten,* CCSL 72 (Turnhout: Brepols, 1959), 3.3.13, 278: "Vescamur carne eius et cruore potemur, non solum in mysterio, sed etiam in scripturarum lectione" (We eat His flesh and drink His blood in the divine Eucharist, but also in the reading of the Scripture); St. Augustine, "Sermo 61," PL 38, col. 381: "Panis quotidianus, sermo Dei, Eucharistia . . . Cibus noster quotidianus in hac terra, sermo Dei est, qui semper erogatur Ecclesiis" (Daily bread—the word of God, the Eucharist . . . Our daily bread on this earth is the word of God, which is always proclaimed to the churches).

52. St. Bernard of Clairvaux, *On the Song of Songs IV,* Sermon 71, 2.5, 51; *Sermones in Cantica Canticorum,* in *Opera,* 2:217: "Bonus paterfamilias, qui suorum domesticorum curam gerit . . .

The reciprocal relationship between the one who eats and the one who is eaten means that Christ, consumed in the scriptures and in the sacrament, also eats those who consume Him, turning them into Himself.[53] When sinners ruminate on the scriptures, accepting the truth of biblical judgment against themselves, has not Christ, Bernard asks, "ground and pressed [them] with the teeth of hard discipline, of mortification of the flesh and heart's contrition, so that He may incorporate them into Himself?"[54]

> My penitence, my salvation, are His food. I myself am His food. . . . I am chewed as I am reproved by Him; I am swallowed as I am taught; I am digested as I am changed; I am assimilated as I am transformed; I am made one as I am conformed. Do not wonder at this, for He feeds upon us and is fed by us that we may be the more closely bound to Him. Otherwise we are not perfectly united with Him. For if I eat and am not eaten, then He is in me, but I am not yet in Him. . . . But he eats me that He may have me in Himself, and He in turn is eaten by me that He may be in me.[55]

In this reciprocal eating, the humility of the divine Word, who has emptied Himself of glory (cf. Phil. 2:5–11) in order not only to become human and to suffer death for our sake, but also to conceal Himself in the letter of the scriptures and in the form of bread and wine, is matched (albeit with an infinite difference) by the humility of the disciple who allows himself to be reproved, instructed, commanded, and thus transformed. In that very conformity of the one to the other resides an ever-increasing beauty, the beauty of truth.

Cupiditas, Amor carnalis,
and the Beauty of the Bride

What one loves and desires depends on how one sees, the *affectus* following the *aspectus*. But how is one to love God and neighbor, if an ingrained *curiositas* keeps

cibans illos pane vitae. . . . At pascens, ita puto, nihilominus pascitur ipse, et quidem escis quibus libenter vescitur, profectibus nostris."

53. The locus classicus for this idea is St. Augustine's *Confessions*, 7.10, trans. Ryan, 171.

54. St. Bernard of Clairvaux, *On the Song of Songs IV*, Sermon 72, 1.2, 64; *Sermones super Cantica Canticorum*, in *Opera*, 2:226: "Ubi namque iam peccatores, quos sibi incorporet Christus, mansos morsosque quasi quibusdam dentibus disciplinae austerioris, afflictione scilicet carnis et cordis contritione?"

55. St. Bernard of Clairvaux, *On the Song of Songs IV*, Sermon 71, 2.5, 52; *Sermones super Cantica Canticorum*, in *Opera*, 2:217: "Cibus eius paenitentia mea, cibus eius salus mea, cibus eius ego ipse. . . . Mandor cum arguor, glutior cum instituor, decoquor cum immutor, digeror cum transformor, unior cum conformor. Nolite mirari hoc: et manducat nos, et manducatur a nobis, quo arctius illi adstringamur. Non sane alias perfecte unimur illi. Nam si manduco et non manducor, videbitur in me ille esse, sed nondum in illo ego. . . . Sed enim manducet me, ut habeat me in se; et a me vicissim manducetur, ut sit in me."

one always on the surface of things, preventing the humble knowledge of self and God and the compassionate understanding of others? *Curiositas* fosters only concupiscence, only selfish desire and idolatry, not love, not charity. A form of prideful illusion and self-deception, *curiositas* keeps one from seeing the truth of things, and thus the beauty of the world; at the same time, through that very distortion of vision, it attaches one's desire to what enslaves it.

For St. Bernard, as for St. Augustine before him, the answer to this problem lies in the existence of an instinctive love that precedes rational evaluation (*aspectus*)—namely, the *amor carnalis,* the Pauline love for one's own body (Eph. 5:29).[56] This love, which belongs to the very make-up of a human being as a composite of body and soul, can develop and influence the *aspectus,* so that it seeks not vain knowledge and glittering appearances, but wisdom, truth, and the beauty of what is real.

Amor carnalis is not the same as *cupiditas,* which is a perversion of the will, a carnal lust predicated upon *curiositas.* According to Bernard, because human beings are composite creatures, they naturally begin loving as infants by desiring for their own bodies the necessities of life. One's own body is the nearest possible "neighbor," the *proximum,* of the soul, and caring for its most basic needs is an instinctive work of charity that is "not imposed by rule but is innate in nature. For who hates his own flesh (Eph. 5:29)?"[57] The hunger and thirst of their own bodies then put people into relationship with other people on whom they depend for survival, people who have the same physical needs for food, drink, and shelter; and whose welfare co-determines their own: "It is in this way that bodily love is shared, when it is extended to the community."[58] As Gilson explains, the love for one's own body, "already expanded into 'social' carnal love of the neighbour so like ourselves in misery," takes a special form when it expands "a second time . . . into a carnal love of Christ, . . . the Man of Sorrows."[59]

The second part of St. Bernard's *De diligendo Deo* (8.23–11.33) outlines the rational progression from a rudimentary *amor carnalis.* In the first degree of love, man loves himself for his own sake. In the second, man loves God for man's own sake. In the third, man loves God for God's sake. In the fourth, man loves himself

56. See St. Augustine, *Sermo* 368, 4.4, PL 38–39, col. 1654: "Ergo dilectio unicuique a se incipit et non potest nisi a se incipere, ut nemo monetur ut se diligat" (Therefore the love of each individual begins with himself, and it cannot begin except from the self, since no one is commanded to love oneself). Quoted in Gilson, *Mystical Theology of Saint Bernard,* 221n24.

57. St. Bernard of Clairvaux, *On Loving God,* in *Bernard of Clairvaux: Selected Works,* trans. G. R. Evans (New York: Paulist Press, 1987), 8.23, 192; *De diligendo Deo,* in *Opera,* 3:138: "Nec praecepto indicitur, sed naturae inseritur. Quis nempe carnem suam odio habuit?"

58. St. Bernard of Clairvaux, *On Loving God,* 8.23, in *Selected Works,* 192; *De diligendo Deo,* in *Opera,* 3:139: "Sic amor carnalis efficitur et socialis, cum in commune protrahitur."

59. Gilson, *The Mystical Theology of St. Bernard,* 78–79.

for the sake of God. "Driven by necessity to serve nature first," since it is weak and infirm, a person begins by loving himself and providing for the physical needs of his own body;[60] that "bodily love" (*amor carnalis*) is "extended to the community" upon which the individual's welfare depends.[61] In these ways at the first degree of love, "man loves himself for his own sake."[62] When he "learns from frequent experience" that "God comes to [his] aid" in answer to his petitions,[63] and that he is helpless without God (*sine ipso posit nihil*), he advances to the second degree of love—when man loves God "for his own sake, not God's."[64] (Elsewhere, in Bernard's letter to the Carthusians, he describes the first degree of love as that of "a slave, fearful on his own account"; the second, as that of a "mercenary" who "desires profit for himself"; the third, as that of a son devoted to his father.)[65]

According to Bernard the frequent contact with God afforded by recourse to Him in prayer and the reception of His gifts allows the soul "to discover by tasting how sweet the Lord is" (Ps. 33:9), so that, at the third degree of love, "God is loved for His own sake," in an attitude of filial piety and benevolence.[66] The fourth degree of love, achieved rarely in this earthly life, is "when man loves himself for the sake of God."[67] Like the first degree of love, the fourth and final stage involves self-love, but a love of self that is inseparable from the love of God and completely "You-centered." One discovers and loves in oneself the likeness of

60. St. Bernard of Clairvaux, *On Loving God*, 8.23, in *Selected Works*, 192; *De diligendo Deo*, in *Opera*, 3:138: "Sed quoniam natura fragilior atque infirmior est, ipsi primum, imperante necessitate, compellitur inservire."

61. St. Bernard of Clairvaux, *On Loving God*, 8.23, in *Selected Works*, 192; *De diligendo Deo*, in *Opera*, 3:139: "Sic amor carnalis efficitur et socialis, cum in commune protrahitur."

62. St. Bernard, *On Loving God*, 8.23, in *Selected Works*, 192; *De diligendo Deo*, in *Opera*, 3:138: "Primus gradus amoris, cum homo diligit se propter se."

63. St. Bernard of Clairvaux, *On Loving God*, 8.25, in *Selected Works*, 193; *De diligendo Deo*, in *Opera* 3:140: "Etiam Deum vel propter se amare incipiat, quod in ipso nimirum, ut saepe expertus est, omnia posit, quae posse tamen prosit, et sine ipso posit nihil."

64. St. Bernard of Clairvaux, *On Loving God*, 9.26, in *Selected Works*, 193; *De diligendo Deo*, in *Opera*, 3:140: "Amat ergo Deum, sed propter se interim, adhuc non propter ipsum."

65. St. Bernard of Clairvaux, *On Loving God*, 12.34, in *Selected Works*, 200. St. Bernard himself attached his "Letter on Charity to the Holy Brethren of Chartruse" to his *De diligendo Deo* as an addendum, and the two works regularly appear together. They treat, as Bernard says, the "same four degrees" of love, albeit under different images. In the epistle Bernard uses the four metaphors of the slave, the mercenary, the son, and the bride. See *De diligendo Deo*, in *Opera* 3:148: "Primus servus est, et timet sibi; secundus mercenaries, et cupit sibi; tertius filius, et defert patri."

66. St. Bernard of Clairvaux, *On Loving God*, 9.26, in *Selected Works*, 194; *De diligendo Deo*, in *Opera*, 3:141: "gustando probari quam suavis est Dominus. . . . cum homo diligit Deum propter ipsum."

67. St. Bernard of Clairvaux, *On Loving God*, 10.27, in *Selected Works*, 195; *De diligendo Deo*, in *Opera*, 3:142: "cum homo diligit se propter Deum."

God, the Word within, and thus (in Gilson's words) "the supposed antinomy be-
tween love of self and love of God vanishes": "Man . . . desires this God whom he
represents, and God covets, so to speak, this soul in whom He recognizes Him-
self."[68] The human lover gazes into God and sees himself, as it were, in God's own
eye, as God sees him. Like the communicant, who eats and is eaten at the same
time, the lover is beloved, knows as he is known. "To love in this way," Bernard
writes, "is to become like God."[69]

As I have argued elsewhere, the anthropocentric answers to the question "why
and how God ought to be loved" ("quare et quo modo diligendus sit Deus") that
are found in part 2 of *On Loving God,* circle back to and overlap with the theo-
centric answers in part 1, which focuses on God's desert of human love, rather
than on the human benefits of loving God.[70] If people do not love God, Bernard
insists, it is because they do not recognize that everything they are and have is His
gift of wooing love, His creation and re-creation. Elaborating on the rhetorical
topos of the gifts of God, Bernard describes the "innumerable kindnesses [God]
showers" on humankind, providing people with "bodily necessities," as well as the
higher spiritual goods of "dignity, knowledge, [and] virtue."[71] The greatest divine
gift, Bernard avers, is God's total gift of Himself in the person of Jesus and Him
crucified (1 Cor. 2:2). Bernard concludes, "The more surely you know yourself
loved, the easier you will find it to love in return."[72] At this point Bernard dra-
matizes, in the person of a feminine, bridal church, the human response to God's
boundless love, which has been revealed in Christ's Passion:

> She says, "I am wounded by love"(Sg. 2:5), and again, "Surround me with flowers,
> pile up apples around me, for I am sick with love" (Sg. 3:11). The church sees King
> Solomon in the crown which his mother had placed on his head (Sg. 3:11). She sees
> the Father's only Son carrying His cross (Jn. 19:17). She sees the Lord of majesty
> (1 Cor. 2:18) struck and spat upon. She sees the Author of life and glory (Acts 3:15)
> transfixed by nails, wounded by a lance (Jn. 19:34), smeared with abuse (Lam. 3:30),
> and finally laying down his precious life for his friends (Jer. 12:7; Jn. 15:13). She sees
> these things, and the sword of sorrow pierces her soul more deeply (cf. Lk. 2:35), and

68. Gilson, *The Mystical Theology of St. Bernard,* 116–17, 118.

69. St. Bernard of Clairvaux, *On Loving God,* 9.28, in *Selected Works,* 196; *De diligendo Deo,* in
Opera, 3:143: "Sic affici, deificari est."

70. See my "Telling Tales of Love: Julia Kristeva and Bernard of Clairvaux," *Christianity and
Literature* 50.1 (2000): 125–48. St. Bernard sums up the theocentric argument with the words:
"Causa diligendi Deum, Deum est" (*De diligendo Deo,* 1.1, in *Opera,* :119): "The cause of loving
God is God himself."

71. St. Bernard of Clairvaux, *On Loving God,* 2.2, in *Selected Works,* 175–76; *De diligendo Deo,*
in *Opera* 3:121.

72. St. Bernard of Clairvaux, *On Loving God,* 3.7, in *Selected Works,* 179; *De diligendo Deo,* in
Opera, 3:124: "Facile proinde plus diligunt, qui se amplius dilectos intelligunt."

she says, "Surround me with flowers, pile up apples around me, for I am sick with love" (Song of Sol. 2:5).[73]

The sight of the church, her contemplative *aspectus,* beholds a gift of love and a beauty to which a prideful *curiositas* is blind. In her vision of Christ's wounded body, the bride's *amor carnalis* is stirred as a powerful, affective form of the love of God, causing her to empathize with Him in His very compassion for her. This *amor,* moreover, works to counteract cupidity, "sweetness conquering sweetness, as one nail drives out another."[74]

What is striking about the passage is that the vision of the bride—a vision accentuated by the five-times repeated phrase "she sees" (*cernit*)—is entirely mediated by scriptural passages. The meditative image of Christ in His suffering is constructed as a collage or pastiche of quotations recalled from memory. Some are linked by concordance—e.g., the crown of thorns and the crown of King Solomon, the wounds of the bride and the wounds of Christ, the sword of love in the bride's heart and the lance in Christ's side. In the immediately following passage, Bernard continues to proceed by association, letting the red color of Christ's blood and the bride's apples suggest the pomegranates of the Song of Songs, the healing fruit "picked from the Tree of Life," to counteract the poisonous fruit of the Fall.[75] Two more times Bernard repeats the verbs of meditative vision: "she sees," "she beholds."

Behind the repeated contrasts of glory and abjection in the passage are two other passages linked to them by concordance, namely, Isaiah 53:2 and Psalm 44:3. As discussed in chapter 2, the fathers of the church invoked these Old Testament passages in their attempt to answer the question, "What did Jesus look like?" John Chrysostom and Jerome, on the one hand, upheld Christ's physical beauty, citing

73. St. Bernard of Clairvaux, *On Loving God,* 3.7, in *Selected Works,* 179; *De diligendo Deo,* in *Opera,* 3:124: "Quae ait: VULNERATA CARITATE EGO SUM, et rursum: FULCITE ME FLORIBUS, STIPATE ME MALIS, QUIA AMORE LANGUEO. Cernit regem Salomonem in diademate, quo coronavit eum mater sua; cernit Unicum Patris, crucem sibi baiulantem; cernit caesum et consputum Dominum maiestatis; cernit auctorem vitae et gloriae confixum clavis, percussum lancea, opprobriis saturatum, tandem illam dilectam animam suam ponere pro amicis suis. Cernit haec, et suam magis ipsius animam gladius amoris transverberat et dicit: FULCITE ME FLORIBUS, STIPATE ME MALIS, QUIA AMORE LANGUEO."

74. St. Bernard of Clairvaux, *On the Song of Songs I,* Sermon 20, 3.4, 150; *Sermones in Cantica Canticorum,* in *Opera,* 1:117: "Vincat dulcedo dulcedinem, quemadmodum clavum clavus expellit."

75. St. Bernard of Clairvaux, *On Loving God,* 3.7, in *Selected Works,* 179; *De diligendo Deo,* in *Opera,* 3:125: "Haec sunt quippe mala punica, quae in hortum introducta dilecti sponsa carpit ex ligno vitae, a caelesti pane proprium mutuata saporem, colorem a sanguine Christi" ("These are beyond a doubt the pomegranate fruits which the Bride brought into her Beloved's garden. They were picked from the Tree of Life, and their taste had been transmuted to that of the heavenly bread, and their color to that of Christ's blood").

the prophetic description in Psalm 44:3 of the Messianic king, who is "fairer . . . than the sons of men."[76] Justin Martyr, Tertullian, and Ambrose, on the other hand, denied any physical attractiveness in Jesus, on the basis of Isaiah's prophecy in chapter 53 of the Suffering Servant, "in whom there is no beauty" (Isa. 53:2).[77] Augustine, for his part, refused to choose between the two, arguing instead for a new understanding of beauty that extended so far as to include the ugliness of Christ's wounds. Augustine's ecstatic discovery of the beauty of the *Christus deformis* inspires Bernard's *amor carnalis* for Jesus in His Passion.[78]

In his classic study of the patristic sources of the theology of St. Bernard, Gilson admits everywhere a "profound" Augustinian influence, finding it "especially apparent in [Bernard's] doctrine of love," in the composition of which "St. Bernard gathered up, systematized, and explored a quantity of indications scattered through the works of St. Augustine."[79] Drawing a contrast, however, between the "thoroughly metaphysical" and "almost neo-platonic" ecstasy of Augustine at Ostia (the "unique instance" of "personal mystical experience" recorded in the *Confessions*), on the one hand, and the "affective ecstasy" of Bernard, on the other,[80] Gilson marvels at Bernard's apparent discovery in Augustine of a model for himself: "Of all who had read and meditated [Augustine] before St. Bernard from the opening of the ninth century, none, not even St. Anselm, ever dreamt that a mystical doctrine could be gathered from his writing."[81] Gilson suggests in passing that Bernard's appropriation of Augustine depended on a synthetic combination of the early doctor's abstract "theological considerations" with the "inspiring contagion of example" found in the Lives of the Desert Fathers, the *Vitae patrum*.[82]

Going beyond Gilson, I would argue that Bernard read the *Confessions* less philosophically, less metaphysically, than Gilson and others have, finding in it not theological abstractions but the "contagious" story of an adult convert, himself

76. See St. John Chrysostom, *In Matthaeam*, PG 57, 27.2; St. Jerome, *Epistolae* 65.8, PL 22, cols. 627–28.

77. See Tertullian, *Adversus Judaeos* 14, PL 2, cols. 639–40; *De Carne Christi* 9, PL 2, cols. 771–72; St. Ambrose, *In Lucam* 7.12.183, PL 15, col. 1748. Justin Martyr speaks of two advents of Christ, the first in ugliness, the second in glorious beauty. See his *Dialogue with Trypho*, in *Writings of Saint Justin Martyr*, trans. Thomas B. Falls (Washington, DC: Catholic University of America Press, 1948), 167 (chap. 13), 203 (chap. 36), and 221 (chap. 49). See also *The First Apology*, chaps. 50–52, in *Writings of Saint Justin Martyr*, 86–89.

78. See St. Augustine, *Enarrationes in Psalmos, 1–50*, ed. D. Eligius Dekkers, O.S.B., and John Fraipont, CCSL 38 (Turnhout: Brepols, 1959), 44.3, 496; Sermon 27, PL 38, col. 181.

79. Gilson, *The Mystical Theology of St. Bernard*, 200n24.

80. Ibid.

81. Ibid., 17.

82. Ibid.

inspired by the Life of St. Anthony,[83] who broke free from his admitted en-
slavement to *curiositas* and *concupiscentia* to enter a life devoted to scriptural
meditation: "Take and read!"[84] As Rachel Fulton has noted, Bernard's Praemon-
stratensian contemporary, Philip of Harvengt, wrote at the urging of his brethren
a short biography of Augustine that focused attention on the saint's conversion
through his scriptural reading, as if to illustrate for them the point that conver-
sion itself is "an act of interpretation, a translation from a clouded or alternative
understanding of reality."[85] For the monks of the "new orders"—the Cistercians,
the Praemonstratensians, the Augustinian canons, and the regular canons of St.
Victor in Paris—who, unlike the Benedictines, recruited their members from
among lay adults (rather than oblates), the life of St. Augustine assumed new im-
portance as a model for the adult convert. Augustine's writings held "great pres-
tige in the first Cîteaux," as they did in the library at Clairvaux.[86] What Jean
Leclercq writes about the Life of St. Anthony applies equally well to Augustine's
Confessions: "For medieval monks [it] is not simply an historical text . . . about a
definitely dead past. It is a living text, a means of formation of monastic life."[87]

From the beginnings, as Leclercq emphasizes, Augustine's "influence was para-
mount in the formation of the 'monastic style'. In his *Sermons* and *Confessions,*
he had produced a model of artistic prose in which all the procedures used in an-
cient rhythmical prose were put to the service of his Christian enthusiasm."[88]
Thus St. Bernard of Clairvaux will frequently "sing a hymn or doxology similar
to those found in . . . the *Confessions* of St. Augustine."[89] For Bernard such pas-
sionate Augustinian hymns are the memorial traces, the proofs, of the saint's
mystical experiences, supported by his scriptural meditation. Thus Augustine's
influence was also "predominant" in the monastic conception of "inner illumi-
nation"—so much so, Leclercq asserts, that all "the monks are Augustinian."[90] In
the specific milieu of the monasteries (as opposed to the universities), Augustine's
Confessions offered "the testimony of the mystic."[91]

Augustine in his aesthetic empathy for the *Christus deformis* provided St.

83. St. Augustine, *Confessions,* 8.6, trans. Ryan, 191.

84. Ibid., 8.8, 202.

85. Rachel Fulton, *From Judgment to Passion,* 378, 468. See Philip of Harvengt, PL 203, cols.
1205–34.

86. Jean Leclercq, *The Love of Learning and the Desire for God: A Study of Monastic Culture,*
trans. Catharine Misrahi (New York: Fordham University Press, 1982), 97. See also Jean Leclercq,
Monks and Love in Twelfth-Century France: Psycho-Historical Essays (Oxford: Clarendon Press,
1979), 64.

87. Leclercq, *Love of Learning,* 99.

88. Ibid., 97.

89. Ibid., 174.

90. Ibid., 221.

91. Ibid., 98.

Bernard with a model of adult Christian conversion from self-centered love or *cupiditas* to *caritas,* the love of God and neighbor. This conversion involves a process. One leaves oneself through a kind of projection, an expansion of *amor carnalis* that puts oneself physically and emotionally at the Other's place, and learns through that process of dislocation and relocation to see things differently. When one returns, altered, to oneself, the Other appears differently to one's eyes—that mystical Otherness being at the root of all properly allegorical interpretation. What was hidden before is suddenly revealed. What was ugly before now appears beautiful and love-worthy.

This process with respect to the *Christus deformis* is especially obvious in St. Bernard's influential commentary on the Song of Songs. There, in Sermon 25, Bernard refers at length to the testimony of both "Saint Isaiah" in Isaiah 53 and "Saint David" in Psalm 44 in his explication of chapter 1, verse 4 of Solomon's *Canticum:* "I am black but beautiful." Bernard's theo-aesthetical starting point here, however, is not (as it was for Augustine) Christ crucified, however, but rather the suffering Christian, the bridal soul, whose mingled, personal experience of earthly affliction and divine grace makes understandable the beauty of Christ in His Passion. In Bernard's anthropology the starting point is the "I." God's self-emptying love is revealed to the soul precisely in and through the soul's own passionate love for God, which is discovered at a certain height of spirituality (the fourth stage of love) to be God's own love for Himself, the Word within: "I am you."[92]

Emphasizing this "I," St. Bernard builds on St. Augustine's theo-aesthetic approach to the beauty of the *Christus deformis,* applying it to the *Christianus deformis,* the "black but beautiful" Bride of Christ. In his meditation on Song of Songs 1:4, St. Bernard first distinguishes between color and form, indicating that blackness can be beautiful. The adversative conjunction *but* in the scriptural verse implies, however, that the bride possesses a "beautiful shape with disagreeable colors."[93] Since the verb is present tense, "I am—not I was—black," the blackness cannot refer to her former "benighted life" (*tetram conversationem,* literally, "hideous habit") of sin,[94] but must characterize "the outward appearance of the saints, . . . how lowly and abject it is," how marred with neglect, fasting, vigils, illness, and mortality itself.[95]

92. See Karl F. Morrison, *"I Am You": The Hermeneutics of Empathy in Western Literature, Theology, and Art* (Princeton: Princeton University Press, 1988).

93. St. Bernard of Clairvaux, *On the Song of Songs II,* Sermon 25, 2.3, 52; *Sermones in Cantica Canticorum,* in *Opera,* 1:164: "in superficie . . . decoloria, in compositione vero decora."

94. St. Bernard of Clairvaux, *On the Song of Songs II,* Sermon 25, 2.4, 52; *Sermones in Cantica Canticorum,* in *Opera,* 1:165: "Sed si hoc ita est, cur non magis de praeterito: 'Nigra fui', et non: NIGRA SUM, dicit?"

95. St. Bernard of Clairvaux, *On the Song of Songs II,* Sermon 25, 3.5, 53; *Sermones in Cantica*

Although St. Bernard's initial stance is to contrast the blackness of the body with the beauty of the soul, he quickly undermines that distinction, suggesting that the *but* in "black but beautiful" is merely an echo of the world's estimation, not a declaration of God's perspective, which employs an *and* instead. In words that must have sounded to his listeners like a self-description, the ascetic and eloquent abbot of Clairvaux points to St. Paul as "a person at once black and beautiful,"[96] because the "wisdom and righteousness of Paul were either produced or merited through the outward impairment of his little body, worn out by constant labors. . . . Hence the ugliness of Paul is more beautiful than jeweled ornaments, than the raiment of kings."[97] Indeed, in the case of a "black and beautiful" saint like Paul, the principle of aesthetic contrast, as well as functionality, comes into play: "Blackness in the pupil of the eye is not unbecoming; black gems look glamorous in ornamental settings, and black locks above a pale face enhance its beauty and charm."[98] Black is beautiful. Similarly, Bernard insists, "nothing in [the saints]"—neither their outward unsightliness nor the spiritual failings that nourish their humility—is without its use (and thus beauty), for everything contributes to an artistic end: "Nothing can be more pleasing to God than His own image when restored to its original beauty."[99]

In Bernard's sermon the imitation of Christ literally conjoins the images of the bride and the bridegroom. "The ignominy of the cross is welcome," Bernard avers, "to the man who will not be an ingrate to the Lord. Though it involves the stigma of blackness, it is also the pattern and the likeness of the Lord. Listen to St. Isaiah, and he will describe him for you as he saw him in spirit: 'A man of sorrows and afflicted with suffering, without beauty, without majesty'. . . . But think at the same time of those words of St. David: 'You are the fairest of the sons of men' and you will find in the Bridegroom all the traits that the Bride ascribes to herself."[100]

Canticorum, in *Opera,* 1:165: "habitum exteriorem sanctorum . . . quam sit humilis utique et abiectus."

96. St. Bernard of Clairvaux, *On the Songs of Songs II,* Sermon 2, 3.5, 53; *Sermones super Cantica Canticorum,* in *Opera,* 1:165: "animam et nigram, pariter et formosam."

97. St. Bernard of Clairvaux, *On the Song of Songs II,* Sermon 25, 3.6, 54; *Sermones super Cantica Canticorum,* in *Opera,* 1:166–67: "Porro in eo hunc sapientiae iustitiaeque candorem nigredo illa exterior de praesentia corporis infirma, de laboribus plurimis . . . aut operabatur, aut promerebatur. Ideoque et quod nigrum est Pauli, speciosius est omni ornamento extrinseco, omni regio cultu."

98. St. Bernard of Clairvaux, *On the Song of Songs II,* Sermon 25, 2.3, 51; *Sermones super Cantica Canticorum,* in *Opera,* 1:164: "Nigredo, verbi causa, in pupilla non dedecet; et nigri quidam lapilli in ornamentis placent, et nigri capilli candidis vultibus etiam decorum augent et gratiam."

99. St. Bernard of Clairvaux, *On the Song of Songs II,* Sermon 25, 4.7, 55; *Sermones super Cantica Canticorum,* in *Opera,* 1:167: "Certi enim sunt Deo non posse quidquam acceptius imagine sua, si proprio fuerit restituta decori."

100. St. Bernard of Clairvaux, *On the Song of Songs II,* Sermon 25, 4.8, 56; *Sermones super Can-*

It is at this point that Bernard suddenly and imaginatively transfers the sentence "I am black but beautiful" from the lips of the bride to that of the bridegroom, the *Christus deformis,* who stands accused and condemned by the "sons of Jerusalem."[101] Bernard's vivid portrayal of Jesus in His Passion harmonizes Isaiah 53:2 and Psalm 44:3 and effects a sort of marriage between the saintly soul and the Lord, both of whom have emptied themselves out of love, both of whom are "black and beautiful." Ecstatic in his contemplation of Christ, Bernard not only addresses his listeners and then Jesus himself with the word *you,* but he also speaks in the first person: "You must pronounce him black. But . . . the beauty you discover will compel your admiration. Beautiful in his own right, his blackness is because of you. Even clad in *my* form, how beautiful You are, Lord Jesus!"[102] To Bernard Jesus appears in the form of Bernard: "I am you."

Seeing Christ in the form of oneself conveys a twofold knowledge: knowledge of the self and knowledge of God. As Leclercq explains, "One is the necessary complement of the other; it leads to the other and cannot be separated from it: *Noverim te—noverim me.*"[103] This characteristically Cistercian anthropology and mysticism, however, transforms the question of the *Christus deformis,* making it not just an objective question of the beauty of Christ in His Passion and death, but also a subjective question of the beauty of the Christian, a beauty that recognizes beauty.

Two Visionary Lives: Bernard of Clairvaux and Gertrude of Helfta

In her spiritual exercises, St. Gertrude of Helfta (1256–1301/2) seems to have taken very seriously St. Bernard's advice concerning the *amor carnalis* for Jesus:

> The soul at prayer should have before it a sacred image of the God-man, in his birth or infancy or as he was teaching or dying, or rising, or ascending. Whatever form it

tica Canticorum, in *Opera,* 1:168: "Grata ignominia crucis ei qui Crucifixo ingratus non est. Nigredo est, sed forma et similitudo Domini. Vade ad sanctam Isaiam, et describet tibi qualem in spiritu illum viderit. Quemnam alium dicit VIRUM DOLORIS, ET SCIENTEM INFIRMITATEM, et quia NON ERAT EI SPECIES NEQUE DECOR. . . . Iunge et illud sancti David: SPECIOSUS FORMA PRAE FILIIS HOMINUM, et habes totum in sponso, quod sponsa de se hoc in loco testata est."

101. St. Bernard of Clairvaux, *On the Song of Songs II,* Sermon 25, 4.9, 56; *Sermones super Cantica Canticorum,* in *Opera,* 1:168: *filii Jerusalem.*

102. St. Bernard of Clairvaux, *On the Song of Songs II,* Sermon 25, 4.9, 57, emphasis added; *Sermones super Cantica Canticorum,* in *Opera,* 1:168: "Nigrum vel tunc profecto fatebere. . . . et nihilominus formosus mirabere. Ergo formosus in se, niger propter te. Quam formosum et in mea forma te agnosco, Domine Iesu!"

103. Leclercq, *Love of Learning,* 221.

takes, this image must bind the soul with the love of virtue and expel carnal vices, eliminate temptations and quiet desires. I think this is the principal reason why the invisible God willed to be seen in the flesh and to converse with men as a man. He wanted to recapture the affections of carnal men who were unable to love in any other way, but first drawing them to the salutary love of his humanity, and then gradually to raise them to a spiritual love.[104]

As Jeffrey Hamburger observes, "Bernard's list reads like a condensed repertory of the standard devotional iconography of his day," and his exhortation to his monks to use a visual imagination seems to have actually "open[ed] the door to the visual arts" in monasteries like Helfta, in contradiction of his iconoclastic stance in the *Apologia*.[105]

St. Gertrude's autobiographical writing and that of her fellow nuns in the early-fourteenth-century compilation *Legatus memorialis abundantiae divinae pietatis* [*The Herald of Divine Love*] is replete with references to visual images, both the sights received in personal, visionary experience and the artifacts (crucifixes, statues, illustrations in books) used as a stimulus to meditation. Among its many accounts of visions, the *Legatus* reports that once, on the feast of St. Bernard, the holy abbot himself appeared to Gertrude to acknowledge gratefully her devotion to him. He stood before her, arrayed in glorious vestments, their colors representing different virtues, the names of which Gertrude read as if carved ("legabat . . . velut sculptae") on the folds of his shining garments.[106] Filled with quotations from St. Bernard's *Sermones super Cantica Canticorum* (*Sermons on the Song of Songs*) the entire *Legatus* shows Gertrude's conscious, deep orientation toward Bernard as her teacher, stylistic model, and guide—so much so, Mary Jeremy Finnegan writes, that "any discussion of her spirituality must take into account this [Bernardine] influence."[107]

Recent scholarly discussions have attempted to resolve the paradox of Gertrude's obvious Cistercian discipleship, on the one hand, and her equally obvious

104. St. Bernard of Clairvaux, *On the Song of Songs I*, Sermon 20, 5.6, 152; *Sermones super Cantica Canticorum*, in *Opera* 1:118: "Adstat oranti Hominis Dei sacra imago, aut nascentis, aut lactentis, aut docentis, aut morientis, aut resurgentis, aut ascendentis; et quidquid tale occurrerit, vel stringat necesse est animum in amore virtutum, vel carnis exturbet vitia, fuget illecebras, desideria sedet. Hance ego arbitror praecipuam invisibili Deo fuisse causam, quod voluit in carne videri et cum hominibus homo conversari, ut carnalium videlicet, qui nisi carnaliter amare non poterant, cunctas primo ad suae carnis salutarem amorem affectiones retraheret, atque ita gradatim ad amorem perduceret spiritualem."

105. Jeffrey F. Hamburger, *The Visual and the Visionary: Art and Female Spirituality in Late Medieval Germany* (New York: Zone, 1998), 121.

106. St. Gertrude d'Helfta, *Le Héraut*, in *Oeuvres spirituelles*, ed. Jean-Marie Clément and Bernard de Vregille, S.J. (SC 255) (Paris: Cerf, 1978), 4.44.3, 398.

107. Mary Jeremy Finnegan, O.P., *The Women of Helfta: Scholars and Mystics* (Athens, GA: University of Georgia Press, 1991), 113.

differences with St. Bernard, on the other. Enumerating the commonalities between the two saints—their practice of *lectio divina,* their eloquent style of expression and use of biblical images, their emphasis on humility as a virtue, their devotion to the name of Jesus and to the humanity of Christ—Finnegan points to a difference in their "attitude toward nature."[108] Ulrike Wiethaus similarly characterizes Gertrude's spirituality as "less dualistic" and more world-affirming than Bernard's.[109]

Hamburger calls attention to the distance in time, space, gender, and culture that separates Gertrude from Bernard, maintaining that "the contrast between Bernard and his late medieval followers [concerning visual images] provides one measure of the degree to which monastic attitudes and aspirations had changed between the mid-twelfth and the late thirteenth century."[110] "For Bernard, as for his contemporaries, vision was clearly linked to the process of [biblical] reading," and they "identified [it] more closely with insight than with sight itself," Hamburger argues.[111] For Gertrude and her contemporaries, by contrast, vision involved visualizing. Interpreting St. Bernard's words contrary to his intention, they turned memorial *imagines,* housed in the mind's church, into actual images, to be seen and handled in meditative exercises. For them "the phenomena of visions and apparitions . . . assumed a new importance," as well as a greater, pictorial concreteness, which was mediated by imagistic objects of a devotion at a greater remove from the scriptures themselves.[112] In the cultural context of heightened eucharistic cult, Hamburger suggests, such objects and experiences of vision gave expression to the longing for a more corporeal presence of God.[113]

Following Amy Hollywood's carefully nuanced approach to the relationship between Meister Eckhart and Mechthild of Magdeburg, I would caution against the scholarly tendencies, first, to lump together St. Bernard's remarks in the *Sermones* about the imageless quality of unitive prayer, which occurs in fleeting moments at the transcendent height of contemplation, and his polemics in the *Apologia* against the use of visual art in monastic churches; second, to conclude that his supposedly "imageless" mysticism—iconoclastic and apophatic—stands at a great remove from the cataphatic, artisanal, and visionary mysticism of St.

108. Ibid., 114.

109. Ulrike Wiethaus, *Ecstatic Transformation: Transpersonal Psychology in the Work of Mechthild of Magdeburg* (Syracuse, NY: Syracuse University Press, 1996), 18.

110. Hamburger, *The Visual and the Visionary,* 147.

111. Ibid.

112. Ibid., 148. See also Ulrich Köpf, "Bernhard von Clairvaux in der Frauenmystik," in *Frauenmystik im Mittelalter,* ed. Peter Dinzelbacher and Dieter R. Bauer (Stuttgart: Schwabenverlag, 1985), 48–77.

113. See Jeffrey F. Hamburger, *Nuns as Artists: The Visual Culture of a Medieval Convent* (Berkeley: University of California Press, 1997), 125–26, 136, 144–45.

Gertrude. There are differences, certainly, between the spiritualities of the two saints, but Gertrude's writings are as scriptural as Bernard's in their pattern of frequent biblical quotation. Bernard's texts are, moreover, as Carruthers stresses, full of vivid images that he commends to the imaginations of his auditors. St. Bernard was, to be sure, alert to the dangers of visual representation, which could, he feared, substitute for the making of personal mental images or lead to a form of idolatry, but he was definitely not against *imagines* as such. Rather he understood them to be vitally necessary to the spiritual life, in keeping with the truth of Hollywood's assertion that "meditation on images *and* texts . . . is foundational for medieval Christian visionary and mystical unitary experience."[114]

According to the account left by her fellow nuns, St. Gertrude knew and understood St. Bernard's dictum that the imageless, unitive prayer of rapture occurs (if at all) "only rarely and for a short time."[115] When she herself experienced such times of inner repose, she wondered about the comparative value of the visionary experiences to which she was accustomed. In answer she recalled St. Bernard's words (quoted in the *Legatus*) that the "holy angels," whom Bernard compares to goldsmiths (*aurifices*), construct "certain spiritual images in order to bring the purest intuitions of divine wisdom before the eyes of the soul."[116] These images of earthly things, according to the abbot of Clairvaux, fill the imagination, "either as an aid to understanding or to temper the intensity of the divine light."[117] They prepare the soul for imageless union (on the way up the ladder), or they help the soul somehow to remember it (on the way down). Identifying her own visions with these Bernardine *imagines*, Gertrude concluded that the imageless prayer of quiet is not of an inferior merit (*non est judicandum inferioris*) to visionary experience, but rather, it is superior (*summae perfectionis*), since it marks a time when God alone floods the soul with His presence, preserving it free from every image: "purum absque omni fantasia corporearum imaginem."[118]

114. Amy Hollywood, *The Soul as Virgin Wife,* 21. Emphasis added. See also my *Song of Songs in the Middle Ages* (Ithaca, NY: Cornell University Press, 1990), 89–103.

115. Gertrude of Helfta, *The Herald of Divine Love,* ed. and trans. Margaret Winkworth (New York: Paulist Press, 1993), 3.74, 237; *Le Héraut,* book 3, in *Oeuvres spirituelles,* 3 (SC 143), ed. Pierre Doyère (Paris: Cerf, 1968), 73.2, 296: *rara hora, parva mora.* For the text quoted in the *Herald,* see St. Bernard of Clairvaux, *On the Song of Songs II,* Sermon 23, 6.15, 38; *Sermones super Cantica Canticorum,* in *Opera,* 1:148: *rara hora et parva mora.*

116. St. Bernard of Clairvaux, *On the Songs of Songs II,* Sermon 41, 3.3, 206; *Sermones super Cantica Canticorum,* in *Opera,* 2:30: "Quasdam spirituales similitudines, et in ipsis purissima divinae sapientiae sensa animae contemplantis conspectibus importare." Quoted in *Le Héraut* 4.26.2 (SC 255, 250).

117. St. Bernard of Clairvaux, *On the Song of Songs II,* Sermon 41, 3.3, 207; *Sermones super Cantica Canticorum,* in *Opera,* 2: "sive ad temperamentum nimii splendoris, sive ad doctrinae usum." Quoted in *Le Héraut* 4.26.2 (SC 255, 250).

118. Gertrude of Helfta, *Le Héraut,* 4.26.2 (SC 255, 250).

Embracing the inferior but gracious experience of visionary prayer, the practice of scriptural meditation, and the reception of the sacraments, Gertrude pursued (as Bernard did) a path of humility, of self-knowledge, and of the knowledge of God. Comparing the "painted pictures" of her visions to the letters "of the alphabet" that children learn, she prays (at the end of the autobiographical portion of the *Legatus*) that they may allow her readers "to taste within themselves that hidden manna (Rev. 2:17), which it is not possible to adulterate by any admixture of material images and of which one must have eaten to hunger for it for ever."[119]

The whiteness of the eucharistic Host, as an outward sign of this "hidden manna," is the site par excellence for Gertrude's *memoria*—a word prominent in the title of her book, *Legatus memorialis abundantiae divinae pietatis* (literally, "The Herald of the Memorial of the Abundance of Divine Love"), and, of course, in Jesus' institution of the sacrament: "Do this in remembrance of me" (Luke 22:19). Feeding on the Eucharist, Gertrude has become (the *Legatus* reports) a richly decorated *templum spiritualis,* such as St. Bernard describes in his *Sermones super Cantica Canticorum.*[120] At the same time, the Lord's "body" has become her "cloister," its parts (heart, feet, hands, mouth, eyes, ears) encompassing all the rooms of her life (chapel, hall, workshop, parlor, library, confessional).[121] The plain whiteness of the Host (an imageless place of divine and human memory that mysteriously houses and releases the multiple, colorful images of Gertrude's visionary experience) corresponds in its memorial function, I suggest, to the bareness of the walls of Bernard's church at Clairvaux, walls that are themselves a bodily symbol of the Host, the Body of Christ, which they enclose and shelter. Their very emptiness and plainness requires and enables a deeper seeing.

This monastic theme gains a remarkable expression in the *Bread of Angels Mandala* (plate 4) by the modern artist Mary A. Zore.[122] Conceiving of the large, central Host as a mandala, a circular object of contemplative adoration that facilitates an inner focus on the One God, Zore positions the Eucharist on the Tree of Life as its precious fruit. Like medieval visionaries before her, Zore combines the motif of the Tree of Life with that of Jacob's ladder—both being vertical images of meditation between heaven and earth, aligned with Christ, the one Mediator. Angel wings on both sides of the Host evoke the theme of adoration, even

119. Gertrude of Helfta, *Herald*, 2.24, 135; *Le Héraut,* books 1 and 2, in *Oeuvres spirituelles,* 2 (SC 139), ed. Pierre Doyère (Paris: Cerf, 1968), 2.24.1, 350: "Sicut per alphabeticum ad logicam perveniunt quandoque studentes, sic per istas velut depictas imaginationes ducantur ad gustandum intra se manna illud absconditum (Apoc. 2:17) quod nulla corporearum imaginationum admixtione valet partiri, sed solus qui edit adhuc esurit."

120. Gertrude of Helfta, *Herald* 1.5, 61; *Le Héraut,* 1.5.2 (SC 139, 148).

121. Gertrude of Helfta, *Herald,* 3.28, 191; *Le Héraut,* 3.28 (SC 143, 128).

122. I thank Mary A. Zore for permission to reproduce her painting and for supplying me with a photograph of it.

as the title of the sketch suggests the feeding of the angels on the Host in a spiritual Communion to be imitated by the beholder. The association of the angels with the central, eucharistic image, moreover, recalls St. Bernard's identification of the angels as artists, who fabricate sensible signs to express and protect the imageless Communion of the soul with God.

One reason for the tendency to exaggerate the distance between Bernard and Gertrude as Cistercian monastics is that they wrote in different genres: Bernard's *Apologia* and *Sermones* and the Gertrudian *Legatus*. In order to assess better the similarities and differences between the two saints, I offer in the remaining pages of this chapter a comparison between the visionary accounts in William of St. Thierry's *Vita prima sancti Bernardi*, composed during the abbot's own lifetime with a view to his eventual canonization, and the *Legatus*, compiled by nuns of Helfta in the hope that Gertrude would receive ecclesiastical recognition as a saint. As already noted, St. Gertrude's Life includes an appearance of St. Bernard, an apparition that makes his life effectually a part of hers. St. Bernard, living long before, has no corresponding vision of St. Gertrude. Brian Patrick McGuire has shown, however, that the later medieval Lives of Bernard include visionary tales not contained in the *Vita prima*—for example, the tales of St. Bernard being nursed at the Virgin Mary's breasts and of the priest's vision of the crucified Christ (*imago pietatis*) standing before him on the altar as he celebrated Holy Mass (see plate 5).[123] Such stories turn Bernard's richly imagistic scriptural exegesis into a hagiographic narrative, transforming the images of his meditations into visionary experiences, on the assumption that his exegesis must have originated in them. "There may be a cultural link," McGuire hints, between this "Bernard of the fourteenth century . . . and some of the female Cistercian visionaries . . . in the thirteenth century."[124] Gertrude of Helfta may, in short, indeed have become (anachronistically and indirectly) a part of Bernard's Life, as his became assimilated to hers; her visions may have given him additional ones posthumously, providing him with a new iconography for a new, eucharistic

123. I thank the curator of the Bodleian Library in Oxford, England, for permission to reproduce this illumination, which is taken from a late-fifteenth-century French manuscript (MS. Douce 264) containing private prayers and devotions written for a member of the Scépeaux family. The Latin text below the picture of the haloed priest is a prayer of adoration in the Bernardine tradition, which can be translated, "I adore you, Lord Jesus Christ, hanging on the cross and crowned with thorns." The popular legend of an apparition of Christ to St. Gregory the Great during Mass inspired the iconography of the Man of Sorrows (*imago pietatis*) seen in this picture, but the priest depicted here seems to be St. Bernard, rather than Pope St. Gregory. This image appears on fol. 37. There is an image of St. Bernard, kneeling before the Virgin and Child, on fol. 38v.

124. Brian Patrick McGuire, *The Difficult Saint: Bernard of Clairvaux and His Tradition*, Cistercian Studies Series 126 (Kalamazoo, MI: Cistercian Publications, 1991), 218.

age.[125] The *Vita prima* is not, however, without its visions—visions that certainly contributed to Gertrude's own.

The *Vita prima*, the earliest Life of Bernard, was composed (in part, before his death) by his intimate friends, William of St. Thierry, Arnold of Bonnevaux, and Geoffrey of Clairvaux. William began the life already in 1147, finishing the first book before he died in 1148; Arnold composed the second part; and Geoffrey, who had been Bernard's secretary at Clairvaux, the third. The frequently copied *Vita prima sancti Bernardi*, which was almost certainly known to the nuns at Helfta, contains by my count no less than nine visions and four eucharistic miracles in the first book alone. Far from depreciating the visions, the *Vita prima* accords them great value as seals of the divine favor bestowed on the saint.

Two of the nine visions concern Bernard. His pregnant mother Aleth, we read, "dreamed that she had within her a barking dog, which had a white coat and a tawny hide."[126] A "certain holy man" then interpreted her dream for her as a prophecy that her son Bernard would be a "marvelous preacher" (*egregius praedicator*), a healer of souls, and a defender of God's house.[127] Similarly, before Bernard's arrival at Cîteaux, one of the monks there saw "in a vision . . . a great crowd of men near the abbey church," who were "busy washing their clothes in the fountain" of grace and favor.[128] Hearing of this vision, the Abbot Stephen "immediately realized that God was going to send them help," the divine assistance realized soon afterward through the arrival of Bernard and his companions.[129]

These visions of others concerning Bernard resemble the auditions and visions of the nuns of Helfta about Gertrude. To cite but one of many: the *Legatus* records the testimony of one who had been praying for Gertrude and seeking to understand her. In answer to her questions, the Lord spoke in praise of Gertrude's five outstanding virtues and showed the visionary a triangular jewel worn on His

125. Concerning this new iconography, Jeffrey Hamburger asks, "What would St. Bernard, the theoretician of imageless devotion, . . . have thought of the numerous images of the late thirteenth and fourteenth centuries which portray him in a similar posture, recast as an exemplar of the new, image-laden ideal of piety?" (*Visual and Visionary*, 134).

126. *St. Bernard of Clairvaux: The Story of his Life as recorded in the Vita Prima Bernardi by certain of his contemporaries, William of St. Thierry, Arnold of Bonnevaux, Geoffrey and Philip of Clairvaux, and Odo of Deuil,* trans. Geoffrey Webb and Adrian Walker (Westminster, MD: Newman Press, 1960), 14; *Vita prima Bernardi,* 1.1, PL 185, col. 227: "somnium vidit praesagium futurorum, catellum scilicet totum candidum, in dorso subrufum, et latrantem in utero."

127. *St. Bernard of Clairvaux,* 14–15; *Vita prima Bernardi,* 1.1, PL 185, col. 228.

128. *St. Bernard of Clairvaux,* 35; *Vita prima Bernardi,* 1.3, PL 185, col. 237: "apparuit innumera hominum multitudo prope basilicam ad fontem lavans vestimenta sua."

129. *St. Bernard of Clairvaux,* 35; *Vita prima Bernardi,* 1.3, PL 185, col. 237: "Intellexit protinus vir magnificus divinam consolationem."

breast in honor of His spouse, Gertrude, whom he loves.[130] Whereas the visions of Bernard in book 1 of the *Vita prima* offer foresight of his greatness, those of Gertrude in the *Legatus* provide insight into the hidden workings of God in her soul. Both employ biblical imagery (fountains, garments, gems). They function similarly to provide a divine and human witness in confirmation of the holiness and mission of the saint. Bluntly put, the visions of others affect, very literally and directly, the way the reader "sees" the saint. Such visions make it seem likely and appropriate, moreover, that someone who is *seen* in visions should also truly *see* them.

The remaining seven visions in book 1 of the *Vita prima* are Bernard's own. The first and most important was granted to him as a youth in the church of Châtillon-sur-Sâone on Christmas Eve, when

> All at once the birth of the infant Jesus was shown to the boy, which strengthened his faith and gave him the first taste of the mysteries of contemplation. The vision was like seeing the bridegroom coming out of the bridal chamber, as the Psalmist would have said. It was as if Bernard saw reenacted the birth of the infant Word, more beautiful than all the sons of men [Ps. 44:3], from the womb of the virgin mother.[131]

Bernard's first vision, like Gertrude's, is tied to the liturgy, for he experiences it precisely on Christmas Eve, "when everyone was making ready for the solemn night office."[132] At that very moment, Bernard suddenly finds himself spiritually present "at the exact moment when our Lord was born."[133] The effect of the vision is to "make Bernard's heart overflow with a love and longing unheard of in a mere boy,"[134] giving him, through the power of that very love, an extraordinary ability to preach and to write about Mary, Jesus, and the mystery of the Incarnation, as manifested in particular (William observes) in Bernard's treatise *In laudibus virginis Matris* (In Praise of the Virgin Mother). Indeed the *Vita prima* suggests that all of Bernard's biblical exegesis is, to some extent, a result of his breathtakingly vivid boyhood vision of the Word-Made-Flesh—a suggestion that effectually authorizes later hagiographers to add accounts of Bernardine visions

130. Gertrude of Helfta, *Herald*, 1.3, 58; *Le Héraut* 1.3.3 (SC 139, 136).

131. *St. Bernard of Clairvaux*, 17; *Vita prima Bernardi*, 1.2, PL 185, col. 229: "Adfuit illico puero suo revelans pueri Jesu sancta Nativitas, tenerae fidei suggerens incrementa, et divinae in eo inchoans mysteria contemplationis. Apparuit enim velut denuo procedens sponsus e thalamo suo. Apparuit ei quasi iterum ante oculos suos nascens ex utero matris Virginis verbum infans, speciosus forma prae filiis hominum."

132. *St. Bernard of Clairvaux*, 17; *Vita prima Bernardi*, 1.2, PL 185, col. 229: "et ad solemnes vigilias omnes, ut moris est, parabantur."

133. *St. Bernard of Clairvaux*, 17; *Vita prima Bernardi*, 1.2, PL 185, col. 229: "eam credit horam fuisse Dominicae Nativitatis."

134. *St. Bernard of Clairvaux*, 17; *Vita prima Bernardi*, 1.2, PL 185, col. 229: "et pueruli sancti in se rapiens minime jam pueriles affectus."

that correspond to the passionate descriptions of Christ and Mary in his writings.[135]

William describes the Christmas vision not in concrete detail, but rather in strikingly biblical, exegetical, and liturgical terms. In this, Bernard's initial vision, as reported by William, is strikingly similar to that of Gertrude, who at age twenty-six first sees Christ standing before her as a handsome youth and then hears Him speaking to her in the language of biblical prayer, thus connecting her vision immediately to the recitation of the Office: "While he was speaking, . . . it seemed to me that I was in the Choir, . . . and it was there that I heard these words: 'I will save you. I will deliver you. Do not fear.'"[136] She begins to hear the words of scripture as a personal address, even as the images of scripture, especially of the Song of Songs, become the content of her visionary experience. Interpreting this first vision of Jesus, from which Gertrude dates her conversion, the writer of the first book of the *Legatus* calls attention explicitly to the change it precipitated in the saint, who had formerly been attached to "secular studies," but who now devoted herself completely to biblical study, filling "the coffers of her heart to the brim with the sweetest and most useful sentences of Holy Scripture," a rich memory hoard out of which to draw *imagines* for meditation and visionary experience.[137]

Both the *Legatus* and the *Vita prima* record visions and auditions that encouraged the saints in the fulfillment of their respective missions—Gertrude in the writing of her book, Bernard in the work of foundation. The prologue to the *Legatus* chronicles the saint's reluctance to write her memoirs in the context of several dialogues between Gertrude and the Lord, who gradually convinces her that He has chosen her, as He chose the prophet Jeremiah, to be His prophet. The Lord promises her, in addition, that the book will be of great spiritual benefit to others, in part because it describes "images of bodily likenesses, appealing to the human understanding."[138]

To the young St. Bernard, too, came audible and visionary reassurances. The second of Bernard's recorded visions comes to him at Clairvaux between Matins

135. Barbara Newman rightly points to the overlapping categories of visionary experience—"the paranormal, the meditational, the aesthetic, and the supernatural"—in the late Middle Ages in her magisterial essay, "What Did It Mean to Say 'I Saw'?: The Clash between Theory and Practice in Medieval Visionary Culture," *Speculum* 80.1 (2005): 1–43.

136. Gertrude of Helfta, *Herald*, 2.1, 95; *Le Héraut*, 2.1.2 (SC 139, 230): "Haec dum diceret, . . . videbar mihi esse in choro, . . . et ibi audivi sequentiam verborum, scilicet: *Salvabo te et liberabo te, noli timere.*"

137. Gertrude of Helfta, *Herald*, 1.1, 53; *Le Héraut*, 1.1.2 (SC 139, 120): "cophinum cordis sui crebo utilioribus et mellitus Scripturae sacrae eloquiis impletis usque ad summum replebat."

138. Gertrude of Helfta, *Herald*, prologue, 49; *Le Héraut*, Prologus (SC 139, 114): "de imaginationibus corporearum similitudinum ad intellectum humanum in libello isto describi voluit. . . ."

and Lauds, when he goes "outside to walk in the grounds of the monastery," praying for God's blessing upon the new foundation. Standing still for a moment and closing his eyes, Bernard sees "coming down from the mountains round about and down into the valley such a great company of men of every type and standing that the valley could not hold them all."[139] Similar to the prophetic vision of the monk at Cîteaux, this vision of Bernard's prophesies the immense fruitfulness of the Cistercian reform. It strengthens Bernard's own hope and consoles the monks.

Two more visions in William's *Vita prima* serve similar purposes of encouragement. In a nocturnal vision, Bernard sees a boy, radiant with divine love, who comes to him, ordering him "to say in all truthfulness whatever came into his mind when he opened his mouth to speak, for, . . . it would not be Bernard who spoke, but the Holy Spirit speaking in him."[140] Thus Bernard's fear about preaching to his holy brothers is put to rest, and he becomes even more zealous and wise in his instructions. In another vision Bernard is summoned from his cell by night by "voices which seemed to come from a great crowd."[141] Following the sound as it moves away, he halts at a certain spot, where he hears with delight the voices coming at him from opposite directions, "like the sound that comes from the two sides of a monastic choir as it stands in parallel rows."[142] Bernard (we are told) "did not fully understand the meaning of this vision until some years later," when the church was "rebuilt at the very place where he heard the voices singing."[143]

William of St. Thierry is eager in book 1 to present St. Bernard in his youth as

139. *St. Bernard of Clairvaux*, 45; *Vita prima*, 1.5, PL 185, col. 242: "egressus foras, et loca vicina circumiens orabat Deum ut acceptum haberet obsequium suum et fratrum suorum. . . . subito stans in ipsa oratione, modice interclusis oculis, vidit undique ex vicinis montibus tantam diversi habitus et diversae conditionis hominum multitudinem in inferiorem vallem descendere, ut vallis ipsa capere non posset."

140. *St. Bernard of Clairvaux*, 49; *Vita prima*, 1.6, PL 185, col. 244: "Vidit in visu noctis puerum charitate quadam divina astantem sibi, et magna auctoritate praecipientem fiducialiter loqui quidquid ei suggeretur in apertione oris sui; quoniam non ipse esset qui loqueretur, sed Spiritus qui loqueretur in eo."

141. *St. Bernard of Clairvaux*, 57; *Vita prima*, 1.7, PL 185, col. 247: "voces . . . tanquam transeuntis multitudinis copiosae."

142. *St. Bernard of Clairvaux*, 58; *Vita prima*, 1.7, PL 185, col. 247: "velut alternantes chori hinc inde dispositi."

143. *St. Bernard of Clairvaux*, 58; *Vita prima*, I.7, col. 247: "Cujus tamen mysterium visionis non prius agnovit quam, translatis post aliquot annos aedificiis monasterii, eodem loco positum oratorium cerneret, ubi voces illas audisset." On his way to the Council of Etampes, Bernard, frightened by the burden of responsibility, was comforted by a "vision of a great church, in which the praises of God were being sung in harmony" (*St. Bernard of Clairvaux*, 77; *Vita prima*, 2.1, PL 185, col. 270: "In itinere tamen consolatus est eum Deus, ostendens ei in visu noctis Ecclesiam magnam concorditer in Dei laudibus concinentem" ("On the way God, however, consoled him, showing to him a vision of the night a great Church harmoniously joined in singing the praises of God").

an exemplary monk. Anticipating the objections of others that his later career drew the abbot of Clairvaux outside his proper, monastic sphere, William closes book 1 of the *Vita prima* with a chapter relating the dramatic, near-death experience of St. Bernard, in which are contained three different visions. This allows William to end his Life of Bernard (for William lived to write only book 1 of the *Vita prima,* completing it while Bernard was yet alive) with Bernard's symbolic "death" as a monk and his "resurrection" to a new, divinely ordained mission extending beyond the walls of the monastery.

In the first of these three visions, the mortally ill Bernard sees himself standing "before the judgment seat of God, while Satan stood opposite, hurling shameless accusations at him," to which Bernard responds in a humble profession both of his own unworthiness and of God's merciful gift of salvation.[144] In the second the mortally ill Bernard sees himself "waiting on the seashore for a ship to carry him off."[145] Three times the ship approaches the shore, and three times it draws back, to indicate "that it was not yet time for him to leave this life."[146] The third and last of the visions in this final chapter is particularly interesting, because it involves the use of sacramentals. Bernard, seemingly on his deathbed, commands one of the monks to go immediately to the church to pray for him. In obedience the monk, who is reluctant to leave the side of the saint, goes to the monastery church and prays there for Bernard "at the altar dedicated to the Blessed Mother of God, and at the altars on either side of it, one in honor of Saint Laurence the martyr, and the other in honor of Saint Benedict the abbot."[147] As he does so, there appear simultaneously to Bernard in his cell "the Blessed Virgin with Saint Laurence and Saint Benedict on either side."[148] Touching him with their hands, the three saints heal Bernard, giving him not only a new gift of life, but also a heavenly seal of approval for the special, controversial missions he will subsequently undertake, leading him outside the walls of the monastery.

The *Legatus* offers no description of St. Gertrude's death. Her serious illness and presentiment of death are, however, discussed, and one can draw some par-

144. *St. Bernard of Clairvaux,* 74; *Vita prima,* 1.12, PL 185, col. 258: "Cumque extremum jam trahere spiritum videretur, in excessu mentis suae ante tribunal Domini sibi visus est praesentari. Adfuit autem et Satan ex adverso improbis eum accusationibus pulsans."

145. *St. Bernard of Clairvaux,* 74; *Vita prima,* 1.12, PL 185, col. 258: "velut in littore quodam positus videbatur sibi navem quae se transveheret exspectare."

146. *St. Bernard of Clairvaux,* 75; *Vita prima,* 1.12, PL 185, col. 258: "protinus necdum tempus suae migrationis adesse."

147. *St. Bernard of Clairvaux,* 75; *Vita prima,* 1.12, PL 185, col. 258: "in honore beatae Dei Geninitricis: duo circumposita, in honore beati Laurentii martyris, et beati Benedicti abbatis."

148. *St. Bernard of Clairvaux,* 75; *Vita prima,* 1.12, PL 185, col. 258: "Eadem igitur hora adfuit Viro Dei praedicta beata Virgo, duobus illis stipata ministris, beato scilicet Laurentio, et beato Benedicto."

allels to the visions of Bernard's near-death experience. Gertrude suffers the re-
proaches of her own conscience and the assaults of the devil, who wishes to ac-
cuse her "after death" (*post mortem*) of failures in living the Rule of the Order.[149]
Not unlike St. Bernard, she overcomes these temptations by affirming God's
mercy, which is able to make up through a gracious "supplying" (*suppletio*) what-
ever she lacks in virtue. Even as Bernard in his second vision waits for the ap-
proaching ship and then lets it depart, standing equally ready for death or life,
Gertrude is so surrendered to the Lord's will, so trusting in God's goodness, that
"death and life," are "one and the same" to her, like roses of different colors to be
plucked for her in turn by her Beloved.[150]

Like Bernard who, in the third of his near-death visions, experiences in his
room the visitation of three saints through the intercessory prayer of another
monk in the church, Gertrude also receives a notable favor through another's in-
tercession. Gertrude had asked another nun (probably her friend, St. Mechthild)
to pray daily "before the crucifix" (*ante imaginem crucifixi*) for her, asking Jesus,
who had been pierced with a lance, to pierce her heart with the arrow of His
love.[151] That prayer was granted, she relates, one day after Communion, when
she felt "interior signs of infused grace" that were matched by "certain signs which
. . . appeared on the picture of [Christ's] crucifixion, [which was] . . . painted in
the book [*depicti in folio*]" that she was using.[152] She saw "a ray of sunlight with
a sharp point like an arrow," extending from the wound on Christ's right side.[153]
Responding to this vision and to the wound given her heart, Gertrude then ap-
plies the "bandage of holiness" to Christ's open side and to her own wound of
love,[154] turning the metaphor into a way of thinking, living, and striving. The
doubling of the nun before the crucifix, in one room, and of Gertrude before her
illustrated prayerbook, in another, reveals the theo-aesthetic implications of
Christ's dictum: "As you did for one of these, the least of my brethren, you did it
for me" (Matt. 25:40).

The role of the Eucharist and of visual artwork in triggering Gertrude's visions
is what distinguishes them most clearly from St. Bernard's in the *Vita prima*. The

149. See Gertrude of Helfta, *Herald*, 3.32, 204–5; 3.57, 223–24; *Le Héraut*, 3.32 (SC 143, 170); 3.57
(SC 143, 240).

150. Gertrude of Helfta, *Herald*, 3.56, 223; *Herald*, 1.10, 69; *Le Héraut*, 3.56 (SC 143, 238). See also
Herald, 1.10, 69; *Le Héraut*, 1.10 (SC 139, 168).

151. St. Gertrude of Helfta, *Herald*, 2.5, 101; *Le Héraut*, 2.5 (SC 139, 248).

152. St. Gertrude of Helfta, *Herald*, 2.5, 102; *Le Héraut*, 2.5 (SC 139, 248, 250): "tam per interi-
oris gratiae infusionem quam per evidentis signi in imagine crucifixionis tuae demonstrationem."

153. Gertrude of Helfta, *Herald*, 2.5, 101–2; *Le Héraut*, 2.5.2 (SC 139, 250): "Prodiret tamquam
radius solis, in modum sagittae acuatus."

154. St. Gertrude of Helfta, *Herald*, 2.5, 102; *Le Héraut*, 2.5 (SC 139, 252): "ligamen justifi-
cationis."

eucharistic miracles recorded in the *Vita prima sancti Bernardi* all evoke, in one way or another, the theme of judgment. On the occasion of a high feast, a monk, whom Bernard has suspended from receiving the sacrament, dares "to approach with the rest to receive the sacrament from the hands of the abbot."[155] Unwilling to refuse him, since his fault was unknown to the others, Bernard gives him the Host, while praying that God will "allow some good to come out of the monk's forwardness."[156] Finding himself unable to swallow the Host, the monk then goes to Bernard to confess his presumption, at which point he is able to receive Communion. On another occasion during Mass, Bernard uses the consecrated Host to exorcise a demon who has taken possession of a woman, declaring to the devil, "Here is your judge, evil spirit."[157] Boldly confronting William, Duke of Aquitaine, and urging him to end a schism by accepting Innocent as the rightful pope, Bernard holds the Host before him as he speaks the words: "Now see whom it really is that you persecute; it is the Lord. . . . He is your judge."[158] In keeping with the warning in 1 Corinthians 11:29 against an unworthy reception of the Eucharist, Bernard in these episodes sees every Communion as an anticipation of the Final Judgment.

A frequent and devout recipient of the Eucharist, St. Gertrude rejected for herself the image of the eucharistic Jesus as a judge, reasoning that Jesus would be the last to condemn a communicant who, confessing herself unworthy, nevertheless approached the sacrament in an attitude of ardent longing and humble trust in God's mercy. "'With such dispositions,'" Jesus assured her, "'it is not possible for anyone to approach unworthily.'"[159] Gertrude understood that Jesus in the sacred Host offered reparation for her sins, made up for all her negligence, and increased her virtues, which she saw flourishing within her in the imagistic form of a verdant tree, laden with healing fruits.[160]

In the thought of St. Gertrude, the Bernardine emphasis on eucharistic judgment and exorcism modulates into that of a humble self-knowledge, coupled with charitable insight into the spiritual condition of others. The visions she sees provide a mirror within which she can see herself in relation to God and others.

155. *St. Bernard of Clairvaux,* 71; *Vita prima,* 1.11, PL 185, col. 256: "ad manum ejus cum caeteris nimium praesumptuosus accessit."

156. *St. Bernard of Clairvaux,* 71; *Vita prima,* 1.11, PL 185, col. 256: "ut de tanta praesumptione melius aliquid ordinaret."

157. *St. Bernard of Clairvaux,* 84; *Vita prima Bernardi,* PL 185, col. 276: "Adest, inique spiritus, Judex tuus."

158. *St. Bernard of Clairvaux,* 92; *Vita prima Bernardi,* PL 185, col. 290: "Ecce ad te processit Filius Virginis, qui est caput et Dominus Ecclesiae, quam tu persequeris. Adest Judex tuus."

159. St. Gertrude of Helfta, *Herald,* 2.19, 120; *Le Héraut,* 219 (SC 139, 306): "'Tali intentione praesumens nunquam aliquis irreverenter accedere potest.'"

160. St. Gertrude of Helfta, *Herald,* 3.18, 176–77; *Le Héraut,* 3.18, SC 143, 84–86.

In prayer before, during, and after Communion, Gertrude receives answers to her questions, not only in locutions ("The Lord replied . . ."), but also in visual images. Sometimes she sees Jesus in the form of the priest distributing Hosts;[161] sometimes Jesus makes Himself so one with her that He receives Communion, receives Himself, with and through her.[162] Jesus prepares her to receive the sacrament in symbolic actions—by washing her hands, adorning her with his own jewels, dressing her in royal garments.[163] After Communion, she sees her soul melting like wax within her and receiving the imprint of a divine seal.[164] After Communion, too, she receives the aforementioned wound of love.[165] She notices that she experiences the "visible presence" of the Lord most often on those days when she "approached the life-giving food of [His] body and blood."[166]

The images Gertrude sees in Communion are sacramental, biblical, and liturgical. The Eucharist has become for her what the scriptures are for Bernard, "the book of our experience," an illustrated text to be read and interpreted in meditation. Whereas Bernard likens the scriptures to the Eucharist, Gertrude conceives of the Host itself as a revelatory, imagistic book. The very plainness of its outward appearance as bread, like the unadorned walls of the Cistercian church, facilitates the recall of a wealth of meditative imagery and the eucharistic reception of visionary experience, leading to a deeper self-knowledge. The goal for both Saints Bernard and Gertude is a humility to match that of the Lord, and, in and through that very truth, a transforming beauty.

Connecting beauty to love, St. Gertrude understands that, even as "beauty is in the eye of the beholder" in the case of earthly lovers, so too beauty is in the eye of the Lord who loves her. His love is not a blindness to her imperfections and deformities, however, but a truth that possesses the power really to transform her, awakening her love in return, and mercifully supplying what she lacks: "'Love *makes* pleasing.'"[167] When the divine image and the human likeness coincide, St. Bernard insists, the bride is black *and* beautiful.

161. St. Gertrude of Helfta, *Herald*, 3.39, 208; *Le Héraut*, 3.38 (SC 143, 184).

162. St. Gertrude of Helfta, *Herald*, 3.18, 184; *Le Héraut*, 3.18 (SC 143, 104): "exorabat Dominum, quatenus ipse pro se Hostiam illam sacrosanctam in persona sua susciperet et sibimet incorporaret" ("She was imploring the Lord to receive His most sacred Host for her Himself in His own person in her place and to incorporate it into Himself"). See also *Herald*, 3.16. 171; *Le Héraut*, 3.16 (SC 143, 70): "Dominus ipsam Hostiam in semetipso suscipiens."

163. St. Gertrude of Helfta, *Herald*,3.18, 179, 182; *Le Héraut*, 3.18 (SC 143, 90, 98).

164. St. Gertrude of Helfta, *Herald*, 2.7, 105; *Le Héraut*, 2.7 (SC 139, 260).

165. St. Gertrude of Helfta, *Herald*, 2.5, 102; *Le Héraut*, 2.5 (SC 139, 250).

166. St. Gertrude of Helfta, *Herald*, 2.2, 96; *Le Héraut*, 2.2 (SC 139, 232): "quin frequenter illis diebus quibus ad vivifica alimenta corporis et sanguinis tui accederem, visibili praesentia tua me dignareris. . . ."

167. *Herald*, 3.30, 200, emphasis added; *Le Héraut*, 3.30 (SC 143, 154): "Amor facit placentiam."

4 : "ADORNED WITH WOUNDS"

Saint Bonaventure's Legenda maior *and the Franciscan Art of Poverty*

Prima imago est quasi sculpta, secunda colorata, tertia irradiata.
—St. Bonaventure

His very marrow burned with love for the sacrament of the Lord's Body.
—*Legenda Maior*

For St. Bonaventure (1221–1274), the stigmatization of St. Francis of Assisi (1182–1226) gave new meaning to the Augustinian question of the beauty of *Christus deformis*—so much so that the "unprecedented miracle,"[1] whereby the wounds of Christ were imprinted on the hands, feet, and side of the *Poverello,* became a key that unlocked the beauty of the universe and brought into relief the artistic pattern and providential design of history. Identifying original sin with concupiscence or covetousness in its various forms, Bonaventure discovered a remedy for the restoration of the world's microcosmic and macrocosmic beauty in a Franciscan poverty that extended itself to the complete embrace of the Crucified and thus to Communion with the self-emptying Lord of the Eucharist. Even as the stigmata sealed the union of Francis with Christ in body and soul, the Eucharist made it possible for others to share in that same harmony (*convenientia*), proportionality, and light (*claritas*).

The importance of an all-pervasive aesthetic in the philosophy of St. Bonaventure has long been recognized,[2] but theologians and scholars of spirituality have

1. *Bonaventure: The Soul's Journey into God, The Tree of Life, The Life of Francis,* trans. Ewert Cousins (New York: Paulist Press, 1978), 323. I use this translation throughout, hereafter citing quotations from *The Life of St. Francis* (*Legenda maior*) parenthetically by page. I do not, however, preserve Cousins's experimental division into sense lines. For the Augustinian locus classicus for the *Christus deformis,* see "Sermo XXVII," 6, PL 38, col. 181. The Latin text of the *Legenda maior* is found in Bonaventure's *Opera omnia,* 8:504–49. For Bonaventure's works I use the ten volumes of the Quaracchi edition, *Doctoris Seraphici S. Bonaventurae opera omnia,* edita studio et cura Collegii a S. Bonaventura, ad plurimos codices mss. emendata, anecdotis aucta, prolegomenis scholiis notisque illustrata, 10 vols. (Quaracchi, Italy: Collegium S. Bonaventurae, 1882–1902).

2. See Sister Emma Jane Marie Spargo, *The Category of the Aesthetic in the Philosophy of Saint Bonaventure,* Franciscan Institute Publications 11 (Saint Bonaventure, NY: Franciscan Institute, 1953); Edgar de Bruyne, *Études d'Esthétique Médiévale* (Brugge: "De Tempel" Tempelhof, 1946), vol. 3, esp. 191–99.

been slow to follow the lead of Hans Urs von Balthasar in probing the related questions of a theological aesthetic and a mystical "via pulchritudinis" (way of beauty) in Bonaventure's writings.[3] The most promising place to begin such a study is Bonaventure's *Long Life of Saint Francis* (*Legenda maior*). A work of art that has inspired countless other artworks, the *Legenda*, long disparaged by historians and regarded suspiciously by political analysts,[4] is now increasingly recognized (in the words of Richard K. Emmerson and Ronald B. Herzman) as "one of the significant artistic achievements" of the Middle Ages, "both because of the saint who is its subject and the saint who is its author."[5] In the *Legenda maior*, as Sister Emma Jane Marie Spargo suggested long ago, "the artistic soul of Saint Bonaventure was endeavoring to give to the reader some share in the extraordinary beauty he perceived in a soul penetrated with divine grace."[6]

In this chapter I argue, first of all, that St. Bonaventure's verbal image of St. Francis in the *Legenda*, meant to be impressed meditatively on the imagination, is comparable to iconic representations of him in visual art. Second that the artis-

3. Hans Urs von Balthasar, *The Glory of the Lord: A Theological Aesthetics*, trans. Erasmo Leiva-Merikakis and ed. Joseph Fessio, S.J., and John Riches (San Francisco: Ignatius Press; New York: Crossroad, 1983–1991), 3:260–362.

4. See Paul Sabatier, *Life of St. Francis of Assisi*, trans. Louise Seymour Houghton (New York: Scribner's, 1894). As Lawrence Cunningham notes, "The polemical character of the earliest Franciscan writings is a problem recognized even in the earliest days of the Franciscan movement" ("Recent Franciscana: A Survey," *Spiritus* 3.2 [2003]: 264). Bonaventure's *Legenda maior* was approved as the official Life of St. Francis in 1266, and previously written Lives were suppressed. At issue is the political motivation of the *Legenda maior* in the quarrel between the Spiritual and the Conventual Franciscans. On this quarrel see David Burr, *The Spiritual Franciscans: From Protest to Persecution in the Century after Saint Francis* (University Park: Pennsylvania State University Press, 2001). Answering to the fraternal strife between the two Franciscan groups, the peace-making Bonaventure seeks to reconcile the Spirituals and the Conventuals through the devotional construction of a beautiful monument to St. Francis in the *Legenda*, which gives structural emphasis to charity as Francis's greatest virtue. In the *Legenda maior*, Bonaventure gives new "life" on earth to the saint through writing his "Life," out of gratitude to his father Francis, through whose intercession Bonaventure's own life was saved from a life-threatening, childhood illness (prologue, trans. Cousins, 182). On a possible analogy between such a reconciliatory hagiography and the tomb-building for prophets, see René Girard, *Things Hidden since the Foundation of the World*, trans. Stephen Bann and Michael Metteer (Stanford: Stanford University Press, 1987), 163–67. What is certain is that the image of St. Francis that emerges from the *Legenda* accords with St. Bonaventure's own mystical experience. Paradoxically the failure of the *Legenda maior* to produce harmony in the larger Franciscan community argues precisely for its truth to St. Francis (and to its author, St. Bonaventure) and against its depiction of Francis as mythic (in the Girardian sense of that adjective). Like the Christ of the Gospels, the Francis of the *Legenda* is and remains a "sign of contradiction" (Luke 2:34–35).

5. Richard K. Emmerson and Ronald B. Herzman, "The *Legenda maior*: Bonaventure's Apocalyptic Francis," chap. 2 in *The Apocalyptic Imagination in Medieval Literature* (Philadelphia: University of Pennsylvania Press, 1992), 41.

6. Spargo, *Category of the Aesthetic*, 86.

tic structure of the *Legenda* as a composition is intended to lead the reader into a series of scriptural meditations and applications that had been formative for Francis.[7] Third that the ordered process of that meditation corresponds in its succession of topics to the different stages in Francis's spiritual development, which Bonaventure understands as a divine work of beatification and beautification. The stigmata and holy death of Francis seal the saint's life as Christ's own artistic masterpiece, an artwork that Bonaventure's *Long Life of Saint Francis* imitates and presents, in turn, as a model for imitation. Fourth that a series of eucharistic allusions gives unity and coherence to the *Legenda* as a whole, pointing to the Eucharist as the source of Francis's own *integritas* in the life of the Beatitudes, in his reception of the stigmata, and in the glorification of his body and soul.

<div style="text-align:center">———</div>

Icons, Relics, and the Image of Francis in the *Legenda Maior*

In the midst of a Trinitarian discussion in his commentary on the *Sentences,* Bonaventure uses the example of an icon of St. Nicholas to explain that unlike the *honor* paid to an image or picture, which is referred to its prototype (in this case, St. Nicholas as an image of God) and not to the icon itself, *beauty* belongs to them both, that is, to the image itself and not just to the one who is portrayed: "nihilominus est in imago pulchritudo, non solum in eo cuius est imago."[8] Bonaventure's *Long Life of St. Francis* may be regarded as such an icon, consciously crafted as a work of beauty in honor of the saint whom Bonaventure regarded as God's artistic masterpiece.

This assertion rests on several grounds, some more obvious than others. First of all the *Legenda* as a narrative serves some of the same functions Boniface attributes to visual, religious artwork: it instructs by concrete examples, it stirs pious affects, and it provides the imagination with a wealth of memorable images.[9] Rona Goffen does not hesitate to say that the early Lives of Francis were consciously fashioned as a series of scenes to be represented later by artists in a variety of media: "Both Celano and Bonaventure very likely had in mind the eventual translation of their texts into the visual language of murals, stained glass, and altar pieces."[10] In addition, as John V. Fleming rightly notes, "the *Legenda Maior* has

7. Unless otherwise indicated I use the Douay-Challoner version of the Holy Bible, ed. John P. O'Connell (Chicago: Catholic Press, 1950).

8. *1 Sent.,* dist. 31, p. 2, art. 1, q. 3, in *Opera omnia,* 1:544b.

9. *3 Sent.,* dist. 9, art. 1, q. 2, in *Opera omnia,* 3:203b.

10. Rona Goffen, *Spirituality in Conflict: Saint Francis and Giotto's Bardi Chapel* (University Park: Pennsylvania State University Press, 1988), 24.

certain special literary qualities" that make it "particularly useful to painters who might seek to relate narrative themes to a large emblematic significance, for its own heuristic principals are . . . allegorical and theological."[11]

Second the *Legenda* points to sacred images and relics in such a way that it becomes a kind of verbal reliquary, encasing or framing them. Bonaventure suggests this in the prologue, declaring that he has "*gather[ed] together* the accounts of [Francis's] virtues like so many *fragments . . . so that they may not be lost* (John 6:12)" (182–83). The contemporary accounts of reliable witnesses preserve Francis's own words as eucharistic fragments of bread, as relics left behind, and these words in turn appear as quotations in Bonaventure's text.[12] A special example of this kind of verbal relic, cited by Bonaventure, is the paper given to Brother Leo by Francis on which the saint had written the *Praises of God* and the Aaronic blessing (Num. 6:24–26), signed with a Tau cross, as a keepsake for his disciple: "The writing was preserved and, since it later worked miracles, it became a witness to the power of Francis" (287).[13]

Visual relics similarly appear within the *Legenda* through Bonaventure's description of them. The reader sees Francis, for example, prostrate before the crucifix at San Damiano from which Christ addressed him with the words, "Francis, go and repair my house" (191). A sacramental of Christ, the crucifix becomes a relic of Francis, a tangible "leaving behind" of his experience. Similarly the reader envisions the historic crib scene at Greccio, contemplates the Christ Child with Francis, and learns that the very "hay from the crib was kept by the people and mysteriously cured sick animals" (279). At the request of Francis, the neglected relics of an anonymous saint—"very beautiful and fragrant bones" (235)—are transported miraculously to an altar where the friars celebrate the Eucharist. In Francis's own life, Goffen remarks, "the saint's direct and pious confrontation with holy images [and relics] was splendidly rewarded by the manifestation of the divine," so that Francis's personal reverence for such sacramentals became an "inspiring example" later for the faithful's veneration, in turn, of him.

Important in the *Legenda maior* are the icons of St. Francis, depicted with the stigmata, through which the saint worked posthumous miracles.[14] Such images

11. John V. Fleming, *From Boniface to Bellini: An Essay in Franciscan Exegesis* (Princeton, NJ: Princeton University Press, 1982), 18.

12. On the Eucharist as a relic, see G. J. C. Snoek, *Medieval Piety from Relics to the Eucharist: A Process of Mutual Interaction* (Leiden: E. J. Brill, 1995). Snoek calls attention to the "transposition of forms of reverence" in reliquaries and monstrances; the "similarities in miraculous power" between the Host and relics; and the "parallel application in actual use" (3).

13. On this relic see Reginald Balfour, *The Seraphic Keepsake* (London: Burns and Oates, 1944).

14. The *Legenda* includes accounts of two miracles that involved images of St. Francis showing the stigmata. In the first a noble woman in Rome owns a picture of Francis that shows him without the stigmata. When the artistic representation causes her to doubt in the saint's stigma-

were so common, Hans Belting asserts, that "the cult of St. Francis of Assisi was
. . . spread not by relics but by icons, before which even miracles occurred, just as
they had before relics."[15] Goffen too compares the iconic images of St. Francis to
relics and calls them "essential for the 'techniques of the faith.'"[16]

Bonaventure's *Legenda* aims at presenting to the reader an iconic life of Fran-
cis that brings the image of the love-worthy saint so vividly before the mind's eye
of the devout reader that the miracle of a spiritual transformation into Francis,
and through him into Christ, can occur. For the *Legenda* to possess such efficacy
it must be beautiful (like the previously mentioned icon of St. Nicholas) in the
sense that it "represents well him of whom it is an image": "imago dicitur pulcra
. . . quando bene repraesentat illum, ad quem est."[17] Only the artist's inspired,
contemplative insight into the saint's spiritual beauty allows for a harmony be-
tween the beauty of the image in itself and that of its prototype.

Bonaventure claims in his *Itinerarium mentis in Deum* (*The Soul's Journey into
God*) to have come to such an insight in October 1259, shortly before he was com-
missioned to write the *Legenda*. Withdrawing "under divine impulse" to Mount
La Verna, "seeking a place of quiet and desiring to find there peace of spirit,"
Bonaventure considered "the miracle which had occurred to blessed Francis in
[that] very place: the vision of a winged Seraph in the form of the Crucified."[18]
Bonaventure suddenly understands the vision to be a symbol representing "our
father's rapture in contemplation and the road by which this rapture is reached."[19]
The *Itinerarium* accordingly presents "six stages of illumination," corresponding
to the "six wings of the Seraph," whereby "the soul can pass to peace through
ecstatic elevations of Christian wisdom."[20] That path leads nowhere else but

tization, the picture is miraculously altered to show his wounds. In the second a cleric named
Roger sees an icon of Francis depicting the sacred wounds, entertains doubts, and then is mirac-
ulously wounded himself in his hands and feet until he professes his faith and Francis heals him.
See Bonaventure, *Opera omnia*, 8:550b–551.

15. Hans Belting, *Likeness and Presence: A History of the Image before the Era of Art*, trans. Ed-
mund Jephcott (Chicago: University of Chicago Press, 1994), 308. In the Franciscan tradition the
distinction between artistic image and relic is conspicuously blurred. Giovanni Morello and Lau-
rence B. Kanter note two famous examples: a picture in the Basilica of Assisi that "was reported
painted on the very board on which Francis's corpse was washed," and "a panel by the Master of
Saint Francis in Santa Maria degli Angeli, which bears an inscription recording that it was painted
on his deathbed" (*The Treasury of Saint Francis of Assisi*, ed. Giovanni Morello and Laurence B.
Kanter [Milan: Electa, 1999], 29).

16. Goffen, *Spirituality in Conflict*, 13.

17. *1 Sent.*, dist. 31, p. 2, art. 1, q. 3, in *Opera omnia*, 1:544b.

18. *Bonaventure*, trans. Cousins, prologue, 54; *Itinerarium mentis in Deum*, in *Opera omnia*,
5:295.

19. Ibid.

20. Ibid.

"through the burning love of the Crucified," the love that transformed Paul (Gal. 2:20) and Francis into Christ.[21]

The *Itinerarium* and the *Legenda,* as scholars have long recognized, provide a kind of commentary on each other.[22] The six stages of illumination in the *Itinerarium* are symbolically cited, for instance, in the six appearances of the cross in Francis's life prior to his reception of the stigmata. The two works differ, however, in literary genre and thus in their specific beauty for, as Bonaventure himself emphasized, "everything is beautiful according to its own genus."[23] The *Legenda* depicts the actual life of Francis and thus guides the reader to him in such a way that the beauty of the saint himself determines the beauty of the biography through a theo-aesthetic correspondence.

The *Forma* of Francis

In the introduction to his translation of the *Legenda maior,* Ewert Cousins asserts, "The spirituality of Bonaventure's biography can best be seen through its structure" (42). The statement astonishes in its simplicity and profundity. It gives reason to pause. What does it mean to say that a "biography" has "spirituality," a spirituality that is revealed through its "structure"? The statement both asserts and assumes an essential link between Bonaventure's spirituality and that of the biography he authors. That authorial, expressive spirituality, in turn, represents and participates in the original spirituality of St. Francis himself, the biography's subject. What Cousins implies is that spirituality becomes visible in a holistic form of life—a distinctive way of thinking, living, and loving—that is analogous to the literary structure that expresses and represents it and with which it corresponds.

The English word *structure* is often used to translate the Latin word *forma,* which is the root of the noun *formositas,* meaning "beauty." Bonaventure draws upon that etymology to argue for beauty as one of the four Transcendentals or Universals of Being (unity, truth, goodness, and beauty), on the grounds that every creature—by reason of its very existence—necessarily has form, and hence beauty.[24] The form of a thing, according to Bonaventure, can be understood in

21. Ibid.

22. The same may be said, of course, of the *Legenda maior* and the *Collationes in hexaemeron,* where Bonaventure identifies Francis with the Angel of the Sixth Seal (Revelation 7:2) and the seraphic order of contemplatives. See *Coll. in hexaem.,* 16.16 and 22.22, in *Opera omnia,* 5:405b, 440b–441a.

23. *Coll. in hexaem.,* 14.4, in *Opera omnia,* 5:393b.

24. See Spargo, *Category of the Aesthetic,* 38; 2 *Sent.,* dist. 34, art. 2, q. 3, in *Opera omnia,* 2:814.

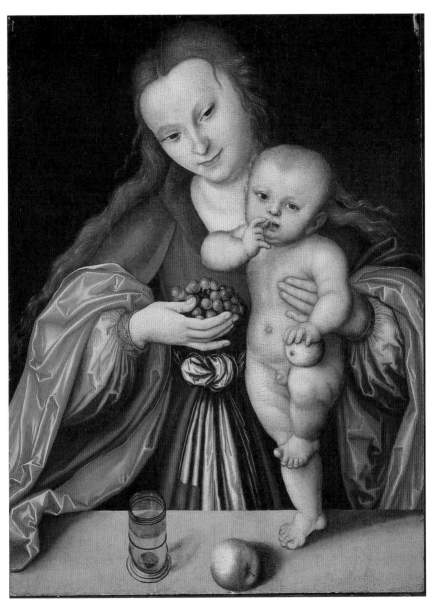

PLATE 1. Lucas Cranach the Elder, *Madonna and Child*, ca. 1535.

PLATE 2. Berthold Furtmeyr, *Eva und Maria*, ca. 1481.

PLATE 3. Salvador Dalí, *The Sacrament of the Last Supper*, 1955.

PLATE 4. Mary A. Zore, *Bread of Angels Mandala*, 2002.

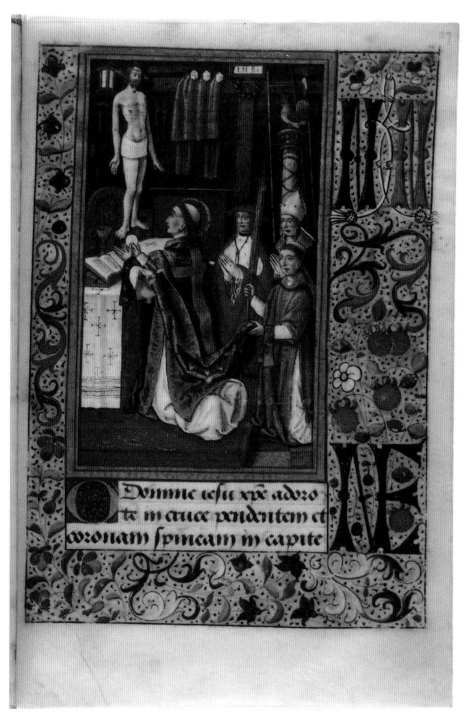

PLATE 5. *Vision of Saint Bernard during Mass*, late fifteenth century.

PLATE 6. *Pater Noster Table*, ca. 1400.

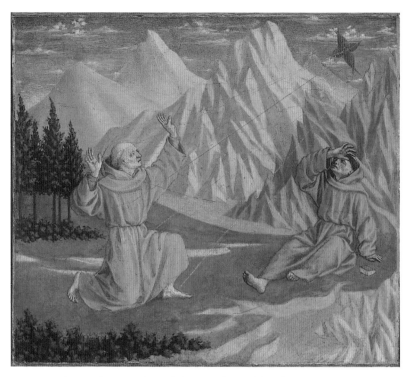

PLATE 7. Domenico Veneziano, *Saint Francis Receiving the Stigmata*, ca. 1445.

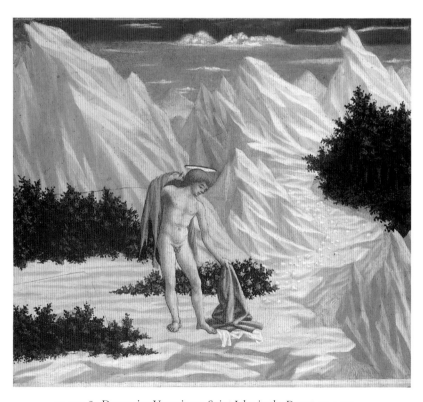

PLATE 8. Domenico Veneziano, *Saint John in the Desert*, ca. 1445.

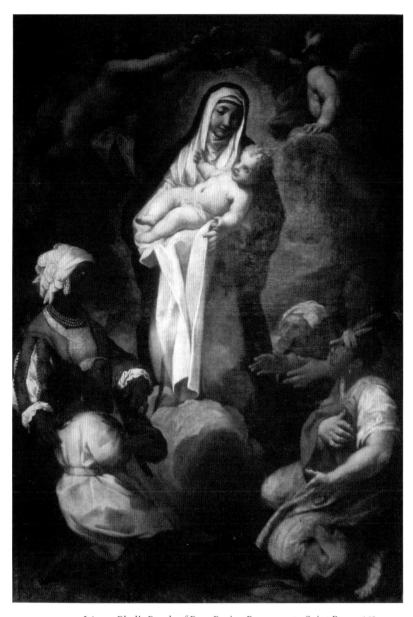

PLATE 9. Lázara Bladi, *People of Peru Paying Reverence to Saint Rose*, 1668.

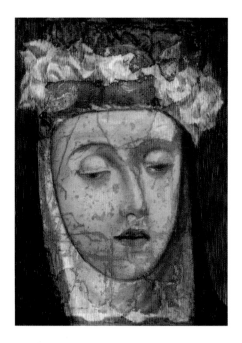

PLATE 10.
Angelino Medoro,
Santa Rosa, 1617.

PLATE 11.
Michelangelo, Florentine
Pietà, ca. 1552.

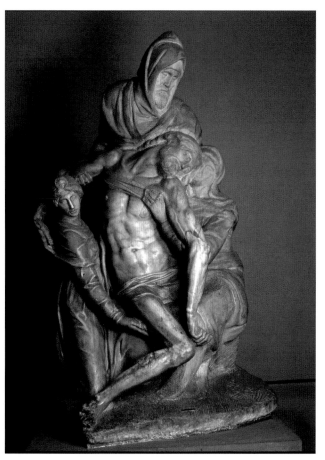

three ways: (1) as its perfection or end; (2) as its exemplar, model, or paradigm; and (3) as its outward appearance or likeness (*species*).[25] The substantial form of a thing unites its essence, nature, and *species,* and its beauty consists in that harmonious unity of expression.[26]

Form, like beauty, entails order and arrangement, whether that structure is synchronic and hierarchical (as in a picture) or diachronic (as in a song, poem, or narrative).[27] Such a claim has enormous theo-aesthetic implications for Christian spirituality, because Christian living conforms itself to the Gospels and, in one way or another, takes the person of Christ as its "form of life." "When it is achieved," Balthasar writes, "Christian form is the most beautiful thing that can be found in the human realm. The simple Christian knows this as he loves his saints among other reasons because the resplendent image of their life is so loveworthy and engaging. But *the spiritual force necessary to have an eye for a saint's life is by no means to be taken for granted.*"[28]

If the "spirituality" of Francis as reflected in Bonaventure's can be seen in the "structure" of the *Legenda maior,* how may that structure be perceived and described? Given the organic wholeness of Bonaventure's system of thought, his fourfold, exegetical *habitus,* and his predilection for the celestial hierarchies of Pseudo-Dionysius, one may describe the *Legenda*'s structure, too, as polysemous and figural.[29] Arranged in a hierarchy, its matter at each level corresponds in structure to that at the next, the complex *convenientia* (coming together) of horizontal and vertical parts forming the beauty of the whole. Bonaventure signals the allegorical arrangement when he admits, "I did not *always* weave the story together in chronological order" (183, emphasis added). The conspicuous violations of chronology constitute gaps that require the reader to discover a hidden meaning or connection at a higher level of interpretation.[30] Bonaventure gives priority, in fact, to a thematic arrangement of his historical material, "relating to the same theme events that happened at different times and to different themes events that happened at the same time" (183).

25. *4 Sent.,* dist. 1, p. 1 Dubia, in *Opera omnia,* 4:29a.

26. *I Sent.,* dist. 31, p. 2, Dubia 5, in *Opera omnia,* 1:551a.

27. See Spargo, *Category of the Aesthetic,* 55–57.

28. Balthsar, *Glory of the Lord,* 1:28. Emphasis added.

29. Dutch Franciscans Edith van de Goorbergh and Theodore Zweerman have argued that Francis's own writings—the *Admonitions* in particular—have a highly symbolic, numerically based, architectural structure. See their *Respectfully Yours: Signed and Sealed, Francis of Assisi* (Saint Bonaventure, NY: Franciscan Institute, 2001).

30. For discussions of allegorical modes of composition and interpretation, see Ann W. Astell, *The Song of Songs in the Middle Ages* (Ithaca: Cornell University Press, 1990); *Job, Boethius, and Epic Truth* (Ithaca: Cornell University Press, 1994); *Chaucer and the Universe of Learning* (Ithaca: Cornell University Press, 1996); *Political Allegory in Late Medieval England* (Ithaca: Cornell University Press, 1999).

In their discussions of the structure, scholars have generally opposed the chronological arrangement to the thematic. Cousins sees a chronological frame in chapters 1 through 4 and in chapters 13 through 15, respectively. This fairly straightforward history of Francis's life, he opines, surrounds "the core of the treatise, nine chapters on the virtues which are organized according to themes" (43). These nine chapters are subdivided, in turn, into three groups of three, corresponding to the stages of mystic purgation, illumination, and perfection. In order to maintain this symmetry, Cousins must count chapter 13 ("On the Sacred Stigmata") twice, arguing that it constitutes a point of overlap between the thematic and the chronological orderings. Emmerson and Herzman depart slightly from Cousins, maintaining that numbers were important to Bonaventure (as they were to Augustine), and that Bonaventure gives seven "chronological" chapters in the outer frame and eight "thematic" ones in the center in order to symbolize the conjunction of temporality, on the one hand, with eternity and timelessness, on the other.[31] Bernard McGinn builds upon Emmerson and Herzman to argue that "Francis's exemplarity" in Bonaventure's *Legenda maior* "has both a vertical [Dionysian] and a horizontal [Joachite] pole," the "vertical pole centering on the conception of Francis as the *vir hierarchicus* or *vir angelicus*" (represented in the eight chapters on the virtues) and the "horizontal or historical pole" (represented in the chronological frame, which gives apocalyptic expression to "Bonaventure's Joachite theology of history").[32]

The *Pater Noster*, the Beatitudes, and the Form of Francis's Life

Without wanting to dispute these characterizations of the literal structure, I would like to propose two additional schemes: the first, biblical and exegetical; the second, homiletic. I begin with the first, according to which the seven "chronological" chapters that frame the chapters on the virtues are also "thematic." Indeed, as shown in the figure, they take as their *forma tractatus* or embedded outline the seven petitions of the Lord's Prayer, whereas the eight chapters on the virtues are inspired by the eight Beatitudes.

31. Emmerson and Herzman, "The *Legenda maior*: Bonaventure's Apocalyptic Francis," in *The Apocalyptic Imagination in Medieval Literature*, 54–55.

32. Bernard McGinn, *The Presence of God: A History of Western Christian Mysticism*, vol. 3, *The Flowering of Mysticism: Men and Women in the New Mysticism—1200–1350* (New York: Crossroad Press, 1998), 94. The standard study of Bonaventure's view of history is Joseph Ratzinger's *The Theology of History in Bonaventure*, trans. Zachary Hayes (Chicago: Franciscan Herald Press, 1971).

The Outer Life (The Petitions of the Pater Noster)	The Life of Virtues (The Beatitudes)	The Outer Life (The Petitions of the Pater Noster)
Chapter 1 On his manner of life while in secular attire. "Our Father, who art in Heaven, Hallowed be thy name" (Matt. 6:9) "There was a man in the town of Assisi, Francis by name . . ."	**Chapter 5** On the austerity of his life and how the creatures provided him comfort. "Blessed are those who mourn, for they shall be comforted." (Matt. 5:4)	
Chapter 2 On his perfect conversion to God and his restoration of three churches. "Thy kingdom come." (Matt. 6:10)	**Chapter 6** On his humility and obedience and God's condescension to his slightest wish. "Blessed are the meek, for they shall inherit the earth." (Matt. 5:5)	
Chapter 3 On the foundation of the Order and the approval of the Rule. "Thy will be done on earth as it is in heaven." (Matt. 6:10)	**Chapter 7** On his love of poverty and the miraculous fulfillment of his needs. "Blessed are the poor in spirit, for theirs is the kingdom of heaven. (Matt. 5:3)	
Chapter 4 On the progress of the Order under his hand and the confirmation of the Rule. "Give us this day our daily bread." (Matt. 6:11)	**Chapter 8** On his affectionate piety and how irrational creatures were affectionate toward him. "Blessed are the peacemakers, for they shall be called sons of God." (Matt. 5:9)	
	Chapter 9 On the fervor of his charity and his desire for martyrdom. "Blessed are those who are persecuted for righteousness' sake, for theirs is the kingdom of heaven." (Matt. 5:10)	
	Chapter 10 On his zeal for prayer and the power of his prayer. "Blessed are those who hunger and thirst for righteousness, for they shall be satisfied." (Matt. 5:6)	**Chapter 13** On his sacred stigmata. "And forgive us our debts, as we also have forgiven our debtors." (Matt. 6:12)
	Chapter 11 On his understanding of Scripture and his power of prophecy. "Blessed are the pure in heart, for they shall see God." (Matt. 5:8)	**Chapter 14** On his patience and his passing in death. "Lead us not into temptation." (Matt. 6:13)
	Chapter 12 On the efficacy of his preaching and his grace of healing. "Blessed are the merciful, for they shall obtain mercy." (Matt. 5:7)	**Chapter 15** On his canonization and the solemn transferal of his body. "But deliver us from evil." (Matt. 6:13)

Saint Bonaventure's *Long Life of Saint Francis*

Using the theme of the *Pater Noster* allows Bonaventure to identify with Francis himself who, at the hour when his natural father publicly disowned him, declared, "'Until now I have called you father on earth, but now I can say without reservation *Our Father who art in heaven* (Matt. 6:9), since I have placed all my treasure and hope in him'" (194). It enables him, too, to obey the words of Christ and of Francis, who told his friars: "When you pray, say 'Our Father . . .' (Luke 11:2)" (208). Finally it challenges the reader to meditate prayerfully on Francis's life—indeed, to see it as a constant prayer—and to understand its temporal events from an eternal perspective.

Viewed under the headings of the verses of the *Pater Noster,* the seven chapters acquire a new, thematic depth. Chapter 1 points to God's fathering of Francis and the hallowing of God's name in the "name" of Francis, "whose memory is held in benediction because God in his generosity foreordained goodly blessings for him" (185). Chapter 2 celebrates the coming of God's Kingdom ("Thy Kingdom come") in Francis's obedient restoration of three churches and his acceptance of God as his only Father. Chapter 3 reflects on the fulfillment of God's will ("Thy will be done") in Francis's response to "the Gospel . . . in which Christ sends forth his disciples to preach and explains to them the way of life according to the Gospel" (199).

Chapter 4 takes as its theme the giving of "daily bread" in the formulation and confirmation of the Rule. The chapter begins with the friars' mysterious encounter with a man who "appeared carrying bread in his hand, which he gave to Christ's little poor and then suddenly disappeared" (207). Near the end of the chapter, Francis sees a vision in which he first feeds "many hungry friars" with "tiny bread crumbs" and then forms "one host out of all the crumbs" (216). The next morning he awakes to hear a voice from heaven that tells him, "Francis, the crumbs of last night are the words of the Gospel, the host is the rule" (216). Bonaventure then deftly links this eucharistic episode to what follows, drawing a parallel between Pope Honorius's approval of the Rule, rewritten by Francis on the holy mountain, and the imprinting of the stigmata on the body of Francis "by the finger of the *Living God* [Rev. 7:2]" (p. 217). Indeed he virtually identifies the two. Even as the Rule of the Order is the Gospel itself as it was perfectly embodied by Francis, the body of Francis literally becomes the body of Christ, marked with His wounds. The pope's sealing of the Rule is confirmed by Christ's seal on Francis.

At this point, after the fourth chapter and the fourth, eucharistic petition of the Lord's Prayer, the exposition of Francis's virtues in the middle section of the *Legenda maior* begins. The depiction of Francis as a lawgiver on Mount La Verna recalls both Moses receiving the commandments on Mount Sinai (Exod. 24:15– 31:18) and Christ delivering the Sermon on the Mount, which begins in St.

Matthew's Gospel with the proclamation of the Beatitudes (Matt. 5:1–12). The eight Beatitudes, combined with the two great commandments of the love of God and neighbor (Matt. 22:36–40), were understood as a restatement in the New Testament of the commandments of the Old. The transition into the eight chapters paralleling the eight beatitudes is, therefore, literally abrupt, but thematically smooth, once the "thematic" character of the "chronological" frame has been recognized.

Exegetes regularly drew parallels between and among the seven petitions of the *Pater Noster*, the Beatitudes, the seven virtues (that is, the four cardinal virtues of prudence, temperance, fortitude, and justice, plus the three theological virtues of faith, hope, and charity), and the seven gifts of the Holy Spirit (the fear of the Lord, piety, fortitude, knowledge, understanding, counsel, and wisdom). As a catechetical illustration of this tradition, the Vernon Manuscript, housed in the Bodleian Library, features a magnificent, gridlike diagram (plate 6) in parallel columns, which list the seven petitions of the *Pater Noster*, the seven gifts of the Holy Spirit, the seven virtues, and their contrary vices.[33] Four extra columns provide what Avril Henry calls "the connective tissue of the main elements" in a formulaic equation: "Þis preier (petition) leduþ a man to (a gift of the Spirit) leduþ a man to (a virtue) is aȝenst (a vice)."[34]

Bonaventure's great teacher, St. Augustine, may be credited with initiating this exegetical tradition in his commentary on the Sermon on the Mount. There he discovers a mystical and aesthetic congruence between and among the various sets of seven.[35] (Augustine reduces the eight beatitudes to seven, explaining that the first and eighth both promise "the kingdom of heaven" as a reward; the eighth beatitude, there, signals the perfection of the previous seven, as does the concluding note in a musical octave in its matching of the first tone.)[36]

In his study of the *Pater Noster* table in the Vernon Manuscript (late fourteenth century), Henry has traced the use and development of the Augustinian scheme from the time of the fathers through the Middle Ages. If I am correct in my analysis, Bonaventure's *Legenda maior*, among his other writings, confirms Henry's observation of frequent variations in the way the petitions, beatitudes, and virtues were correlated. Calling these variations "of particular interest," Henry writes, "They show that loose connections between the various concepts were accept-

33. I thank the curator of the Bodleian Library in Oxford, England, for permission to reproduce this image.

34. Avril Henry, "'The Pater Noster in a table ypeynted' and Some Other Presentations of Doctrine in the Vernon Manuscript," in *Studies in the Vernon Manuscript,* ed. Derek Pearsall (London: D. S. Brewer, 1990), 90.

35. St. Augustine, "De Sermone Domini II," in *De Sermone Domini in Monte Libros Duos,* ed. Almut Mutzenbecker, CCSL 34 (Turnhout: Brepols, 1968), 11:38, 128–30.

36. Ibid., "De Sermone Domini I," in *De Sermone Domini in Monte Libros Duos,* 3.10, 9.

able, and that familiar patterns were often modified."[37] In the *Breviloquium* Bonaventure concludes his discussion of the Lord's Prayer by sketching a "seven-fold set of sevenfolds": "the capital sins, the sacraments, the virtues, the gifts, the beatitudes, the petitions, and the dowries of glory."[38] In the *Legenda maior*, Bonaventure, like Primasius Adrumetanus (sixth century) before him, goes fur-ther, suggestively relating the "sevenness" of the Lord's Sermon not only to the beatitudes and the virtues, but also to the apocalyptic seven seals through his ex-plicit identification of St. Francis with the Angel of the Sixth Seal (Rev. 7:2).[39] Bonaventure also employs an order of explicit virtues (and veiled beatitudes) that differs somewhat from Augustine's scheme, while nonetheless evoking it.

What dictates these observable variations is Bonaventure's desire (1) to con-figure Francis's virtues (as Cousins suggests) to the threefold, Dionysian scheme of mystical ascent: purgation, illumination, and perfection and to his own, more complicated, fourfold scheme of reformation, transformation, expression, and expressivity; and (2) to highlight at every stage the inseparability of the Beatitudes from the holiness of *beatus Franciscus*. The *Legenda maior*, in fact, illustrates the singularly important position occupied by the Beatitudes in Bonaventure's mys-tical theology. In the *Breviloquium* Bonaventure explains that since the "restora-tive principle" of grace has sanctity or beatitude as its final cause, "the gift of grace . . . ought to be divided into habits of perfection" that approximate that same end, namely, the Beatitudes.[40] Because of the "perfection and fitness" of the Beatitudes in themselves, the virtues, the twelve fruits of the Spirit, and the five "spiritual senses" are "added" to them not as additional powers, but as acts or enactments of them.[41] Karl Rahner observes that one consequence of this stance is that "for Bonaventure, in contrast to modern mystical theology, the gifts of the Holy Spirit are of secondary importance," because they are subordinated to the "blessings of beatitude."[42] As Bonaventure asserts, whereas "the habits of the virtues dispose one principally to the active life," and "the habits of the gifts for the quiet of the contemplative way," the "habits of the beatitudes [dispose a person] for the per-fection of them both."[43]

In the *Breviloquium* Bonaventure explicitly correlates the beatitudes with the

37. Henry, "'The Pater Noster in a table ypeynted' and Some Other Presentations of Doctrine in the Vernon Manuscript," 99.

38. St. Bonaventure, *Breviloquium*, trans. Erwin Esser Nemmers (London: B. Herder, 1947), 5.10, 171; *Opera omnia*, 5:264b. Subsequent page references to *Breviloquium* are to this translation.

39. For references to the angel of the seal, see *The Life of St. Francis*, in *Bonaventure*, trans. Cousins, 181, 314.

40. *Breviloquium*, 5.6, 157; *Opera omnia*, 5:258b.

41. Ibid.

42. Karl Rahner, S.J., "The Doctrine of the 'Spiritual Senses' in the Middle Ages," in *Theologi-cal Investigations 16*, trans. David Morland, O.S.B. (New York: Crossroad, 1979), 112.

43. *Breviloquium*, 5.6, 159; *Opera omnia*, 5:259b.

threefold way of perfection. "For the fullness of perfection," he writes, "a complete withdrawal from evil is necessarily required, then a perfect progression in good and a perfect repose in the best."[44] Since evil proceeds "either from the swelling of pride, from the rancor of malice, or from the languor of concupiscence, three beatitudes are necessary" at the purgative stage: namely, poverty of spirit, meekness, and mourning.[45]

The *Legenda* conforms to this pattern. Chapter 5, the first of the eight chapters on the virtues, deals with Francis's practice of mortification, his fear of the Lord in avoiding sensual and sexual temptation, and his initial pursuit of holiness. It may be correlated to the beatitude, "Blessed are they who mourn" (Matt. 5:5), for it represents his death to the world and "how creatures provided him comfort" (218). Chapter 6 deals with Francis's humility and obedience; it illustrates the beatitude, "Blessed are the meek, for they shall possess the earth" (Matt. 5:4). Chapter 7 concerns itself with Francis's love of poverty. Bonaventure explicitly correlates it with the Beatitudes when he quotes the words of Francis: "For the Lord is pleased with poverty. . . . This is the royal dignity which the Lord Jesus assumed when he *became poor* for us that he might enrich us by *his poverty* (2 Cor. 8:9) and establish us as heirs and kings of *the kingdom of heaven* if we are truly *poor in spirit* (Matt. 5:3)" (245).

Treating poverty in third position (chastity, obedience, and poverty) instead of the more usual first position (poverty, chastity, obedience) allows Bonaventure to place it in chapter 7, at the very center of Francis's life as recounted in the *Legenda maior*. (The *Legenda* has fifteen chapters in all, but the fifteenth concerns events that occur after Francis's death, which is narrated in chapter 14.) Using this third position in the life of the virtues also permits Bonaventure to make poverty preeminent among the three evangelical counsels and virtues. Bonaventure gives symbolic expression to this virtuous trinity through Francis's mysterious encounter with three poor women. Their sudden appearance to Francis and hailing of Lady Poverty "appropriately showed that the beauty of Gospel perfection, in poverty, chastity, and obedience, shone forth all perfectly equal in the man of God, although he had chosen to glory above all in the privilege of poverty" (244).

Chapters 8 through 10 deal with virtues appropriate to the way of illumination and transformation. Chapter 8 discusses Francis's "affectionate piety" toward his fellow humans and his remarkable kinship with animals—qualities that "symbolically showed a return to the state of original innocence" (250). The childlike harmony illustrated by the chapter shows Francis to be one of the "blessed" who are cosmic "peacemakers" and "children of God" (Matt. 5:9). Chapter 9 takes as its theme Francis's fervent charity, yearning for the Eucharist, and "desire for mar-

44. *Breviloquium*, 5.6, 157; *Opera omnia*, 5:258b.
45. Ibid.

tyrdom"—virtues that can be correlated with the beatitude, "Blessed are they who suffer persecution for justice'[s] sake, for theirs is the kingdom of heaven" (Matt. 5:10). Chapter 10 offers an exposition of Francis's transformative prayer and its effectiveness, qualities that recall the evangelical word, "Blessed are they who hunger and thirst for justice, for they shall be satisfied" (Matt. 5:6).

Chapters 11 and 12 show Francis's attainment of Christian perfection in wisdom and preaching. In the eleventh chapter Bonaventure demonstrates Francis's profound understanding of the sacred scriptures, characterizing it as a way of seeing (insight) that is a fruit of Francis's purity: "Blessed are the clean of heart, for they shall see God" (Matt. 5:8). In the twelfth chapter, Bonaventure depicts Francis's Christlike preaching and healing as an expression of overflowing concern for others: "Blessed are the merciful, for they shall obtain mercy" (Matt. 5:7). The pairing of scriptural understanding with preaching in these two chapters suggests, moreover, Francis's perfection in both the contemplative and active lives.

At this point in the *Legenda maior,* Bonaventure returns to the themes of the Lord's Prayer in the framework of the so-called chronological chapters. He picks up in chapter 13 precisely where he left off at the end of chapter 4, namely, with the account of Francis's reception of the stigmata. This chapter, which unites Francis with the Crucified Jesus in his atoning sacrifice, takes as its prayer the fifth petition of the *Pater Noster:* "And forgive us our debts, as we also forgive our debtors" (Matt. 6:12). Chapter 14 deals with Francis's patience in suffering and his passing away. Here the sixth petition of the Lord's Prayer, "Lead us not into temptation" (Matt. 6:13), gains expression in Francis's dying prophecy: "Temptation and tribulation are coming in the near future, but happy are they who will persevere in what they have begun" (319). Finally chapter 15 describes Francis's glorification in body and soul after death, a passage into eternity that marks both his final deliverance from evil in accord with the seventh petition (Matt. 6:13: "But deliver us from evil") and his posthumous power to deliver others: "For every disease, every need, every danger, he offered a remedy" (327).

Bonaventure's portrayal of Francis in these three chapters of the *Legenda* matches in general outline his discussion of the Lord's Prayer in the *Breviloquium,* where he groups together the last three petitions: "The removal of harmful evil is sought in the three final petitions because all evil clings to us in the past, present, and future, or in other words, we retain traces of the commission of evil, of the battle with evil, or of the punishment for evil."[46] These "traces" are visibly obliterated in Francis by the marks of the sacred wounds.

As the figure shows, the correlation of the seven petitions of the *Pater Noster* with the eight Beatitudes and virtues effects a close thematic relationship between

46. *Breviloquium,* 5.10, 171; *Opera omnia,* 5:264b.

the "outer" (chronological) and "inner" life of St. Francis. It allows for a horizontal reading of the chapters in pairs. Both chapters 1 and 5 narrate the beginning of Francis's life of conversion and his turning from sin, albeit from different perspectives. Chapters 2 and 6 both concern Francis's obedience to God. Chapters 3 and 7 celebrate the Franciscan Rule of poverty and Francis's personal practice of poverty as a virtue and beatitude. Chapters 4 and 8 highlight eucharistic unity in the one Rule and the cosmic peace that was Francis's own in relation to others.

Chapter 9—the chapter explicitly about charity—stands alone, unpaired with any other. As the Pauline sum and perfection of all virtues and the bond between and among them, charity is the eighth virtue (seven plus one) that allows for the matching of the seven other virtues and beatitudes with the seven petitions. In its most radical form as the love for one's enemies, charity overcomes all division. Highlighting the theme of Francis's desire for martyrdom—a desire unfulfilled in his journey to the Orient but granted in the stigmata—chapter 9 neatly bridges the two chapters in the Outer Life (chapters 4 and 13) that refer explicitly to the reception of the stigmata. The numeration is precise. Four plus nine is thirteen, the exact number of the chapter "on his sacred stigmata." As a crossover chapter that effects the logical transition between chapters 4 and 13, chapter 9 encodes the cruciform structure of the *Legenda maior*. Through it Bonaventure points to charity as the outstanding features of Francis's life and as the virtue and beatitude needed to heal all division within the Franciscan family, which was then bitterly divided between Spirituals and Conventuals.

Chapter 13, which recounts Francis's miraculous reception of the wounds of Christ, pairs beautifully with chapter 10, which describes Francis's fervor in prayer. Chapters 11 and 14, when read as a pair, link the *subtilitas* of Francis's understanding of scripture (a penetration of its carnal, literal meaning) with the passage of his soul from his body in death. Chapters 12 and 15 neatly correlate Francis's miracles of healing during his earthly life with those performed posthumously.

When Bonaventure structured the Life of St. Francis as a combined meditation on the *Pater Noster* and the eight Beatitudes, he represented him in the profoundest way possible as a man of the Gospels that he had embraced as his Rule of life. In Francis every scriptural verse had been applied, every word enfleshed. Thus Francis may be identified with Christ, the Incarnate Word of the Father, as He abides in the scriptures and the Eucharist. For Bonaventure that identification was sealed by Christ Himself through the imprinting of His sacred wounds on the body of Francis.

Another *Forma:* Francis as a Fourfold Seal

The imprinting of Francis's body makes it in a special way an artwork carved by Christ, who is Himself (in the preferential vocabulary of Bonaventure) the Incarnate Image, the Beauty (*Species*), and the Art of God.[47] Because the seven appearances of the Cross of Christ all occur in the frame chapters of the Outer Life, scholars have had difficulty relating the core chapters on the virtues thematically to the obvious aesthetic interest of the stigmatization. To facilitate an approach to the beauty of Francis's life (as beheld by Bonaventure) and *Legenda* (as composed by him), I take a side-glance at one of Bonaventure's sermons, preached at Paris on the Feast of St. Francis, October 4, 1266. There Bonaventure, quoting Haggai 2:23 ("I will make you . . . like a signet ring"), describes Francis as a "signaculum *reformatum, transformatum, expressum, expressivum*" (a seal reformed, transformed, imprinted, and dedicated).[48]

This fourfold *distinctio* of seals can easily be applied to the different periods in Francis's spiritual life as Bonaventure structures it in the *Legenda*. The time of reformation during which Francis is refashioned as a seal is addressed in the frame in chapters 1, 2, and 3, and also in the "core" chapters on the purgative virtues (chapters 5 through 7). The stage of transformation appears in chapter 4 in the frame, and in the eucharistic "core" chapters, 8 and 9. The stage of expression, when Francis is imprinted as a seal "through being an example of perfect virtue" is represented in chapter 13 in the frame, as well as in chapter 10 in the core, where Francis is depicted expressing himself in prayer.[49] Finally Francis appears as a dedicatory seal (*signaculum expressivum*), empowered with expressivity, in the concluding chapters, 14 and 15, which are paired with the core chapters on Francis's prophecies (chapter 11) and on his preaching in word and deed (chapter 12). Again see the figure.

An approach to Bonaventure's *Legenda maior* under these sermonic headings has three obvious benefits. It allows us to bring Bonaventure's own aesthetic vocabulary to bear on the language of the *Legenda*. It permits a dialogue between the "chronological" chapters (in the Outer Life) and the exposition in the core chapters of the virtues—a dialogue that is appropriate, due to the congruence of

47. On Bonaventure's use of these terms, see Spargo, *Category of the Aesthetic*, x, 92–107. Bonaventure glosses *Species* as "Beauty" (*Pulchritudo*) and insists that the words *Imago* or *Species* are to be preferred over *Filius* (Son) in naming the Second Person of the Trinity. See *1 Sent.*, dist. 31.2, art. 1, q. 3, in *Opera omnia*, 1:545a.

48. "De S. Patre Nostro Francisco. Sermo I," in *Opera omnia*, 9:575a.

49. "Sermon Three on St. Francis," in *The Disciple and the Master: St. Bonaventure's Sermons on St. Francis of Assisi*, ed. and trans. Eric Doyle, O.F.M. (Chicago: Franciscan Herald, 1983), 101. Notice that Doyle numbers Bonaventure's sermons differently than they appear in *Opera omnia*.

sevens in the petitions and the Beatitudes. Finally it highlights a major theme in the *Long Life* as a whole—namely, the stigmata as a seal upon Francis's entire life as an authoritative, beautiful, and beautifying pattern of living.

1. *Signaculum reformatum*

In the *Breviloquium* Bonaventure explains that God "recreates by reforming through the habit of grace and justice what was deformed through the vice of sin."[50] The aesthetic vocabulary of *forma* suggested to Bonaventure and to other medieval theologians, as it had to the fathers, a wealth of artistic analogies—for example, the cutting away of excess, the bending straight of what has been curved, the removal of coatings of dirt and grime, the filling in of holes, the joining of broken pieces, and the rearrangement of parts.[51] In the *Collations on the Six Days,* for example, Bonaventure likens the divine artistry that shapes in souls a contemplative disposition to the work of a sculptor "who adds nothing to the figure, but rather removes matter, leaving the noble and beautiful form to be found in the stone itself": "qui sculpit figuram nihil ponit, immo removet et in ipso lapide relinquit formam nobilem et pulcram."[52]

Through such analogies Bonaventure and others sought to illustrate a theological aesthetics that defines the state of grace as beauty and sin as ugliness. Quoting Augustine on the topic of the beauty of the universe (*pulchritudo universi*), Bonaventure declares, "Omne peccatum est . . . 'Privatio modi, speciei, et ordinis.'"[53] That is to say, sin is the lack of a sapiential limit, moderation (*modus*), or measure (*mensura*); the lack of a beautiful conformity to one's proper kind (*species*) or number (*numerus*); and the lack of the order (*ordo*) or weight (*pondus*) that orientates one to one's proper end.[54]

Whereas Bonaventure's treatment of the sin of Adam and Eve is complex (that is, inclusive of disobedience, gluttony, avarice, and pride),[55] his understanding of original sin as humanity inherits it is simple. Lacking original justice at concep-

50. *Breviloquium*, 5.3, 148; *Opera omnia*, 5:255a.

51. On this topic as developed by the Fathers, see Gerhart B. Ladner, *The Idea of Reform: Its Impact on Christian Thought and Action in the Age of the Fathers* (Cambridge: Harvard University Press, 1959).

52. *Coll. in hexaem.*, 2.33, in *Opera omnia*, 5:342b. My translation. I thank Peter Casarella for calling this passage to my attention.

53. *2 Sent.*, dist. 32, art. 3, q. 1, in *Opera omnia*, 2:770; quoted in Spargo, *Category of the Aesthetic,* 69.

54. On the parallel between the two triads, *modus-species-ordo* and *mensura-numerus-pondus,* see Spargo, *Category of the Aesthetic,* 125. The biblical locus for the latter triad is Wisdom of Solomon 11:20(21): "But thou hast arranged all things by measure and number and weight."

55. See *2 Sent.*, dist. 32, art. 1, q. 1, in *Opera omnia*, 2:517a.

tion, humans suffer from a fundamental disordering of the innate desire for God which, detached from its proper end, seeks its satisfaction blindly in created things instead of in the Creator. "Original sin is concupiscence," Bonaventure writes in his *Commentary on the Sentences,* "and not just any sort, but precisely that concupiscence that derives from the lack of due justice."[56] Actual sin intensifies this disorder, which affects all the different faculties, inclining them to different forms of covetousness: of the flesh, of the eyes, and finally, that desire for the acquisition of excellence that Bonaventure calls "the pride of life."[57] The tenth commandment, "Thou shalt not covet . . ." (Exod. 20:17, Deut. 5:21) counters this fundamental concupiscence or covetousness, which St. Paul terms "the root of all evils" (I Tim. 6:10).[58]

Given this Augustinian and Franciscan diagnosis, the remedy to be prescribed for the restoration of beauty in the microcosm and macrocosm is obviously the divinely infused and humanly practiced virtue of poverty, by which one desires to be free of the inordinate desire for worldly goods, practices detachment and renunciation, embraces the experience of want and neediness, and emphasizes trust in divine providence. Because it directly opposes avarice, the "root of all evils" (1 Tim. 6:10), Bonaventure declares "poverty of spirit [to be] . . . the foundation of all evangelical perfection."[59]

In the person of St. Francis, St. Bonaventure discovered the proof of this spiritual prescription. Embracing poverty, Francis follows Christ to pioneer a path of return to Eden. In so doing, he conquers the serpent that deceived Adam and Eve (Gen. 3). Chapter 7 of the *Legenda* represents this boldly in a scene where Francis refuses to pick up an apparently full money bag left on his path, declaring it to be "a trick of the devil" (242). When a large snake emerges from it in confirmation of Francis's prophetic knowledge, the saint of Assisi tells the friar accompanying him: "'To the servants of God, brother, money is the very devil and a poisonous snake'" (243).

Francis is for Bonaventure a Christlike, new Adam, the *signaculum reformatum,* a "seal that has been refashioned, made new, through lament and sorrow for

56. *2 Sent.,* dist. 30, art. 2, q. 1, in *Opera omnia,* 2:722b. Translation mine.

57. *Breviloquium,* 5.9, 168; *Opera omnia,* 5:263b.

58. For a modern restatement of this doctrine of covetousness from the anthropological point of view of mimetic theory, see René Girard, *I See Satan Fall Like Lightning,* trans. James G. Williams (Maryknoll, NY: Orbis, 2001), esp. 7–18. For a theological perspective, see Karl Rahner, S.J., "The Theological Concept of Concupiscence," in *Theological Investigations* 1, trans. Cornelius Ernst, O.P. (Baltimore: Helicon, 1961), 347–82. Referring to the longing of the mystics for the gift of integrity, Rahner concludes, "The fact that man never really wholly possesses this collected heartfelt inwardness of his whole life in the ultimate deed of his inmost being is what is really meant by concupiscentia in the theological sense" (374).

59. *Breviloquium,* 5.6, 158; *Opera omnia,* 5:259a. See also *Bonaventure,* trans. Cousins, 241.

the sins of his past life."[60] The *Legenda maior* traces the process of reformation in Francis's life, but it is, in a certain sense, a process that can never end, even after Francis has been completely purified and perfected in virtue, because of Francis's penitential mission as an exemplar of poverty "*to call men to weep and mourn, to shave their heads and to put on sackcloth* [Isa. 22:12]" (181). Specially chosen by God, Francis was from the very beginning a seal, because created in the image of God through the Son (cf. John 1:1–3, 10), who is the Father's own Image, expressed Likeness, and Art.[61] Francis was, moreover, filled "with gifts of heavenly grace" (185) from his childhood, graces that prepared him for the reception of greater gifts later on and that set him apart from his family members, neighbors, and friends. Still he was a seal in need of reforming, because he "was distracted by the external affairs of his father's business and drawn down toward earthly things by the corruption of human nature" (187).

Bonaventure thus sets Francis's merchant father and his coinage both of his son and of worldly wealth in opposition to God's coinage of Francis in his Son's likeness. By calling Francis out of a merchant's family, God vividly teaches the need for one to detach oneself from the pursuit of lucre if one is to be free for God's service. Elsewhere, in a sermon on Matthew 22:20 ("Whose are this image and the inscription?"), Bonaventure likens the soul to a coin, marked with the image of God and belonging to Him for three theo-aesthetic reasons: first of all because God made or sculpted the soul in its first creation ("quia fecit vel sculpsit in creatione"); second because God painted or colored it in the blood of Christ's Passion ("depinxit in passione"); third because he illuminated it in the glory of heaven, transforming it through an infusion of light "a claritate in claritatem" (2 Cor. 3:18).[62]

The sermon is replete with citations of scriptural passages in which the imagery of artwork appears, among them a controlling verse from the book of Sirach containing the word *signaculum:* "'So too is every craftsman [*faber*] and master workman [*architectus*] who labors by night as well as by day; those who cut the signets of seals [*qui sculpit signacula sculptilia*] each is diligent in making a great variety [*variat . . . picturam*]; he sets his heart on painting a life-like image'" (Sirach 38:27).[63] Applied to Christ in Bonaventure's sermon, the verse provides a scriptural gloss for Christ's artistic fashioning of Francis in the *Legenda,*

60. "Sermon Three on St. Francis," in *Disciple and Master,* 101; "De S. Patre Nostro Francisco. Sermo I," in *Opera omnia,* 9:574b.

61. On the Son as the Father's expressed Likeness and Art, see *1 Sent.,* dist. 31, part 2, art. 1, q. 3, in *Opera omnia,* 1:544, and *Coll. in hexaem.,* 1:13, in *Opera omnia,* 5:331; quoted in Spargo, *Category of the Aesthetic,* 98.

62. "Sermo VI. Dominica XXII Post Pentecosten," in *Opera omnia,* 9:446b–49.

63. Ibid., 448b.

where Francis appears already in the prologue, bearing "*the seal of the likeness* [Ezech. 28:12] of the living God, namely of *Christ crucified* [1 Cor. 2:2]" on his own body (182).

In the *Legenda* Christ's outward carving of Francis through the stigmata comes as a confirmation of a life of penance by means of which Christ's grace had already made Francis a work of art. Indeed Francis's free cooperation with this grace makes him, too, an artist.[64] Given a "poor, cheap cloak" to cover his nakedness, Francis marks "a cross on it with a piece of chalk" (194). He enrolls others in the order of poverty and penitence, marking them with the Tau of repentance and blessing them with the cross. Later he designs a cross-shaped habit for the Friars Minor to wear.[65] He rebuilds three churches—San Damiano, San Pietro, and the Portiuncula—restoring their beauty. He sings and composes poetry in praise of God. He builds snowmen in order to counter the heat of lust (221). He has visions of extraordinary loveliness, which he only gradually learns to interpret correctly. He heals a leper's hideously diseased face by kissing it, restoring its beauty (195–96).

The very first chapter of the *Legenda maior* contains a leprous image of the Augustinian *Christus deformis* and thus anticipates the stigmatization that occurs near the end of Francis's life. Francis encounters a leper, to whom he gives alms and a kiss, and shortly thereafter "Jesus Christ appeared to him fastened to the cross" (189). The apparition "impressed" the meaning of Christ's Passion "on the innermost recesses of his heart" (189)—so much so that, from this time on, instead of withdrawing from the abhorrent ugliness of lepers and beggars, he frequented their houses "in order that he might completely despise himself, because of Christ Crucified, who . . . was despised *as a leper* (Isa. 53:3)" (190).

Chapter 5 (the first on the virtues) similarly shows Francis acting against his sensual appetites and restricting the intake of his five senses. As a result of his mastery over fleshly desires out of love for the Crucified, his senses are awakened to the beauty of creation, and nature itself responds to his prayers. Struck with an initial horror at the sight of the fire in which a physician prepares an iron for cauterizing him, Francis counters his fear by praising the "beauty" of his "brother Fire," whom "the Most High has created . . . strong and beautiful and useful"

64. Bonaventure records only one episode in which Francis's natural artistic propensities come in conflict with his mysticism, but it is an instructive one. "One Lent," Bonaventure relates, Francis "was whittling a little cup to occupy his spare moments and to prevent them from being wasted." When the thought of the cup distracted him during his praying of the Office, "he burned the cup in the fire, saying: 'I will sacrifice this to the Lord, whose sacrifice it has impeded'" (*Bonaventure*, 277).

65. On the cross-shaped garment, see Goffen, *Spirituality in Conflict*, 36. The account of Francis designing it appears in Thomas of Celano's Life of Francis.

(224–25).[66] Recognizing the fire as a fellow creature and artwork of God, Francis enters into harmony with it, becoming a "divine miracle" and a new creation in the process through the "strength of spirit" he exhibited (225). Blessed with the sign of the cross, the fiery iron that touches his skin causes Francis no pain. A cup of water similarly blessed changes into "the best wine" (225). Because Francis renounces during a time of illness the comfort of human musicians, he hears the angelic "sound of a lute playing wonderful harmony" (226). Exposed to danger on a dark road, Francis prays, and he and his companions are suddenly surrounded by a "heavenly radiance" that guides their steps (227).

What makes possible the striking, aesthetic coincidence in Francis's life (as in the Beatitudes themselves) of these opposites: darkness and light, hunger and feasting, silence and music, mourning and laughter, poverty and heavenly inheritance?[67] In part, as Umberto Eco suggests, these paradisiacal alterations can be explained in purely natural, psychological terms, for a fasting person learns an intense appreciation for the goodness and beauty of the things that he has renounced completely or that he uses and enjoys sparingly.[68] This psychological explanation alone, however, clearly does not suffice, for it divorces Christian asceticism from its orientation toward the Passion of Christ and its proper, mystical context in union with Him.

Karl Rahner would have us distinguish carefully between and among the various forms of asceticism, according to their motivations. The "bourgeois-Christian" conception of asceticism reduces Christian asceticism to a Stoic "training" in self-control that defends against the propensity toward sin, on the one hand, and aims at "the right balance of an evenly distributed humanity," on the other.[69] Extended into the experience of the mystics of the different religions, this moral asceticism becomes a "pretending" of death, "an existentially harmless phenom-

66. This passage anticipates the lines addressed to Brother Fire in St. Francis's "Canticle of Brother Sun." See *The Writings of St. Francis,* trans. Benen Fahy, O.F.M. (Chicago: Franciscan Herald, 1964), 130. The qualities that Francis attributes to Fire—strength, beauty, and usefulness— are those that Bonaventure elsewhere ascribes to works of art: "For every artificer, indeed, aims to produce a work that is beautiful, useful, and enduring" (*St. Bonaventure's De reductione artium ad theologiam: A Commentary with an Introduction and Translation,* ed. and trans. Sr. Emma Thérèse Healy [Saint Bonaventure, NY: Saint Bonaventure College, 1939], 55). Healy's is a facing-page edition and translation of the Latin text. Cf. *Opera omnia,* 5:323a.

67. Ewert Cousins calls particular attention to this "coincidence of opposites" in his introduction to *Bonaventure,* 44. See also Ewert Cousins, *Bonaventure and the Coincidence of Opposites* (Chicago: Franciscan Herald, 1978).

68. Umberto Eco, *Art and Beauty in the Middle Ages,* trans. Hugh Bredin (New Haven: Yale University Press, 1986), 6.

69. Karl Rahner, S.J., "The Passion and Asceticism," in *Theological Investigations,* 3, trans. Karl-H. and Boniface Kruger (Baltimore: Helicon, 1967), 60–62.

enon of psychological training for some kinds of mystical experience."[70] Such a mystical asceticism becomes (in Rahner's words) "an attempt, as it were, by man himself to force the divine to come alight in man."[71] Neither moral nor mystical asceticism, thus defined, are identifiable with a genuinely Christian asceticism which, Rahner avers, is distinguished from other kinds of asceticism by its necessary connection to the Passion and death of Christ: "The Christian death, the Christian flight from the world and asceticism are the imitation of the Crucified and a participation in the destiny of death of the one whose whole structure of life is passed on to us by baptism and faith."[72] Thus, whereas a merely moral or mystical asceticism attempts to control both oneself and the divine, Christian asceticism makes "an act of faith in the *free* grace of God," knowing "that God's grace is free, even if man managed to divest himself completely of himself into death."[73]

Rahner's analysis seems especially apropos in the case of St. Francis, whose penitential asceticism is clearly motivated by Christ's Passion, whose radical practice of poverty presupposes the free almsgiving of a provident God, and whose status as the greatest of the medieval mystics derives from the stigmata as the outward sign of his union with Christ Crucified. Francis does not taste wine in the cup of water because of his abstinence, but because of his spiritual closeness to Christ, who rewards his unconditional faith, childlike trust, and boundless, selfless love with equally free gifts.

Confronted with St. Francis's mystical experience, as well as his own, St. Bonaventure turned with renewed interest to the patristic doctrine of the spiritual senses, returning to it again and again in his writings and developing it with original insights.[74] The theory concerns itself with the gift of grace and its effects on the human body and soul. It classically examines the direct, mystical experience of God's presence and posits the operation of five spiritual senses, analogous to the physical senses, in the apprehension of spiritual realities. In an Epiphany sermon, for example, Bonaventure urges his listeners to "arise [and] be enlightened" (Isa. 60:1) through devotion and to enter spiritually into the presence of a manifestly divine Christ:

> To the *sight* of highest elegance or beauty by reason of the eternal splendor existing in him . . . to the *hearing* of consummate harmony sounding forth from him by reason of the Uncreated Word . . . to the *taste* of unsurpassed sweetness proceeding from him by reason of his all-comprehending Wisdom . . . to the *smell* of the highest fragrance emanating from him by reason of the Word inspired in the heart . . . to the *embrace* of greatest joy or pleasure by reason of the Incarnate Word abiding in him.[75]

70. Ibid., 68.
71. Ibid., 80.
72. Ibid., 81.
73. Ibid., 80.
74. See Rahner, "The Doctrine of the 'Spiritual Senses,'" 109–26.
75. "Ephiphania Sermo IX," in *Opera omnia*, 9:166b–167a. My translation. For other passages

What the *Legenda maior* suggests is that the operation of the spiritual senses is not simply analogous to that of the physical senses, but somehow continuous with them. In the words of Balthasar, "One cannot suppose that the outer and inner senses are two faculties separate from one another, perhaps even opposed to one another: rather, they must have their common root in the single intellectual-material nature of man."[76] The mystical experience of God by the spiritual senses actually affects and conditions the physical senses in their apprehension of the world around them, which becomes a transfigured medium of encounter with God. Living gratefully and humbly in the presence of God, Francis drinks water, but miraculously tastes wine. Since the spiritual senses and the virtues are added to the Beatitudes, including those associated with the life of reformation, the return to Paradise begins already at the start of Francis's conversion. "To fear the Lord" is truly "the beginning of Wisdom [*Sapientia*]" (Sirach 1:16), the first tasting and savoring of God's goodness.

Through the operation of the spiritual senses, the properties of the resurrected body are already in evidence in the *signaculum reformatum,* and they become increasingly so in the stages of transformation and perfect expression, leading up to Francis's final glorification. The link between the spiritual and physical senses is confirmed beyond any doubt for Bonaventure by the stigmatization of Francis, and that miracle (as we shall see) adds force to the doctrine (summarized by Bonaventure in the *Breviloquium*) of the four qualities of the glorified body: brightness (*claritas*), subtlety, agility, and impassibility:

> Because the spirit is clarified by the sight of the eternal light, exceeding keenness of sight ought to result in the body. Because the spiritual effect *in summa* lies in the enjoyment of the most high spirit, there ought to be a corresponding acuteness and spirituality [*subtilitas*] in the body. Because by possessing eternity man is made completely passionless [that is, without suffering], there ought to be in the body a complete external and internal lack of passion. Because the spirit is made most agile in the quest of God, . . . the greatest agility ought to be found in the glorified body. . . . [B]y these four properties the body is made to conform to the spirit.[77]

The final conformity of the body's qualities to those of the soul in beatitude depends on the degree of the soul's conformity in this life to Christ,[78] a transformation that is wrought through the assimilating power of love, which melts and softens the soul, allowing for it to be changed. Whereas the soul is reformed through compunction and tears of sorrow for sin, it is transformed, Bonaventure

where Bonaventure describes the objects of the spiritual senses, see *Breviloquium,* 5.6 (*Opera omnia,* 5:259b), *Itinerarium,* 4.3 (*Opera omnia,* 5:306b), *Coll. in hexaem.,* 3.22, in *Opera omnia,* 5:347a.

76. Balthasar, *Glory of the Lord,* 2:319.

77. *Breviloquium,* 7.7, 240; *Opera omnia,* 5:290a.

78. On the correspondence between the earthly practice of virtue and the properties of the glorified body, see "Feria II. Post Pascha," in *Opera omnia,* 9:284b.

avers, through the enkindling of love (*per incendium dilectionis*), as was the soul of Francis.[79]

2. *Signaculum transformatum*

Already in chapter 3 of the *Legenda*, Francis appears as a man at peace with himself and God, and therefore able to impart peace to others, greeting his listeners at the start of every sermon with the inspired salutation: "'*May the Lord give you peace*' (Matt. 10:12; Luke 10:5)" (200). This benediction accords with his transformed inner state, which dates from the day when "the joy of the Holy Spirit [suddenly] came over him and he was assured that all of his sins had been completely forgiven" (202). Chapter 4, which is replete with eucharistic imagery, subtly connects Francis's complete spiritual transformation, mirrored in the Life of the virtues in chapters 8 and 9, to the transubstantiation that occurs in the sacrament.

In the attainment of Christian perfection, Francis is so conformed to Christ, the Light of the world (cf. John 1:9), that the saint's *claritas* appears not simply as light but also as color. Bonaventure's fourth chapter significantly includes an account of the vision of Brother Pacificus, who saw "a great Tau [a T-shaped cross] on Francis's forehead, which shone in a variety of colors and caused his face to glow with a wonderful beauty" (214). That same chapter ends with a proleptic reference to the stigmata, soon to be imprinted on Francis's body. Francis's great love of the Tau as a penitential sign of conversion to Christ (cf. Ezec. 9:4) becomes the means for his spiritual and physical assimilation to the crucified and glorified Lord.

In chapter 8, which pairs directly with chapter 4, Bonaventure announces that Francis has been so completely "appropriated" into the "dominion" of piety and "transformed . . . into Christ" that he "symbolically showed a return to the state of original innocence" (250) in his relationship to nature, to his fellow humans, and to God. Chapter 8 focuses on the first of these relationships, showing Francis's remarkable harmony with animals—lambs, rabbits, birds, fish, wolves—whom he called "by the name of brother or sister, because he knew they had the same source as himself" (254–55).

The opening of chapter 9 continues this theme of "heavenly harmony" in language that recalls the *Itinerarium mentis in Deum*: "In beautiful things he saw Beauty itself and through his *vestiges* imprinted on creation *he followed his Beloved* everywhere [Job 23:11; Song of Sol. 5:17], making from all things a ladder by which he could climb up and embrace him *who is utterly desirable* [Song of

79. "De S. Patre Nostro Francisco. Sermo I," in *Opera omnia*, 9:574b.

Sol. 5:16]" (263). In chapter 9, however, the emphasis shifts from Francis's frater-
nal relationship with nature (the "vestiges" of the Creator) to his ardor for God's
human "images": "The charity of Christ made him more than a brother to those
who are stamped with the image of their Creator and *redeemed with the blood* of
their Maker [Rev. 5:9]" (265). Francis is ready to die a martyr's death for the con-
version of souls; indeed, his readiness to "walk into the fire" (270) in order to win
the Sultan for Christ stands as a measure for his spiritual advance since the time
of his earlier encounter with "brother Fire" at the physician's hands (224–25).[80]

Radiance or *claritas* is, as we have seen, an attribute of the beautiful in classi-
cal and Christian aesthetic theory; it is also one of the endowments (*dotes*) of the
resurrected body. In the theological aesthetics of St. Bonaventure, however, *clar-
itas* has an especially important place, because he maintains that light (*lux*), like
beauty, belongs to the very substance of everything that exists and actively radi-
ates from everything as *lumen, splendor,* or *color*.[81] Light itself, moreover, pos-
sesses all four properties of the glorified body, which may be therefore reduced
(that is, traced or led back) to their origin in light. In his commentary on the
Sentences, Bonaventure writes: "Light has brightness [*claritas*] because it il-
lumines; impassibility, because nothing corrupts it; agility, because it moves
quickly; penetrability, because it passes through diaphanous bodies without
damage to them."[82]

In *De reductione artium ad theologiam,* Bonaventure interprets the creation of
light on the first day of the week of creation (Gen. 1:3) to mean that all God's crea-
tures "had their origin in one light" in a double sense: first of all in the Uncreated
Light of God, "the Father of Lights" (James 1:17), and second in created light as
the primary, common element of all creatures.[83] In his *Collationes in hexaemeron*
(*Collations on the Six Days*), Bonaventure describes the divine ray shining in the
various creatures according to the degree of their opacity, even as a single beam
of light, shining through a stained-glass window, is broken into diverse colors.[84]
Light is thus "the queen of colors," a substantial component of all things in their
wondrous variety.[85]

By "the light of sense perception" in all its forms (visual, auditory, gustatory,

80. Elsewhere Bonaventure refers to poverty as the "furnace" in whose flames Francis was pu-
rified, as gold is refined in fire. See his "Sermon Four on St. Francis," in *Disciple and Master,* 116–
17; "De S. Patre Nostro Francisco. Sermo II," in *Opera omnia,* 9:579a.

81. On Bonaventure's doctrine of light, see Etienne Gilson, *The Philosophy of St. Bonaventure,*
trans. Dom Illtyd Trethowan and F. J. Sheed (London: Sheed and Ward, 1940), 271–93.

82. *4 Sent.,* dist. 49, p. 1, art. 2, q. 1, in *Opera omnia,* 4:1016a.

83. Healy, *Saint Bonaventure's De reductione artium ad theologiam,* 49, 70–73.

84. *Coll. in hexaem.,* 12:14, in *Opera omnia,* 5:386b.

85. *Comment. In Sapientiam,* 7.10, in *Opera omnia,* 6:153a. As noted there the phrase "queen of
colors" actually comes from St. Augustine, *Confessions,* 10.34.51.

olfactory, tactile), the "light present in the elements" is perceived, according to "the adequacy of the senses."[86] Citing St. Augustine's commentary on Genesis, Bonaventure explains the "nature of the light present in the elements" as follows:

> If the light of brightness, which makes possible the discernment of things corporeal, exists in a *high degree of its own property,* and in a certain purity, it is the sense of *sight; commingled with the air,* it is *smell; with a fluid* of the body, it is *taste; with a solid earthly substance,* it is touch. Now the sensitive life of the body [*spiritus sensibilis*] partakes of the nature of light, for which reason it thrives in the nerves which are naturally unobstructed [*clara*] and capable of transmitting impressions [*pervia*].[87]

The *claritas* of the human body, which thrives in the nervous system, enables it to perceive the "lightness" of all things. Commenting on this Augustinian doctrine, Ivan Illich observes: "the eye also sparkles. . . . According to the spiritual optics of the early scholastics, the *lumen oculorum,* the light which emanates from the eye, was necessary to bring the luminous objects of the world into the onlooker's sense perception. The shining eye was a condition for sight."[88] Since sensory impressions are received to the degree that the individual senses and the total sensorium are able to accommodate them, the world appears dark if the light of the eyes has become diminished. In *Itinerarium mentis in Deum,* Bonaventure explains that "in the initial state of creation, man was made fit for the quiet of contemplation, and therefore *God placed him in a garden of delights* (Gen. 2:15),"[89] where his spiritual capacity to see beauty matched the light-filled beauty to be seen, heard, smelled, tasted, and touched. Paradise, in short, was proportioned to him. Because humankind turned away "from the true light" who is the source of all light and color, it was "blinded" and "sits in darkness," unable to apprehend the theophanic beauty of the world.[90]

The implications for medieval art of this theological aesthetics are, of course, enormous, whether one considers manuscript illuminations, icons, or stained glass. Illich writes, "Following this tradition, . . . the world is represented as if its beings all contained their own source of light. Light is immanent in this world of medieval things."[91] Confronted with the decision about how to portray St. Francis after his death, the Franciscans (as Hans Belting notes) "rejected three-dimensional sculpture . . . and chose instead the medium of the icon with a gold

86. Healy, *Saint Bonaventure's De reductione artium ad theologiam,* 43.

87. Ibid.

88. Ivan Illich, *In the Vineyard of the Text: A Commentary to Hugh's Didascalicon* (Chicago: University of Chicago Press, 1993), 20. See also Wolfgang Schöne, *Über das Licht in der Malerei* (Berlin: Mann, 1954).

89. *Bonaventure,* 1.7, 62; *Itinerarium,* in *Opera omnia,* 5:297b.

90. *Bonaventure,* 1.7, 62; *Itinerarium,* in *Opera omnia,* 5:297b–298a.

91. Illich, *In the Vineyard of the Text,* 19.

ground."[92] Rona Goffen has demonstrated that in the six narrative scenes in the Bardi Chapel in Santa Croce in Florence, Giotto "associated [St. Francis] with the actual light of the chapel," making "the fictive illumination coincide with the dominant source of natural light."[93] Bellini's *San Francesco nel deserto* portrays what Millard Meiss has called Francis's "stigmatization by light."[94] In the *Paradiso* Dante places St. Francis in the sphere of the sun.[95]

Turned toward the God who is Light, clarified and transformed by Him, Francis regained what Adam and Eve had lost: the grace-filled ability to recognize with shining eyes the world's beauty in all its forms. What Bonaventure emphasizes is the proportion between the *claritas* of the saintly subject and his spiritual and physical senses, on the one hand, and that of the object, on the other. That proportion is itself beauty, a harmonious matching or proportionate equality (*aequalitas numerosa*).[96] As a "transformed seal" (*signaculum transformatum*), Francis is a paradisiacal person, someone who is not only the image but also the likeness of the God who created him.

3. *Signaculum expressum*

As a seal in which God expresses Himself (*signaculum expressum*), Francis is an *alter Christus,* for the Son of God is the Father's perfect Image or Expressed Likeness. Even as the Father, as it were, empties Himself, pouring Himself out expressively into the Son, so too the Son is the great Exemplar, the Logos, who expresses the Father (and thereby Himself as the Father's Image) in the created world. Bonaventure explains this doctrine succinctly in the *Breviloquium*:

> The first principle made the sensible world to make Himself known so that, as it were, by a vestige and a mirror man should be led back to the loving God the artificer and to praising Him. In accord with this idea there is a double book, one written within, which is the eternal Art and Wisdom of God, and the other written without, namely the sensible world. . . . And because in Christ eternal wisdom and His work [of creation] concur in one person, He is called the book "written within and without" [Ezec. 2:10] for the reparation of the world.[97]

92. Belting, *Likeness and Presence*, 384.

93. Goffen, *Spirituality in Conflict*, 64–65.

94. Millard Meiss, *Giovanni Bellini's St. Francis in the Frick Collection* (New York: Princeton University Press, 1964); quoted by Fleming, *From Bonaventure to Bellini*, 4. Fleming shows that the source of light in the painting is a tree representing the burning bush of Exodus 3:1–4:18.

95. In *Paradiso*, Canto 11, the Dominican St. Thomas Aquinas tells the life of St. Francis, to which the Franciscan St. Bonaventure replies in Canto 12 with the life of St. Dominic.

96. On Bonaventure's treatment of the Augustinian idea of a numbered equality, see Spargo, *Category of the Aesthetic,* 38, 55. The Augustinian locus classicus is *De musica,* 6:13.

97. *Breviloquium,* 2.11, 73; *Opera omnia,* 5:229a. Bonaventure similarly compares Christ to the Father's Art and Book of Wisdom, written within and without, in an Eastertide sermon, adding

As a divine person within the Trinity, Christ, the Art of the Father, is a spiritual book that is "written within," containing within Himself all the Father's eternal ideas for creation. As a human Christ is a corporeal book that is "written without," and thus able to be read by God's creatures.

Given this expressive theme, it is no accident that the three chapters in the *Legenda maior* immediately preceding the account of the stigmatization of Francis in chapter 13 deal with Francis's inspired prayer (chapter 10), with his prophetic reading of God's expression of Himself in the sacred scriptures (chapter 11), and with Francis's inspired preaching (chapter 12). "Free from all stain" and "illumined by the brilliance of eternal light" (280), Francis's spiritual *claritas* was so great, by Bonaventure's witness, that he could pray effectively in accord with God's own will, penetrate the veiled truths of the Bible, and read the secret thoughts of humans prophetically.

Chapter 10, which pairs directly with chapter 13, shows Francis's direct relationship with God in prayer. The account symbolically anticipates the saint's actual reception of the stigmata. Bonaventure reports the eyewitness of Francis's companions: "There [Francis] was seen praying at night, with his arms outstretched in the form of a cross, his whole body lifted up from the ground and surrounded by a sort of shining cloud. The extraordinary illumination around his body was a witness to the wonderful light that shone within his soul" (275). In this episode the radiance of Francis's own body at night recalls the mysterious radiance that illumined Francis's path in the dark in chapter 5 (197), as well as the "globe of light" that "lit up the night" in chapter 4 (209).

Even as Francis's prayer and meditation were full of light, his preaching expressed the fire of his love and engendered warmth in his auditors. It was so authoritative and efficacious that "it was clearly evident that it was not he, but the *Spirit* of the Lord who *was speaking* (Acts 6:10)" (298). These expressive powers, moreover, directly correspond to Francis's embodiment of the Word. Bonaventure observes, "Nor should it sound odd that the holy man should have received from God an understanding of the Scriptures, since through his perfect imitation of Christ he carried into practice the truth described in them" (281).

In these chapters (10, 11, and 12) that demonstrate Francis's attainment of perfection, the endowments of *subtilitas* and *agilitas* become increasingly manifest in Francis, albeit not yet with the fullness that belongs to the glorified state. Francis not only can plumb the depths of the scriptures, passing through their literal meaning, but he can also foresee the future with "the penetrating power of the

that "this book is only opened on the cross" ("iste liber non est apertus nisi in cruce"). See "Feria VI in Parascheve. Sermo II," in *Opera omnia,* 9:263b. See too *Coll. In hexaem.,* 12:14, in *Opera omnia,* 5:387b. Similar imagery appears in *Bonaventure,* trans. Cousins, 170; *Lignum vitae,* in *Opera omnia,* 9:84a–85b.

spirit of prophecy" (289). He is "aware of things absent as if they were present" (281). He appears, moreover, "to the friars, although absent, transfigured in a fiery chariot," so that the friars realized "that their holy father, who was *absent physically,* was *present in spirit* (1. Cor. 5:3)" (289, 209). To confirm the theme of agility, Bonaventure refers specifically to the openness of Francis's spirit "to the light of *eternal wisdom, which is mobile beyond all motion* [Wisdom 7:24]" (291). In chapter 12 that mobility gains physical expression when Francis "[takes] to the roads," running "swiftly" to proclaim the Gospel everywhere (294).

Chapter 12 ends with a retrospective summary of all of Francis's virtues and miracles, "which testify without any doubt to the whole world that Francis, the herald of Christ, is worthy of veneration" (302). That listing is key to the understanding of the stigmata as beautiful because it shows that Francis's soul is adequately proportioned to the Christ whom he announces expressly to the world. In Bonaventure's view, as Sister Emma Thérèse Healy observes, "beauty does not belong exclusively to things, as the Greeks thought, nor is it merely an attitude of the subject; it is mid-way between the object and the subject and consists in the correspondence of the one to the other. . . . The impression of beauty is reduced to proportion."[98]

4. *Signaculum expressivum*

Francis's proportionality to Christ in the life of the Beatitudes makes him receptive both to Christ's divine wisdom (signified in the six-winged Seraph) and to His wounds as reflections of the two-in-oneness of His divinity and humanity. In Bonaventure's thought, loving Christ in the hypostatic union of His divine and human natures allows for the perfect fulfillment of the twinned commandments of love of God and love of neighbor.[99] "On this point," Spargo notes, "Bonaventure shows his artistic insight, in stressing the union of opposites, the harmonizing of dissonants, and bringing together of extremes."[100] Balthasar agrees, noting that when the "beauty of Wisdom appears to Francis in the form of the crucified Seraph, it is almost as if the crucified one, who appears in the late Gothic (as late as Grünewald) in the form of pure distortion, must here make use of the clothing of Wisdom."[101]

Prior to the apparition on Mount La Verna, Francis was prepared to receive it,

98. Healy, *Saint Bonaventure's De reductione artium ad theologiam,* 99.

99. *Itinerarium,* 4.5, in *Opera omnia,* 5:307b.

100. Spargo, *Category of the Aesthetic,* 84.

101. Balthasar, *Glory of the Lord,* 2:270. Balthasar's point here is that Bonaventure's composite image looks back on a long Wisdom tradition and forward to the new, pathetic realism in artistic depictions of the Passion.

for his affections were being moved in opposite directions: "By the Seraphic ardor of his desires, he was being borne aloft to God; and by his sweet compassion he was being transformed into him who chose to be crucified because of the *excess of his love* (Eph. 2:4)" (305). This spiritual state opened Francis's soul and body to such an extent that it could be assimilated to the hypostatic union in its height and depth. The imprint of the wounds corresponds to the opening wide of the saint's soul. Balthasar writes: "It is decisive for Bonaventure's aesthetic theology that the stigmata [were] branded on the body precisely when the soul was in an ecstatic rapture: it is when the form of the divine beauty is seen that this divine beauty receives its form in the world. For Bonaventure, it is vital that ecstasy . . . is not a flight out of the world that leaves it behind, but rather the opening of the world for God."[102]

In Bonaventure's theological aesthetics, *expressio* and *impressio* belong together and are proportioned to each other. "It is significant," Balthasar insists, "that although the power of expression goes out from the Crucified, the bodily sign [of the stigmata] is imprinted only because Francis, through grace and his own inflamed love, has already become in spirit an expression of the love of the Crucified."[103] The "open seeing of faith" that is an expression of Francis's soul is exactly configured to the image of the crucified Seraph, so that the image, in turn, "stamps [its] impression" on Francis's body.[104] Like Christ, the stigmatized Francis becomes a book that is "written within and without" (Ezec. 2:10).

As a declaratory seal (*signaculum expressivum*), the stigmata confirm the life of St. Francis as a divine artwork, a masterpiece to which Christ the Artist lays claim by affixing His wounds as a kind of signature. Francis belongs to Christ, and Christ to Francis. Rahner notes that Bonaventure's original treatment of the five spiritual senses associates the deepest possible experience of mystical union not with sight, but with taste and touch—a judgment that finds its objective correlative in the stigmata of Francis.[105] Indeed Francis's perfect union with Christ constitutes a beauteous integrity that surpasses even the deiformity of Adam in the unfallen state. "The whole spirit of the just man," Bonaventure writes in the *Breviloquium*, "is directed to the Trinity according to the integrity of his image" in the rational soul.[106] Francis's directedness toward Christ and conformity with Him in body and soul accord to the saint an integrity that extends even to the loss of physical integrity through wounding. Francis is integral, is "whole," because he

102. Balthasar, *Glory of the Lord*, 2:273.
103. Ibid., 2:271.
104. Ibid., 2:282.
105. Rahner, "Doctrine of the 'Spiritual Senses,'" 116, 126.
106. *Breviloquium*, 7.7, 239; *Opera omnia*, 5:289b.

embraces the whole Christ; he is upright and hierarchical through his conformity to the Incarnate Word, who is the Most High and the Most Humble.

The healing power of Francis's wounds makes them a gateway to paradise for others. Bonaventure describes the stigmata as a sacred image "depicted not on *tablets of stone* or on panels of wood by the hands of a craftsman, but engraved in the members of his body *by the finger of the living God* [Exod. 31:18; John 11:27]" (307). Endowed with miraculous powers, the wounds of Francis bring a permanent stop to destructive hailstorms in the region of La Verna; they eradicate plague in another district; they bring heat in the cold of winter; they heal the wounds of others.

Paradoxically the wounds portend Francis's attainment of *impassibilitas* through a share in Christ's Passion. Whereas Francis had previously called animals his brothers and sisters, in the last, pain-racked months of his life, he calls "his trials not by the name of torments but sisters" (316). Death he welcomes as "Sister Death."[107] When he finally strips himself that he might die "naked on the naked ground" (317), the symbolic action makes the penitential abjection of total poverty a way back to the innocence of Adam, whose body God had sculpted in paradise out of "dust from the ground" (Gen. 2:7), and who walked there, unashamed in his nakedness, because clothed in virtue and free from all concupiscence.

Francis's death is accompanied by paradisiacal signs of glorification. One of the brothers sees his soul carried aloft "under the appearance of a radiant star" (319)—a vision that confirms an earlier prophecy that the humble Francis was destined to take a brightly bejeweled throne in heaven that one of the fallen angels had lost in his pride (234). The larks circle and sing over the place where Francis's body is housed (320). Francis's flesh is transfigured, so that "his skin, which before was inclined to be dark both naturally and from his illness, now shone with a dazzling whiteness, prefiguring the beauty" of the resurrected body (322). His limbs are "so supple and soft to the touch" that they seem "to have regained the tenderness of childhood and to be adorned with clear signs of his innocence" (322–23). Bonaventure likens the wound in Francis's side to "a most beautiful rose" (322); it was, he says, "red *like a rose* in springtime (Sirach 50:8)" (323). All wondered, he reports, "at the sight of such varied and miraculous beauty" (323). The stigmatized Francis who had praised God in his rapture, saying, "You are beauty,"[108] is now in death the *signaculum expressivum* of that same beauty.

The comparison of the side-wound to the red rose is noteworthy. In *The Tree of Life* (*Lignum Vitae*), Bonaventure names the risen Jesus "extraordinary Beauty" (*Iesus, decor praecipuus*) and identifies his glorified body with the most beautiful

107. "The Canticle of Brother Sun," in *The Writings of St. Francis of Assisi*, 131.
108. "Praises of God," in *Writings of St. Francis of Assisi*, 125.

flower of Jesse (*flos ille pulcherrimus*), blossoming in a new and eternal spring-time.[109] John Saward calls attention to an Easter Monday sermon in which Bonaventure, taking as his theme *Refloruit caro mea* (Ps. 27:7), likens the properties of the risen body of Jesus to four different flowers: "the rose in brightness, the lily in subtlety, the almond in agility, the palm in impassibility."[110] Among these flowers the rose takes first place, even as light and clarity come first among the created forms and are essential to all the others: "The flesh of Christ . . . flowered like the rose through the beauty of brightness (*per pulchritudinem claritatis*). For as the rose in its beauty is among flowers, so the splendor of light is among colors."[111]

Francis's light-filled rose-wound, moreover, is red. Even as streaming light is primary to the work of creation and glorification, so too Christ's flowing blood is essential to the work of recreation. Bonaventure therefore speaks in a previously cited sermon about how God's image in the soul is crafted in three artistic stages: first carved in creation, then colored or dyed [*depinxit, coloravit*] in Christ's Passion, and finally illumined in eternal glory.[112] According to Bonaventure red is the noblest of all colors, because Christ used it to paint the gift of His own heart. When the soldier pierced Christ's side with a lance, Christ gave His heart through that same opening "in the likeness of a picture" (*in similitudinem picturae*).[113] In the person of the stigmatized Francis, Christ was to offer His body and blood anew to the eyes of the faithful in a similar artistic picture or *signaculum*.

Francis, Elijah, and the Eucharist

The eucharistic coloring of the whole of St. Bonaventure's *Life of St. Francis* becomes apparent when one considers, among other things, the repeated comparisons of Francis to Elijah and his disciple Elisha. Previous studies of these allusions have emphasized the presence of Moses and Elijah with Christ on the Mount of Transfiguration (Matt. 17:1–9) and the frequent identification of these Old Testament figures with the Two Witnesses of Revelation 11:3–13, and thus

109. *Opusculum III. Lignum Vitae*, in *Opera omnia*, 8:81b; *Bonaventure: The Tree of Life*, 160.
110. John Saward, "The Fresh Flowers Again: St. Bonaventure and the Aesthetics of the Resurrection," *The Downside Review* 110 (1992): 9; "Feria II post Pascha," in *Opera omnia*, 9:283a.
111. Ibid.
112. "Dominica XXII. Post Pentecosten. Sermo VI," in *Opera omnia*, 9:449b.
113. Ibid., 448b.

with Bonaventure's Joachite apocalypticism.[114] As representatives of the patriarchs and prophets, respectively,[115] Moses and Elijah stand both for the historical ages prior to the Incarnation (in application to the church) and for the stages of purification and illumination (in application to the individual soul).[116] Even as they conversed with the transfigured Christ on Mount Tabor about the suffering He would soon undergo (Luke 9:31), they bear symbolic witness in the *Legenda* to the stigmatized Francis on Mount La Verna as an *alter Christus*. A close reading of references to Elijah in the *Legenda maior* and elsewhere suggests, however, an additional level of interpretation, according to which the pairing of Moses with Elijah/Elisha represents the two sacramental foods on which Francis feeds and which he embodies, namely, the scriptures and the Eucharist.

In a sermon on the Eucharist ("De sanctissimo corpore Christi"), St. Bonaventure gives an extended commentary on the story of Elijah that helps to explain the prophet's function in the *Legenda* as a type or *figura* of Francis. The commentary appears within the larger context of a treatment of prefigurements of the Eucharist in the Old Testament through the six symbols of oil, bread, honey, the paschal lamb, the heavenly treasure-trove, and manna. Bonaventure associates the second eucharistic prefigurement—namely, that of bread (*panis*)—specifically with the prophet Elijah, to whom an angel brought a hearthcake and a vessel of water (3[1] Kings 19:5–7).[117]

Prior to his reception of this miraculous food, Elijah had gone out alone into the desert (*perrexit in desertum*)—a retreat that Bonaventure connects with Elijah's renunciation of worldly consolation and freedom from a threefold concupiscence: of the flesh, of the eyes, and of vainglory.[118] In the wilderness the prophet sat down to rest under a juniper tree, signifying humility and enduring, charitable love.[119] The angelic visitation signifies divine grace and the sacramental character of the bread that nourishes Elijah, strengthening him for good works, lifting him up to contemplation, disposing him to revelation, and enkin-

114. See Emmerson and Herzman, "The *Legenda maior:* Bonaventure's Apocalyptic Francis," 50–52, 67, 72, 75; Fleming, *From Bonaventure to Bellini,* 64, 94.

115. Bonaventure makes this traditional identification in the chapter entitled "Iesus, transfiguratus" in *Opusculum III. Lignum Vitae,* in *Opera omnia,* 8:74a.

116. In *The Soul's Journey into God,* Bonaventure distinguishes "three principal parts" of the Scriptures: "the law of Moses, which purifies, prophetic revelation which illumines, and the gospel teaching which perfects" (91); *Itinerarium,* 4.6, in *Opera omnia,* 5:307b.

117. See Fleming's interpretation of the jug of water in Bellini's *San Francesco nel deserto* as a symbol of Elijah (*From Bonaventure to Bellini,* 69–70).

118. "De sanctissimno Corpore Christi," in *Opera omnia,* 5:556b–57a.

119. Ibid., 557b. Bonaventure explains that the quality of enduring love for God and neighbor is symbolized in the peculiar property of juniper ashes, which are reputed to hold the fire's heat for a whole year.

dling his desire for heavenly goods.[120] Strengthened by this food, Elijah walks for forty days and forty nights (symbolizing the spiritual path marked by the Old and New Testaments) to Horeb, the holy mountain, where the Lord had previously appeared to Moses in a flame of fire (*in flamma ignis*) in the burning bush (Exod. 3:1–2).[121] There Elijah too encounters the Lord, whose coming is heralded by a strong wind, an earthquake, and a fire. In the quiet of contemplation, signified by the stirring of a gentle breeze, Elijah goes to the entrance of the cave, even as his raptured soul almost parts from his mortal body in the experience of God's palpable presence. Standing at the mouth of the cave, Elijah beholds the immensity of God's beauty: *illius pulchritudinem immensitatem.*[122] Later, as the scriptures bear witness, Elijah's body and soul take flight, as he is borne heavenward to God in a whirlwind and a fiery chariot (4 [2] Kings 2:11).

In the *Legenda maior,* Bonaventure likens Francis to Elijah by name three times, and to Elijah's disciple Elisha twice. The prologue refers to Francis preaching repentance "in the desert" (180), like John the Baptist, whom Christ himself identified with Elijah (Matt. 17:12–13). At the end of his life, Bonaventure relates, Francis was "lifted up in *a fiery chariot*" in proof that he had come, like St. John before him, "*in the spirit and power of Elijah*" [Luke 1:17] (180–81). The friars see a vision of Francis in a fiery chariot (209, 289). At the end of the *Legenda,* Bonaventure repeats what he asserts in the prologue, namely, that Francis was "carried off to heaven like Elijah *in a fiery chariot*" (326).

Because Elisha was granted a "double portion" of the spirit of his master Elijah (4 [2] Kings 2:19), the two prophets are often conflated. The vision of Francis that recalls Elijah's flaming chariot (4 [2] Kings 2:11), for example, also evokes Elisha's "chariots of fire" (4 [2] Kings 6:17). Similarly, Francis's multiplication of food provisions (248, 267) recalls the eucharistic prefigurements of both Elijah and Elisha (3 [1] Kings 17:10–16; 4 [2] Kings 4:1–7).

These explicit references are clearly intended as keys to unlock a series of implicit, allegorical comparisons of Francis to Elijah, for Bonaventure refers in the prologue to the whole "course of [Francis's] life" as being filled by Elijah's spirit and power (181). Like Elijah Francis leaves the world to embrace a life of poverty and total dependence on God. The many stories in the *Legenda* of St. Francis talking to the birds and being miraculously supplied with food recall Elijah being fed by ravens (3 [1] Kings 17:6). Like Elijah Francis preaches, heals, raises the dead, and risks martyrdom out of burning zeal for the Lord. Bonaventure's *Legenda maior* relates the story of Francis's proposed ordeal by fire before the sultan (a tale

120. "De sanctissimo Corpore Christi," in *Opera omnia,* 5:557b.
121. Ibid., 558a.
122. Ibid., 558b.

not included in previous Lives of Francis), in part, perhaps, because of the sug-
gestive parallels to Elijah's fiery competition with the priests of Baal (3 [1] Kings
18:21–39). Francis, too, encounters God on a holy mountain. There he sees a cru-
cified Seraph as a symbol of the flight of his soul. Even as Elijah was taken, body
and soul, to heaven, Francis's spiritual ecstasy marked his body as well.

For Bonaventure, however, as "De sanctissimo corporis Christi" makes clear,
Elijah is primarily a eucharistic prophet, whose eating of miraculous food is an
expression of, and a means for, mystical Communion with God in virtuous ac-
tion and contemplative prayer. Comparing Francis to Elijah, therefore, serves to
characterize Francis too as a specifically eucharistic saint.

Francis's ardent love for the Eucharist is everywhere evident in his extant let-
ters, where he urges the greatest possible reverence for the Blessed Sacrament and
for priests, because of their unique contact with the Eucharist.[123] "Our whole be-
ing," he writes, "should be seized with fear, the whole world should tremble and
heaven rejoice, when Christ the Son of the living God is present on the altar in
the hands of the priest."[124] The ability to see the Host for what and who it truly
is, is for Francis a regaining of the light of paradise. In a letter addressed to all the
faithful, Francis insists, "All those who refuse to do penance and receive the Body
and Blood of our Lord Jesus Christ are blind, because they cannot see the true
light, our Lord Jesus Christ."[125] To priests he proclaims, "In this world there is
nothing of the Most High himself that we can possess and contemplate with our
own eyes, except his Body and Blood, his name, and his words, by which we are
created and by which we have been brought back from death to life."[126]

Bonaventure's *Legenda maior* presents a Francis who not only receives Holy
Communion often and ardently (264), but who also treasures every morsel of
bread as a reminder of the Eucharist as "daily bread" (Matt. 6:11) and a sign of
God's sustenance. When a man appears "carrying bread in his hands" to feed
them, Francis and his friars are "refreshed more by the gift of God's generosity
than by the food they had received for their bodies" (207). In a vision Francis him-
self feeds his brothers with crumbs that he fashions into a Host (216)—a vision
that unites the two foods of the Gospels and the Eucharist into one. Francis re-

123. S. J. P. Van Dijk, O.F.M., and J. Hazelden Walker trace the spread of private adoration of
the reserved Sacrament in the early thirteenth century from Umbria to the influence of St. Fran-
cis and his thousands of followers. See *The Myth of the Aumbry: Notes on Medieval Reservation
Practice and Eucharistic Devotion* (London: Burns and Oates, 1957), 67–72. On the eucharistic
piety of a famous disciple of St. Francis, see Mary Walsh Meany, "Angela of Foligno: A Eucharis-
tic Model of Lay Sanctity," in *Lay Sanctity, Medieval and Modern: A Search for Models,* ed. Ann W.
Astell (Notre Dame, IN: University of Notre Dame Press, 2000), 61–75, 208–11.
 124. "Letter to a General Chapter," in *Writings of St. Francis of Assisi,* 105.
 125. "Letter to All the Faithful," ibid., 97.
 126. "Letter to All Clerics," ibid., 101.

joices in the bread procured through begging, calling it by a eucharistic name, "the bread of angels" (245). He honors little lambs especially, because they are for him symbols of the Eucharist, the paschal Lamb of God (255–56, 271). He blesses bread morsels that heal the sick who eat them (300–301). At Christmas he erects a crib, over which Mass is celebrated to dramatize the ancient, Christian identification of the Eucharist with the Incarnate Son of God, born in Bethlehem, the House of Bread (278).[127]

To accentuate the eucharistic association between St. Francis of Assisi and Elijah, who was believed to have returned to earth in the person of St. John the Baptist (John 1:21; Matt. 11:14), an altarpiece by Domenico Veneziano (ca. 1410–1461) pairs the scene of Francis's stigmatization (plate 7) with an image of St. John in the desert (plate 8)].[128] Naked, poor, and innocent, John has divested himself, even as the young Francis did. A penitent, he has come to preach penance and to prepare a straight way for Christ, announcing in the wilderness, "Every mountain and hill shall be brought low" (Luke 3:5; Isaiah 40:4). John stands against a mountainous background of snowy-white peaks, as does the barefooted St. Francis on Mount La Verna. John's pure and perfect body, painted on the altarpiece, typifies the very body of Christ, to which John's words bear witness in the *Agnus Dei* recited before Communion at every celebration of the Eucharist: "Behold, the Lamb of God, who takes away the sin of the world!" (John 1:29). At the same time John's body points to that of Francis, whose arms and hands are outstretched in awe to receive the piercing beams of light, radiating from the Christ-seraph, that wound him in his palms, feet, and side. Christ's wounds, Christ's body, become mysteriously Francis's own. Depicted on an altarpiece, the miracle of the stigmatization of Francis represents analogously the miracle of the sacrament, wherein bread is changed to become the body of Christ. Brother Leo, Francis's companion, witnesses the scene in wonder, shielding his face.

As the paired paintings in Domenico Veneziano's altarpiece suggest, the logical outcome of his eucharistic way of life is that Francis is literally transformed, body and soul, into the Christ he loves. In "De sanctissimo Corpore Christi,"

127. Steven F. Ostrow has shown how the Franciscan Pope Sixtus V highlighted the eucharistic significance of St. Francis's crib scene at Greccio by "placing the tabernacle of the Sacrament above the Presepio" in the Sistine Chapel of Santa Maria Maggiore" in December 1589. In so doing, Ostrow explains, "Sixtus gave expression to one of the most time-honored and fundamental concepts of Christian thought—the Eucharistic interpretation of the Nativity. As early as the fourth century the connection between the birth of Christ and the Sacrament of the Eucharist had been formulated. . . . Etymologically, Bethlehem was interpreted as the *domus panis,* from the Hebrew *Beth lechem,* meaning house of bread" (*Art and Spirituality in Counter-Reformation Rome* [Cambridge: Cambridge University Press, 1996], 49–50).

128. I thank the curator of the National Gallery of Art in Washington, DC, for permission to reproduce these paintings.

Bonaventure paraphrases a well-known saying of St. Augustine, declaring, "It is the power of this bread to change a person into Christ, who is supremely blessed in his essence and beatifying others through grace."[129] In "Vitis Mystica," Bonaventure repeats that Augustinian formula of transformation, but first he links Christ's sacramental Body, as the fruit of the Tree of Life, to the wood of the cross, whereon the Host, as it were, hangs in order to be plucked and eaten.[130] Because of their openness to the working of grace, the saints have been most affected by the Eucharist, Bonaventure explains, citing the example of St. Clare.[131] In the *Legenda maior,* Francis himself is the example par excellence of the effects of eucharistic transformation. Having eaten personified Beatitude and Beauty, he is sculpted by the Seraph, adorned with Christ's own wounds, colored with his blood, and lustrous with his light.

129. "De sanctissimo Corpore Christi," in *Opera omnia,* 5:555b; my translation. Cf. St. Augustine, *Confessions,* 7.10: "cibus sum grandium. cresce et manducabis me. Nec tu me in te mutabis sicut cibum carnis tuae, sed tu mutaberis in me" (ed. James J. O'Donnell [Oxford: Clarendon Press, 1992], 1:82): "I am the food of full-grown men. Grow and you shall feed on me. But you shall not change me into your own substance, as you do with the food of your body. Instead you shall be changed into me."

130. "Opusculum X. Vitis Mystica seu Tractatus de Passione Domini," 4.4, in *Opera omnia,* 8:167b: "Behold the wood of the cross sent into our bread, the purest bread, delightful bread, *the bread of Angels, who came down from heaven,* that he might give himself to us in food."

131. "De sanctissimo Corpore Christi," in *Opera omnia,* 5:565b.

5 : "IMITATE ME AS I IMITATE CHRIST"

Three Catherines, the Food of Souls, and the Dominican Art of Preaching

Without preaching . . . , a most dangerous famine would prevail universally.
—Humbert of Romans

They eat the bread of souls in the person of this glorious Word.
—St. Catherine of Siena

Is your food celestial or terrestrial?
—St. Catherine of Genoa

Depending on which virtue is brought to the fore, a different Christian form of life appears, and the beauty of the church as a whole is thus variegated and enhanced. The early Dominicans found in the book of the prophet Zachariah a metaphoric and allegorical verse that foretells the establishment of the mendicant orders and characterizes the difference between the Franciscans and the Dominicans. Speaking as a shepherd who guides his flock by means of sweetness and strictness, the Lord declares: "And I will feed the flock. . . . And I took unto me two rods; one I called Beauty, and the other I called a Cord, and I fed the flock" (Zech. 11:7).[1] Writing in defense of the mendicants, Thomas of Cantimpré (AD ca. 1270–72) applies this biblical verse to the two mendicant orders, "one of which is called by the Creator from all eternity 'Beauty', . . . and that is the Order of Preachers, the other of which is called 'Rope', by which we may obviously understand the Minors."[2]

In her *Dialogue* (*Il Dialogo della divina provvidenza*), St. Catherine of Siena (1347–1380) similarly distinguishes the spirituality of the Franciscans from that of the Dominicans. The Lord explains to her that just as "this virtue is peculiar to one, that to another, though all are grounded in charity," so too the various religious orders differ in their "principle aspect[s]": "True poverty was peculiar to the poor Francis, and in love he made this poverty the rule of his ship," whereas Do-

1. I use the Douay-Challoner version of the Holy Bible, ed. John P. O'Connell (Chicago: Catholic Press, 1950).

2. Thomas of Cantimpré, "Defense of the Mendicants," in *Early Dominicans: Selected Writings*, ed. and trans. Simon Tugwell, O.P., Classics of Western Spirituality (Mahwah, NJ: Paulist Press, 1982), 136.

minic wished his sons to be attentive only to . . . the salvation of souls with the light of learning," upon which "light" he sought to "build his foundation."[3] This light, Catherine declares, reveals God to be "Beauty above all Beauty [*Bellezza sopraogni bellezza*]."[4] St. Francis (AD 1226) imitated Christ in his poverty, while St. Dominic (AD 1221) followed Christ as the Divine Word through study and preaching. When the Dominicans studied the scriptures in order to preach effectively, they were, therefore, "'studying to be beautiful'" (Sirach 44:6), according to Humbert of Romans (AD 1277).[5] Connecting the light of Truth outpoured through preaching with the flowing of Christ's Blood, St. Catherine envisions the church as a leprous woman, whose "dirtied" face is healed through being washed in the Word, in tears of contrition, and humble prayer: "I promise you that thus her beauty [*la bellezza sua*] will be restored."[6] Catherine's own extreme, eucharistic asceticism, through which she took on herself the deformity of the bridal church, allowed her to become its feminine counterpart and thus the image of Christ's mystical body in its beauteous reformation and transformation.

The Dominicans' self-conscious identification of their spiritual "way" with Beauty is striking. In this chapter I argue that the peculiarly functional definition of Dominican spirituality, which centers on the task and the art of preaching, highlights the artistic dimensions of the pursuit of holiness—its inspired originality, its use of models, its ascetical craft and techniques of meditation, its ritual aura and epiphanic power of attraction. St. Catherine of Siena's imitation of her spiritual father, St. Dominic, shows an important, gendered difference between two expressions of Dominican form—so much so that the "seraphic virgin" stands as a feminine complement to Dominic and as the "second founder" of the Dominican family.[7]

Catherine was, in turn, imitated by other "Catherines"—notably, Saints Catherine of Genoa (1447–1510) and Rose of Lima (1586–1617)—who conformed to her saintly type, even as they gave it new and unique expressions.

For these women saints, the Dominican imperative to preach—an activity

3. St. Catherine of Siena, *The Dialogue*, trans. Suzanne Noffke, O.P., Classics of Western Spirituality (New York: Paulist Press, 1980), 337; *Libro della Divina Dottrina*, ed. Matilde Fiorilli (Bari: Gius, Laterza, 1912), chap. 158, 374–75: "tucte le virtú hanno vita della caritá; e nondimeno, come in altri luoghi t'ho decto, a cui è propria l'una, e a cui è propria l'altra. . . . a Francesco povarello gli fu propria la vera povertá, facendo il suo principio della navicella, per affecto d'amore, in essa povertá. . . . E se tu raguardi la navicella del padre tuo Domenico, . . . ché voles che attendessero solo a l'onore di me e salute de l'anime col lume della scienzia."

4. St. Catherine of Siena, *Dialogue*, 366; *Libro*, chap. 167, 406.

5. Humbert of Romans, *Treatise on the Formation of Preachers*, in *Early Dominicans*, 294.

6. St. Catherine of Siena, *Dialogue*, 160, 54; *Libro*, chap. 86, 168; chap. 15, 38.

7. Richard Woods, O.P., *Mysticism and Prophecy: The Dominican Tradition* (Maryknoll, MD: Orbis, 1998), 105.

from which women, by narrow definition, were excluded—translated into an urgent command to spread the Gospel message from those symbolic pulpits that were open to them, and to do so in a variety of genres. They fasted, received the eucharistic Host, fed the hungry, nursed the sick, counseled and exhorted, suffered, and thus made out of the pattern of their lives and the very fabric of their bodies graphic illustrations of the Gospels. In using a kind of "body language," these Dominican women followed in an original way the practice of mendicant preachers—Franciscan and Dominican—who (Margaret R. Miles reminds us) "used a repertoire of gestures known to their audiences from paintings," when they "recounted and interpreted the events depicted on the walls of the church, using the gestures and postures of the painted figures."[8] Their contemplation of God in biblical images and scenes was inseparable from the metonymic and allegorical forms of their preaching in word and deed. In the colonial context of Peru, Rose of Lima's reading of St. Catherine's *Life* and her imitation of Catherine's gestural preaching shows the transcendent power of an auratic art and beauty to bridge linguistic and cultural differences. Seeing Catherine through the eyes of St. Rose enables us, moreover, to gain a new insight into the medieval saint's use of verbal and visual images as a way of eucharistic peacemaking through beauty.

Dominican Spirituality as a Way of Beauty

Although St. Catherine of Siena sets Dominican "learning" next to Franciscan poverty as radical virtues at the foundations of twinned schools of sanctity, twentieth-century scholars of spirituality are more likely to stress that Dominican spirituality, unlike most others, is primarily task- and goal-oriented. Writes William A. Hinnebusch in a now-classic study: "The salvation of souls through preaching is the specific note distinguishing Dominicans from all other Orders."[9] Another Dominican scholar, Richard Woods, declares, "Ours is a spirituality . . . founded on our mission, and that mission is the same as it was in the beginning: to announce the good news of salvation."[10] Observing that "even the prayers and devotions of the Dominicans have an apostolic quality," Simon Tugwell admits that "one is hard pressed to find any spiritual books at all, let alone 'spiritual classics,'" that date from the time of the Order's foundation.[11] The thirteenth-cen-

8. Margaret R. Miles, *Image as Insight: Visual Understanding in Western Christianity and Secular Culture* (Boston: Beacon Press, 1985), 68.
9. William A. Hinnebusch, O.P., *Dominican Spirituality: Principles and Practices* (Washington, DC: Thomist Press, 1965), 2.
10. Woods, *Mysticisim and Prophecy*, 27.
11. Tugwell, introduction to *Early Dominicans*, 1.

tury treatise *On the Formation of Preachers* by Humbert of Romans was indeed "the only attempt made in the Middle Ages to present preaching . . . as a focus for a person's whole life and spirituality, and its failure, as a book, is one symptom of the originality (eccentricity, some would say) and difficulty of the whole notion of a religious order defined as an Order of Preachers."[12]

Preaching, as St. Augustine knew and taught in *De doctrina Christiana,* was a divine and human art, and every sermon thus a work of art and beauty that communicated the very Word of God, the Art and Beauty of the Father.[13] Dominic, as Woods reminds us, was "a Canon Regular at the Cathedral of Osma, where the community followed the Rule of St. Augustine."[14] As the medieval founder of the most rhetorical of Orders and spiritualities, Dominic imitated both the ever-mobile Apostle Paul and St. Augustine of Hippo (AD 354–430), who was a converted rhetorician, a zealous preacher, a passionate lover of biblical eloquence, an earnest opponent of heresies, and the founder of a monastic order. Benedict Ashley shows the inner logic connecting a mobile, mendicant preaching with an Augustinian monasticism: "Preaching must flow from contemplation of the Divine Word to be preached, and this is most perfectly expressed in community worship, based as it is on meditation on the Bible and the commemoration of the great, saving events of Christ's life and their imitation by the saints."[15] From the paradise of the cloister, the world was to be renewed through the sending out of apostles who lived by a motto that St. Thomas Aquinas (AD 1274) was to make famous: *Contemplata aliis tradere.*[16]

Finding the state of the thirteenth-century church to be a shambles where clergy and laity alike, lacking orthodox instruction, fell easy prey to heretical, Albigensian teaching, the early Dominicans envisioned a return to the beauty of a spiritual paradise through the vigorous, inspired preaching of God's Truth, as revealed in the sacred scriptures. The dominant images used by the Dominicans to express this return to Eden are those of light and food (planted seeds, harvested grain, wholesome bread, and inebriating wine)—conjoined images that link beauty (*claritas*) with eating. Humbert of Romans, the fifth Master of the Order of Preachers, writes: "Without preaching, which sows the word of God, the whole world would be barren and without fruit. . . . Men who lack preaching are like

12. Ibid., 2.

13. See John C. Cavadini, "The Sweetness of the Word: Salvation and Rhetoric in *De doctrina Christiana,*" in *De doctrina Christiana: A Classic of Western Culture,* ed. Duane W. H. Arnold and Pamela Bright (Notre Dame, IN: University of Notre Dame Press, 1995), 164–81.

14. Woods, *Mysticism and Prophecy,* 22.

15. Benedict Ashley, O.P., *The Dominicans* (Collegeville, MN: Liturgical Press, 1990), 21.

16. "To give to others the fruits of one's contemplation." See St. Thomas Aquinas, *Summa theologica,* trans. Fathers of the English Dominican Province (New York: Benziger, 1947), part 2-2, q. 188, art. 6, 2:1999.

men in the dark. At the beginning of creation, we are told that the abyss was covered with darkness, but that once light was created, all that matter was illuminated. In the same way men are illuminated by preaching."[17]

Although the Dominican theologians do not explicitly argue for gluttony as the first sin (since pride already held that place in the general, theological understanding, due to the strong, historic influence of monastic spirituality), the emphasis they place on preaching as a way of reversing the effects of the Fall fixes particular attention on the right and wrong uses of the mouth. Sermons and treatises on the Seven Deadly Sins, moreover, kept alive throughout the Middle Ages the biblical and patristic understanding of the first sin as including gluttony. Not unlike St. Augustine, who experienced his fallenness as a youth in the stealing of pears,[18] the followers of St. Dominic saw the mouth as the gateway either to a sinful realm of destructive, gluttonous consumption or to a state of paradisiacal beauty, creativity, and fruitfulness. Commenting on the account of Christ's temptation in the desert in Matthew 4:3 (a text often used, as we have seen in chapter 2, to argue for the primacy of the sin of gluttony), the Dominican gloss reads, "When there is a lack of preaching, there is famine, because man does not live by bread alone, but by every word which comes from the mouth of God."[19]

Contemporary witnesses to the sanctity of St. Dominic remark again and again on his zealousness in preaching, on the one hand, and on his avoidance of the sins of the tongue, on the other. According to Brother Ventura, "On a journey or wherever he was, [Dominic] would be always preaching or talking or arguing about God. . . . He was also persistent in prayer."[20] Ventura and other companions report that they "never saw [Dominic] speaking ill of anyone, or ever saw him utter an idle word."[21] Extremely self-controlled in eating, drinking, and speaking, Dominic possessed a mouth that was filled with kind words, wise counsel, courageous frankness, and inspired preaching. Abstinence in one field conditioned abundance in another, and vice versa. A veritable hound of heaven, Dominic came forth from his mother's womb (in an oft-recounted, prophetic dream of hers) as a "puppy . . . carrying a blazing torch in its mouth."[22]

Following St. Dominic's example and, through his, that of Jesus, the Dominican preacher avoids idle speech and all the sins of the tongue—gossiping, backbiting, rude complaints, indiscreet remarks, frivolous jokes, off-color stories,

17. Humbert of Romans, *On the Formation of Preachers,* in *Early Dominicans,* 187–88.

18. St. Augustine meditates on this theft in *Confessions,* ed. James O'Donnell (Oxford: Clarendon Press; New York: Oxford University Press, 1992), 2.4–9.

19. Humbert of Romans, *On the Formation of Preachers,* in *Early Dominicans,* 189.

20. "The Canonization Process of St. Dominic, 1233," in *Early Dominicans,* 66.

21. Ibid., 67. See also 70, 75, 77, 82, and 84.

22. Jean de Mailly, *The Life of St. Dominic,* in *Early Dominicans,* 53.

lies.[23] Citing Jeremiah 15:19, Humbert of Romans declares: "Since preachers are called the Lord's mouth, . . . they must make sure that nothing comes from their mouth which is unworthy of the mouth of the Lord."[24] At the same time, they must not be too taciturn or lacking in friendliness. "There are some," Humbert notes, "who observe the mean, not being unduly silent, but equally not being careless in what they say, overflowing with edifying words. And this is excellent."[25]

Given this Dominican context, it is easy to see why St. Thomas Aquinas takes the patristic argument for gluttony as the first or root sin so seriously, even as he refutes it. He argues, on the one hand, that Eve's "sin of gluttony resulted from the sin of pride,"[26] and that "the sins of the flesh, among which gluttony is reckoned, are less culpable" than the sins of the spirit.[27] On the other hand, he acknowledges temperance to be a cardinal and a special virtue, to which the vice of gluttony is directly opposed. "Gluttony consists properly in an immoderate pleasure in eating and drinking," Thomas writes, "wherefore those vices are reckoned among the daughters of gluttony, which are the results of eating and drinking immoderately."[28] These consequences include mental dullness, unseemly joy, inordinate words (loquacity, foolish talk, scurrility), and various forms of physical uncleanness (vomiting, incontinence), disease, and disfigurement—all of them destructive of humanity's spiritual and physical beauty. Gluttony, Thomas asserts, has a "certain gravity," when its ugly offshoots are taken into account.[29]

Temperance, by contrast, preserves and enhances the beauty of body and soul. If moral virtue "is a habit of choosing the mean,"[30] then the virtue of temperance, which avoids excess, moderates the passions, and keeps them under the rule of reason, is a component of all moral virtue. St. Thomas consciously recognizes and acknowledges the aesthetic aspect of the ethical life: "The good of that which is measured or ruled consists in its conformity with its rule: *thus the good of things made by art is that they follow the rule of art.* Consequently, in things of this sort, evil consists in discordance from their rule or measure."[31] Gluttons knowingly exceed a reasonable measure out of a desire for pleasure in several ways: in *what* they eat or drink (e.g., by choosing costly, dainty fare), in *how much* they consume, in *how* they dine (e.g., hastily or greedily, without observing proper table

23. See Humbert of Romans, *On the Formation of Preachers,* in *Early Dominicans,* 299–302.

24. Ibid., 224.

25. Ibid., 295.

26. St. Thomas Aquinas, *Summa theologiae,* part 2-2, q. 163, art. 1, 2:1863.

27. Ibid., part 2-2, q. 148, art. 3, 2:1794.

28. Ibid., part 2-2, q. 148, art. 6, 2:1796.

29. Ibid., part 2-2, q. 148, art. 3, 2:1794.

30. Ibid., part 1-2, q. 59, art. 1, 1:838.

31. Ibid., part 1-2, q. 64, art. 1, 1:857. Emphasis added.

manners), or in *when* they eat (e.g., between meals, or too early on a fast day).[32] The saint, by contrast, is an artist who keeps a proper order and decorum, subordinating what is temporal to what is eternal, so that the body may serve the soul in its loving obedience to God.

For St. Thomas, Jesus Christ was, of course, the unique saint of saints and the greatest possible exemplar of human and divine beauty. Pointing to Him (in the words of the psalmist) as "'beautiful above the sons of men,'" Thomas calls particular attention to David's praise of the messianic king: "'Grace is poured abroad in thy lips'" (Ps. 44:3).[33] Glossing the Latin *gratia* in this verse from Psalm 44 ("effusa est gratia in labiis tuis") with the Greek *eucharis* in Sirach 6:5 ("Lingua eucharis in bono homine abundabit" [A pleasing tongue will abound in a good man]), Thomas strengthens both the identification of the royal bridegroom with the eucharistic Lord and the association of his outpoured word with gracious, apostolic teaching as the food of souls.[34]

In so doing Thomas continues a Dominican tradition. Tugwell observes: "Early Dominican sources are continually exploiting the ambiguity of the words related to *gratia*. It can mean 'grace' (as in God's grace), but it also means 'graciousness', which in turn wins the 'favour' of men."[35] Alluding to Psalm 44:3, Humbert of Romans points to the gracious lips of Christ, which "poured out edifying words, not only in his public preaching, but also in private conversations."[36] Writing more than a century later, St. Catherine of Siena imagines the Davidic and Christological "overflowing" of words as a kind of holy vomiting. According to Catherine the preacher who has drunk the eucharistic wine, that is, the blood flowing from Christ's pierced side, cannot help but overflow with it in the translated form of inspired sermons: "And when we have drunk enough, out it comes over the heads of our brothers and sisters!"[37]

Since God is infinite and infinitely deserving of love, it is impossible to love Him excessively or viciously. The Dominicans therefore delight in exploring the possibility of a holy, licensed, and paradoxically virtuous gluttony. Humbert of

32. Ibid., part 2-2, q. 148, art. 4, 2:1795. Emphasis added.

33. See Thomas F. Ryan, *Thomas Aquinas as Reader of the Psalms,* Studies in Spirituality and Theology 6 (Notre Dame, IN: University of Notre Dame Press, 2000), 140–43.

34. St. Thomas Aquinas, *Expositio in Psalmos David,* in *Opera omnia* (Parma, 1863; New York: Musurgia, 1949), 14:320b.

35. Tugwell, introduction to *Early Dominicans,* 231n81.

36. Humbert of Romans, *On the Formation of Preachers,* in *Early Dominicans,* 295.

37. St. Catherine of Siena, Letter 6 (To Frate Bartolomeo Dominici), in *The Letters of St. Catherine of Siena,* ed. and trans. Suzanne Noffke, O.P., Medieval and Renaissance Texts and Studies (Binghamton: State University of New York, 1988), 1:50; *Epistolario di Santa Caterina da Siena,* ed. Eugenio Dupré Theseider (Rome: Senato, 1940), 1:31–32: "E quando egli à bene beiuto, egli el gitta sopra el capo de' fratelli suoi." Noffke promises a complete, four-volume translation and edition, but only the first two have been completed to date.

Romans, for example, observes: "There are many who are always eagerly on the look out for tasty things to eat. But there is no more delightful food for a healthy palate than the word of God."[38] Eagerly devouring the Word of God and savoring His wisdom (*sapientia*), the Christian eats heavenly things and thus avoids being eaten by devilish forces. "Lack of knowledge contributes to the filling up of Hell," Humbert insists, citing Isaiah 5:13–14 as a proof text: "'The people has been taken captive because it has no knowledge. That is why Hell has enlarged its appetite, opening its mouth wide beyond measure.'"[39] Whereas Eve sought the knowledge of good and evil, was deceived by the serpent, and seduced by the beauty of the fruit, the Christian is to regain paradise through the science of God's Truth, apostolic preaching, and feasting on the Word and the Eucharist.

Humbert of Romans highlights the instrumental power of artistic beauty to restore spiritual beauty by comparing the art of preaching to the various *artes*. "Preaching is a kind of singing," he declares.[40] Elsewhere he likens it to hunting, to architecture, and to trading.[41] He advises preachers to imitate good models as they prepare their sermons: "We see this in painters, who paint better when they follow a good model which they keep before their eyes."[42] Comparing the art of preaching to that of cookery, he gives the following advice concerning invention: "[The preacher] should first make sure that what he proposes to say is useful, like a good host making sure that the food he prepares for his guests is good. Then, out of such useful material, he should aim to prepare something which is not immoderately long, just as a good host does not serve up absolutely everything that can be found at the butcheries."[43] Having done that, and arranged everything fittingly, the preacher trusts in God to inspire his delivery, knowing that "it belongs to God's grace to open man's mouth."[44]

By this Humbert clearly means a man's mouth, and not a woman's. On the authority of St. Paul, Humbert insists, "[The preacher] must be of male sex."[45] He goes on to explain why:

> "I do not permit a woman to teach" (I Tim. 2:12). There are four reasons for this:
> first, lack of understanding, because a man is more likely to have understanding than
> a woman. Second, the inferior status imposed on women; a preacher occupies a su-
> perior position. Thirdly, if a woman were to preach, her appearance would inspire

38. Humbert of Romans, *The Formation of Preachers,* in *Early Dominicans,* 201.
39. Ibid., 187.
40. Ibid., 191.
41. Ibid., 193–94.
42. Ibid., 293.
43. Ibid., 206.
44. Ibid., 195.
45. Ibid., 223.

lustful thoughts, as the Gloss on this text says. And fourthly, as a reminder of the
foolishness of the first woman, of whom Bernard says, "She taught once and wrecked
the whole world."[46]

I have quoted this passage at length because it helps to explain why women
were slow to find a home in the Dominican family, given the centrality of preach-
ing to the very definition of the order's spirituality. The friars of the first Order
of Preachers were ambivalent about accepting pastoral responsibility for houses
of religious women, and the spirituality of the women under their direction did
not accord easily with their own.[47] Writing about the early Dominican women,
Tugwell admits: "There is . . . an ambiguity about many of the houses of Do-
minican nuns, and in all of them there is an incompleteness about their Domini-
can identity. . . . The members of the Order of Penance [the third Dominican
Order, founded 1285] had a social, rather than a doctrinal apostolate; they typi-
cally ran hospitals and hospices."[48] Catarina Benincasa, an unschooled, four-
teenth-century, Dominican tertiary, who is now known to the world as St.
Catherine of Siena and revered as a Doctor of the Church, first made it possible
for women to make Dominican spirituality truly their own.

St. Catherine of Siena's Dominican Discipleship

The life of Catarina Benincasa, as related in the *Legenda maior* written by her Do-
minican disciple and confessor, Raymond of Capua (1399), emphasizes her spir-
itual closeness to St. Dominic and the Dominican family. From her infancy, she
attends the liturgies at the Church of St. Domenico in Siena. At age five, she is
(miraculously) reading the lives of the saints, especially that of St. Dominic
("gesta quorumdam Sanctorum et potissime B. Dominici"), and resolves to fol-
low their example.[49] In her great desire to follow St. Dominic as a preacher work-

46. Ibid. As Tugwell notes, the source for the concluding aphorism is actually St. John Chrysos-
tom (PG 62, 545), not St. Bernard. See *Early Dominicans*, 231n41.

47. Amy Hollywood has amply demonstrated the formative influence of the spirituality of the
beguine mystics, Mechthild of Magdeburg and Marguerite Porete, on the Dominican Meister Eck-
hart. See her *The Soul as Virgin Wife: Mechthild of Magdeburg, Marguerite Porete, and Meister Eck-
hart,* Studies in Spirituality and Theology 1 (Notre Dame, IN: University of Notre Dame Press,
1995).

48. Tugwell, introduction to *Early Dominicans*, 29.

49. Raymond of Capua, "De S. Catharina Senensi, virgine de poenitentia S. Dominici," in
AASS 12 (April 3), 1.1.31, 875. Hereafter I refer to Raymond's Life of St. Catherine as the *Legenda
maior*. For a modern translation, see Bl. Raymond of Capua, *The Life of St. Catherine of Siena*,
trans. George Lamb (London: Harvill, 1960).

ing for the salvation of souls, she considers disguising herself as a man in order to enter the Order: "fingendo se masculum Ordinem Praedicatorum intraret."[50] Later St. Dominic addresses her as his dear daughter (*filia dulcissima*) in a vision and promises to clothe her in the garb of the order.[51] Eventually she receives the mantle of a Dominican tertiary, joining the Order of Penitents founded by St. Dominic.[52] Her mystical marriage to Christ is witnessed by St. Dominic, in company with the Virgin Mary, Mary Magdalene, and other saints.[53] She sees St. Dominic in other visions, one of which establishes a parallel between Christ as the *Verbum divinum* sent from the Father's mouth, on the one hand, and Dominic, as the preacher of God's Word, on the other.[54] Shortly after their mystical marriage, Christ reminds Catherine of her childhood zeal for souls and of her desire to be a Dominican preacher, even at the risk of disguising her sex; he then calls her to leave her contemplative seclusion, embracing the active life as his apostle of charity in Siena.[55] Later, after a near-death experience during a prolonged trance, Catherine is sent to preach in wider and higher circles, confounding the proud.[56]

Composed to support her canonization, the *Legenda* defends Catherine against her detractors and thus exhibits a typically Dominican concern with the proper and improper uses of the mouth and tongue. Raymond contrasts Catherine's prayer, eucharistic fervor, extreme abstinence, teaching, and moral exhortation with the backbiting of her enemies, who spread slanderous gossip,[57] accuse her of an unhealthy asceticism (especially excessive fasting), criticize her for her frequent Communions, and blame her for vainglory in her public appearances.[58] Catherine responds charitably to those who slander her, suffers pangs of guilt and self-doubt for having caused offense, and accepts the cross of being spoken against as a divine seal on her apostolic vocation.[59]

Catherine's own writings—the 382 extant letters, the *Dialogue,* and the twenty-six long prayers—give ample evidence of her self-identification as a preacher and a follower of St. Dominic. In a letter to her confessor, Raymond of Capua, for example, she relates a vision that she had on the night of April 1, 1376, in which she walked, in company with her "father Saint Dominic [*padre mio santo Domenico*]," into the open side of Jesus, from whom she received a commission to go forth to

50. *Legenda maior,* AASS 12 (April 3), 1.1.38, 872.
51. Ibid., 1.3.53, 875.
52. Ibid., 1.4.69–78, 879–81.
53. Ibid., 1.7.114–1, 890–91.
54. Ibid., 2.7.199–202, 911–12; 2.7.204–5, 912–13.
55. Ibid., 2.1.121–22, 892.
56. Ibid., 2.8.216, 915.
57. Ibid., 2.4.156–57, 901.
58. Ibid., 2.5.168–76, 904–6.
59. Ibid., 2.5.177, 906.

proclaim the Gospel joyfully to Christians and unbelievers alike, carrying "the cross on [her] shoulder and an "olive branch in [her] hand" as iconic representations of her calling and message.[60]

Whereas the monastic saint Hildegard of Bingen (1098–1179) depicts the stages of ascent to Heaven in the combined forms of the Tree of Life, the Tree of Virtues, and Jacob's Ladder,[61] the Dominican seer, Catherine of Siena, depicts the steps on the way of perfection in her *Dialogue* in the visionary images of (1) a flowering Christ-Tree of Life and Virtues; (2) a busy city bridge, teeming with travelers and built with variegated stones that represent virtues; and (3) the tiered zones of Christ's body—his feet, his pierced side, his mouth—extended on the cross as a priestly bridge or staircase of mediation between Heaven and earth. The Cistercians similarly use the three bodily zones to represent stages in the spiritual life, but they see Christ's mouth primarily as the site of the mystic kiss ensealing an intimate union between the soul and God,[62] whereas Catherine emphasizes the mouth of Christ the preacher, speaking from the table of the cross, in whose mission the mature disciple shares.

The soul who "has arrived at his mouth . . . shows this by fulfilling the mouth's functions [*facendo l'officio della bocca*]," declares Catherine in her *Dialogue*.[63] Since "the mouth speaks with its tongue and tastes flavors,"[64] that office is two-fold. Speaking involves both prayer to God and preaching to others: "This tongue has an external and an internal language. Interiorly, the soul offers me loving desires for the salvation of souls. Externally, she proclaims the teaching of my Truth, admonishing, advising, testifying without any fear for the pain the world may please to inflict on her."[65] Tasting means eating "the food of souls [*el cibo de l'anime*] for [Christ's] honor at the table of the most holy cross," that high pulpit of suffering whereon Jesus hung, declaring his longing for souls in the words: "I thirst" (John 19:28).[66]

60. St. Catherine of Siena, Letter 65, *Letters*, 1:207; *Epistolario*, 1:275: "Allora mi dava la croce in collo, e l'ulivo in mano."

61. See St. Hildegard of Bingen, *Scivias*, trans. Mother Columba Hart and Jane Bishop (New York: Paulist Press, 1990), Vision 8.13–25, pp. 435–48.

62. See St. Bernard of Clairvaux, *On the Song of Songs, I*, trans. Kilian Walsh, O.C.S.O. (Spencer, MA: Cistercian Publications, 1971), Sermons 3 and 4, pp. 16–25.

63. St. Catherine of Siena, *The Dialogue*, 140; *Libro*, chap. 76, 145.

64. St. Catherine of Siena, *The Dialogue*, 140; *Libro*, chap. 76, 145: "La bocca parla con la lingua che è ne la bocca; el gusto gusta."

65. St. Catherine of Siena, *The Dialogue*, 140; *Libro*, chap. 76, 145: "Questa lingua parla actuale e mentale: mentale, offerendo a me dolci e amorosi desidèri in salute de l'anime; e parla actuale, anunziando la doctrina della mia Veritá, amonendo, consigliando e confessando senza alcuno timore di propria pena che 'l mondo le volesse dare."

66. St. Catherine of Siena, *The Dialogue*, 140; *Libro*, chap. 76, 145: "Dico che mangia predendo el cibo de l'anime, per onore di me, in su la mensa della sanctissima croce."

In the multivalent expression "the food of souls," which is ubiquitous in Catherine's writings, the originality of her spiritual doctrine shows itself. Other saints had used the expression, to be sure, and it is in keeping with the traditional, biblical, and Dominican imagery of the preacher as the Lord's mouthpiece, who feeds and nourishes others with the Word he sows, the bread he consecrates. Following an Augustinian tradition, the Dominicans had always also emphasized the need for the preacher to eat spiritual food, to savor the scriptures through meditation and study, feasting on them and on the Eucharist before feeding others. Catherine, however, emphasizes that desire itself is also a food, a source of energy, and that the preacher feeds directly on the souls of those whom he longs to nourish.

Catherine stresses the reciprocal relationship, the Communion between those who eat and those who are eaten, their mutual neediness, and the permeability of the "I" who lives for and by others. One can only feed souls if one also eats the food of souls, eagerly desiring the salvation of others. "Our souls must always be eating and savoring the souls of our brothers and sisters," Catherine writes to Sano di Marco di Mazzacorno. "In no other food ought we ever to find pleasure. . . . This, after all, was our gentle Savior's food. I assure you, our Savior gives us plenty of them to eat!"[67]

Catherine's letter to Louis, Duke of Anjou, exemplifies her spiritual emphasis. In it she criticizes the duke indirectly by complaining in general terms about the callous self-absorption of the rich: "The poor are dying of hunger, but they are busy looking for plenty of big meals, elegant dishes, expensive tables, and fine, fancy clothes."[68] The next sentence of Catherine's letter draws a startling parallel between the poor, who are dying of physical hunger, and the wealthy materialists, whose "wretched souls are dying of starvation because they deprive them of their food: holy virtue, holy confession, and God's holy Word," the Incarnate, only begotten Son of God present in the Eucharist.[69] Because the rich do not feed their own souls, they starve the poor, and vice versa, because they neglect the starving poor, their own souls go hungry. Feeding their immortal souls with the improper food of "dead, transitory things [*morte e transitorie*]," the self-indulgent rich are

67. St. Catherine of Siena, Letter 25, *Letters*, 1:95; *Epistolario*, 1:108: "[S]empre si conviene che l'anime nostre sieno mangiatrici e gustatrici dell'anime de' nostri fratelli. E di nullo altro cibo ci dobiamo mai dilettare. . . . che questo fu il cibo del nostro dolce Salvatore. Ben vi dico che 'l nostro Salvatore me ne dà a mangiare."

68. St. Catherine of Siena, Letter 79, *Letters*, 241; *Epistolario*, 1:321: "E' povarelli si muoiono di fame, ma essi sempre cercano le grandi e le molte vivande, nettezza di vasi, le care mense, e' dilicati e ornate vestimenti."

69. St. Catherine of Siena, Letter 79, *Letters*, p. 241; *Epistolario*, 1:321: "che si muore di fame, però che le tolgono el cibo della virtú e della santa confessione, e della parola santa di Dio, cioè della parola incarnata, unigenito suo Figliuolo."

like whitened sepulchers that "give off the disgusting stench of bodily and spiritual corruption," instead of the sweet odor of sanctity.[70]

The proper "food of souls" comes, in Catherine's understanding, from multiple sources. Receiving the Eucharist, one partakes in Christ's own soul and thus becomes imbued with Jesus' own hunger and thirst for the coming of God's kingdom to all. From noble friendships one draws vital, spiritual strength. Through personal contact with the needy, one's own power to give and to receive is enhanced. Through accepting and giving correction, one eats a sometimes bitter, spiritual food that can effect a purging of the soul's illness. Such spiritual food also increases one's immunity to undue concern about worldly honor and public opinion. "Every virtue of yours and every vice is put into action by means of your neighbors," Christ teaches Catherine.[71]

Indeed, according to Catherine, the proof that one has arrived at "the third stair, that is, to his mouth," is that nothing limits the freedom of the apostolic soul, which is "clothed in [God's] loving charity and enjoying the food of the salvation of souls with true and perfect patience"—a state in which "nothing can disturb her," because "she has . . . drowned her own will, and when that will is dead, there is peace and quiet."[72] Their virtues refined and perfected in charity, such souls "begin to eat and savor souls [*diventa mangiatore e gustatore dell'anime*] and have no fear of losing their bodily life."[73] Mature in Christ, they "go into battle filled and inebriated with the blood of Christ crucified," which charity places before them "in the Hostel [*la bottiga*] of the mystic body of holy Church to give courage to those who would be true knights."[74]

Her linkage of inebriation with apostolic fearlessness in this passage harkens back to the Pentecostal scene described in Acts 2:13–15, but Catherine also sees in the wine of the Eucharist, which is Christ's Blood, a literal, sacramental means to renew that same fervor in the present. On the bridge that represents for Cather-

70. St. Catherine of Siena, Letter 79, *Letters*, 241; *Epistolario* 1:322: "che generan puzza e fastidio di disonestà nell'anima e nel corpo." Catherine's ability to read souls included the ability actually to smell such a foul odor.

71. St. Catherine of Siena, *Dialogue*, 33; *Libro,* chap. 6, 11: "[O]gni virtú si fa col mezzo del prossimo, e ogni difecto."

72. St. Catherine of Siena, *Dialogue*, 140–41; *Libro,* chap. 76, 146: "Cosi in questo terzo stato truova la pace per si facto modo che neuno è che la possa turbare, perché ha perduta e annegata la sua propria volontá, la quale volontá dá pace e quiete quando ella è morta vestito l'affecto loro de l'affecto della caritá, gustando el cibo della salute de l'anime con vera e perfecta pazienzia."

73. St. Catherine of Siena, Letter 61 [To Cardinal Pietro Corsini of Florence], *Letters*, 194; *Epistolario,* 1:254.

74. St. Catherine of Siena, *Dialogue*, 143; *Libro,* chap. 77, 148–49: "anco con dilecto sta nella bactaglia, pieno e inedbriato del sangue di Cristo crocifixo. El quale Sangue v'è posto dinanzi nella bottiga del corpo mistico della sancta Chiesa da la mia caritá, per fare inanimare color che vogliono essere veri cavalieri."

ine the mediation of Christ and the whole way of salvation, she imagines there to be a "Hostelry [*la bottiga*], . . . to serve the bread of life and the blood, lest the journeying pilgrims . . . grow weary and faint on the way."[75] In this same tavern, Catherine insists, one can also get drunk, if "the soul is inebriated [*inebbria l'anima*]" by "the blood of Christ" and "set on fire and sated with holy longing, finding herself filled completely with love of [God] and of her neighbors."[76]

Catherine as Mary Magdalene:
Preaching from the Scaffold

In true Dominican fashion, Catherine takes a biblical apostle as her example, namely "that loving apostle Magdalen [*quella appostola inamorata Magdalena*]": "As a sign that she *was* drunk with love for her Master, she showed it in her actions toward his creatures, when after his resurrection she preached in the city of Marseilles."[77] According to the *Legenda maior,* God gave Mary Magdalene to Catherine to be her teacher and spiritual mother: "Ipsam Magdalenam dederunt huic virgini sacrae in magistram et matrem."[78] Writing to Monna Bartolomea di Salvatico of Lucca, Catherine paints a vivid portrait of Magdalena as her apostolic model: "The dear Magdalen . . . was no more self-conscious than a drunken woman [*come ebbra*], whether alone or with others. Otherwise she would never have been there among those soldiers of Pilate, nor would she have gone and stayed alone at the tomb. Love kept her from thinking, 'What will it look like? Will people speak ill of me because I am rich and beautiful?' Her thoughts weren't here, but only on how she might find and follow her Master."[79] Unlike Humbert of Romans, Catherine evidently did not regard the mere possibility of lustful

75. St. Catherine of Siena, *Dialogue,* 66; *Libro,* chap. 27, 53: "la bottiga . . . , la quale tiene e ministra el Pane della vita, e dá bere il Sangue, acciò ch' e' viandanti peregrini delle mie creature, stanchi, non vengano meno nella via."

76. St. Catherine of Siena, *Dialogue,* 123; *Libro,* chap. 66, 124.

77. St. Catherine of Siena, Letter 2 [To Monna Agnesa Malavolti and the *Mantellate* of Siena], *Letters* 1:42; *Epistolario,* 1:13–15. On Mary Magdalene as a preacher, see Marjorie M. Malvern, *Venus in Sackcloth: The Magdalen's Origins and Metamorphoses* (Carbondale: Southern Illinois University Press, 1975), 74–75, 126–27. On the saint's Italian cult, see Nicola di Bari, *Il culto di S. Maria Maddalena in Puglia: Fonti letterarie, monumentali e iconografiche* (Bari: Ecumenica Editrice, 1990).

78. *Legenda maior,* AASS 12 (April 3), 1.2.45, 874.

79. St. Catherine of Siena, Letter 59, *Letters,* 186; *Epistolario,* 1:242: "Costei, come ebbra, non si vede più sola che acompagnata, ché, se ella si fusse veduta, non sarebbe stata tra quella gente de' soldati di Pilato, né andata e rimasa sola al monimento; l'amore non le faceva pensare: Che parrà egli? sarà egli detto male di me, perché io so' bella e di grande affare? Non pensa qui, ma pur in che modo possa trovare e seguitare el maestro suo."

thoughts on the part of observers a reason for women, strongly motivated by charity, to refrain from teaching by word and by action. Indeed she recognized that their very attractiveness as women espoused to Christ might be a bait that would lead others to Him through a divine strategy that she elsewhere calls a "holy trick."[80]

A famous letter written to Raymond of Capua in 1375 shows the extent to which Catherine identified with the "drunken" Mary Magdalene and claimed a similar license to teach by word and example. Her letter to Raymond is itself a teaching. She first greets him "in the precious blood of God's Son," in the flood of which she longs to see him be "engulfed and drowned," "fill[ed] to drunkenness," and thus enabled to inundate others with God's outpoured Word.[81] She describes herself as similarly intoxicated with Christ's blood and drawing nourishment from the food of souls, both Christ's soul and Raymond's: "This soul of yours has become my food. Not a day passes that I am not eating this food at the table of the gentle Lamb that was slain."[82]

She goes on to tell Frate Raimondo about the execution of an unnamed man, whom scholars identify as Niccolò di Toldo, whose recent, politically motivated beheading in Siena left her garments literally stained with his blood.[83] She had consoled the prisoner, assisted him in the final reception of the sacraments, and awaited him at the scaffold to give him courage. Before a spiritually transformed Niccolò arrived at the scene, Catherine performed an amazing public gesture. First she invoked Mary and St. Catherine of Alexandria, a pairing wherein a Catherine substitutes for Mary Magdalene, who stood with Mary on Calvary. Then, in the sight of all, she silently "knelt down and stretched [her] neck out on the block [e distesi el collo in sul ceppo]," apparently to beg God either for the grace to die a martyr in Niccolò's stead or to merit for him "at his last moment . . . light and peace of heart," as well as eternal happiness thereafter.[84] Receiving a "sweet promise [la dolce promessa]" in response to her prayer to Mary, the Mother of Sorrows, Catherine lost whatever self-consciousness remained: "My soul was so filled

80. See Letters, 309n18.

81. St. Catherine of Siena, Letter 31, Letters, 1:108–9; Epistolario, 1:126–27.

82. St. Catherine of Siena, Letter 31, Letters, 1:108; Epistolario, 1:127: "non potrebbe venire, dolcissimo padre, l'anima vostra, la quale mi s'è fatta cibo, e non passa ponto di tempo che io non prenda questo cibo alla mensa del dolce agnello."

83. The exact crime for which Niccolò was beheaded is unknown. Since the vicar general of Perugia interceded on his behalf, Niccolò may have been a victim of the incipient, anticurial movement. See Letters, 107. Karen Scott calls him "a Perugian envoy and spy" ("Mystical Death, Bodily Death: Catherine of Siena and Raymond of Capua on the Mystic's Encounter with God," in Gendered Voices: Medieval Saints and Their Interpreters, ed. Catherine M. Mooney [Philadelphia: University of Pennsylvania Press, 1999], 149).

84. St. Catherine of Siena, Letter 31, Letters, 1:110; Epistolario, 1:130.

that although a great crowd of people was there, I couldn't see a single person [*Empissi tanto l'anima mia che, assendo la moltitudine del popolo, non potevo vedere creatura*]."[85]

Blind to the crowd, she nonetheless remained visible to them as she subsequently interacted with Niccolò, who died calling her name ("Catarina!") and that of Jesus.[86] Catherine then entered an ecstasy. At the moment when the prisoner's severed head fell into her hands, her spiritual vision immediately identified, first, the bloody wound of her friend with the pierced side of Christ, and then, her own hands, holding Niccolò's head, with "the hands of the Holy Spirit" that "locked [Christ] in" during his final hour on the cross."[87] Her eyes, "fixed on divine Goodness," saw Christ welcoming Niccolò into "the open Hostelry [*bottiga aperta*] of his side," a door Niccolò entered "as does a bride when, having reached her husband's threshold, she turns her head and looks back, nods to those who have attended her, and so expresses her thanks."[88] For Catherine the flowing of Niccolò's blood in defense of the church renewed Christ's own sacrifice and augured a new age of martyrs: "No more apathy now, my sweetest children, because the blood has begun to flow [*poi che 'l sangue cominciò a versare*]."[89]

This scene, described in one of Catherine's own letters, shows her readiness to teach and exhort a Dominican preacher, Raimondo; to offer spiritual comfort and instruction to a fellow layman, Niccolò; to intercede in prayer for others; and to preach a kind of iconic sermon in a public place, not through words, but through eloquent, self-forgetting actions: mounting the scaffold as her pulpit, putting her head on the block, holding Niccolò's head in her hands, as the *Pietà* shows Mary cradling Christ's dead body.

Apparently her preaching was not without effect on her audience. Among those present that day was the Dominican friar Tommaso da Siena (ca. AD 1432), better known as Caffarini. He later recorded the episode in his *Legenda minor*, an abridgement of Raymond of Capua's *Legenda maior* to be used by preachers in their sermons on St. Catherine. Raymond does not tell this particular story, which Tommaso groups together with other tales of miracles worked by God through the virgin's intercession for the salvation of souls. It is useful to compare his eye-

85. Ibid.

86. Heather Webb observes that "Jesus and Catherine" merge "into one entity" in Catherine's account of the execution. See Heather Webb, "Catherine of Siena's Heart," *Speculum* 80.3 (2005): 810. Webb gives a richly nuanced interpretation of this famous incident in Catherine's life.

87. St. Catherine of Siena, Letter 31, *Letters*, 1:111; *Epistolario*, 1:131: "Le mani dello Spirito santo el serravano dentro."

88. St. Catherine of Siena, Letter 31, *Letters*, 1:110–11; *Epistolario*, 1:131: "volsesi come fa la sposa quando è gionta all'uscio dello sposo, che volle l'occhio e 'l capo adietro, inchinando chi l'à acompagnata, e con l'atto dimostra segni di ringratiamento."

89. St. Catherine of Siena, Letter 31, *Letters*, 1:111; *Epistolario*, 1:132.

witness account with Catherine's. Whereas Catherine in the letter to Raimondo places her own dramatic experience in the foreground, Tommaso focuses on Niccolò's three-part transformation from a prisoner frightened and in despair, to a hero calmly accepting his death, and finally to a saint in glory.

In his account of what transpired, Tommaso first calls attention to his own status as an eyewitness, mentioning that he was present at the execution and showing familiarity with the particular facts of the case: "A rather similar case occurred right here, in this very city of Siena (I was personally present there at the time), concerning a certain noble of Peruga, Nicolaus Tuldi by name, who had received the capital punishment on account of certain statements of his concerning the state of the city, which he had rashly published."[90] Tommaso relates that Niccolò grew desperate in prison: "et ex hoc per carcerem uti desperatus incederet."[91] For that reason St. Catherine visited him and comforted him, with the result that he went peacefully to his death like a lamb and light in heart: "ex quo virgo visitavit eum atque confortavit, velut agnus corde letissimo processit ad mortem."[92] Then Tommaso reports a miracle that was apparently witnessed by the crowd, but not by Catherine in her trance: "His soul by the merits and prayers of that same virgin visibly [*visibiliter*] flew, right then and there, to heaven."[93] Tommaso ends this brief account (eight lines of text in the modern edition) with a reference to Catherine's "beautiful letter" to Frate Raimondo concerning this same matter.[94]

The specific reference to the letter in the *Legenda* inseparably joins two genres (autobiography and hagiography) and two perspectives (female and male) that modern scholars have tended to separate.[95] Catherine's own extraordinary writings reveal a very different Catherine, they say, than the one described in Raymond of Capua's *Legenda maior* and Tomasso Caffarini's *Legenda minor*. Karen Scott, in particular, has emphasized that the *Legenda maior* presents a passive, uniquely elected Catherine, whose extraordinary words and work are a miraculous proof of God's activity in and through her, whereas Catherine's own letters give expression to her sense of personal vocation, to her belief in a universal call

90. *Sanctae Catharinae Senensis legenda minor,* Fontes Vitae S. Catharinae Senensis Historici 10, ed. E. Franceschini (Milan: Fratelli Bocca, 1942), 92: "Quasi similis casus accidit adhuc in ipsa civitate Senarum, personaliter ibi me presente, de quodam nobili Perusino nomine Nicolaus Tuldi; qui, cum ex quibusdam verbis statum civitatis concernentibus incaute prolatis ab eo, capitalem sententiam incurrisset." Translation mine.

91. *Sanctae Catharinae Senensis legenda minor,* 92.

92. Ibid.

93. Ibid: "cuius anima meritis et orationibus eiusdem virginis visibiliter ipso tunc evolavit ad celum."

94. Ibid.

95. See the essays in *Gendered Voices: Medieval Saints and Their Interpreters,* ed. Catherine M. Mooney (Philadelphia: University of Pennsylvania Press, 1999).

to holiness, and to her freely chosen cooperation with God.[96] Whether this difference is primarily due to the generic conventions of hagiography (as Karen Scott and Amy Hollywood have argued) or to sexist bias or to a combination of both remains a topic of scholarly debate.[97]

A comparison of Catherine's and Tomasso Caffarini's accounts of Niccolò di Toldo's execution, however, certainly argues for the overriding importance of considerations of genre and of rhetorical purpose. Referring to Jacobus de Voragine's popular *Legenda aurea,* Tommaso states that he has written his short *Legenda* with a similar purpose, as an aid to busy preachers who want to speak about St. Catherine to their congregations.[98] The main purpose of such sermons would be to spread Catherine's cult and to encourage people to pray to St. Catherine for help in particular needs and situations—distress of soul, physical sickness, demonic possession—where she has proven her miraculous, intercessory power as a close friend of God. The faithful, therefore, were invited to identify not with St. Catherine, but with the unfortunate Niccolò, who received the saint's comfort on earth and, through her prayers, bliss in heaven.

The moving, symbolic actions performed by Catherine at the scene of execution are not even mentioned by Tommaso. Was he, a witness to the scene, as blind to them as Catherine was blind to the crowd? Is he being discreet, downplaying Catherine's controversial appearances in public, veiling Catherine's feminine indiscretion?[99] Is the omission simply directed by his aim to be brief? (He does, after all, refer to the existence of the letter as a supplement to his own account.)

A closer look at Tommaso's miracle story suggests that he did indeed see Catherine's gestural preaching on the scaffold, but that he, not unlike Catherine herself, saw through and past it, recognizing in it an allegorical beauty, the expressed form of a higher reality. The Catherine whom Tommaso sees is a mediator and intercessor, someone who enables Niccolò to move from one spiritual state to another. When Tommaso describes Niccolò going to his death "like a

96. See Karen Scott, "'*Io Catarina*': Ecclesiastical Politics and Oral Culture in the Letters of Catherine of Siena," in *Dear Sister: Medieval Women and the Epistolary Genre,* ed. Karen Cherewatuk and Ulrike Wiethaus (Philadelphia: University of Pennsylvania Press, 1993), esp. 91–96; Karen Scott, "Mystical Death, Bodily Death," in *Gendered Voices,* 136–67.

97. See Catherine M. Mooney, "Voice, Gender, and the Portrayal of Sanctity," in *Gendered Voices,* 115; Hollywood, *The Soul As Virgin Wife,* 26–52.

98. *Sanctae Catharinae Senensis legenda minor,* 2.

99. Karen Scott detects a rhetorical protection of Catherine in Raymond of Capua's *Legenda maior,* observing: "Raymond's account of Catherine's life reflects a certain uneasiness about her apostolic activities that is not present in her own writings. . . . He seems to be on the defensive" ("Catherine of Siena and Lay Sanctity in Fourteenth-Century Italy," in *Lay Sanctity, Medieval and Modern: A Search for Models,* ed. Ann W. Astell [Notre Dame: University of Notre Dame Press, 2000], 89).

lamb" (*velut agnus*), that single phrase recalls Christ's death at the time of Pass-
over, the prophetic announcement of John the Baptist (John 1:29: "Behold, the
lamb of God, who takes away the sin of the world"), the slain Lamb of Revelation
13:8, and the *Agnus Dei* of the Mass.[100] It connects Niccolò's execution to Christ's
death on the cross in a way that suggests that Tommaso understood what Cather-
ine as a latter-day Magdalene was teaching him through her gestural preaching
on the scaffold.

The reference to Niccolò's "very happy heart" (*corde letissimo*) as he approaches
the block suggests the lightness, the *agilitas*, with which his soul will fly to Heaven,
sharing in the martyr's victory over sin and death that was won by Christ on the
Cross. When Tommaso declares that Niccolò's soul *visibly* flew to Heaven, he
claims to have had a vision (was it seen by others in the crowd?) that differs from
the vision of Christ's wounds that Catherine describes in her letter, but which con-
firms the "sweet promise" that the Virgin Mary had made to her concerning Nic-
colò's salvation. Tommaso's sight of the ascending soul seems to be not only a
consequence of his view of Catherine's symbolic action on the scaffold as a drama
of salvation, but also a participation in her own faith-filled vision of things un-
seen. Tommaso sees Niccolò's soul fly heavenward because Catherine sees in Nic-
colò the Jesus who died and rose from the dead, and Niccolò in Jesus.

What I would suggest is that Catherine's own propensity, clearly demonstrated
in this historical episode and in her letter to Raimondo concerning it, to preach
through moving symbolic actions (a tendency in keeping with her luxuriant use
of images in her writings) allows us to narrow the gap between the Catherine of
the life-writings and the saint of the *Legenda*. Catherine kept her focus on God
and was "blind" to the crowd, but she knew herself to be preaching to Niccolò,
Tommaso, Raimondo, and others in the saint they saw, and she did not shrink
back from that iconic role. Indeed the self-image Catherine presents in her writ-
ings is what Scott terms "an extroverted self-portrait," or apostolic icon.[101] In her
letters Catherine never simply calls attention to herself, Scott observes, but rather
she identifies herself with her varied apostolates: "Even when she inserted per-
sonal dialogues with God in her letters, she wanted less to explore the intricacies
of self, or to write a formal autobiography, than to present the self as a general
model and source of encouragement to others."[102] A model and teacher in the
letters, Catherine appears as a mediator in the *Legenda*, but she is an apostle in all
of her roles, as the posthumous use of her life and recorded *miracula* in both Do-
minican sermons and iconography proves. Even after her death, her life spoke to
others, her preaching in word and deed became the subject of preaching.

100. See also Rev. 4:12: "Worthy is the Lamb who was slain!"
101. Scott, "'*Io Catarina*,'" 106.
102. Ibid.

Catherine and her contemporaries knew that one could preach in pictures as well as words; that words needed affective delivery; that speeches needed to be performed if they were to inspire deeds. Scott rightly emphasizes that Catherine was semi-literate, and that her letters are best understood as reflecting an oral culture. Catherine dictated her letters to others, speaking in a personal, passionate way in her native, Sienese dialect. Thus, "for Catherine the writing of letters was really a form of speech, in continuity with other kinds of words which she believed God called her to utter, and that is, informal preaching and prayer."[103] Extending Scott's argument, I suggest that Catherine also knew how to preach through the *biblia pauporum* of illustrative, symbolic gestures, through a refined "body language" (if you will) of outward signs and actions configured to biblical types and liturgical ritual. The beauty of her life as an authentic "performance art" arose from her original mimesis in her own time and place of expressed, evangelical forms.[104] St. Francis stripped himself naked; St. Dominic prayed in nine different postures;[105] St. Catherine mimed a beheading. To this often-dramatic, visual dimension of her preaching through example, the hagiographers and painters were particularly sensitive.

The earliest painting of St. Catherine, a fresco (ca. 1385) in the church of S. Domenico in Siena by her friend Andrea Vanni, shows her in the garb of a Dominican tertiary, holding a lily and accepting the homage paid to her by a kneeling figure, who kisses her hand. The picture is unusual, both because it blends the personal qualities of a modern portrait with the hieratic distance of a medieval icon, and because it includes within its frame a representation of accepted veneration. The kiss on Catherine's hand gives visible expression to the hope of artist and patron alike of obtaining the saint's favor through honoring her, and it sets a pattern of veneration for others, viewing the fresco, to follow.

Accused of vainglory during her lifetime, Catherine insisted (as does Vanni's painted Catherine, who permits her hand to be kissed) on her God-given mission to mediate God's presence for others, even at the risk of standing in the foreground or being exposed to view in the middle, in the no-man's-land between warring parties. When she was asked why she allowed people to kneel before her,

103. Ibid., 109.

104. Kathleen Biddick characterizes the fasting women of Caroline Walker Bynum's *Holy Feast and Holy Fast* (Berkeley: University of California Press, 1987) as highly visible performance artists in her "Genders, Bodies, Borders: Technologies of the Visible," *Speculum* 68.2 (1993): 389–418. Biddick emphasizes the negative, political uses of saints and their ascetic expressions within historical *Christianitas*.

105. See "The Nine Ways of Prayer of St. Dominic," in *Early Dominicans,* 94–103. Observing St. Dominic in prayer as he knelt, lay prostrate, stretched out his arms, and so on, the author of the treatise asserts that his example approves "the way of praying in which the soul uses the members of the body in order to rise more devotedly to God" (94).

Catherine replied that she was so occupied with reading their souls that she paid no attention to what they did with their bodies—an answer that recalls her blindness to the crowd when she stood on the scaffold at Niccolò di Toldo's execution: "Nec de ipsis hominibus quomodolibet cogitabat, nisi quando orabat pro ipsorum salute, vel quando eamdem salutem suis laboribus procurabat."[106] Turned toward God in others, Catherine is self-forgetful. Vanni daringly immortalizes this self-representation by Catherine in his portrait of her.

George Kaftal has shown that Tuscan representations of the life of St. Catherine of Siena likened her to St. Martin of Tours (in her succor of Christ, disguised in a poor beggar) and to St. Francis of Assisi (in her reception of invisible stigmata).[107] Besides the scenes that show these familiar motifs, however, "there is another group of scenes which seem to reflect the fashion in which her contemporaries assessed her [chief] powers."[108] In this group of depicted miracles, St. Catherine appears as a "prophetess," a "healer of the souls of men," and as a "wonder-worker" in the realm of spiritual transformation.[109] Among such miracles the change wrought by her in the despairing soul of Niccolò di Toldo is paradigmatic.

<hr />

Catherine's Eucharistic Preaching:
Fasting and Feeding

Depicting Catherine, artists imitated Catherine's own practice of the art of preaching, an art that entailed great asceticism. René Girard's anthropological approach to the origins of art asserts that it arose in the earliest human societies as a substitutive means to preserve in existence communities threatened by internal division and therefore prone to the violent expulsion or killing of human scapegoats. Greek tragedy, a dramatic genre that depicts the killing of kings and whose very name, meaning "goat song," recalls rituals of animal sacrifice, gives evidence of this historical development.[110]

In a complex way, the ascetic art of sanctity also recalls and answers to the human propensity toward fratricide. Confronted with societies torn by acquisitive competition and mimetic strife, saints throughout history have distanced them-

<hr />

106. *Legenda maior*, AASS 12 (April 3), 3.3.365, 953.

107. George Kaftal, *St. Catherine in Tuscan Painting* (Oxford: Blackfriars, 1949), 10–11.

108. Ibid., 12.

109. Ibid.

110. See René Girard, *Violence and the Sacred*, trans. Patrick Gregory (Baltimore: Johns Hopkins Press, 1977), 64–65, 93–96.

selves from the quarreling parties, voluntarily taking upon themselves the traditional signs of the scapegoat: wearing penitential hair shirts, made from goatskin; fasting; withdrawing to hermitages; renouncing the goods of marriage, wealth, and power over which people compete. Indeed the art of the saints involves freely taking the part of the scapegoat in order to prevent the demonic creation of real victims. The saintly peacemakers are people whose transcendence over material things through union with God puts them in a position to preach eternal truths by word and example to self-divided persons and warring parties, and thus to mediate between them.

Catherine of Siena can easily be numbered among such penitential, artistic peacemakers and mediators. In the face of a church torn by sin and schism, the ascetical Catherine represents the beauty of Christ's mystical body as a *Christiana deformis,* beautiful in the deformity of a reconciling at-one-ment (the literal meaning of *atonement*). When her twin sister Giovanna died in 1347 at birth, Catherine was literally formed from the womb to know the potential cost of mimetic strife among siblings, a tragic competition epitomized in ancient myth as a warfare between twin brothers.[111] Surviving when her sister died, Catherine was also formed by that experience to mediate between heaven and earth, to occupy a certain psychological and spiritual threshold between the realms of time and eternity. At age six she had her first vision of Christ, to whom she vowed her virginity. At thirteen Catherine mourned the death of Bonaventura, the sister to whom she was closest. That same year she cut off her hair in stubborn defiance of her parents' plans for her to marry—a gesture that symbolically links her grieving for the dead with her own death to the world. In 1363, when her younger sister Nanna (named after her twin sister Giovanna) died, the fourteen-year-old Catherine began to abstain from food and openly declared that she would never marry.

Admitted in 1364 to the *Mantellate* (the Dominican Third Order of the Sisters of Penance, called the *Mantellate* because of the distinctive black cape they wore), Catherine lived in seclusion in her parents' house for more than three years, devoting herself to prayer. At the end of that time, she emerged at Christ's call to undertake corporal works of mercy, tending to Sienese victims of famine and plague. Fasting herself and feeding on the Eucharist, she fed the hungry poor and began to gather together a like-minded band of disciples, the *famiglia* (family), with whom she had spiritual conversations. The execution in 1375 of Niccolò di Toldo, a victim with whom she identified, spurred her involvement in public mediation. In 1376 she made a historic trip to Avignon, appeared before Pope Gregory XI, and convinced him to return to Rome. With papal authorization she preached the cause of peace in the Sienese countryside in 1377. In 1378 she worked

111. Ibid., 55–58, 61–65.

for months to smooth relations between Florence and the papacy. That same year saw the outbreak of the Great Schism that divided the church between the forces of pope and antipope—a division Catherine died (AD 1380) trying to heal.

Catherine fed on souls. Read with knowledge of Catherine's *inedia*, the saint's words about eating the food of souls and drinking eucharistic Blood acquire a metonymic force, a palpable reality and a literalness, that no mere metaphor or simple analogy could convey. At age fifteen Catherine was eating only bread, water, and raw vegetables. By 1370 she could no longer tolerate bread. For the last eight years of her life, during which she was most active in ecclesiastical and civic politics and prolific in her writings, she subsisted on liquids. When Catherine of Siena died in Rome at age thirty-three in 1380, she could not swallow even a drink of water. Truly she had arrived at what she called the stage of the Mouth, making Christ's words on the cross her own: "I thirst!" (John 19:28).

Finding herself physically unable to eat, despite her best attempts, and knowing that her inedia was a scandal to some, Catherine struggled to make sense of her condition. The answer to which she came at the end of her soul-searching harkens back to the original loss of Eden and to the "Eve" within herself: "When I have done as much as I can, I enter within myself to get to know my own weakness and God, and I realize that he has given me a very special grace to overcome the vice of gluttony [*el vitio della gola*]."[112] That root sin eradicated through a near-complete abstinence from food, paradise could return, Catherine believed, through a different use of the mouth in inspired prayer, blessing, and preaching. Abstinence from physical food licensed a carnivalesque gluttony in the spiritual realm, where the "food of souls" is eaten. Catherine jokes in a letter to Sano di Maco di Mazzacorno, one of her spiritual sons, concerning a virtuous resolution that he had kept: "I'll wager you've never eaten more delicious food! I'm afraid you may even have been guilty of gluttony (Credo che non mangiaste mai i più dolci cibi. Temo che non abbiate offeso nel peccato della gola)!"[113]

Many different theories have been advanced concerning Catherine's excessive fasting and that of other holy medieval women. Such theories have derived for the most part from a comparative understanding of medieval inedia and the modern eating disorder anorexia nervosa, even though, as William N. Davis observes, "the hallmark of anorexia nervosa, its single most telling diagnostic sign," is completely absent from the medieval accounts—namely, "a dread of fatness, and a self-conscious, unremitting pursuit of thinness."[114] Richard Woods con-

112. St. Catherine of Siena, Letter 19, *Letters*, 1:79; *Epistolario* 1:82.

113. St. Catherine of Siena, Letter 26, *Letters*, 1:97; *Epistolario*, 1:111.

114. William N. Davis, epilogue, in Rudolf M. Bell, *Holy Anorexia* (Chicago: University of Chicago Press, 1985), 181.

curs with this objection: "If Catherine suffered from anorexia nervosa, it was in a form vastly different from that which afflicts young women in the twentieth century."[115]

Problems of definition in such analyses abound. To equate the saint's striving for holiness with the anorectic's pursuit of "thinness" (as Rudolf Bell does) both reduces the holiness of the medieval saint to nothing more than a culturally valued good—a materialist object of symbolic exchange—and denies to the present-day anorectic any conscious or unconscious quest for God as the real, underlying object of her desire (when, in fact, former anorectics not infrequently point to a personal experience of God's love as curative).[116] The clinical definition of anorexia nervosa is too narrow to account for the full range of possible motivations for fasting and its consequences. Even today not all forms of inedia conform to the medically accepted definition of anorexia, the symptoms of which include what Noelle Caskey calls a "highly elaborated visual distortion, . . . the anorexic's inability to 'see' her body as it truly is."[117] Caroline Walker Bynum rejects Bell's notion of "holy anorexia" as a projection of the present on the past but, as Margaret R. Miles rightly observes, neither she nor Bell acknowledges that modern women who fast "reveal a diversity of motivations, an intensity of longing, and an awareness of the social and political leverage gained through their food practices that is comparable to the diversity and complexity of medieval women ascetics."[118] Davis, responding to Bell, remarks: "Perhaps there is more here than disease. . . . Moreover, for a holy anorectic to be truly in control of herself might mean more, or other, than conquering her bodily needs and desires."[119]

Some of the putative causes of modern inedia have been advanced as possible explanations for saintly, feminine fasting. Perhaps the refusal to eat reflects resistance to becoming part of an economic system (patriarchal, capitalist, colonial, consumerist, etc.) that consumes its members, absorbing them as objects to be used and then discarded. Perhaps it connotes a desire to bring a chaotic or oppressive environment under control by exerting self-control. Perhaps it expresses a hunger and thirst to belong to, and to be deeply connected with, something unchanging (e.g., a diet) or someone who loves her in a transcendent way. Perhaps

115. Woods, *Mysticism and Prophecy,* 107.

116. See Karen Way, *Anorexia Nervosa and Recovery: A Hunger for Meaning,* Haworth Women's Studies (New York: Haworth Press, 1993).

117. Noelle Caskey, "Interpreting Anorexia Nervosa," in *The Female Body in Western Culture: Contemporary Perspectives,* ed. Susan Rubin Suleiman (Cambridge: Harvard University Press, 1986), 181–82.

118. Margaret R. Miles, "From Ascetics to Anorexics," review of Caroline Walker Bynum's *Holy Feast and Holy Fast, The Women's Review of Books* 5.2 (November 1987): 23.

119. Davis, Epilogue, 183–84.

it signals a deep empathy and moral solidarity with the hungry poor, such as Simone Weil's.[120]

These and other twentieth-century explanations, which reflect contemporary self-understanding, are very useful to the extent that they find an echo, a cognate expression, in the fasting saints of the Middle Ages. To discover such expressions, as well as others that suggest perceptions and experiences different from our own, we must pay close attention to the larger, semiotic context of a saint's spirituality, the specific way of life and holiness within which fasting and feasting find their meaning.

Recent, influential studies of St. Catherine of Siena have curiously ignored the internal logic of Dominican spirituality—its fasting, feasting, and preaching—as a context for her doctrine and food asceticism. Rudolf M. Bell notes that Dominican women of the Middle Ages were more prone than their Franciscan counterparts to what he calls "holy anorexia," but he explains this difference without reference to the major themes of Dominican spirituality, pointing rather to a complex of societal and psychological circumstances. Since Dominicans "were likely to come from Tuscany or the northeast, that is, from Florence and Venice, centers of opposition to the Papacy," Dominican women typically experienced greater opposition from their immediate environment, according to Bell: "The composite Dominican was more likely . . . to have struggled against parents opposed to her religious vocation who tried to force her to marry."[121] The "struggle for autonomy from the male world around them" translated into "detachment from their own bodies" in the form of "substantially higher levels of austerity, mystical contemplation, fasting, reclusion, and fortitude in bearing painful illnesses."[122] Blending the anthropologies of René Girard and Mary Douglas,[123] Martha Reinecke follows Bell, but emphasizes instead "the different social positions of the Dominicans and Franciscans within the social body," wherein the Dominicans stood more exposed, as border guards on the frontiers of orthodoxy, and therefore were more inclined to exercise control over female bodily passages.[124]

Bynum resists any attempt to distinguish among the women of the various Orders, arguing, "The extent to which women of all life styles and affiliations revered the Eucharist . . . has been obscured" by the correlation of "Eucharistic concern

120. Ibid., 183–85.

121. Bell, *Holy Anorexia*, 132–33.

122. Ibid., 133.

123. See Mary Douglas, *Purity and Danger: An Analysis of the Concepts of Pollution and Taboo* (Boston: Ark Paperbacks, 1985).

124. Martha J. Reinecke, "'This Is My Body': Reflections on Abjection, Anorexia, and Medieval Women Mystics," *Journal of the American Academy of Religion* 58.2 (1990): 256n3.

with factors other than gender. . . . Theologians and historians have failed to notice that food miracles, Eucharistic piety, and abstinence are all food practices."[125] Bynum's major thesis concerns all medieval women, regardless of their spiritualities, because it takes the female body as a common denominator: "Religious women derived their basic symbols from such ordinary biological and social experiences as giving birth, lactating, suffering, and preparing and distributing food."[126] Rather than hating their bodies, they used them as symbols in order to draw closer to God: "Thus they gloried in the pain, the exudings, the somatic distortions that made their bodies parallel to the consecrated wafer on the altar and the man on the cross."[127] Bynum admits that social setting affected this basic symbolism, causing some differences between "women who lived *in* the world (either as tertiaries or beguines or as laywomen) and . . . nuns raised in convents,"[128] but she emphasizes what is common to medieval women as women, giving minimal attention to how the various spiritual "ways" of holiness nuanced feminine identification with the Eucharist and practices of fasting. She cites St. Catherine of Siena as a prime example of womanly, rather than Dominican, spirituality.

Karen Scott criticizes Bell and Bynum alike for their heavy reliance on Raymond of Capua's *Legenda* which, she contends, disassociates Catherine's asceticism and mysticism from her apostolic vocation and work. Whereas they stress Catherine's fasting and eucharistic reception, Scott highlights the saint's preaching, writing, and prayer. According to Scott, Catherine "portrayed herself as an itinerant preacher and peace-maker, as a female apostle or *apostola,* and . . . this role enabled her to integrate the political and contemplative dimensions of her life."[129] Scott calls attention to Catherine's conscious self-identification with Mary Magdalene and the apostles. Citing Humbert of Romans, Scott also observes in passing that Catherine's letters of 1377 portray her "as a sower of grain and a guildsmember or artisan," using "imagery usually reserved for male preachers."[130]

Despite this salutary emphasis on the preaching Catherine, Scott avoids seeing St. Catherine of Siena as a Dominican. The Dominicans proudly claim Catherine as a faithful follower of St. Dominic and as a second founder of the Dominican family, attributing thousands of spiritual children, men and women, to her. Scott, by contrast, discounts Dominic's spiritual fathering of the Sienese saint

125. Bynum, *Holy Feast and Holy Fast,* 75.
126. Ibid., 6.
127. Ibid., 296.
128. Ibid., 26.
129. Scott, "St. Catherine of Siena, '*Apostola*,'" *Church History* 61 (April 1992): 37.
130. Ibid., 39.

(however much she herself points to him), as well as the formative influence of her Dominican pastors and directors, who certainly presented preaching as an ideal calling, however anxious they may have been to see a woman following it. Emphasizing the unusualness of a female preacher, Scott views Catherine's spirituality as unprecedented, sui generis, and dead-ended: "There were no religious institutions for lay people, especially women, who wanted to be apostles. . . . Her originality is underscored by the fact that she left no legacy as an apostle. . . . [S]he founded no new religious order for apostolic women; and after she died, her *famiglia* disintegrated."[131] In the sixteenth century, Scott acknowledges, St. Catherine did become "a significant model for the lives of women in enclosed monasteries," but the Catherine they knew and followed was "the mystical Catherine" of Raymond of Capua's *Legenda,* rather than the apostle she proclaimed herself to be in her own writings.[132]

Certainly Catherine of Siena was unique, as all persons and especially all saints are, but Scott errs in misunderstanding the nature of saintly mimesis and in the related question of how medieval saints' lives were read. The feminist impulse to discount male-authored *legenda* of women saints must be resisted not only because they give us (admittedly perspectival and generic) contemporary portraits of real women's lives, but also because these *legenda* were read and interpreted by other women, who patterned their lives, in turn, after the saints'. As Anne Clark Bartlett has insisted, women knew how to discover viable models for themselves in the male-authored lives of women saints and in their artistic representations, even as they knew how to accomplish the more difficult, hermeneutical feat of interpreting the hagiographies of saintly men as imitable by women.[133] St. Rose of Lima's reading of St. Catherine's life (even as that reading is reported in Rose's own *legenda*) enables us to understand both lives in a different, polyvocalic, polysemous way and to rediscover the *apostola* represented in them.

In each case, as Alejandro García-Rivera suggests, a sort of deep reading is involved, an interpretive praxis that recognizes an expressed form without reducing a *form* to its *expression* in a literally idolatrous way. "The polarity of form and expression is at the heart of real distinction," García-Rivera emphasizes. "The [polar] unity between form and expression does not allow expression to be a blind copy of what is being expressed," as in the putative example of a "material holo-

131. Ibid., 44.

132. Ibid., 36.

133. See Anne Clark Bartlett, *Male Authors, Female Readers: Representation and Subjectivity in Middle English Devotional Literature* (Ithaca: Cornell University Press, 1995). Bartlett argues that women readers filtered misogynist texts, using a variable literacy that allowed them to discover and to appropriate what was valuable to them and to disown the rest.

gram copy of Michelangelo's *David*."[134] Rather, "a successful copy of a great work of art"—like the genuine *imitatio* or "following after" (in German, *Nachfolge*) of a saintly model—"requires that the [nonidentical] relation between a form and its expression . . . be preserved."[135] Contra Frank Graziano, who approaches "sanctity as tautology,"[136] I join García-Rivera in emphasizing this nonidentical-ness in saintly relationships.

When St. Catherine of Siena named herself a daughter of St. Dominic and determined to follow him, imitating him as he had imitated Christ (cf. 1 Cor. 11:1), she knew full well that she could never be exactly like him, nor did she desire to be. Instead she viewed Dominic as an expressed form of Christ, an epiphany of Christ, which she impressed on her soul in order to give it an entirely new and fresh expression, which differed in gender and historical context from his. The food images used by St. Catherine of Siena are those of the early Dominicans, but she renders them newly vibrant in her writings and literally embodies them to an unprecedented degree through metonymic gestures of preaching, fasting, feeding, and feasting that transform her life into a Dominican icon. What St. Clare was for St. Francis of Assisi during his lifetime, St. Catherine became for St. Dominic in the second century after his death, thereby taking her place at his side as his equal and giving the Order of Preachers a second, distinctly feminine, and mystical foundation.

The Dominican preachers and artists, who represent themselves as Catherine's "sons," presented the Sienese tertiary in *legenda* and sermons as a powerful intercessor for souls, but also as a saintly model for other "Catherines," both men and women, to follow. Turned toward Christ, she could lead others to him. Focusing on the mystical phenomena in the *Legenda maior* (the mystical marriage, the exchange of hearts, the stigmata) and separating them from Catherine's verbal preaching, Scott defines what she calls the "Catherinian model" too narrowly, even in application to monastic women mystics, who have often shown a great, conscious apostolic spirit, supporting the direct missionary work of others with their prayers and cloistered martyrdom.[137] She ignores later developments in the

134. Alejandro García-Rivera, *The Community of the Beautiful: A Theological Aesthetics* (Collegeville, MN: Michael Glazier/Liturgical Press, 1999), 84.

135. Ibid., 85.

136. Frank Graziano, *Wounds of Love: The Mystical Marriage of Saint Rose of Lima* (Oxford: Oxford University Press, 2004), 53. Graziano "explores mysticism in atheistic perspective" (viii), drawing on Marxist and psychoanalytical theory.

137. Scott, "St. Catherine of Siena, 'Apostola,'" 36. As an example of a cloistered nun who thought of herself as an apostle, the Carmelite Doctor of the Church, St. Thérèse of Lisieux (1873–1897), patroness of missionaries, comes readily to mind. Segundo Galilea mentions another Doctor of the Church, St. Teresa of Avila (1515–1582), as someone who combined the contemplative

Dominican Second Order of Nuns, who have devoted themselves to educational work in schools. The lives of at least two prominent women saints, Catherine of Genoa (1447–1510) and Rose of Lima (1586–1617), moreover, strongly contradict Scott's thesis that Raymond of Capua's *Legenda* removed Catherine the *apostola* entirely from view, leaving her with no uncloistered, female following.

<hr>

Another Catherine: Saint Catherine of Genoa

In the eyes of modern scholars, Catarinetta Adorna of Genoa appears similar in many respects to Catarina Benincasa of Siena. Caroline Walker Bynum, for example, writes: "We find in the two greatest women writers of medieval Italy, Catherine of Siena (d. 1380) and Catherine of Genoa (d. 1510), a similar concentration on eating and drinking, on bread and blood, as the crucial images for encounter with God."[138] The association of the two saints has, however, a long history. Writing twenty-five years after the death of Catherine of Genoa, Monsignore Agostino Giustiniano, Bishop of Nibio, likens the two saints on the basis of their heroic virtues. In his *Castigatissimi Annali,* published in 1537, he writes about the Genoese saint: "And her life, after the Divine goodness had touched her heart in the years of her youth, was all charity, love, meekness, benignity, patience, incredible abstinence, and a mirror of every virtue, so that she can be compared to St. Catherine of Siena."[139] In 1737, on April 30, the Feast of St. Catherine of Siena, Pope Clement XII ordered the decree for the canonization of St. Catherine of Genoa.[140]

Friedrich von Hügel finds clearly evident in Dominican spirituality the three key elements of the great world religions: institutionalism, intellectualism, and mysticism: "Dominicans have, from the first, been really representative of external authority, as well as of the speculative, rational bent; and the mystical side has never been wanting, as amongst the early German Dominicans, Tauler and Suso, and many a Dominican female saint."[141] He focuses on Catherine of Genoa's mysticism, suggesting its Dominican qualities. Catherine of Genoa never became a Dominican tertiary, however, nor did she join her converted husband Giuliano

<hr>

and apostolic vocations. See his *Cuando los santos son amigos* (Bogotá, Columbia: Ediciones Paulinas, 1992), 89. I thank Peter Casarella for referring me to this book.

138. Bynum, *Holy Feast and Holy Fast,* 165.

139. Quoted in Friedrich von Hügel, *The Mystical Element of Religion as Studied in Saint Catherine of Genoa and Her Friends,* Milestones in the Study of Mysticism and Spirituality (New York: Herder and Herder, 1999), 1:382.

140. See ibid., 1:306. The actual canonization took place on May 18.

141. Ibid., 1:64.

Adorno in entering the Franciscan Third Order. She had, in fact, no formal connection to any of the orders, but her spiritual closeness to the mendicants is nonetheless certain. Quotes from the *Lodi* of the Franciscan friar Jacopone da Todi (1228–1306) appear in her writings. Her cousin and close associate, Tommasina Fiesca, became a Dominican nun in 1497 and, shortly thereafter, prioress at the Monastero Nuovo di San Domenico, which she reformed. Dominican Inquisitors glossed the texts of the writings attributed to Catherine of Genoa, and the Dominican friar Geronimo of Genoa approved the *Vita e Dottrino* published by Jacobo Geneti in 1551, on which all subsequent biographies and editions of Catherine's work are based.

It is inconceivable that Catarinetta Adorna, a well-educated Italian saint from the powerful Guelph family of the Fieschi, would not have known the story of St. Catherine of Siena, whom she must have numbered among her patron saints. (Catherine of Siena, born exactly a hundred years before her, was renowned as a saint already during her lifetime, and canonized by Pope Pius II in 1461, when the Genoese Catherine was fourteen.) We do not know, however, what Catherinian *legenda* Catarinetta read or heard, nor is there any positive evidence for her reading of Catherine's *Dialogue*. There is no explicit mention of the Sienese saint in Catarinetta's *Vita e Dottrina,* but that does not rule out her strong devotion to her. References to Christ and quotations from scripture are also virtually absent from Catarinetta's writings, but her eucharistic practice and vision of the Crucified Jesus make her attachment to Christ undeniable, and her knowledge of the Bible is equally certain. Catarinetta's Life and all of her writings were actually composed and compiled by her disciples, moreover, during the twelve years after her death in 1510, and their precise origins remain mysterious. They contain Catarinetta's authentic sayings and express her characteristic themes, to be sure, but selectively and embedded in other matter.

There is nonetheless considerable indirect evidence in the *Vita e Dottrina* for Catarinetta's familiarity with Catarina's teaching and Raymond of Capua's *legenda* in its full or abbreviated form. The following parallels are particularly notable.

Both saints identified closely with St. Mary Magdalene, although Catarinetta seems to have viewed her more as a penitent and lover of Christ than as an apostolic preacher.[142] To both of them was granted a vision of the crucified Christ and

142. In *The Life and Sayings of Saint Catherine of Genoa,* ed. and trans. Paul Garvin (Staten Island, NY: Alba, 1964), we read: "While listening to a sermon about the conversion of Mary Magdalen, she felt her heart saying inside her: 'I understand you'. So much of the sermon was applicable to herself that she felt her own conversion was very like that of the Magdalen" (30). Another episode subtly depicts her as a Magdalen who declares her love for Christ with such fervor that her hair comes undone and covers her shoulders (32).

of His flowing blood. Both saints spent three or four years in prayerful seclusion before entering into vigorous, charitable service through corporal works of mercy. Both worked among the destitute poor, nursing plague victims and overcoming their initial aversion to the sights and smells of disease through a radical immersion in them, eating lice and drinking pus. Both embraced a definitively lay vocation, pursuing holiness in the world in an urban setting. Both practiced a remarkable abstinence from food, coupled with fervent and frequent reception of the Eucharist. (Catarinetta received the sacrament daily). Both combined lives of intense mystical prayer with effective, practical works of social justice. (Catarinetta ably administered the large Pammatone Hospital from 1490 to 1496). Around both women a circle of disciples gathered, beloved friends with whom they held spiritual conversation and cooperated in charitable service. Both women authored spiritual literary classics. Both reflected deeply on the related topics of the food of the soul and of the proper use of language. Both valued religious works of art and had artist friends; they responded to sacred images, identifying in them archetypal patterns for their own lives, and they were both portrayed by painters who were their contemporaries.

Given these parallels that imply Catarinetta's following of Catarina, the differences between them take on added importance from a theo-aesthetic perspective, illustrating the possibility and meaning of a nonidentical, saintly mimesis. Unlike Catarina Benincasa, the unschooled daughter of a dyer, Catarinetta Fieschi Adorna was well educated and from a wealthy, Guelph family. Although she had wanted to enter an Augustinian convent, she submitted to her parents' wishes and married at age sixteen the Ghibelline aristocrat Giuliano Adorno, who neglected her, had a child by his mistress, and led a generally profligate life that ended in financial bankruptcy, prompting his spiritual conversion. Catarinetta's sadness in the midst of material comfort during the early years of their marriage was dispelled in an hour of grace when she knew God's personal love for her and resolved to change her life's course: "'O Lord, no more world, no more sins!'"[143]

Formed by these experiences, Catarinetta's spiritual insight and message focus not on temporal peacemaking (for which the arranged marriage between a Guelph and a Ghibelline was a too-worldly symbol), but on the ways of conversion and purification that can make life on earth an ardent purgatory of love in preparation for heaven. Whereas earlier spiritual paths distinguish the three steps of purgation, illumination, and union (represented in Catherine of Siena's *Dialogue* in the ascending zones of Christ's feet, side, and mouth), Catarinetta's doctrine sees all three stages as purifications of the soul through the infused fire of

143. St. Catherine of Genoa, *Purgation and Purgatory, The Spiritual Dialogue,* trans. Serge Hughes (New York: Paulist Press, 1979), 109; *Life and Sayings,* 24.

God's love and the conversion of the soul's food into ever higher forms of spiritual energy.

Both Catherines are strongly eucharistic in their approach to Christ and see the Host as the food of the soul. For Catherine of Siena, receiving the Eucharist is taking the very Word of God and his Truth into her mouth, that she might preach the Good News to others, uniting them in the one Truth and one Bread. Her emphasis is on the gracious, missionary outpouring of God's Word and of his Blood. For Catherine of Genoa, by contrast, the Eucharist is the self-emptying, kenotic Christ, the food that frees her to deny her very self in keeping with the saying of St. Paul: "It is now no longer I that live" (Gal. 2:20).

Anticipating Simone Weil's insight by centuries, Catherine of Genoa uses the obedience of matter and of bread as a model for human submission to the process of purification. She identifies herself closely with the denizens of nature, addressing herself to plants and trees: "'Are you not also creatures created by my God? Are you not, too, obedient to Him'?"[144] Made extremely sensitive to the transitory beauty of all things by her own self-denial of worldly pleasures, "she was most compassionate towards all creatures, so that, if an animal were killed or a tree felled, she could hardly bear to see them lose the existence God had given them."[145]

She imagines for her disciples an extraordinary dialogue in which a piece of bread speaks to protest its imminent consumption. The human interlocutor answers: "Bread, your being was meant for the sustenance of my body, which is of more worth than you, and so you ought to be more content with the end for which you were created than with simply being. It is only your end that makes your being of any value; it gives you your dignity, which you cannot attain except by means of your annihilation. If you live for your end, you will not care about your being, but you will say: 'Quickly, quickly, take my being from me and set me to accomplish my end for which I was created.'"[146]

Making this speech of the personified bread her own, Catarinetta prays before receiving the Host, which she sees held in the priest's hand: "Now quickly, quickly, send it down into my soul, for it is the food of it."[147] The repeated adverbs "quickly, quickly" link the eucharistic annihilation of the bread's substance (through transubstantiation) and appearance (through swallowing) with the overcoming of Catherine's self-love, her "I." She explains the connection as a metonymic process, whereby the one who eats bread thereby surrenders him- or herself to be consumed by God. Recognizing that it is diseased by self-centeredness, the soul

144. St. Catherine of Genoa, *Life and Sayings*, 42.
145. Ibid., 41.
146. Ibid., 123.
147. Ibid., 27.

turns to God: "I offer myself to [God], and make Him a gift of my body and all that I have and may have, so that He may do with me what I do with the bread. When I eat it, nature retains only the substance that is good and throws away the remainder, and so I keep healthy. If God did not bring about this result in us, our natural part would never let itself be annihilated. . . . Our happiness is a contentment that God is doing with us what He pleases."[148]

We reach this paradisiacal state of total God-centeredness in progressive stages, according to Catarinetta. First the body is consumed and purified by the eating of the graced soul: "As, when the bread is eaten, part of it is kept back for nourishment, and the remainder is evacuated, so the soul, by the operation of God, casts off from the body all the superfluities and evil habits acquired by sin and retains within itself the purified body, which then acts with its senses purified."[149] Then the soul, eaten by God, is similarly purified of its imperfections: "When the soul has consumed all the evil inclinations of the body, God consumes all the imperfections of the soul . . . by the infusion of a pure, full, and simple love with which it loves God without questioning."[150]

The more the soul is eaten by God, the more it also recognizes God in the form of a bread for which it hungers. "Let us imagine," she writes, "that in the whole world there was but one bread, and that it could satisfy the hunger of all."[151] The consumption of the soul by God (a process that highlights the spiritual senses of touch and taste) heightens the soul's ability to recognize God and God alone as its desired food (through the spiritual sense of sight). The longing to eat divine beauty that results from this vision is an ardor so great that the fire of this love is the soul's purgatory. The suffering of souls in purgatory (whether in this life or the next) is "the waiting for the bread that will take away their hunger," as they grow closer and closer to it.[152]

Catarinetta envisions the purified soul's return to the state of its pristine creation as the reestablishment of an order in which God reigns without any opposition, a state in which the "You" comes before the "I." Whereas the plebian Catherine of Siena, filled with prophetic zeal, boldly uses the first-person pronoun without fear of egotism; beginning her letters to popes and kings with the words "Io, Catarina," the patrician Catherine of Genoa expresses aversion to any form of self-centeredness and imagines for herself a new way of speaking: "Never say 'I will' or 'I will not'. Never say 'my' but always 'our'. Never excuse yourself, but be always ready to accuse yourself."[153] Not only pronouns but also prepositions

148. Ibid., 123–24.
149. Ibid., 125.
150. Ibid., 126.
151. St. Catherine of Genoa, *Purgation and Purgatory, The Spiritual Dialogue*, 76.
152. Ibid., 77. Cf. Von Hügel, *Mystical Element*, 1:289.
153. St. Catherine of Genoa, *Life and Sayings*, 68.

trouble Catarinetta: "I cannot bear the word *for* or the word *in,* because they denote something that may be in between God and me. This is a love that pure love cannot bear, since pure love is God Himself."[154] Identifying her self with the end of her being, the *telos* that is God, she declares, "My *me* is God, I know no other *me* but this my God."[155] According to *The Spiritual Dialogue,* Catarinetta was often overheard speaking to herself, because she had no one to whom she could adequately communicate her experience.[156] Addressing her close friends, she calls her "poor words" about God hopelessly inapt: "For I know that all that can be said about God is not God, but only tiny crumbs that fall from the table."[157]

With those "tiny crumbs," Catarinetta fed the disciples that gathered around her in the last years of her life. She met the young Genoese lawyer, Ettore Vernazza, the future founder of the Oratory of Divine Love, when they were both assisting plague victims in 1493. In 1499 she accepted Don Cattaneo Marabotto as her confessor and (first and only) spiritual director. Others in the circle of Catarinetta's close friends were her widowed cousin Tommasina Fieschi and Don Jacopo Carenzo, rector of the Pammatone Hospital. Whereas Catherine of Siena's *famiglia* formed early around her as their "mother," the members of the Genoese circle (with the exception of Tommasina Fieschi) first came to know their saint in the twilight of her earthly life. Unlike the cult of Catarina Benincasa, who was acclaimed as a living saint, Catarinetta Adorna's popular cult began eighteen months after her death, when her body was found miraculously incorrupt, and cures started to be attributed to her intercession.

Catherine of Siena used Pentecostal imagery in her many letters to fire the extroverted zeal of her fellow apostles, sending them out into the world. Catherine of Genoa also recalled the hour of Pentecost, but in a symbolic action that characteristically emphasizes the purifying quality of divine fire, the unintelligibility of the fiery tongues (without an accompanying gift of interpretation), the newness of mystical language, and the unity of the two cenacles of the Last Supper and of the Spirit's descent. On the night of August 25, 1510, dying in the midst of her disciples, her body burning with fever and fed only by the Eucharist, Catarinetta "had them open the windows so that she could see the sky. Later in the evening, she had them light candles. As the candles were burning, she sang as well as she could the 'Veni Creator Spiritus', and the others accompanied her."[158] Then she fell silent, and looked up to heaven. After an hour and a half, she spoke: "Let us leave, let us leave."[159]

154. Ibid., 81.
155. Ibid.
156. St. Catherine of Genoa, *Purgation and Purgatory, The Spiritual Dialogue,* 132.
157. St. Catherine of Genoa, *Life and Sayings,* 83.
158. St. Catherine of Genoa, *Purgation and Purgatory, The Spiritual Dialogue,* 142.
159. Ibid.

Both Catarina and Catarinetta understood the beauty of a life as consisting in its conformity to the pattern of Christ's in the Gospels. They recognized their own lives as His followers, therefore, as analogous to works of art—paintings, sculptures, songs—representing evangelical scenes (in various degrees of resemblance) in ever-new settings. Catarina's reception of the stigmata in a church in Pisa literally blends an artwork with a vision, for she was kneeling before a crucifix at a side altar after receiving Communion, when beams of light from Christ's wounds pierced her hands, feet, and heart.[160] Her visions reveal Christ to be an allegorical artist and a master of theatrical disguises, who transforms her humble offerings to beggars into radiant, bejeweled crosses and robes.[161] The child of a humble dyer,[162] she describes the wounds of the martyrs as ornaments (*per adornamento*) enhancing the beauty of their glorified bodies, like the dyeing of cloth: "si come la fregiatura sopra del panno."[163]

Her quotations of scripture (as recorded by Raymond of Capua in the *Legenda maior*) continually cast scenes from her life as a biblical imitation of Christ. When Florentine partisans seek to kill her in a darkened woods, for example, she repeats the "I am" of Jesus in the Garden of Olives at the time of his arrest (John 18:5–8), stepping forward fearlessly to identify herself as the one for whom they are looking: "I am Catarina."[164] Her last words as she dies in Rome are Christ's on the cross: "Into your hands I commend my spirit" (Luke 23:46).[165]

Less vocal than Catarina and more introverted, Catarinetta also drew inspiration for her life from religious artwork, as von Hügel emphasizes. He points to the *Pietà* on the wall in Catarinetta's bedroom, a painting that affected her as a child whenever she looked upon it.[166] To illustrate further her attachment to such art objects, he calls attention to a triptych carefully described by Catarinetta herself in her Codicil of January 1503, and mentioned in her Wills of 1506 and 1509: "The picture evidently represented the Adoration of the Infant Jesus and was painted on wood . . . with Catherine's [coat-of-arms] painted both inside and outside the two wings."[167] Obviously treasured by Catarinetta, this *Maestà* was most probably painted by her pious cousin Tommasina Fiescha, "a distinguished

160. Raymond of Capua, *Legenda maior*, AASS 12 (April 3), 2.7.192–95, 910.

161. Ibid., 2.2.134–36, 895–96.

162. Raymond of Capua describes Giacomo Lapa as an expert dyer of linens: "Porro dictus Jacobus artem exercebat componendi seu faciendi colores, quibus panni lanei seu lanae tinguntur" (Further, the man named James mentioned previously practiced the art of mixing or making colors, with which cloths of wool or linen were dyed)(*Legenda maior*, AASS 12 [April 3], 1.1.25, 869).

163. St. Catherine of Siena, *Dialogue*, 86; *Libro*, chap. 42, 78.

164. *Legenda maior*, AASS 12 (April 3), 4.8.427, 966.

165. Ibid., 3.3.367, 954.

166. Von Hügel, *Mystical Element*, 1:99.

167. Ibid., 1:168.

artist," some of whose paintings and needlework survive.[168] The place of religious art in Catarinetta's spirituality is best illustrated, however, by an episode recorded in *The Spiritual Dialogue.* Suffering purgatory in her body after her soul had received in November 1509 a spreading spark of divine love (*scintilla*), Catarinetta "turned to a picture of the Lord speaking to the Samaritan woman at the well and cried out, 'Lord, I beg of you, give me a drop of that water which you gave to the Samaritan woman, for I can no longer endure this fire'. And her wish was granted. Tongue cannot tell the joy and freshness of the water He gave her."[169]

Catarinetta's spontaneous identification here with the Samaritan woman— and elsewhere, with the penitent Mary Magdalene and the Syro-Phoenician woman, who begged to feast on the scraps from the table (Matt. 15:27)—affords insight into the degree of her virtues and the character of her apostolate. The Christ Catarinetta preaches through her whole way of being is less the One she knows through an infused science, than the One who knows her, who lovingly recognizes the abyss of her sinfulness, her need, her nothingness, and who descends from heaven in and through her, emptying Himself to fill her emptiness and to satisfy her longing. Appropriately it was on the Feast of the Annunciation, when Christ took flesh in the womb of Mary, that "the Lord gave her the desire of Holy Communion, and this desire [to receive Communion daily] never failed her for the rest of her life."[170]

A eucharistic work of art, a monstrance of the Christ she ate in the sacrament, Catarinetta Adorna inspired the artwork of others. Her disciples recorded her life story, and they recast her history and sayings into experimental, mixed literary forms, combining biography with a dialogue between personifications. Her portrait, painted by a contemporary artist, hangs in the Pammatone Hospital, where she lived and worked among the sick for over twenty years. It shows her without a nimbus, as an attractive woman with a sensitive face, not a saint to be venerated. No one ever accused this second, aristocratic Catherine of vainglory. She was truly another, but also an "other" Catherine of Siena.

Saint Rose of Lima: The Creole "Catherine"
of Colonial Peru

The official *Vita S. Rosae Virginis* (1671) by Leonard Hansen, O.P. (AD 1685) endeavors to present the early modern Peruvian saint, Rosa de Santa Maria de las

168. Ibid., 1:168, 1:132.
169. St. Catherine of Genoa, *Purgation and Purgatory, The Spiritual Dialogue,* 137.
170. St. Catherine of Genoa, *Life and Sayings,* 26.

Flores as a virtual reincarnation of the medieval, Italian saint, Catarina Benin-
casa, whose *legenda* Rose had read as a child, and whom she strove consciously to
emulate in every detail.[171] Indeed Rose's asceticism and specific mystical experi-
ences make her an outstanding, uncloistered example of what Scott calls the
"Catherinian model" of female sanctity.[172] Calling Rose "la réplica sudamericana
de santa Catalina de Siena," theologian Segundo Galilea aptly sums up the salient
correspondences:

> Both were daughters of St. Dominic, both were extraordinary mystics and penitents,
> both were filled with the love of Christ from their infancy, both remained in the
> parental home and there lived out their consecration to God and their neighbors
> (with similar difficulties in the family), both spoke and wrote with incredible, theo-
> logical profundity on topics for which they had no educational preparation (in the
> two cases they were examined by theologians and declared to possess infused knowl-
> edge), both were followed by numerous disciples in their respective cities of birth,
> both died prematurely in great suffering and agony.[173]

The great and decisive difference between the two, he remarks, is geographi-
cal.[174] Taking up that passing comment by Galilea, and following a model of
analysis advanced by Alex García-Rivera in his brilliant study of another Peru-
vian saint, Martin de Porres (1579–1639), who was Rose's contemporary in Lima,
I argue that St. Rose's imitation of St. Catherine (Santa Catalina) was guided by

171. Leonard Hansen, O.P., "De sancta Rosa virgine ex tertio ordine S. Dominici Limae in Pe-
ruvia, Americae provincia," 3rd ed. [of 1688], AASS 39 (August 5), 892–1029. Hereafter cited as *Vita
S. Rosae*. Hansen, a German Dominican, taught theology in Vienna, Austria, in 1638, before being
transferred to Rome. The earliest edition of Hansen's *Life* was published under the title *Vita
mirabilis et mors pretiosa venerabilis sororis Rosae de S. Maria* in 1664, followed by another edition
in 1668, the year of her beatification. Antonio González de Acuña (AD 1682) published an abridge-
ment of Hansen's earliest *Vita* in 1665, entitled *Compendium admirabilis vitae Rosae de S. Mariae
Limanae*. A second edition followed in 1668, and a third, entitled *Admirabilis vita, virtus, Gloria
S. Rosae*, in 1671, the year of her canonization. The second and third editions of González de
Acuña's abridgements of Hansen's *Vita* were, in turn, translated into French by Jean Baptiste
Feuillet (AD 1687) and published in 1668 and 1671 under the title *Le vie de bienheureuse espovse de
Jesus-Christ, Soeur Rose de Saint Marie*. There is no full-length, English translation of Hansen's
Vita, but Feuillet's 1671 French work has been (anonymously) translated and is available under
the title *The Life of Saint Rose of Lima*, 3rd ed., ed. F. W. Faber (New York: P. J. Kenedy, 1900). As a
gloss on Hansen's *Vita*, I have used this translated *Life*, as well as a 1968 biography by Sr. Mary
Alphonsus, O.SS.R., *St. Rose of Lima, Patroness of the Americas* (Rockford, IL: TAN Books, 1982).
Also useful was Frank Graziano's *Wounds of Love: The Mystical Marriage of St. Rose of Lima* (Ox-
ford: Oxford University Press, 2004), and the brief biography of St. Rose by M. A. Habig, O.F.M.,
Saints of the Americas (Huntington, IN: Our Sunday Visitor, 1974), 229–36. Habig's book includes
biographies of St. Martin de Porres (223–28) and St. Toribio de Megrovejo y Robles (208–14).

172. Scott, "St. Catherine of Siena, 'Apostola,'" 36.

173. Galilea, *Cuando los santos son amigos*, 85. My translation.

174. Ibid., 85: "La gran diferencia (y decisiva) entre la gran santa italiana y la gran santa peru-
ana es geográfica."

her sense of the Sienese saint as a peacemaker and preacher whose symbolic language mediated between opposed factions in a violent world, internalizing and transcending their divisions. What St. Catherine did in her time and place, St. Rose endeavored to do in the setting of colonial Peru, only a few decades after its conquest by the Spaniards. A creole, St. Rose saw in Catharine a saint who spoke, as it were, two (and more) languages at once, making sermons out of visions.

More divided than Catherine's, Rose's world was characterized by *mestizaje*, defined by García-Rivera as "the violent and unequal encounter of cultures."[175] To read St. Rose's life only from a Spanish, European perspective is therefore to misread it, to fail to decode its layers of meaning. That layering, moreover, is evident in the obvious gaps in Hansen's *Vita*, which both sums up the grounds for Rosa's canonization by Pope Clement X on April 12, 1671, and stitches together, albeit through the filter of previous lives of the saint, the colorful little stories of the 210 Peruvians who knew St. Rose personally and who gave testimony in Lima during her process of beatification.

Teodoro Hampe Martínez, who has studied these original testimonies, calls St. Rose a "símbolo de la identidad criolla," someone who answered to a cultural need for a powerful, appealing synthesis of values, indigenous and Spanish.[176] On the one hand, the personal mysticism of Rose encompassed and harmonized "a series of original elements from the native civilization, such as the sensibility and the ancient, universal cosmology of the Incas."[177] That same cosmological sensibility, which bound her "indissolvably to the American soil," also connected her to a truly universal Catholicism, while setting her apart from the *tradición imperial* of Spanish conquest.[178]

An oil painting by Lázara Bladi (plate 9), which hangs in the Church of Saint Mary in Rome, is entitled *The People of Peru Paying Reverence to Saint Rose*.[179] Commissioned to mark the occasion of Rose's beatification by Pope Clement IX in 1668, it shows Indians, Africans, and Spaniards gazing upward at the central figure of the saint, who, dressed in the white of the Dominicans, holds the Child Jesus lovingly in her arms, presenting Him to view. Her gaze falls upon the Child, while angels above her prepare to wreathe her head with a thorny crown of roses—the iconic mark of her holiness (as a substitute for a halo) and of her one-

175. Alex García-Rivera, *St. Martin de Porres: The "Little Stories" and the Semiotics of Culture* (Maryknoll, NY: Orbis , 1996), 33.

176. Teodoro Hampe Martínez, *Santidad e identidad criollo: Estudio del proceso de canonización de Santa Rosa* (Cuzco, Peru: Centro de Estudios Regionales Andinos "Bartolomé de las Casas," 1998), 109.

177. Ibid.

178. Ibid., 109, 111.

179. I thank Teodoro Hampe Martínez for permission to use this image, which appears in his book.

ness with Christ in His Passion. The painting suggests her eucharistic power to unite a diverse population in Christ, even as it attributes to her a missionary role. At her canonization in 1671, she was declared patroness of Peru, the Americas, the Indies, and the Philippines.

How is St. Rose's status as a hemispheric missionary to be reconciled with her short life as a solitary ascetic? With Hampe Martínez I argue that the cult of St. Rose reflects the full combination of things in her life and the creative tension resulting from that mixture.[180] Rose's Spanish parents were both born in the New World. Her father, Don Gaspar de Flores, was (probably) born in Puerto Rico, settled in Lima in 1580, and entered into service as a member of the viceroy's guard. Her mother, María de Oliva, was born in Peru of Spanish parents; her grandmother Isabel was in all probability the child of an Inca mother and a Spanish father.[181] An Indian maidservant, Mariana, formed part of the chronically poor household, which expanded to include thirteen children. The cities in which Rose lived—chiefly Lima, but also Quives—were populated with Indians, African slaves (imported to work in the silver mines), Spaniards, and people of mixed ancestry, as is reflected in Hansen's list of those whom she housed, nursed, and supported with the work of her hands (needlework, gardening): "egentibus Hispanicis, et Indis, Aethiopibus, candidis, mixtisque (quas Mulatas vocant)."[182]

The parenthetical reference to the term *mulatto* is but one of the many signs of translative, linguistic self-consciousness in Hansen's *Vita*—signs that are highlighted in the *Acta sanctorum* edition by the notes, which were added to try to explain various references to names, customs, and places. Hansen, for example, at one point calls the mining region where Rose was confirmed Canta, using the name of the province, rather than that of the city, Quives.[183] The Bollandist editor Jean Baptiste Carnandet (1820–1880) notes that he has found no place by that name in Peru and goes on to speculate that *Canta* might be a corruption of *Guanca pagus Indorum* or of *Guanca cognomento Velica,* which was famous for its silver mines.[184]

180. Cf. Graziano, *Wounds of Love,* 7: "There seems to be a mutual interdependence . . . between Rose of Lima and the culture that conferred canonical sanctity on her." Whereas Graziano argues for a "tautological" and "narcissistic" relationship between the culture and its chosen saint, however, I emphasize Rose's transformative, countercultural suffering and action.

181. Sr. Mary Alphonsus, *St. Rose of Lima,* 1.

182. *Vita S. Rosae,* AASS 39 (August 5), 965: "Poor Spaniards, and Indians, Africans, whites, and mixed (whom they call Mulattos)."

183. Ibid., 906. Elsewhere Hansen names *Quives.* See 902.

184. *Vita S. Rosae,* AASS 39 (August 5), 907. Canta is a rural province to the east of Lima; Canta is also the name of the capital of that province. The "pagan" *guanca* of the Indians were stones piled in a cairn, often marking the place where a holy person (*huaca*) had been transformed into a rock. *Huanca Velica* survives as the name of a region in contemporary Peru.

The linguistic layering of the *Vita* points to the polyglot circumstances in which St. Rose lived and evangelized. In medieval Europe the illiterate laity were catechized in large part through religious artwork—the paintings, stained-glass windows, sculptures, sacramental signs, and liturgical actions that presented biblical scenes and doctrinal beliefs and that mediated graces to those who meditated on them. In Peru (and indeed, throughout America), missionaries faced a much more challenging linguistic situation. How were they to proclaim the Christian creed, when they lacked fluency in the native languages and cultural codes?[185] When the target languages (Quechua, Aymara, etc.) lacked the necessary terms for translation, such as a generic word for God? When even apparently equivalent lexical terms, analogous narratives (e.g., a Noah-like tale of a Great Flood), similar religious practices (fasting, confession), coincident feasts (e.g., the harvest festival *Caruamita* and Corpus Christi), and identical symbols, such as the sun and the cross, meant different things to the Spanish and the Indians? Given the *mestizija* between the indigenous natives and the colonizers, how could one distinguish a genuine conversion to Christianity from a superficial acceptance of the outward signs of the faith, perhaps as a deceitful cover-up for the continuance of pagan cults?

From the early days of colonization, missionaries to America were divided on these issues, advocating either the gradual acculturation of the faith or the forceful extirpation of Indian idolatry. For the most part, the advocates of acculturation prevailed. "Missionary evangelization," notes García-Rivera, "took the form of aesthetic productions aimed at overcoming the limitations of language."[186] The beauty of the Catholic devotions attracted the indigenous peoples of the Andes who, according to Kenneth J. Andrien, "eagerly embraced outward displays of Catholic worship—the veneration of the cross and colorful devotional objects, ornate churches, cults of the saints, and the ritual use of music, dances, and prayer."[187] Reaching out to the Indians, "Fray Bartolomé de las Casas and his disciple in the Andes, Fray Domingo de Santo Tomás . . . favored using Andean religious imagery of the sun to adorn churches, uniting indigenous iconography with Roman Catholic tradition."[188]

The mixing of religious art forms was facilitated by the working together of

185. The first Christian catechism in the New World was in Aztec picture language. See D. E. Tanck's article, "Catechisms in Colonial Spanish America," *New Catholic Encyclopedia* (New York: McGraw Hill, 1967), 3:232–34.

186. Alejandro García-Rivera, *The Community of the Beautiful: A Theological Aesthetics* (Collegeville, MN: Michael Glazier/Liturgical Books, 1999), 46–47.

187. Kenneth J. Andrien, *Andean Worlds: Indigenous History, Culture, and Consciousness Under Spanish Rule, 1532–1825* (Albuqerque, NM: University of New Mexico Press, 2001), 154.

188. Ibid., 162. The influential *Apologética Historia* of Bartolomé de las Casas, a defense of Amerindian culture, was published in 1559.

artisans—silversmiths, tailors, musicians, bakers, pharmacists, barber-surgeons, smiths, carpenters, and tanners. James Lockhart numbers the Spanish artisans among "the most constructive, stable elements in the Hispanic Peruvian world," noting that "their training of Negro and Indian artisans was one of the principal processes in the acculturation of these groups."[189] At Lake Titicaca a popular shrine dedicated to our Lady of Copacabana was established at the site of an ancient temple of sun worship, in part through the artistry of a devout, Indian Christian, Tito Yupanqui, whose carved, wooden statue of the Madonna and Child (1582) proved to be a medium of miracles. Modeled on the statue of the Virgin in the Church of Santo Domingo (a statue venerated by St. Rose), Yupanqui's image was (in the words of Verónica Salles-Reese) "a sculpture in which native indigenous and European Hispanic elements coalesced to forge a new, intermediary form of representation."[190] A replica of the miraculous statue of the Virgin of Copacabana was also, through the efforts of Bishop St. Toribio Alfonso de Megrovejo (1538–1606), housed and venerated in Lima, where it worked prodigies during St. Rose's lifetime.[191]

Struck by the similarity between many indigenous and Christian beliefs and by native legends suggesting a prior evangelization, Ramos Gavilán, Antonio de la Calancha, Guamán Poma, and Santa Cruz Pachacuti Yamqui maintained that Christian saints—the apostles Thomas and Bartholomew—had preached the faith in the Andes.[192] A Christian cult thus came to surround ancient traces of Viracocha, a *huaca* (holy one), whose footprints left in stone were regarded as the relics of the apostles.[193] In his *Historia general del Perú*, published in Córdoba in 1617, the year of St. Rose's death, Garcilaso de la Vega, a creole with a Spanish father and an Inca mother, argued that the native Indians had been worshiping the true God all along, albeit by the light of reason and in their native language. Thus (as Sabine McCormick observes), Garcilaso defended the controversial actions of the Inca Sairi Tupa, who in 1557 had left his place of royal exile, resigned his sovereignty as emperor at the command (he said) of the divine Sun and Pachacamac

189. James Lockhart, *Spanish Peru, 1532–1560: A Colonial Society* (Madison: University of Wisconsin Press, 1968), 113.

190. Verónica Salles-Reese, *From Viracocha to the Virgin of Copacabana: Representation of the Sacred at Lake Titicaca* (Austin: University of Texas Press, 1997), 24. Salles-Reese documents Yupanqui's efforts to obtain a painting and sculpting license from Spanish authorities, the aesthetic criteria that were invoked, and the whole fascinating history of the statue (18–29).

191. See Sr. Mary Alphonsus, *St. Rose of Lima*, 74–75.

192. See Salles-Reese, *From Viracocha to the Virgin of Copacabana*, 154–56; Andrien, *Andean Worlds*, 162–63.

193. See Salles-Reese, *From Viracocha to the Virgin of Copacabana*, 136–58; Sabine MacCormack, *Religion in the Andes: Vision and Imagination in Early Colonial Peru* (Princeton: Princeton University Press, 1991), 364.

(the Creator Spirit), and then proceeded to visit "the churches of the various monasteries that were being constructed, including the monastery of Santo Domingo [in Lima]," where he "adore[d] the Eucharistic Host, calling it 'Pachacamac, Pachacamac.'"[194]

By 1564 the mixing of indigenous and Christian religious forms and understandings was so ingrained that even the radical *Taki Ongoy* movement, which aimed at a pan-Andean alliance of the Indians to overthrow the Spanish colonizers and restore the cult of the native *huacas,* included Christian elements. Steve J. Stern points especially to the women *taquiongos* who identified themselves with Christian saints, such as Mary Magdalene. They invoked her aid in the rebellion and numbered her among "a pantheon of Hispanic huacas headed by God."[195]

The *Taqui Ongoy* uprising, which reached as far as Lima, sparked the first of several efforts to extirpate indigenous religious practices and awakened anxieties that the Indians' outward observances of Christian devotion masked the stubborn continuance of idolatry, facilitated by the hiding of *huacas* on altars.[196] Cristóbal de Albornoz launched what Stern calls a "thorough anti-idolatry campaign, which consumed two to three years and condemned more than 8000 Indians."[197] Andrien notes the influential 1588 treatise by the Jesuit José de Acosta, *De Procuranda Indorum Salute,* which "called for using stronger tactics—forceful destruction of idols and pagan rituals, followed by the imposition of a rigid Roman Catholic orthodoxy."[198] "Campaigns of extirpation were renewed in 1607 [the year after Bishop St. Toribio's death]," according to MacCormack, "when Francisco de Ávila began investigating cults, myths, and huacas in his parish of San Damián in Huarochiri."[199]

Preaching against idolatry in Quechua and Castilian, Ávila conducted a spectacular *auto de fey* (public act of faith) in the Plaza de Armas in Lima, on December 9, 1609. In the presence of the Viceroy, the city's leaders, and a large crowd, Ávila set fire to a huge pile of ancestral mummies and confiscated *huacas.* As the assembly looked on, Hernando Pauccar, a priest of the indigenous Chaupi Ñamca cult, was shorn of his hair, flogged with two hundred lashes, and sent into exile in Chile.[200] As a member of the viceroy's guard, Don Gaspar de Flores, St. Rose's father, certainly witnessed this scene, which launched extirpation campaigns in the archdiocese of Lima between 1610 and 1627.

194. MacCormack, *Religion in the Andes,* 366.

195. Steve J. Stern, *Peru's Indian Peoples and the Challenge of Spanish Conquest, Huamanga to 1640* (Madison: University of Wisconsin Press, 1982), 66–67.

196. MacCormack, *Religion in the Andes,* 420.

197. Stern, *Peru's Indian Peoples,* 51.

198. Andrien, *Andean Worlds,* 163.

199. MacCormack, *Religion in the Andes,* 389.

200. Andrien, *Andean Worlds,* 173.

These campaigns were, however, exceedingly controversial and evoked, Andrien observes, a loud and sustained "chorus of complaints," both among those in the viceroyalty and within the ranks of the clergy.[201] The bishops of the dioceses surrounding Lima—Arequipa, Huamanga, Cusco, and Trujillo—all refused to participate, and in Lima itself the heavy-handed policy of Archbishop Bartolomé Lobo Guerrero was so unpopular that in 1621 "the cathedral chapter of Lima . . . suspend[ed] all idolatry investigations just one day after the bishop's death."[202]

Where did St. Rose stand on the questions that divided her contemporaries? Rose, a Dominican tertiary, was passionately interested in the work of missionaries, and she openly declared her desire to preach to the Indians in the Andes Mountains, to the distant peoples of China and India, and to sinful Christians in Lima itself: "Ah, if it were permitted to me to exercise the function of a preacher, I would go by day and by night, barefoot, into the most public places, covered with a hairshirt, and wearing a large cross on my shoulders, to exhort sinners to do penance."[203] Rose's declaration shows a keen awareness that formal, public preaching is off limits to her as a woman, but it does more than that. In it Rose imaginatively depicts herself as a preacher who employs, through her penitential costume and dramatic gestures, a highly visible symbolism that renders verbal expression almost superfluous. Rose's imagined, symbolic way of preaching, moreover, matches her actual asceticism: "She [would] walk about barefooted in the garden, carrying a long and heavy cross on her wounded shoulders."[204] The concurrence suggests (as does a wealth of other evidence) that she was in fact "preaching" in Lima to sinners there (albeit without a pulpit); that her penitential preaching spoke to Spaniards and Indians alike; and that her position in the clerical debate about evangelical methods strongly favored a theo-aesthetic acculturation, not a violent extirpation.

Rose's very name suggests a *mestizo* calling. Baptized Isabel, after her Spanish

201. Ibid., 176.

202. Ibid. Pablo Joseph de Arriaga's *La extirpación de la idolatría en el Peru* was published in Lima in 1621.

203. Feuillet, *Life of St. Rose of Lima,* 164; Hansen, *Vita S. Rosae,* AASS 39 (August 5), 961: "Aiebat si quoquo modo sibi licuisset praedicatoris fungi officio, utique se opertam horrido cilicio, nudipedem, squalidam, interdiu noctuque per omnes Limensium vicos et compita, circumlaturam crucifixi Redemptoris imaginem et ubique per foras, per trivia, per angiportus identidem clamore lugubri vociferaturam: "Resipiscite, o resipiscite, peccatores" (She was saying that if somehow the office of a preacher had been granted to her to fulfill, she would certainly busy herself to go by day and night through all the quarters of Lima and its crossroads, clad in a coarse garment, barefooted, dressed in mourning, carrying around an image of the crucified Redeemer through open places, in public areas where three roads meet, through narrow streets, and everywhere she would cry out in a sad voice the same message: "Come to your senses, O come to your senses, sinners!").

204. Feuillet, *Life of St. Rose,* 60; Hansen, *Vita S. Rosae,* AASS 39 (August 5), 916: "noctu perambulabat hortum nudipes, imposita sibi oblonga cruce, quam dum lividis gestabat humeris."

(creole) grandmother, the newborn was first given the name Rosa by the family's Indian maidservant, Mariana, who (together with others) saw the vision of a beautiful rose appear on the face of the three-month-old baby. Called thereafter Rosa by her mother, and Isabel by her grandmother, the child became the center of a feud between the two that was resolved only when Archbishop St. Toribio (canonized a saint in 1726) gave Rosa (somewhat surprisingly) as her confirmation name. Even then the girl was troubled in conscience about the name Rosa, because of the physical beauty it implies, and because she did not apparently associate it with a particular patron saint. She only gained peace about the matter when she was inspired in prayer to associate her name with the Virgin Mary's allegorical title, Rosa Mystica, by calling herself Rosa de Santa María.[205]

Rosa's hagiographers, of course, find a rich, prophetic meaning in her name, seeing her *nomen* as an omen. Juan de Vargas Machuca, an erudite Hispanic friar from the Dominican Province of St. John the Baptist in Lima, published in Seville in 1659 a panegyric in verse and prose that celebrates Rose's virtues (humility, modesty, purity, poverty, charity, penitence, obedience, prayer, fortitude, and prophecy). The central meditations on the virtues are framed by an opening chapter on her birth and name and a closing chapter on her death and funeral. Entitled *La rosa de el Perú,* the work is studded with quotations using floral imagery from the scriptures, the fathers of the church, and the classical and medieval poets (Virgil, Ovid, Petrarch). The composition aims at instilling in readers the desire to imitate the beautiful Rose in her practice of virtue.[206]

Vargas Machuca's praise of the saintly sister is thoroughly European in its genre, markedly allegorical, and artistic, but lacking in the biographical detail that properly implants Rose in America. To be named after a flower carried with it a weight of meaning in the Peruvian culture of the time. As Pamela R. Frese attests, the lush incorporation of flowers into the cult of Catholic saints was an important means of acculturation in the sixteenth century, given the use of flowers in the indigenous religious festivals of Latin America.[207] (Pachamama, the Quechua

205. Hansen, *Vita S. Rosae,* AASS 39 (August 5), 902–3.

206. Juan de Vargas Machuca, *La Rosa de el Peru, soror Isabel de Santa María, de el hábito de el glorioso patriarca Santo Domingo de Guzmán ... escrita en panegýrica chronológica oración* (Seville: Juan Gomez de Blas, 1659), 34. A copy of this work is housed in the Rare Book Room of the Library of Congress, where I was able to see it. Vargas Machuca also composed an *Oración sobre San Martín de Porres.*

207. See Pamela R. Frese, "Flowers," *Encyclopedia of Religion,* ed. Mircea Eliade (New York: Macmillan, 1987), esp. 359–60. Pointing to the place of roses in the cult of our Lady of Guadelupe, García-Rivera similarly observes, "Mesoamerican religious sensibility emphasized the role of flower and song, *flor y canto,* as dialogue or prayer with God" (*Community of the Beautiful,* 40n3). Flowers also had a place in European Catholic religious culture. On the latter, and the Protestant unease about it, see Jack Goody, *The Culture of Flowers* (Cambridge: Cambridge University Press, 1993), esp. 166–205.

earth mother, was honored as the progenitor of plants and flowers, and this be-
lief influenced the syncretic depiction of the Virgin Mary at Copacabana.)[208]
Rose came to see her very name as a calling to participate in this aesthetic means
of evangelization. In the garden adjacent to her parent's home, she made a tiny hut
(4 feet by 5 feet) for herself out of tree branches.[209] There she prayed for hours
each day and did manual work to support the family. She cultivated a flower gar-
den, selling its blooms for income, but also using them in other ways.[210] Her *Vita*
relates that she decorated the Chapel of the Rosary in the Church of Santo
Domingo with flowers every Saturday, sometimes supplying them miraculously
out-of-season. She similarly decorated the altar of St. Catherine of Siena, to
whom she was greatly devoted.[211]

Rose was intensely aware of the symbolism of flowers and used them as visual
aids in her private preaching. When she walked with people in the garden, for ex-
ample, "she spoke to them of the sovereign beauty of God, which spreads itself
over flowers as a mirror, in which men may see the faint representation of that
Source of beauty from which they derive their colour and brightness."[212] She di-
rected the praises that others lavished on her gardening to the Creator, *ille ad-
mirabilis mundi artifex,* who is the supreme Artist of the universe and of the soul's
virtue.[213] In the garden grew a large Rosemary, the principal branches of which
Rose had shaped into the form of a cross.[214]

Flowers also appeared in the designs of Rose's needlework. "She was a perfect
mistress of needlework," we read, "whether in designing flowers or executing
them in embroidery or tapestry."[215] She worked at night to decorate altar linens
with "flowers of gold or silk."[216] Her needlework, according to sixty-eight differ-
ent testimonies in her Process of Beatification, displayed "so much perfection,
beauty, delicacy, and care that it seemed to surpass the limits of human art and

208. See Salles-Reese, *From Viracocha to the Virgin of Copacabana*, 30–33.
209. Feuillet, *Life*, 80; Hansen, *Vita S. Rosae*, AASS 39 (August 5), 925.
210. Hansen, *Vita S. Rosae*, AASS 39 (August 5), 907.
211. Ibid., 952, 955.
212. Feuillet, *Life*, 95–96. Cf. Hansen, *Vita S. Rosae*, AASS 39 (August 5), 930: "si cum aliis fem-
inis hortum intranti, operosius laudabatur viridarii amoenitas, respondebat comiter: 'Venustus
ac pulcher est hortus, Deus illi flores adaugeat'" (if when other women entered the garden, the
pleasantness of the greenery was greatly being praised, she used to reply: 'Lovely and beautiful is
the garden where God may give the flowers growth'").
213. Hansen, *Vita S. Rosae*, AASS 39 (August 5), 931.
214. Feuillet, *Life*, 158; Hansen, *Vita S. Rosae*, AASS 39 (August 5), 954: "Rosa in suo hortulo
plantaverat libanotim (Rosmarinus vulgo dicitur) ejusque tres arbusculas distinctis cespitibus
ita in crucis formam coegerat."
215. Feuillet, *Life*, 35.
216. Ibid., 146. Cf. the fulsome account in Hansen, *Vita S. Rosae*, AASS 39 (August 5), 959, where
her embroidered flowers on the altar cloths are said to surpass living flowers in their beauty: "[E]t

industry": "illa singula tam consummatae fuisse perfectionis, elegantiae, curae, ut plerumque metas humanae artis et industriae viderentur excedere."[217] She used this talent also to vest the statues of Mary and of the Infant Jesus in the Church of Santo Domingo, and she combined the physical creation of such garments, stitch by stitch, with intercessory prayer, as this sample entry in her journal indicates: "The material for this mysterious robe shall be of six hundred Ave Marias, six hundred Salve Reginas, fifteen Rosaries, and fifteen fasting days in honour of the joy she felt in going to visit her cousin S. Elizabeth."[218]

The *Vita* of Santa Rosa is replete with artistic and artisanal references. She composed poetry—love-elegies (*saucii querimonias amoris*) to Christ and canticles of praise to God—that she sang in the garden, accompanying herself on a harp.[219] She also designed the implements with which she performed her extraordinary penances. Among these the most famous is the crown of thorns (a symbol she undoubtedly associated with her name Rose), which she wore about her head under her veil in the form of "a circlet of a plate of silver three inches broad, in which she fixed three rows of sharp points, to represent the thirty-three years of the earthly life of Christ, who died for mortals."[220]

To the design of such instruments must be added her actual use of them on the material of her body and soul. That Rose conceived of her penances as an artistic process aimed at the creation of something beautiful for God and humanity becomes evident in one of her visions. Jesus showed her a sculptor's studio in which "an almost innumerable troop of virgins, resplendent with brightness, were occupied in sawing and cutting marble, and He invited her to join in the number of these chaste spouses, whom she saw employed in this hard labour."[221] The virgins wept to wet the stone, and sweated as they cut and

quidquid textile ad sacram hanc supellectilem spectare poterat, omni pietatis ingenio arte, elegantia conficiebat. Insuper vivis floribus neutiquam contentam, pretiosiores et filis sericis fingebat versicolori artificio" (And whatever woven cloth for this holy furnishing she had been able to see, she was decorating with elegance, by every art and natural talent of devotion. Moreover, by no means content with living flowers [as models], she was fashioning more precious flowers with silken threads and parti-colored artwork).

217. Feuillet, *Life*, 35; Hansen, *Vita S. Rosae*, AASS 39 (August 5), 907.
218. Feuillet, *Life*, 156; Hansen, *Vita S. Rosae*, AASS 39 (August 5), 953.
219. Hansen, *Vita S. Rosae*, AASS 39 (August 5), 947, 931–32, 941. Cf. Feuillet, *Life*, 132, 110–11.
220. Feuillet, *Life*, 65; Hansen, *Vita S. Rosae*, AASS 39 (August 5), 918: "[L]amellam argenteam sibi flexit in circulum, huic ab intus ex eodem metallo tres infixit aculeorum ordinis, ita ut quaelibet series triginta et tres continerit aculeos videlicet pro numero annorum Christi, quos mortalis pro mortalibus explevit in terra."
221. Feuillet, *Life*, 86; Hansen, *Vita S. Rosae*, AASS 39 (August 5), 927: "Ostendit Rosae lapidariam officinam peramplam ac speciosam, quam solae implebant virgines arduo labori gnariter intentae" (He showed Rose a workshop for stonecutting, big and beautiful, which only virgins, expertly engaged in hard labor, were filling).

carved,[222] and Rose marveled at the scene, which assigned such hard, physical work to women who seemed by their attire more suited to a wedding party or fashionable theater than to a sweatshop.[223] When she suddenly saw herself in beauty, "covered with a mantle woven of gold and precious stones," and placed into the midst of the others, she understood the artistic labor to be the cultivation of virtues in she was heroically engaged.[224]

This vision can, of course, be read in the long, aesthetic tradition dating back to Plotinus, which depicts the beautiful soul as a work of art, the realization of a divine Exemplar. It derives its freshness from the historical context in which Rose experienced this vision and from the literalness of its meaning in application to her life of penance. The crown of thorns she wore made her, as Jean Feuillet's 1671 *Life* states, "a perfect image of Jesus crucified," a faithful "portrait" that "represented the bloody thorns which crowned the head of her Divine Spouse, and which were the dearest object of her thoughts."[225] Playing on the words Rosa/corona and Esposo/Espinas, Juan de Vargas Machuca highlights the double nature of the crown as a sign of humiliation and royalty: "Rosa, imitando a su Esposo, corona la cabeça de Espinas" (Rose, to imitate her Spouse, crown[ed] her head with thorns).[226] The link between Rose's penitential artistry and the religious artwork that inspired her meditation and sculpting of herself was made explicit after her death, when someone spontaneously took the crown of thorns from the statue of St. Catherine of Siena and placed it on Rose's head.[227]

For whom was Santa Rosa doing penance and to whom was she preaching? The silver in her crown of thorns hints at an answer. The eleven-year-old Rose moved in 1597 with her family to Quives, about 50 miles away from Lima, where her father had been appointed superintendent of the silver mines. Rose's sister

222. Feuillet, *Life*, 86; Hansen, *Vita S. Rosae*, AASS 39 (August 5), 927: "secabant, excavabant, laevigabunt, defricabant, et, ut ferramenta citius durior lapis admitteret, hunc affatim emolliebant crebro suarum lachrymarum stillicidio" (They were cutting, carving, smoothing, rubbing, and so that the harder stone might admit the iron easier, they were softening it sufficiently by the repeated dripping of their tears).

223. Hansen, *Vita S. Rosae*, AASS 39 (August 5), 927. "vestis erat singulis virginibus, non plebeia ex more opificii, sed pretiosa, fulgida, solemnis, quae nuptiale convivium, aut publicam theatri pompam saperet magis, quam sudoriferam officinam" (The dress was appropriate for single virgins, not plebian according to the custom of laborers, but rich, radiant, and festive—a dress that seemed better suited for a wedding banquet or a public, theatrical procession than to a sweaty workshop).

224. Feuillet, *Life*, 86; Hansen, *Vita S. Rosae*, AASS 39 (August 5), 927: "repente se deprehendit in cyclade gemmis et auro distincta."

225. Feuillet, *Life*, 65. A roughly parallel passage in Hansen's *Vita S. Rosae* describes the saint's devotion to the *Ecce Homo* figure, the Man of Sorrows. See AASS 39 (August 5), 918.

226. Vargas Machuca, *La rosa de el Peru*, 52.

227. Feuillet, *Life*, 70; Hansen, *Vita S. Rosae*, AASS 39 (August 5), 919.

Mercedes fell ill and died soon after their arrival there, and Rose herself became paralyzed. Thus Rose shared in the cruel fate of the Indian slaves, who were forced to work in the poisonous atmosphere of the mines at Potosí and Quives and died in the *mita* (labor draft) in great numbers.[228] Hansen's *Vita* attributes her seemingly mortal illness to the unhealthy climate in the mining region.[229] The exact cause of her paralysis, which lasted for months, is unknown, but it surely had a psychological component, for Quives was a hostile place of five thousand inhabitants, among whom Spanish Christians were a powerful but hated minority.

García-Rivera has argued that the miracles of healing in the Process of Beatification of the mulatto saint, Martín de Porres, show a pattern wherein the Spaniards who are cured typically suffer from hidropesia (gout) or "some inflammation or illness of the leg," whereas "the majority of hurts among Indians, Negroes, mulattos, and mestizos involve wounds due to some violent encounter."[230] Interpreting this narrative pattern as a semiotic code indicative of the spiritual sickness of Peruvian society, he suggests that the paralysis of the legs of the Spaniards points to their ill treatment of those who were under them and to their gluttonous greed.

Rose, the daughter of Don Gaspar, was mysteriously cured of her paralysis in a two-part process. Her mother, desperate to help her, tried an ancient Indian remedy laden with cultural symbolism. She wrapped Rose's legs in the uncured skin of a slaughtered llama,[231] an animal sacred to Pachamama, the Quechua earth mother.[232] Enclosed too tightly and long, Rose's legs were covered with festering blisters when her mother released her. No immediate cure resulted, but the episode, which is related in the *Vita* to illustrate Rose's patience and silent obedience, seems to have increased her self-identification with the Indians slaughtered under Spanish rule. Perhaps that identification also helped to heal her. At any rate Rose grew well and walked unaided, a few weeks later, to the church to be confirmed at the hands of St. Toribio. She accepted Rosa anew as her name and embraced a penitential mission for her people, Spanish and Indian alike. Within

228. See Andrien, *Andean Worlds,* 52, 73, 80–81.

229. Hansen, *Vita S. Rosae,* AASS 39 (August 5), 906.

230. García-Rivera, *St. Martin de Porres,* 71, 77, 80.

231. Sr. Mary Alphonsus identifies the animal as a llama (*St. Rose of Lima,* 117). Hansen's *Vita S Rosae* is vaguer and ignores the indigenous significance of the act: "Mater vim morbid praesentissimo (ut putabat) remedio depulsura, quorumdam animalium illic frequentium hispidas pelliculas arcte circumposuit patienti Filiae" (Her mother, intending to put down the sickly force [of the disease] by the remedy (so she thought) nearest at hand, wrapped her ailing daughter in the hairy skins of those animals common there in the north) (AASS 39 [August 5], 906). Graziano identifies the wrappings without explanation as "vulture skins" (*Wounds of Love,* 158).

232. Otto Zerries, "Lord of the Animals," trans. John Maressa, *Encyclopedia of Religion,* 25.

three years the mines at Quives closed, as St. Toribio predicted, and Don Gaspar moved his family back to Lima in 1600.[233]

The fasting of St. Rose takes its meaning not as the idolatrous aping of the medieval, European St. Catherine, but as a genuine Christian imitation and reparation for sins. The gluttonous greed of the conquistadores for precious metals was such that an Andean folk legend (cited by Stern) maintained "that Spaniards ate gold and silver instead of food."[234] Rose's response was to fast, to season the little food she ate with bitter herbs and sheep's gall, and to receive the Eucharist.[235] Distancing herself from the glittering of gold and silver, Rosa "was often surrounded with light at the altar," when she went to Communion.[236]

Rose's refusal to marry similarly marks her resolve not to participate in a system that enslaved others. As the famously beautiful daughter of a "Don," albeit one in the lower echelons of Spanish society, Rose was a much desired participant in the marriage market.[237] Commenting on the "formidable demand for marriageable women," Lockhart observes, "Practically all marriages were strategic alliances arranged with a view to improving the partners' wealth or social standing."[238] Rose wished no such alliance, seeking instead to give herself to Christ. To avoid engaging in the rituals of courtship, she scorned cosmetics and actually disfigured her face on occasion, according to her *Life,* rubbing "her eyelids with pimento, which is a very sharp burning sort of Indian pepper."[239]

The *Vita* struggles to describe the heroic obedience of a saint who nonetheless opposed her parents' wishes at every turn. Little story after little story shows Rose cleverly outwitting her mother Oliva—by practicing a too literal obedience that subverts her mother's actual intent, by answering Oliva in ambiguous phrases and actions that mask her true resistance, by hiding a sharp, penitential pin in the garland of flowers her mother makes her wear to parties.[240] In this regard Rose no doubt drew inspiration from Catherine of Siena; the stories, however, exhibit a

233. St. Toribio's prophecy at the occasion of Rosa's confirmation in Quives is admittedly ambiguous: "Miserable ones! You shall not exceed three!" My interpretation of it differs from that of Sr. Mary Alphonsus (*St. Rose of Lima,* 126). The mines did close within three years, however, and Bishop Toribio was well known for his advocacy of the Indians.

234. Stern, *Peru's Indian Peoples,* 27.

235. Feuillet, *Life,* 53–57; Hansen, *Vta S. Rosae,* AASS 39 (August 5), 906.

236. Feuillet, *Life,* 142; Hansen, *Vita S. Rosae,* AASS 39 (August 5), 957: "Dum virginis sacram Synaxim porrigit, natavit saepius vultum ipsius caelesti splendore perfusam, . . . ita quod prae fulgoris vehementia sibi tremuerint oculi" (When she came forward for holy Communion, she frequently radiated [light], the face of the virgin suffused with heavenly splendor, . . . so much so that the eyes themselves will have trembled at the force of the refulgence).

237. On the meaning of the term *Don* in colonial Peru, see Lockhart, *Spanish Peru,* 35–45.

238. Ibid., 155.

239. Feuillet, *Life,* 31; Hansen, *Vita S. Rosae,* AASS 39 (August 5), 905.

240. Hansen, *Vita S Rosae,* AASS 39 (August 5), 905–6.

cultural difference that suggests a more immediate model in the coded language that Indian and African subalterns addressed to their Spanish masters. Mariana, Rose's Indian maid, taught her young mistress, in short, how to read the life of "Santa Catarina."

To this Indian maidservant Rose also looked for occasional help in her secret penitential practices. Mariana was "the servant and the dear confidant of [Rose's] austerities," according to the *Life* of 1671.[241] When, for instance, a prophecy circulated that an earthquake would destroy Lima because of its sins, Rose did reparation for the city in a metonymic way, instructing Mariana to load her down with stones as she prayed in a corner of her garden, until she was practically crushed under their weight and fell to the ground.[242] By being buried alive, so to speak, Rose enacted a childlike prayer of atonement to avert the city's being swallowed by the earth. The action, which vaguely recalls the enclosure of medieval anchorites in Europe, takes on a new meaning in the Peruvian context. Observing that "in Quechua, the word *runa* (man) is similar to *rumi* (stone)," art historian César Paternosto suggests that the Andean sites that were *huaca* (holy [pronounced *wak'a*]) because a living "saint" had taken a lasting form there, usually in stone, were also connected to the myth of human origins out of rocks: "The first beings who emerge from caves, rocks, springs, rivers, trees, and so on (the *paqarina*) . . . elucidate, to my mind, the places that were *wak'a*."[243] Taking a mountain (*moles*) of stones upon herself, Rose, in union with Christ, bore the weight of her people and their sins, making Christ's sufferings present and efficacious anew. Letting the Indian girl Mariana pile them on her suggests, moreover, that Rose was atoning in particular for the sins of the conquistadores, who had cruelly overburdened the native peoples, enslaving them.

Rose also flagellated herself, and she probably asked Mariana at times to apply the discipline as a whip to her back. Such a request allowed Rose to atone for the beatings inflicted by the Spaniards on the slaves; to participate empathically in

241. Feuillet, *Life*, 60; Hansen, *Vita S. Rosae,* AASS 39 (August 5), 916.

242. Feuillet, *Life*, 60; Hansen, *Vita S Rosae,* AASS 39 (August 5), 916: " . . . sub ea mole, gravique obtruti, durabat parvula in oratione prolixa et laboriosa, tandem innuebat ancillae, sine strepitu pondus aufferet, ne forte superveniens mater furtivae devotionis turbaret scenam, aditumque similia iterandi praecluderet" (Under that pile, heavy and obtruding, the young girl was enduring in prayer, extended and labored; nevertheless, she was signaling to the maidservant that she might remove the weight without a loud noise, lest by chance her mother, coming upon them, might disturb the scene of their furtive devotion and preclude the possibility of repeating such things).

243. César Paternosto, *The Stone and the Thread: Andean Roots of Abstract Art,* trans. Esther Allen (Austin, TX: University of Texas Press, 1989), 184. As Paternosto observes, not only Greco-Roman myth, but also the Gospels contain hints of an early belief in human origins out of stones. See, for example, Luke 19:40, Luke 20:17, and especially Matthew 3:9.

their sufferings and those of Christ; and to preach to others the need to do
penance. The *Vita* explicitly describes Rose's penance as a means of diverting to
herself the divine punishment that would fall upon the city.[244]

Whipping and self-flagellation, such as St. Rose and St. Martín de Porres (like
Catherine of Siena) practiced thrice daily in imitation of St. Dominic, spoke
to Spaniards and Indians alike. The use of the discipline in medieval and early
modern Europe is well documented, but little understood in the modern West to-
day.[245] Anthropological studies help to illumine it. As Lawrence E. Sullivan ex-
plains, Indian ordeals and rites of initiation typically included whipping, but
also fasting, night vigils, silences, stasis, and physical isolation, in accord with a
metonymic logic, whereby one participates in one's own recreation as a new be-
ing, opening "the senses to the spiritual world that gives rise to reality, and . . .
mak[ing] the sensual body itself a manifestation of what is sacred."[246] Abiding in
her hut in the garden outside her parents' home, Rose perpetuated what was for
most people of her time and place a temporary rite of passage (for example, from
adolescence to adulthood, from sickness to health) or a seasonal observance of
reparation, in order to mediate God's presence for others and to bridge the gap
between the peoples of different cultures. She seems to have understood very well
what García-Rivera means when he writes, "Only a cultural aesthetic which can
face up to suffering, even find its aesthetic force there, could adequately describe
Hispanic and Latin American experience."[247]

A great measure of the beauty of St. Rose's life was the love she showed to peo-
ple of all kinds and awakened in them in return. Baptized in the same church and
by the same priest, St. Rose and St. Martin de Porres shared a charitable aposto-
late among the poor of Lima.[248] Adept at gardening, Rose was skilled in herbal
medicines. She "nursed [the sick], made their beds, dressed their ulcers, washed
their clothes and, in a word, rendered them every sort of service, making no dis-

244. Hansen, *Vita S. Rosae*, AASS 39 (August 5), 915.

245. See, for example, Piero Camporesi, *The Incorruptible Flesh: Bodily Mutation and Mortifi-
cation in Religion and Folklore*, trans. Tania Croft-Murray and Helen Elsom (Cambridge: Cam-
bridge University Press, 1988).

246. Lawrence E. Sullivan, *Icanchu's Drum: An Orientation to Meaning in South American Re-
ligions* (New York: Macmillan, 1988), 352. See also 346–55. On fasting, see MacCormack, *Religion
in the Andes*, 146, 185, 392, 431. See also Ariel Glucklich, *Sacred Pain* (New York: Oxford University
Press, 2001).

247. García-Rivera, *Community of the Beautiful*, 60.

248. Modern biographies, such as Sr. Mary Alphonsus's *St. Rose of Lima*, stress the intercon-
nections between the two saints. There is no mention of Martin's name in Hansen's *Vita S. Rosae*,
but they must have known each other and cooperated with each other, since they were moving in
the same places and within the same, close circles. Juan de Vargas Machuca links them in his
praises.

tinction between the Spaniard and the Indian, the free and the slave."[249] When
the city was threatened on the vigil of the Feast of St. Mary Magdalene in July 1615
with invasion by a Dutch fleet, Rose united the people by rallying them all to the
defense of the Eucharist in the Church of Santo Domingo—a gesture that won-
derfully expresses the connection she saw between the sacramental Body of Christ
and His Mystical Body, composed of many members.[250]

At the start of August 1617, Rose suddenly fell seriously ill, and she predicted
that she would die (as she indeed did) precisely on the Feast of St. Bartholomew,
August 24. When her curious (*curiosa*) mother asked her why she would die on
that particular day, Rose reportedly replied with a wordplay on BarTHOLOMew's
name, answering that her death day would begin her heavenly nuptials (*thala-
mum*).[251] The mother's inquiry and the saint's coded rejoinder point to another
answer, however, that sets a seal on Rose's particular combination of mysticism
with missionary zeal, of penance with preaching. By dying on the Feast of St.
Bartholomew, Rosa identified herself with the apostle who was believed to have
first evangelized the Americas. Rose's choice of Bartholomew allies her with
the "*criollo, mestizo,* and native writers" who defended the legends of apostolic
evangelization, legends that were rejected by "most Spaniards" (according to
Salles-Reese), and that had potentially serious implications for the Inquisition's
handling of idolatry cases.[252] Rose, who had been summoned herself before the
Inquisition, answers her mother's question only with a verbal allegory, but the
symbolism of her death on St. Bartholomew's feast would not have been lost on
the Peruvian Christians who venerated the imprint of the apostle's feet in the
stones of Lake Titicaca.[253]

At Rose's death thousands thronged the streets and filled the church, making
it extremely difficult for the priests to conduct her wake, funeral, and burial. Days
passed before the burial could take place, during which time the dead saint's
countenance displayed an exceptional beauty, and her body, which showed no

249. Feuillet, *Life,* 171; Hansen, *Vita S. Rosae,* AASS 39 (August 5), 965.

250. Feuillet, *Life,* 147–49; Hansen, *Vita S. Rosae,* AASS 39 (August 5), 959–60. Rose feared that
the sacrament would be desecrated by the Calvinist invaders and called for adoration of the Host.
The fleet withdrew from Peru's shores, and Rose was widely credited with having saved the city.

251. Feuillet, *Life,* 189; Hansen, *Vita S. Rosae,* AASS 39 (August 5), 997.

252. Salles-Reese, *From Viracocha to the Virgin of Copacabana,* 156. Some insisted that if there
had been a prior evangelization during the time of the apostles, then the Indians were subject to
charges of heresy.

253. For a complementary study that emphasizes the role of Santa Rosa in the development of
a creole mentality in Peruvian culture, see Luis Miguel Glave Testino, *De Rosa y espinas: Econo-
mia, sociedad y mentalidades andinas, siglo XVII* (Lima: Instituto de Estudios Peruanos: Banco
Central de Reserva del Peru, Fondo Editorial, 1998). This study came to my attention late in the
development of this essay.

sign of decay, gave off a sweet fragrance. An Italian painter, Angelino Medoro, who knew St. Rose and was present in Lima at the time of her funeral, painted a portrait of the young saint in death (plate 10), the first of many relic-like pictures of her, through which posthumous miracles were worked.[254]

Miracles were worked, too, through the soil that people daily carried away from her grave.[255] When Rose's body was exhumed and found incorrupt, fifteen years after her death, the examiners also discovered that the soil at the burial site had been miraculously replenished, "though several bushels had been carried away": "Almighty God caused this miraculous earth to be, as it were, an inexhaustible source for the relief of the inhabitants of Peru."[256] To the Christian this miracle resonates with an Edenic new creation, but this particular cultic practice and miracle also point to a close association of Rose in the popular, syncretic imagination with Pachamama, the earth mother.

The language of signs that Rose used in her Dominican "preaching" of penance spoke to Spaniard and Indian alike, and thus her *Legenda* can and should be read from two different cultural perspectives. Spaniards, Indians, Africans, and *mestizos* all claimed her during her lifetime as their saint, and as one whose love of God united them. Scholars like Alberto Flores Galindo err, therefore, when they view St. Rose as someone who *originally* belonged "to the Spanish colonial pantheon of Catholic saints" and only "*eventually* . . . was incorporated into the peasant world as well."[257] Puzzled by the role that St. Rose's name, cultic image, and supposed prophecies played in the Inca revivals and rebellions of Tupac Amaru in 1780–81 and of Gabriel Aguilar and Juan Manuel Ubalde in 1814, they would do well to reconsider the culturally polysemous quality of her life and *Life*.[258]

254. For help in obtaining this image, I thank Frank Graziano, who put me in touch with Teodoro Hampe Martínez, who gave me the addresses of the Santuario de Santa Rosa in Lima, Peru, where Medoro's painting is housed, and of the Banco de Crédito del Perú, which contributed to the restoration of the painting. I thank David Flory, who translated correspondence for me, and Jeff Gore, whose connections in Lima helped me finally to obtain a photograph of this "imagen auténtica" of St. Rose through the kind hands of Sra. María Luisa Ugarte. On the paintings of St. Rose, see Hampe Martínez, *Santidad e identidad criolla*, 75–108; Rubén Vargas Ugarte, S.J., *Santa Rosa in the Arts* (*Santa Rosa en el Arte*) (Lima: Los Talleres Gráficos de Sanmarti S.A., 1967). For miracles involving pictures and statues of St. Rose, see Feuillet, *Life*, 232–35, 252–57; AASS 39 (August 5), 994, 1009–12.

255. One is reminded of this very same practice that occurs today at one of North America's most famous places of pilgrimage, the Santuario de Chimayó, near Abiquiu, New Mexico. An estimated 300,000 pilgrims visit this tiny adobe church annually to touch their feet to its holy ground and to carry away containers of the earth, through which miracles of healing have occurred.

256. Feuillet, *Life*, 217, 246; Hansen, *Vita S. Rosae*, AASS 39 (August 5), 1005–8.

257. Alberto Flores Galindo, "In Search of an Inca," in *Resistance, Rebellion, and Consciousness in the Andean Peasant World, 18th to 20th Centuries*, ed. Steve J. Stern (Madison: University of Wisconsin Press, 1987), 204, emphasis added.

258. For references to St. Rose in studies of these rebellions, see Galindo, "In Search of an Inca,"

St. Rose, a Dominican tertiary, strove to imitate St. Catherine of Siena. Her contemporaries, moreover, regarded her as a second St. Catherine, someone whose prayer and acculturative, aesthetic "preaching" greatly advanced the (re?)evangelization of the Andes. The question arises: did Rose misread the mystical *Legenda* of St. Catherine, or did her New World, cultural perspective allow her to see more clearly than most the power of evangelical proclamation in Catherine's symbolic actions and asceticism? I have obviously been supporting the latter view, according to which Catherine, like Rose after her, was an apostle, a preacher, both when she fasted and received Communion and when she dictated letters. By the same token, both Dominican saints were artists for whom there was literally (in the words of George Kubler) "art in every *art*ifact"—including the implements of penance—and a beauty to be discerned in each thing in accord with its usefulness and auratic, symbolic intensity.[259] In the context of sixteenth-century South America, as in medieval Europe, a thing's beauty was inseparable from its metonymic meaning, its art of preaching.

203–4, 208n9; Andrien, *Andean Worlds,* 202, 214; Jan Szemiński, "Why Kill the Spaniard? New Perspectives on Andean Insurrectionary Ideology in the 18th Century," in *Resistance, Rebellion, and Consciousness in the Andean Peasant World, 18th to 19th Centuries,* ed. Steve J. Stern (Madison: University of Wisconsin Press, 1987), 179, 182, 185; Charles F. Walker, *Smoldering Ashes: Cuzco and the Creation of Republican Peru, 1780–1840* (Durham: Duke University Press, 1999), 57; Ward Stavig, *The World of Túpac Amaru: Conflict, Community, and Identity in Colonial Peru* (Lincoln: University of Nebraska Press, 1999), 238–45.

259. George Kubler, *Esthetic Recognition of Ancient Amerindian Art* (New Haven: Yale University Press, 1991); quoted in Paternosto, *The Stone and the Thread,* 6.

6 : THE EUCHARIST, THE *SPIRITUAL EXERCISES*, AND THE ART OF OBEDIENCE

Saint Ignatius of Loyola and Michelangelo

My food is to do the will of him who sent me.
—Jesus (John 4:34)

And consequently terror,
Closely linked to beauty.
Feeds my great desire with a strange food.
—Michelangelo Buonarroti

The director *gives* the *Exercises* (virtually as one gives food—or a whipping).
—Roland Barthes

I n Rome on October 6, 1554, in the presence of Ignatius of Loyola (1491–1556), Michelangelo Buonarroti (1475–1564) went down into the newly excavated foundation to set with his own hands the cornerstone for the Gesù, the mother church of the fledgling Society of Jesus.[1] Michelangelo, the master architect, had constructed a model of the church that he hoped soon to build. In a letter Ignatius enthusiastically endorsed Michelangelo's plans: "Taking charge of the work is the most celebrated man known here, Michelangelo—who also has charge of St. Peter's—and for devotion alone, without any other consideration."[2]

Due to various complications, the Church of the Gesù was built much later, in fact, and by other hands.[3] Michelangelo's initial undertaking of the project with so much personal enthusiasm and generosity has nonetheless prompted reflection on the "devotion" of the famous artist to the equally famous Jesuit saint. Virtually nothing is known, however, about their direct, historical relationship,

1. Philip Caraman, *Ignatius Loyola: A Biography of the Founder of the Jesuits* (San Francisco: Harper and Row, 1990), 190.

2. St. Ignatius of Loyola, *Epistolae et Instructiones* (Madrid, 1903–11), 7:100; quoted in Clement J. McNaspy, S.J., "Art in Jesuit Life," *Studies in the Spirituality of Jesuits* 5.3 (1973): 93–111, esp. 95.

3. Cardinal Alessandro Farnese laid anew the foundation stone for the church, which was to become "a kind of prototype of baroque religious architecture," on June 26, 1568. The master architects were Giovanni and Lorenzo Tristano, blood-brothers and Brothers within the Society of Jesus. See William V. Bangert, S.J., *A History of the Society of Jesus,* 2nd rev. ed. (St. Louis: Institute of Jesuit Studies, 1986), 59.

which was almost certainly mediated in its origins through their mutual friend and supporter, Vittoria Colonna (1490–1547).[4] In a talk given on June 16, 1972, Pedro Arrupe, then General of the Society of Jesus, declared, "What is certain is that Michelangelo would not have made the offer unless he saw in Ignatius a kindred spirit, appreciative of beauty, and of what the artist was about."[5] Nor, presumably, would Ignatius have accepted the services of Michelangelo had he not perceived in him someone seeking "the greater glory of God" through his artwork.[6] More recently psychoanalytic critic W. W. Meissner has suggested psychological affinities between the two men, based on their childhood experiences.[7]

This chapter compares Ignatius with Michelangelo, approaching the issue of their mutual admiration from the perspective of eucharistic asceticism, mysticism, and aesthetics. Their spiritual brotherhood, I argue, derives from their common practice of an art of obedience strongly centered on the sacrament of the altar. The eucharistic character of Ignatius's spirituality of obedience is clearly evident from his *Autobiography,* his *Spiritual Diary,* his letters, and his *Spiritual Ex-*

4. While the friendship between Michelangelo and Vittoria Colonna is greatly celebrated, the connection between Ignatius and Vittoria Colonna is little known and ignored by most of her biographers. Vittoria and Michelangelo probably first met in 1536. When Ignatius first arrived in Rome in 1538, he and his companions were welcomed by Cardinal Gasparo Contarini, to whom Ignatius shortly thereafter gave the spiritual exercises. (Earlier, in 1536, Ignatius had given spiritual direction in Venice to the cardinal's nephew, Pietro Contarini.) Cardinal Contarini was a member of a reformist circle to which Cardinal Reginald Pole and Vittoria Colonna, the widowed marchioness of Pescara, also belonged. Vittoria herself apparently first met the Jesuits in 1538 in Ferrara, where she was hoping to embark on a pilgrimage to the Holy Land. Impressed with their spirit, she introduced them to Duke Hercules II. From Ferrara Vittoria moved to Rome and then from Rome to Viterbo, where she lived from October 1541 to 1544, making frequent visits back to Rome. While in Viterbo Vittoria became well acquainted with a Jesuit master, Fr. Antonio Araoz, who put her in direct contact with his cousin, Ignatius Loyola. In a grateful letter sent from Viterbo to the General of the Society of Jesus, dated January 21, 1542, Vittoria addresses Ignatius by his Spanish name as "Don Ignygo." When she moved to Rome in 1544, she met with Ignatius to intercede with him for help for the apostate Capuchin, Bernadino Ochino, and help also with the troubled marriage of her brother Ascanio and his wife, Joanna Colonna, whom Ignatius also counseled. Vittoria was a member of the Compagnia della Grazia, a charitable organization of pious women established in 1543 by St. Ignatius in Rome, with the specific purpose of maintaining the House of St. Martha, a home for the rehabilitation of prostitutes. Vittoria begged Ignatius to preach at the Convent of Saint Anna in Rome, where she resided in her last years. In an indirect tribute to Ignatius, Vittoria composed a sonnet in honor of his patron saint, Ignatius of Antioch (*Rime Spirituali* no. 125). When Michelangelo laid the cornerstone for the Church of the Gesù in 1554, Vittoria had already been dead for seven years. See Hugo Rahner, S.J., ed., *Saint Ignatius Loyola: Letters to Women* (New York: Herder and Herder, 1960), 129–33.

5. Pedro Arrupe, S.J., "Art and the Spirit of the Society of Jesus," *Studies in the Spirituality of Jesuits* 5.3 (April 1973): 83–92, esp. 86.

6. The motto of the Jesuits is "All for the greater glory of God" (*Ad majorem gloriam Dei*).

7. W. W. Meissner, *The Psychology of a Saint: Ignatius of Loyola* (New Haven: Yale University Press, 1992), 362–63.

ercises, wherein the prayer *Anima Christi* is repeatedly addressed to the Lord present in the sacrament. In the case of Michelangelo, eucharistic devotion gains expression in repeated portrayals of the Man of Sorrows in painting, sketches, and sculpture; in the building of churches and altarpieces, such as the *Last Judgment,* as well as in his poems and letters.

Under the pressure of ecclesial fissure and in the context of Protestant revolt, Ignatius and Michelangelo identified Jesus in the Eucharist as the obedient Son of the Father who first fashioned the world as Word, who came into the world through Incarnation as a New Adam, and who comes anew during every Mass in order to restore to the world its original, paradisiacal order. They heard, received, and imitated Christ as the obedient son and suffering servant whose attitude is best expressed in the words of Psalm 40:7–9 (Cf. Heb. 10:5–7): "Sacrifice or oblation you wished not, but ears open to obedience you gave me. . . . To do your will, O my God, is my delight, and your law is within my heart."[8]

Finding in obedience to Christ as Creator and Lord an unfailing bond of ecclesial unity and of personal, spiritual Communion with God and others, these two Catholic reformers of the sixteenth century creatively define a specifically eucharistic spirituality as the source of the world's beauty. In so doing, they renew the ancient, apostolic sense of a first sin of disobedience and respond to the dangers of a possible, sacramental idolatry (much decried by their Protestant contemporaries) with appropriate remedies.[9] Continuing the medieval Franciscan tradition of image-based meditation on the life of Christ, they also depart significantly from it. Whereas humility was the foundational virtue for the monastic saints, poverty the virtue of virtues for St. Francis, and preaching the art of arts for the Dominicans, for Michelangelo and St. Ignatius "obedience more than any other virtue" constituted spiritual perfection, the beauty of the soul.[10]

In the *Constitutions of the Society of Jesus,* Ignatius made a mediated concept of obedience the hallmark of the Jesuits. Each superior is to command those in his charge, speaking not "as man to man," but humbly "as Christ to man, since he is commanding in His place."[11] Similarly "the person who obeys ought to con-

8. I use throughout the Douay-Challoner version of the Holy Bible, ed. John P. O'Connell (Chicago: Catholic Press, 1950).

9. For one study of Protestant iconoclasm that seems especially appropriate from a eucharistic perspective, see Lee Palmer Wandel, *Voracious Idols and Violent Hands: Iconoclasm in Reformation Zurich, Strasbourg, and Basel* (Cambridge: Cambridge University Press, 1995). For these iconoclasts, as Wandell writes, "To 'do away with the images' was to 'reform'" (4).

10. St. Ignatius of Loyola, "Letter 3304: To the Members of the Society in Portugal," *Letters of St. Ignatius of Loyola,* ed. and trans. William J. Young, S.J. (Chicago: Loyola University Press, 1959), 287.

11. St. Ignatius of Loyola, *The Constitutions of the Society of Jesus,* trans. George E. Ganss, S.J. (St. Louis: Institute of Jesuit Sources, 1970), [85], 102.

sider and weigh the order which comes from the cook, or from another who is his superior, as if it were coming from Christ the Lord."[12] The virtue of Christ-centered obedience, in which Jesuits are to "distinguish themselves," is to be "shown first to the sovereign pontiff and then to the superiors of the Society" and then "in all things into which obedience can with charity be extended."[13]

Ignatius's concept of obedience gains its most eloquent expression, however, in his famous "Letter to the Members of the Society in Portugal," dated March 26, 1533. In that letter Ignatius urges a strict, supernaturally motivated practice of obedience, which is, he asserts, "the only virtue which plants all the other virtues in the mind, and preserves them once they are planted. And insofar as this virtue flourishes, all other virtues will flourish and bring forth the fruit which I desire in your souls, and which He claims *who by His obedience redeemed the world after it had been destroyed by the lack of it,* becoming obedient unto death, even to the death of the cross" (cf. Phil. 2:8).[14] Obedient to his Father and keeping the commandments perfectly, Christ was murdered, as the prophets before him had been (cf. Matt. 23:29–36), because his life was a constant reproach to the religious and civil leaders of his time, who lived by different standards and were willing to sacrifice the one for the many (John 11:50). Quoting 1 Kings [1 Sam.] 15:22, Ignatius explicitly defines obedience as "anti-sacrificial" in the Girardian sense of that word: "'Obedience is better than sacrifices,' for, according to St. Gregory, 'In victims the flesh of another is slain, but in obedience one's own will is sacrificed.'"[15]

Not a Jesuit, Michelangelo nonetheless practiced an outstanding, practical obedience that cost him dearly, but which led to the unfolding of his artistic talents as sculptor, painter, and architect. In the *Moses* Michelangelo celebrated the great patriarch of Israel, even as he honored Pope Julius, who had commissioned it. Michelangelo's art of obedience was often sorely tested in his patient dealings with a series of demanding pontiffs, but obedience also awakened his artistic talents, literally giving birth to beauty. A sculptor, Michelangelo undertook the difficult painting of the vault of the Sistine Chapel against his own will and under protest, after recommending his rival Raphael as more suited to the task, but (Vasari relates) "the more he excused himself, the more the impetuous Pope was determined he should do it."[16] Similarly, in 1546, at the death of Antonio da Sangallo, Michelangelo declared emphatically that "architecture was not his art,"

12. Ibid.

13. Ibid., [547], 246–47.

14. *Letters of St. Ignatius of Loyola,* 288. On the primacy of obedience, Ignatius cites St. Gregory the Great's *Moralium,* 35.10 (PL 76, col. 765).

15. Ibid., 289.

16. Giorgio Vasari, *The Lives of the Painters, Sculptors, and Architects,* trans. and ed. William Gaunt (London: Dent, 1963), 4:124.

when Pope Paul III requested and "ultimately commanded" him to serve as architect of St. Peter's.[17]

Michelangelo's late letters confirm his practice of a mediated obedience as radical as that of Ignatius Loyola. To Giorgio Vasari he writes: "I call God to witness that ten years ago I was put in charge of the fabric of St. Peter's by Pope Pagolo, under duress and against my will. . . . Were [I] to abandon it now, it would result in nothing but the uttermost disgrace and the loss of the whole reward for the pains I have endured for the love of God during the said ten years."[18] He writes similarly to his nephew Lionardo of his desire to stay in Rome and continue working on St. Peter's: "I have always been, and am, thus diligent, because many people believe, as I do myself, that I was put there by God. . . . I serve for the love of God, in Whom is all my hope."[19]

Michelangelo's obedience to the voice of God speaking through the pope presupposes and confirms a more fundamental yes, given in his youth, to his personal vocation as a Christian artist. Like Vittoria Colonna, who wrote poetry in response to a calling from God,[20] Michelangelo followed his artist's vocation with the inner, quasi-astrological conviction that he was fulfilling his destiny, doing what he had been created to do.[21] To Vittoria Colonna he addressed a sestina that contains the lines: "Per fido esempio alla mia vocazione / nel parto mi fu data la bellezza, / che d'ambo l'arti m' è lucerna e specchio" (As a trustworthy model for my vocation, / at birth I was given the ideal of beauty, / which is the lamp and mirror of both my arts).[22]

In conscious opposition to the iconoclasm of their own time, Michelangelo and Ignatius emphatically fostered image-making—Ignatius in his *Spiritual Exercises,* and Michelangelo in his extraordinary works of art—as a means of increased self-knowledge, love for God, charitable instruction of others, and communal worship. Ignatius's *Spiritual Exercises,* a handbook for directors of retreatants, was first published in 1548, but St. Ignatius had begun giving the exercises much earlier and only gradually developed them into a prescribed sequence. In his "Rules for Thinking with the Church," Ignatius explicitly urges his follow-

17. Ibid., 4:145.

18. *The Letters of Michelangelo, Translated from the Original Tuscan,* ed. and trans. E. H. Ramsden (Stanford: Stanford University Press, 1963), 2:175.

19. Ibid., Letter 436, 177.

20. See Mila Mazzetti, "La poesia comme vocazione morale: Vittoria Colonna," *Rassegna della letteratura Italiana* 77 (1973): 58–99.

21. For allusions to astrology, see *The Poetry of Michelangelo,* trans. James M. Saslow (New Haven: Yale University Press, 1991), 224, 234, 257, 322, 332.

22. *Poetry of Michelangelo,* 322. The two arts to which Michelangelo refers are sculpture and painting. For other poems in which Michelangelo expresses his love of beauty and its anagogic power to lead him upward to God, see 85, 122, 195, 224, 236, and 238.

ers to "praise relics of saints, by venerating the relics and praying to the saints" (alabar reliquias de Santos haciendo veneración aellas, y oración a ellos); similarly, to "praise church buildings and their decorations; also statues and paintings, and their veneration according to what they represent" (alabar ornamentos y edificios de Iglesias, asimismo imagines, y venerarlas según que representan).[23] Even more important than this exhortation, however, are the directions Ignatius gives in the *Spiritual Exercises,* which famously invite the individual retreatants to imagine vividly different biblical scenes as a "composition of place," within which to carry on a dialogue ("colloquy") with Jesus, the Father, or Mary. These same biblical scenes were the subjects of Michelangelo's artwork, much of which was commissioned for liturgical use.

The two reformers upheld the use of images in prayer, but they also confronted humbly the potential for idolatry in themselves and in the church. Venerated during his own lifetime, Ignatius insisted in the *Exercises:* "We ought to be on our guard against comparing . . . [the] living with the blessed of the past. For no small error is made when one says, for example, 'He knows more than St. Augustine', or 'He is another St. Francis'" ([364], 135). Called divine even before his death,[24] Michelangelo typically responded to praise as he did to Niccolò Martelli's: "I see that you imagined me to be the man that I would to God I were. I am a poor fellow, and of little worth."[25] When Francesco Berni half-seriously offered a saint's cult to Michelangelo, announcing his readiness to light a candle before him, Michelangelo wittily called attention to the poor artistic quality of most pictures of grace, even as he expressed the sincere hope that by some "great miracle" the "painted man" would become "a real one."[26]

Facing death, the aged Michelangelo labored over a sonnet, extant in multiple drafts, in which he accuses his "affectionate fantasy" of having made "art" his "idol

23. *The Spiritual Exercises of Saint Ignatius,* ed. and trans. George E. Ganss, S.J. (St. Louis: Institute of Jesuit Studies, 1992), [358 and 360], 134; *The Spiritual Exercises of St. Ignatius Loyola, Spanish and English,* ed. and trans. Joseph Rickaby, S.J., 2nd ed. (New York: Benziger, 1923), 221. Hereafter I use Ganss's edition, giving references parenthetically by paragraph number and page. For the Spanish text I use Rickaby's edition, giving citations by page only.

24. Vincenzo Borghini inscribed the words *Il divino Michelangelo* on the artist's tomb, but Ludovico Ariosto first coined the phrase, referring to Michelangelo in the line "Michel più che mortal Angel divino" in *Orlando Furioso* (1516). Michelangelo's fears as a sculptor about committing idolatry may have been compounded by his awareness of the etymology of the name of his patron saint. Michael the Archangel was regularly shown in artworks as a warrior, holding a shield with a Latin translation of his Hebrew name: *Quis ut Deus?* (Who is like God?) Michael's name was believed to be the battle cry of the righteous angels in Heaven against the forces of Lucifer, the great idolater. See Revelation 12:7–12.

25. *Letters of Michelangelo,* 2:12.

26. See *Poetry of Michelangelo,* 200–201.

and sovereign."[27] Throughout his life this fear led Michelangelo, obedient to his vocation as an artist, not to iconoclasm but rather to an iconic art that praised the glory of God, above all in the figure of the human being, whom God himself had created in His image and likeness (Gen. 1:26). For Michelangelo the human body was always already intended for the body of Christ—in the Son's Incarnation, in the Eucharist, and in the church as a whole—and not for itself, in keeping with the words of St. Paul: "Now the body is . . . for the Lord, and the Lord for the body" (1 Cor. 6:13). Among the most complex expressions of Michelangelo's anti-idolatrous fashioning of images are his *Moses* (1515); the *Last Judgment* (1536–41), where he painted his own disfigured face in the flayed skin of St. Batholomew; and his unfinished, Florentine *Pietà*, where Nicodemus's features are his own.

For his part Ignatius guards against an idolatrous imagery by being decidedly nonprescriptive about the specific images of the hour-long meditations, leaving them to each person's invention. His purpose is to enable the retreatant to confront himself and to arrange for his face-to-face encounter with Christ. The *Exercises* provide a temporal and topical frame within which the exercitant's imagination, inspired by the Holy Spirit, can and must work to create images as vehicles for self-knowledge and affective communication with God. Knowing the power of the imagination, Ignatius prescribes the employ of what phenomenologist Antonio T. de Nicolas terms "technologies of the visible" to effect conversion and transformation.[28] "This strategy of Ignatius," de Nicolas writes, "is so demanding," because it "rests more on the actual technologies of imagining than on any images"; it requires the retreatant's "concentration in order to bring out the pure image, the uncontaminated image, the image in perfect solitude, the original image, the divine image. One cannot borrow it, one must create it. The image created in meditation is the only image that will gain currency."[29]

In the *Spiritual Exercises* Ignatius refuses to impose any particular image, lest it block the original work of art that God seeks to realize in each individual as a divine likeness. The exercitants' practice of imaging throughout the four-week retreat should enable them, first of all, to recognize themselves as they are and as they are called to be; and second, to elect to cooperate with God's call through obedience to Him in the ongoing work of creation and redemption.

In Ignatius's own case, Ludolph of Saxony's *Life of Christ* and Jacopo de Voragine's *Golden Legend* provided him with an initial reservoir of narrative images

27. Ibid., 476.

28. Antonio De Nicholas, *Powers of Imagining: Ignatius de Loyola: A Philosophical Hermeneutic of Imagining through the Collected Works of Ignatius de Loyola, with a Translation of These Works* (Albany: State University of New York Press, 1986), 84–88.

29. Ibid., 41.

for imagining a possible life for himself. At first, indeed, he set out to imitate the saints of old according to their external acts. In the end, however, he emphatically rejected such an outward mimesis as inadequate, deforming, and potentially idolatrous, because unsuited to his own particular vocation from God. He discovered (in de Nicolas's memorable phrase) that "one needs to be very humble to be original."[30]

When in Paris he chose a new name for himself—Ignatius, rather than Iñigo—and selected as his patron a patristic martyr, St. Ignatius of Antioch, whose fiery name and attitude resonated with his own ideal.[31] With Ignatius of Antioch, whose name Jacopo de Voragine interprets to mean "he who has experienced the fire of divine love (*ignem patiens diuini amoris*),"[32] the sixteenth-century Ignatius took as his motto the words of Christ: "I have come to cast fire upon the earth; and what will I but that it be kindled?" (Luke 12:49). Ignatius of Loyola, in short, saw Christ through and behind Ignatius of Antioch, who served for him as it were, as a transparency of Christ. The *Golden Legend* suggests this transparency function, for the body of the martyr was reportedly cut open to reveal the name of Jesus imprinted on the saint's heart.[33]

A divine name written on a human heart! What worries Roland Barthes about Ignatius of Loyola is the recognition that the sixteenth-century saint understood very well that there is a kind of language that is (in Barthes's words) "neither decorative nor instrumental . . . but primal, antecedent to man," a kind of language that is Image, namely, the Son of the Father, the Logos of God.[34] Labeling the Jesuit saint a "logo-technician," Barthes argues that Ignatius responded to the supposedly dominant, mystical mistrust of images with a "radical imperialism of the image," forging in his *Spiritual Exercises* a new kind of meditative, questioning language, characterized by a syntax of unitary signs arranged in succession.[35]

Whereas Barthes likens "Loyola" to the Utopian philosopher Charles Fourier (1772–1837) and the nefarious Marquis de Sade (1740–1814) as fellow "Logo-thetes," I compare Ignatius with Michelangelo. Barthes omits any "life" of Ignatius of

30. Ibid., 44.

31. Given the significance of Ignatius's choice of name, it is shocking to read the words of Roland Barthes, who names him "Loyola" instead: "I know one should say 'Ignatius' or 'Ignatius Loyola', but I persist *in speaking of this author as I have always named him for myself*" (*Sade, Fourier, Loyola*, trans. Richard Miller [New York: Wang and Hill, 1976], 11n1). Emphasis mine.

32. *The Golden Legend of Jacobus de Voragine,* trans. Granger Ryan and Helmut Ripperger (New York: Longmans, Green, 1941), 1:145; Iacopo de Varazze, *Legenda Aurea*, ed. Giovanni Paolo Maggioni, 2nd rev. ed. (Tavarnuzze: SISMEL-Edizioni del Galluzzo, 1998), 1:233.

33. *Golden Legend* 1:148. Vittoria Colonna meditates on this legend about St. Ignatius of Antioch in a sonnet that she probably composed as a tribute to St. Ignatius of Loyola. See Vittoria Colonna, *Rime*, ed. Alan Bullock, *Rime Spirituali* 125 (Rome: Gius, Laterza, 1982), 147.

34. Barthes, *Sade, Fourier, Loyola,* 40.

35. Ibid., 66.

Loyola, whereas he provides the "lives" of Sade and Fourier, on the grounds that "hagiography" even in the modern period is completely coded and lacking in historicity: "We know nothing of this saint but his misty eyes and his claudication."[36] My concern, on the contrary, is precisely with Ignatius's life as a background to the *Spiritual Exercises,* which reflect his own experience of conversion and perpetuate it as a formative process in which others can participate. "Our authors," Barthes writes, "have each had recourse to the same [four] operations": self-isolation, articulation, ordering, and theatricalization.[37] Barthes's "four operations," however, bear little or no resemblance to the four steps that the Jesuits themselves traditionally attach to the four weeks of the Ignatian retreat known as the *Spiritual Exercises*—steps that, given their explicit concern with the progressive formation of the soul, are simultaneously ethical and aesthetic: "(1) *Deformata reformare,* (2) *Reformata conformare,* (3) *Conformata confirmare,* (4) *Confirmata transformare.*"[38] The four weeks of the *Exercises* thus summarized give a classic structure to the conversion process sketched in Ignatius's *Autobiography* and provide a convenient heuristic for an extended comparison of the saint with the artist, Michelangelo.

Deformata Reformare: The First Week of Ignatius's *Exercises*

Our investigations in previous chapters have confirmed Gerhart B. Ladner's assertion, "The idea of the reform of man to the image and likeness of God became the inspiration of all reform movements in early and mediaeval Christianity."[39] The Latin rubric for the First Week of the *Spiritual Exercises,* which corresponds to what Ignatius calls the "purgative life" (*la vida purgativa*),[40] forcefully demonstrates that Catholic Christianity in the early modern period also understood "reform" to be an artistic process, metaphorically understood as a bending straight of what had been curved, a carving away of excess, a healing of the wounds due

36. Ibid., 11n5. Barthes's mention of claudication highlights in Ignatius of Loyola a frequent attribute of scapegoat figures in myth, such as the swollen foot of Oedipus. See René Girard, *Things Hidden since the Foundation of the World,* trans. Stephen Bann and Michael Metteer (Stanford: Stanford University Press, 1987), 122–23. Given Barthes's refusal to name Ignatius and his denial of a "life" to him, this obsession with the saint's physical handicap cannot be without significance.

37. Barthes, *Sade, Fourier, Loyola,* 5–6.

38. Ibid., 60. I have been unable to identify Barthes's source for the Latin formula.

39. Gerhart B. Ladner, *The Idea of Reform: Its Impact on Christian Thought and Action in the Age of the Fathers* (Cambridge: Harvard University Press, 1959), 62.

40. See Ganss's editorial note, *Spiritual Exercises,* 221–22.

to sin, and a purifying of what had become tarnished or discolored: *Deformata reformare.*

The First Week is to be devoted, Ignatius instructs, "to the consideration and contemplation of sins" ([4], 22), beginning with the first sin (that of the angels), the second (that of Adam and Eve), and the third (that of a soul damned to hell because of mortal sin). The exercises of the First Week—each of them involving a vivid imagination of sights, sounds, smells, taste, and touch—include repeated meditations on one's own sins and on hell. Accompanying the actual meditations (five exercises per day, each lasting a full hour or more) are additional practices that Ignatius recommends as helpful "for making the exercises better and finding more readily what one desires" ([73], 48). These include shorter meditations when a retreatant is falling asleep, awakening, dressing; changes in bodily posture while the retreatant is praying (sitting, standing, kneeling, lying prostrate, walking); observance of silence; and interior and exterior penitential practices as self-punishment for the sins one has committed. Performing these exercises, in turn, helps to bring about movements in the soul—affective responses of sorrow, joy, fear, hope—that gain expression in colloquy with Mary, Christ, and God the Father. The retreatant gradually learns, through personal practice and the director's guidance, how to discern the deeper meaning of his or her changing feelings. All these exercises of meditation, penance, and prayer prepare the retreatant to make a general confession and to receive Communion at the end of the First Week.

The First Week of the *Spiritual Exercises* models itself on Ignatius's personal experience of conversion. According to Ignatius's own account, as related to the young Portuguese Jesuit Luis Gonçalves de Câmora the conversion of Iñigo Lopez de Loyola began abruptly on May 20, 1521, when his legs were broken by a cannon ball in the French bombardment of Pamplona. Immobilized, the thirty-year-old soldier, who had been driven by "a great and vain desire to win fame," survived the infection, the fever, and the repeated surgeries that ensued.[41] His convalescence was protracted, however, and he whiled away the time of confinement reading the two books that were available to him: Ludolph of Saxony's *Life of Christ* and Jacopo de Voragine's *Golden Legend,* a thirteenth-century collection of saints' lives.

The pious reading that he at first undertook reluctantly (he would much have preferred to read chivalric romances) gradually captured his imagination, and he asked himself, "What if I should do what St. Francis did, what St. Dominic did?" (23). As he contemplated his future, he imagined, on the one hand, "the worldly deeds he wished to achieve"; on the other, "the deeds of God that came to his

41. *The Autobiography of St. Ignatius Loyola,* trans. Joseph F. O'Callaghan, ed. John C. Olin (New York: Fordham University Press, 1992), 21.

imagination" (24); and he discerned a striking difference in the affects produced by these thoughts: the vainglorious, worldly imaginations in which he indulged instilled only an immediate pleasure and left him feeling "dry and discontented" afterward, whereas the daydreams of saintly work and suffering effected not only a short-lived consolation, but also a lingering happiness and contentment. Ignatius attributed the different effects of these thoughts to their different spiritual origins, the former proceeding from the devil as the enemy of souls; the latter from the Spirit of God. This rudimentary association of imagination, resultant affect, and spiritual source (later confirmed, along with other insights, by Ignatius's illuminative mystical experience on the banks of the River Cardoner near Manresa) was the first of the principles that Ignatius subsequently developed with great psychological sophistication and codified in the *Spiritual Exercises* as "Rules to Perceive and Somewhat Understand the Motions Caused in the Soul by the Diverse Spirits" ([313–27], 121–25).

More and more his desire grew to imitate the saints in following Christ, and his desire turned into a firm resolve: "All he wanted to do was to go to Jerusalem as soon as he recovered, . . . performing all the disciplines and abstinences which a generous soul, inflamed by God, usually wants to do" (24). This resolution, which had begun in his imaginings, was in turn confirmed by a vision in which "he clearly saw an image of Our Lady with the holy child Jesus," a "sight" that expelled by its beauty "all the [worldly] fantasies he had previously pictured in his mind" (24). Contemplating the natural beauty of the heavens also uplifted him spiritually: "The greatest consolation he received was to look at the sky and the stars, which he often did and for a long time, because as a result he felt within himself a very great desire to serve our Lord" (25).

Only by acting on his resolution and putting his new-found ideals into practice, however, could Iñigo be reformed, his moral deformities corrected. As soon as he could walk physically again, he began to pursue his new way of life, which was marked by a penitential change of place, of clothes, of diet; by the making of "a general confession in writing which lasted three days" (31); by weekly confession and Communion; and by seven hours of prayer a day, including prayer at midnight, during which he gained experience in the discernment of spirits. At Manresa (from March 1522 until early 1523) Iñigo carried out his decision "to do great penances" for his sins, such as saints before him had done, imitating their outward actions, not knowing at first "what humility was or charity or patience or discretion to regulate and measure these virtues" (30). Only very gradually did the increased strength of his interior life dictate the moderation of exterior penances; bring about the recognition of his specific, personal vocation and mission; and direct the channeling of his energies into apostolic work.

Iñigo's "purgative life" at Manresa ended in a series of consoling illumina-

tions concerning five different mysteries: (1) the harmonious relationship among the persons of the Trinity, whom he saw "in the form of three [musical] keys"; (2) the "manner in which God had created the world" out of a source of light; (3) the form of Christ's presence in the "most holy sacrament," elevated at Mass; (4) the luminous humanity of Christ; and (5) a final, summative enlightenment by the Cardoner River that was "so great an enlightenment that everything seemed new to him" (37–39). Reformed as a Pauline "new creation" (Gal. 6:15), Iñigo "gave up those extremes he had formerly observed, and he now cut his nails and his hair" (38).

Iñigo's experience of personal reformation—illuminated by a new understanding of the Trinity, creation, the Incarnation, and the Eucharist—gained expression years later in the "Principle and Foundation" of the *Spiritual Exercises:* "Human beings are created to praise, reverence, and serve God our Lord, and by means of doing this to save their souls" ([23], 32). This "end" defines the proper use-value of all created things for humanity: "We ought to desire and choose only that which is more conducive to the end for which we are created" ([23], 32). What is beautiful for Ignatius is whatever matches God's design, conforms to the order of His creation, obeys his command, carries out his plan, furthers his creative work—whatever, in short, is fitting to human nature as beings created in God's Image and Likeness (Gen. 1:26). "Indifferent" to all things, humans are then free to use whatever happens in their lives in order to praise and serve God, be it sickness or health, wealth or poverty, honor or dishonor ([23], 32). "Such *indiferencia*," Karl Rahner remarks, "becomes a seeking of God in *all* things," and thus the opposite of the idolatry that seizes on any "determinate thing which man is tempted to regard as *the* point in which alone God meets him."[42] The alignment of every means with the single end of God's greater glory is thus for Ignatius an aesthetic and ethical principle that makes whatever is fitting, proper, and decorous for God's creatures the standard for their desires, decisions, and actions.

Sin, by contrast, is a principle of ugliness that disrupts this alignment, confusing means with ends. The first exercise of the First Week focuses on the sins of the angels, of Adam and Eve, and of souls in hell, respectively, so that by "remembering and reasoning about all these matters" the retreatant might first be brought "to greater shame and confusion" by comparing their sins with his or her "own many sins" ([50], 41) and recognizing the consequences of a deforming misuse of freedom. Because of their disobedience, the angels "were changed from grace to malice, and were hurled from heaven into hell" ([50], 41). Adam and Eve disobeyed God's command; then, "clothed in garments of skin and expelled from

42. Karl Rahner, S.J., "The Ignatian Mysticism of Joy in the World," *Theological Investigations* (Baltimore: Helicon, 1967), 3:290–91.

paradise, they lived out their whole lives in great hardship and penance, deprived of the original justice which they had lost" ([51], 42).

The first colloquy of the *Exercises* moves suddenly from these images of deformity due to sin to the image of *Christus deformis*: "Imagine Christ our Lord suspended on the cross before you and converse with him" ([53], 42).[43] Ignatius invites the retreatant to wonder about the causes of Christ's Incarnation and death: What moved "the Creator . . . to make himself a human being? How is it that he has passed from eternal life to death here in time, . . . to die in this way for my sins?" ([53], 42). For Ignatius, as Hugo Rahner explains, Jesus Christ is the foundation (cf. 1 Cor. 3:11), "the beginning and end of all beings created in grace."[44] Contrasting the obedience of Christ to the disobedience of the sinner, Ignatius prompts the retreatant during the first exercise to ask: "What have I done for Christ? What am I doing for Christ? What ought I to do for Christ?" ([53], 42). Such questions engage the will, instill the desire to atone for past sins, open the soul for direction, and awaken love: "Gazing on him in so pitiful a state as he hangs on the cross, speak out whatever comes to your mind" ([53], 42).

The beauty of creation and its wondrous variety, Ignatius realized, depends on obedience—Adam's, Christ's, and in Christ, that of every person. Ignatius characteristically applies the antisacrificial criterion of obedience to ascetical practices. Whereas St. Francis of Assisi, the saint of poverty, had lived an austerely penitential life until his death as an example to others, St. Ignatius, the saint of obedience, maintained that as a rule penitential practices are most appropriate to the "purgative life" of the recent convert and should not detract from the fulfillment of one's vocation in life. Even activities that are commonly regarded as "spiritual and holy, such as fasts, prayers, and other pious works," must take place, he writes, "in Bethania, which is interpreted to mean 'the house of obedience.'"[45]

While in Manresa, the penitent Iñigo had once felt inspired to fast from food and drink, and for a whole week he endured, "without putting anything into his mouth nor ceasing to do his usual exercises," until his confessor told him to cease.[46] Similarly, in the *Spiritual Exercises*, Ignatius does not absolutely forbid exterior penances, such as "wearing hairshirts, cords, or iron chains" ([85], 50), but he counsels moderation and insists that exercitants do nothing to "harm [themselves] or weaken [their] constitution" ([84], 50). Most important, he directs that such penances be viewed not as goods in themselves, but as a means to achieve a corrective or transformative purpose. His advice to Inés Pascual is typical of his counsel: "The Lord does not command you to do things that might

43. On the Augustinian notion of the *Christus deformis*, see Hugo Rahner, S.J., *Ignatius the Theologian*, trans. Michael Barry (New York: Herder and Herder, 1968), 100–101.

44. Rahner, *Ignatius the Theologian*, 64.

45. *Letters of St. Ignatius*, 289.

46. *Autobiography of St. Ignatius*, 36.

cause suffering or harm to your person, but rather wants you to live with him in joy, giving the body whatever things are necessary for it."[47]

In his "Rules to Order Oneself Henceforth in the Taking of Food," Ignatius offers eight practical guidelines to exercitants who want to avoid "what is disordered in the taking of food" ([210–17], 88–89). The first four concern the quality and quantity of food and how to discover "the right mean to keep for oneself in eating and drinking" ([213], 88). The last four suggest ways of subordinating the physical appetite to the human spirit both during meals (by occupying the mind with uplifting thoughts and conversations) and before meals (by deciding ahead of time at some "hour when the appetite to eat or drink is not strong" ([217], 89) how much one will eat later).[48] The latter rules are key to the understanding of Ignatian food asceticism, for they envision the body's obedience to the spirit. "A healthy body," Ignatius writes to Sister Teresa Rejadall, "is a great help for . . . good in those whose will is entirely given to God and trained to habits of virtue. . . . And the soul so conformed makes the body conformed, whether it wish it or not, to the divine will."[49]

All of these food practices are thus linked to the proper reception of the Eucharist, through which the exercitant comes into direct contact with Christ Himself, the obedient Word of the Father: "Behold, I come to do thy will, O God" (Heb. 10:7). The First Week of the *Spiritual Exercises* is regularly marked by the reception of the sacraments of confession and Communion—a twinned reception that seals the purgative process (*Deformata reformare*) through the putting off of the Pauline "old man" and the putting on of the "new" in the eucharistic Christ (cf. Col. 3:9–10). As we have seen, Ignatius's own purgation at Manresa ended with illuminations, one of them occurring "at the elevation of the Body of the Lord," when he "saw with interior eyes something like white rays coming from above," a radiant sight that confirmed his faith that "Jesus Christ was there in that most holy sacrament."[50] After his ordination Ignatius "had many visions when he said Mass."[51] He practiced and urged the frequent (weekly or even daily) reception of Communion as a source of spiritual strength, and that eucharistic attitude, according to Harvey D. Egan, brought him under scrutiny by the Inquisition at Salamanca.[52] The vision of November 1537 at La Storta confirmed Ignatius's understanding that sacramental Communion was indispensable to a life

47. *St. Ignatius Loyola: Letters to Women*, 177–78,

48. Michelangelo's practice of eating during work shows him to have shared Ignatius's impulse to subordinate the physical to the spiritual. See Ascanio Condivi, *The Life of Michelangelo*, trans. Alice Sedgwick Wohl, ed. Hellmut Wohl (Baton Rouge: Louisiana State University Press, 1976), 106.

49. *Letters of St. Ignatius*, 25.

50. *Autobiography of St. Ignatius*, 38.

51. Ibid., 93.

52. Harvey D. Egan, S.J., *Ignatius Loyola the Mystic*, The Way of the Christian Mystics 5 (Wilmington, DE: Michael Glazier, 1987), 112.

in the company of Jesus (*Compañía de Jesús*), a title that literally recalls the communal breaking of bread (*pan*).[53]

The first exercise on the first day of the First Week of the *Spiritual Exercises* ends with the exercitant's colloquy with Jesus Crucified. All the exercises, from the beginning to the end of the retreat, promote union with Christ, principally through meditations on scenes from the Gospels, but also through the reception of the Eucharist. Ignatius secures the identification of the Christ of the scriptures with the Lord of the sacrament through the daily recitation of the traditional, eucharistic prayer *Anima Christi*, which regularly concludes a colloquy with Jesus:[54]

> Soul of Christ, sanctify me.
> Body of Christ, save me.
> Blood of Christ, inebriate me.
> Water from the side of Christ, wash me.
> Passion of Christ, strengthen me.
> O good Jesus, hear me.
> Within your wounds hide me.
> Do not allow me to be separated from you.
> From the malevolent enemy defend me.
> In the hour of my death call me,
> And bid me to come to you,
> That with your saints I may praise you
> Forever and ever. Amen.[55]

Even as the senses of the exercitants are broken apart through the exercises, which require them in imagination first to see, then to hear, to smell, to taste, to touch the objects of their meditation, so too the parts of Christ are separated in the prayer to recall, first, His brokenness on the cross and, second, the fullness of His eucharistic presence: Body, Blood, Soul, Divinity. What has been deformed is reformed; what has been torn apart is reconciled through confession and joined in Communion.

53. On the history of the terms *Compañía de Jesús* and *Societas Jesu*, see Ganss's edition of *The Constitutions of the Society of Jesus*, 345–49. Prior to the vision at La Storta, just outside of Rome, Ignatius "had decided to spend a year without saying mass, preparing himself and begging our Lady to deign to place him with her Son" (*Autobiography of St. Ignatius*, 89).

54. Colloquies with Mary conclude with the Hail Mary; colloquies with the Father, with the Lord's Prayer.

55. See *Spiritual Exercises*, ed. Ganss, 20. According to Gordon S. Wakefield, the prayer most probably dates from the fourteenth century. The 1344 diary of Margaret Ebner mentions it. See *The Westminster Dictionary of Christian Spirituality*, ed. Gordon S. Wakefield (Philadelphia: Westminster Press, 1983), 16; Herbert Thurston, *Familiar Prayers* (Westminster, MD: Newman , 1953), 38–53.

Michelangelo's "First Week" of Reform

And what of Michelangelo? Is there anything corresponding to the First Week of the *Spiritual Exercises* in the life and work of the great artist? What is immediately striking is that the masterpieces of Michelangelo's early maturity—the *Pietà* in St. Peter's (1499), the *David* (1501–4), the Genesis cycle on the ceiling of the Sistine Chapel (1508–12), and the *Moses* (1506–15)—probe the very same themes of Incarnation, Creation, Sin, and (Dis)Obedience that are the prescribed topics of the initial exercises, and they do so in the intensely imaginative way of an exercitant. There can be no question of an Ignatian influence, because these works all precede Ignatius's first arrival in Rome in 1537–38. What is indisputable, however, is a spiritual affinity between the two reformers which merits elaboration.

Just as Ignatius's own conversion story stands behind the *Spiritual Exercises*, so too (as Paul Barolsky and others have argued) "Michelangelo's 'autobiography'" is the generative principle at work in his sculptures, paintings, sonnets, and buildings—all of which give expression to "his struggle to create himself, to 'form' himself into a perfect being, hence, to 'reform' himself spiritually."[56] In the process he hoped (in the words of Alexander Nagel) to reform art itself, restoring to it the "aura of authentic religiosity" that belonged to the devotional art and sacred images of an earlier time.[57] Perhaps his sense of a vocation to accomplish that reformist end for art and for the church intensified his personal striving for sanctity. In his *Three Dialogues on Painting* (ca. 1540), Francisco de Hollanda attributes to Michelangelo the opinion that "in order to imitate even partially the venerable image of our Lord, it is not enough for a painter to be a master, great and well-advised. . . . It is necessary for him to be of a very good life, even saintly, if he can, so that the Holy Spirit may inspire his *intelletto*."[58]

Ignatius was not the first man of the Spirit to enkindle Michelangelo's devotion. As a youth in Florence Michelangelo had heard the passionate call to repentance issued by the Dominican preacher, Fra Girolamo Savonarola (1452–1498). Ascanio Condivi's *Life of Michelangelo* (1553) witnesses to Michelangelo's sustained reading of the Old and New Testament, "as well as the writings of those who have studied them, such as Savonarola, for whom he has always had great affection and whose voice still lives in his memory."[59] Following this hint from

56. Paul Barolsky, *Michelangelo's Nose: A Myth and Its Maker* (University Park: Pennsylvania State University Press, 1990), 140.

57. Alexander Nagel, *Michelangelo and the Reform of Art* (Cambridge: Cambridge University Press, 2000), 12.

58. Quoted by Robert J. Clements, *Michelangelo's Theory of Art* (New York: New York University Press, 1961), 86.

59. Condivi, *Life of Michelangelo*, 105. Vittoria Colonna's poem "Trionfo di Cristo" was inspired

Condivi, scholars have seen Michelangelo as among those "artists most affected by Savonarola and his preaching," and yet, as Ronald M. Steinberg cautions, "the evidence attesting to this influence in the case of a particular work is unquestionably tenuous."[60] Nor can a direct line be traced from Savonarola's theology and philosophy to Michelangelo's theories of art, since both men drew on common biblical, classical, and patristic sources. Parallels in thought and imagery are to be "expected between two roughly contemporary men with similar interests."[61] Even Steinberg admits, however, to the actual existence of such "parallels between some of Michelangelo's art and Savanarola's ideas," pointing without explanation in an endnote to Michelangelo's *David*.[62]

Steinberg rightly reacts against arguments for Savonarola's "influence" on Michelangelo, because they imply a simple, one-directional movement from the preacher to the artist, and because they cannot easily be proven. Steinberg's emphasis on parallelism, however, goes to the opposite extreme, suggesting the absolute autonomy of the artist, at the cost of denying his biographical connections with, and love for, Savonarola. A careful, phenomenological observation of similarities ("parallels," if you will) between the works of historically related persons (in this case, Savonarola and Michelangelo, on the one hand, and Michelangelo and Ignatius Loyola, on the other) can be of great value as a means to discover their mutual affinities and intersubjectivity and thus to characterize the spirituality they hold in common, as well as the larger communion—metaphysical, ecclesial, societal—in which they are held and supported.

What conceptual parallels, then, link Michelangelo's marble *David* (1501) to Savonarola's penitential preaching and to the "purgative life" (*deformata reformare*) of an Ignatian retreat? As Giorgio Vasari (1511–1574) relates, Michelangelo was given a damaged block of marble that had been "hacked and spoiled" by another sculptor's frustrated attempt to carve a giant.[63] Michelangelo discovered the potential for his statue within the existing shape of the deformed stone. "This revival of a dead thing," Vasari declares, "was a veritable miracle."[64] The success

by Savonarola's *Trionfo della Croce*. See Maud F. Jerrold, *Vittoria Colonna* (1906; Freeport, NY: Books for Libraries, 1969), 287–91.

60. Ronald M. Steinberg, *Fra Girolamo Savonarola, Florentine Art, and Renaissance Historiography* (Athens: Ohio University Press, 1977), 39.

61. Ibid.

62. Ibid., 42, 127n18.

63. Giorgio Vasari, *The Lives of the Painters, Sculptors and Architects*, trans. and ed. William Gaunt (London: Dent, 1963), 4:116. Vasari identifies the bungling sculptor as Simone da Fiesole, but current scholarship indicates Agostino di Duccio or Baccellino. See Ludwig Goldscheider, *Michelangelo: Paintings, Sculpture, Architecture*, 6th ed.(London: Phaidon, 2000), 12.

64. Vasari, *Lives*, 4:116.

of the *David* validated Michelangelo's belief that forms already inhere in things; that the artist recognizes the preexistent form through the grace (*grazia*) of his God-given, intuitive understanding (*intelletto*) and, on the basis of that recognition, conceives a mental image (*concetto*) of the work.[65] The sculptor then realizes that idea to the best of his technical ability through a process that involves cutting away the excess matter within which the hidden form is obscured or imprisoned. According to Vasari Michelangelo's pioneering example "taught sculptors the way to make statues without spoiling them by removing the marble."[66] In a letter to Benedetto Varchi dating from 1547, Michelangelo declares simply, "By sculpture I mean that which is fashioned by the effort of cutting away."[67]

Commissioned by the wardens of Florence, Michelangelo's statue of the youthful David, armed only with a sling, gave new expression to Savonarola's millennial prophecies concerning Florence as an elect city,[68] which should be (in Vasari's words) "boldly defended and righteously governed, following David's example."[69] The innovative technique used by Michelangelo in carving the statue, moreover, literally realized in stone the repeated call of the apocalyptic prophet to strip away *superfluità*, the unnecessary possessions, comforts, ornaments, and outward trappings that detract from the vision of the pure form, the soul, and the *semplicità* of God. Savonarola had called for the cleansing of Florentine society in every sphere of activity, but in his view (as Steinberg notes) *superfluità* was "the worst sin for the artist, be he sculptor, painter, or musician," because of the artist's special vocation to teach the truths of the faith and to promote worship.[70] For Michelangelo the nudity of David represented the perfection of virtuous simplicity, detachment from the world, all-conquering trust in God, and the return to paradisiacal beauty.

Michelangelo's poems confirm his conscious awareness of a symbolic—indeed, a sacramental—relationship between his exterior carving in stone and his interior striving for virtue. In a well-known madrigal composed for Vittoria Colonna, he writes:

65. Clements notes, "Whereas most of the Renaissance theorists on art and literature adhered to the usual classical (non-Platonic) vocabulary in ascribing genius to an artist or poet, Michelangelo clung to the word *intelletto*" (*Michelangelo's Theory of Art*, 15). On Michelangelo's theoretical debt to neo-Platonism, see Charles de Tolnay, *The Art and Thought of Michelangelo*, trans. Nan Buranelli (New York: Pantheon, 1964); and especially David Summers, *Michelangelo and the Language of Art* (Princeton: Princeton University Press, 1981). On the *David* see Clements, 23.

66. Vasari, *Lives*, 4:117.

67. *Letters of Michelangelo*, 2:75.

68. See Lorenzo Polizzotto, *The Elect Nation: The Savonarolan Movement in Florence, 1494–1545* (Oxford: Oxford University Press, 1994).

69. Vasari, *Lives*, 4:116.

70. Steinberg, *Fra Girolamo Savonarola*, 51.

Sì come per levar, donna, si pone
in pietra alpestra e dura
una viva figura,
che là più cresce ú più la pietra scema;
tal alcun' opre buone,
per l'alma che pur trema,
cela il superchio della propria carne
co' l'inculta sua cruda e dura scorza.

[Just as, by taking away, lady, one puts / into hard and alpine stone / a figure that's
alive / and that grows larger wherever the stone decreases, / so too are any good
deeds / of the soul that still trembles / concealed by the excess mass of its own flesh,
/ which forms a husk that's coarse and crude and hard.][71]

The poem plays on Michelangelo's surname "*Buona*rotti" in its reference to the
"good [*buone*] deeds" that are to be brought out in him through Vittoria's virtu-
ous influence, even as his inordinate, fleshly desires are curtailed.[72] Blending neo-
Platonic and biblical images, Michelangelo takes the attitude of John the Baptist,
willing Christ's increase (*cresce*) through his own decrease (John 3:30). With John
the Baptist he welcomes the messianic threshing of the wheat and the burning of
the chaff, for the sake of the grain (Matt. 3:12). Contrasting the "living figure [*viva
figura*]" with the "hard and alpine stone [*pietra*]," he evokes Christ's resurrection
from the tomb. As he addresses Vittoria as "lady" (*donna*) in this context, she be-
comes another Mary for him, a *pietà*, calling him from death to life, making both
artistic creation and spiritual transformation possible.

The Virgin Mary literally inspired Michelangelo's first major work, the *Pietà*
in St. Peter's, Rome.[73] Commissioned in August 1498, only a few months after the
execution of Savonarola on charges of false prophecy and conspiracy, the statue
was completed in 1499 and bears Michelangelo's unique signature. Mario Ferrara
characterizes it as a memorial of "il sacrificio del Savonarola all' offerta del
supreme Martire della carità."[74] Because the chapel of St. Petronilla, in which the

71. *The Poetry of Michelangelo*, 305.

72. Michelangelo was not the only one to make such wordplays with his name. See *The Divine
Michelangelo: The Florentine Academy's Homage on His Death in 1564: A Facsimile Edition of Ese-
quie del Divino Michelangelo Buonarroti, Florence, 1564*, trans. and ed. Rudolf and Margot Witt-
kower (London: Phaidon, 1964), 30.

73. On the popularity of the Pietà as an artistic subject and on its important place in the spir-
ituality of the Beguines, see Joanna E. Ziegler, *Sculpture of Compassion: The Pietà and the Beguines
in the Southern Low Countries, c. 1300–c. 1600* (Brussels: Belgian Historical Institute of Rome,
1992).

74. Mario Ferrara, "L' influenza del Savonarola sulla Letteratura e l'arte del quattrocento," in
Savonarola: Prediche e scritti commentati e collegati da un racconto biografico, ed. Mario Ferrara
(Florence: Olschki, 1952), part 2, 64. For an interesting study of the Florentine cult of martyrs, see

Pietà was originally housed, was destroyed before 1520, the question whether the statue was originally used as an altarpiece or as a tomb memorial remains open. The comparative work of Loren Partridge, Alexander Nagel, and others strongly suggests, however, that Michelangelo intended the statue to appear on the altar, where it could be viewed by the faithful during the celebration of Mass.

"Altarpieces," according to Partridge, "gave visible form to beliefs about the Mass or Eucharist" and shared in the power of the sacrament to mediate between humankind and God.[75] Nagel agrees, noting that whatever the specific subject of the altarpiece—be it a biblical scene or an episode in the life of a saint—its "close association with the altar naturally encouraged an emphasis on those features of the subject that connected it to the scheme of redemption celebrated in every mass rite."[76] Altarpieces frequently depicted either the Deposition from the Cross or the Entombment of Christ, for example, because the Mass renewed the sacrifice of Christ on Calvary; the altar itself contained the relics of saints or perhaps the consecrated Host and thus recalled the Lord's sepulcher; the altar, moreover, was covered with a white linen cloth, in remembrance of the Lord's shroud.

Considered as an altarpiece, Michelangelo's *Pietà* comments on the eucharistic altar and the action of the Mass. Seated on an outcropping of marble, her legs spread in order to support the dead body of her Son, Mary forms an altar on her lap. She thus becomes a type, a *figura*, of the church, Christ's mystical bride and mother, who offers Christ in the Eucharist to the Father. The fingers of Mary's right hand frame the wound in His side from which flowed blood and water, symbolizing the sacraments of the Eucharist and Baptism; her left hand (as Partridge observes) gently "offers her dead son to the worshippers with a gesture recalling the priest about to elevate the Host."[77]

What seems to have troubled Michelangelo's contemporaries, arousing suspicions of heresy, was the unrealistic youth of the calmly sorrowing Virgin, who holds her Son's crucified body on her lap as if he were sleeping.[78] Perhaps as a defense of the artist's orthodoxy, Condivi records in his biography a long speech in which Michelangelo explains the youthful beauty of Mary as a natural effect of her spotless virginity and fullness of grace; Christ's wounds, by contrast, attest to His humanity and the suffering He endured on account of humankind's sin.[79]

Richard C. Trexler, "Lorenzo de' Medici and Savonarola, Martyrs for Florence," *Renaissance Quarterly* 3 (1978): 293–308.

75. Loren Partridge, *The Art of Renaissance Rome, 1400–1600* (New York: Harry N. Adams, 1996), 79.

76. Nagel, *Michelangelo and the Reform of Art*, 38.

77. Partridge, *Art of Renaissance Rome*, 103.

78. See Goldscheider, *Michelangelo*, 12.

79. Condivi, *Life of Michelangelo*, 24–27.

Pairing Mary and Jesus thus allows Michelangelo to represent the death of Christ in a way that conveys the mystery of His humanity and divinity. The seeming slumber of Christ's naked body, moreover, promises His life-giving resurrection and images what Nagel calls "an incipient radiance and beauty" even in death.[80] It effectively aligns the historical body of the crucified Christ with the eucharistic *Corpus Christi,* which possesses the paradisiacal qualities of Christ's resurrected body, especially its impassibility.[81]

As we have seen, the "Principle and Foundation" of the *Spiritual Exercises* is the truth of humanity's creation in the image and likeness of its Creator and Lord, for the purpose of praising Him. The first exercise, a meditation on the Fall, ends in a colloquy with the Crucified. Savonarola had prayed: "La Croce e 'l Crucifisso / Sia nel mio cor scolpito" (May the cross and the Crucified be carved into my heart).[82] Similarly Michelangelo begins his life's work as a sculptor with a *Pietà.* In and through Mary's contemplative conversation with Christ, the young artist asks, as it were, the question Ignatius prescribes for the exercitant: "What ought I to do for Christ?" ([53], 42). In its function as an altarpiece, the *Pietà* prompts the same question in the faithful who participate in the Mass.

Throughout the First Week, Ignatius urges repeated meditations on the Creation, the Fall, and the effects of disobedience. These same topics of meditation engaged Michelangelo from 1508 to 1512, when he painted the ceiling frescoes in the Sistine Chapel. The nine, famously beautiful, narrative panels are inspired by the book of Genesis and divide into three groups of three. The first group depicts the origins of the world: God's division of light from darkness; the creation of the sun, moon, and stars; the division of land from sea. The second shows the beginnings of humanity: the creation of Adam, the creation of Eve, the Fall and expulsion from Paradise. The third represents the effects of sin: the altar of sacrifice, the flood, and the drunkenness of Noah.[83] Repeated gestures encourage the comparison and contrast of scenes. The drunken sleep of Noah, for instance, recapitulates the innocent sleep of Adam; the flood reverses God's initial separation

80. Nagel, *Michelangelo and the Reform of Art,* 99.

81. Nagel points in this direction too by associating Christ's sleep with a Bacchic or ecstatic drunkenness and thus with the wine of the Eucharist. See his *Michelangelo and the Reform of Art,* 87–98.

82. *Savonarola: Prediche e scritti,* 81.

83. My summary reflects that of Goldscheider, *Michelangelo,* 17. There is a controversy about the seventh narrative panel, which both Condivi and Vasari identify as the sacrifice of Cain and Abel. Modern scholars, Goldscheider included, see it as representing the sacrifice of Noah, out of chronological sequence. The ambiguity of the scene, I would suggest, is intentional on Michelangelo's part, since it stands for all the sacrifices that would be offered as a result of sin. The figures in front of the altar suggest Cain and Abel, preparing for their separate sacrifices. The old man at the altar recalls their father Adam, but also Noah, Abraham, and a host of patriarchs and priests, all of whom offered sacrifice in atonement.

of the land from the sea. The serpent coiled around the tree of knowledge reappears as an agent of salvation in the corner spandrel depicting the bronze serpent lifted by Moses in the desert (Num. 21:9).

Typologically considered, the bronze serpent raised on the pole by Moses to heal the Hebrews, who have been bitten by poisonous serpents, foreshadows Jesus hung on the cross. Jesus himself draws the comparison in John 3:14–15: "And as Moses lifted up the serpent in the desert, even so must the Son of Man be lifted up, that those who believe in him may not perish, but may have life everlasting." Introducing the bronze serpent, Michelangelo—like Ignatius in the First Week's colloquy with the crucified Christ—confronts the viewer with the image of the *Christus deformis.*

Moses, the great lawgiver who lifts up the bronze serpent (even as Michelangelo does after him by painting it) and who recalls God's people to the path of obedience, is Michelangelo's subject both in painting and in sculpture during this time period. Michelangelo began his monumental *Moses* in 1506 and finished it circa 1515. His mental and physical labor on this sculpture, commissioned for the tomb of Pope Julius II, must be seen in conjunction with his contemporaneous work on the ceiling frescoes of the Sistine, where he depicts a wealth of Old Testament figures and scenes. Like Ignatius of Loyola,[84] Michelangelo had a deep respect—born of his biblical readings, Roman contacts with Jews, and personal practice of obedience—for the Jewish people, a respect that was reciprocated. Vasari praises the *Moses* as "unequalled by any modern or ancient work" and reports, "The Jews still go every Saturday in troops to visit and to adore it as a divine, not a human thing."[85]

Deformata reformare. In the great artworks of his early period, as in the Ignatian spiritual exercises of the First Week, Michelangelo concerned himself with the original beauty of creation, imaged on the Sistine Chapel ceiling and in the youthful features of the sinless Virgin Mary. He confronted the power of sin—represented in the deformed stone out of which he fashioned the *David,* in the biblical scenes of rebellion painted on the ceiling of the Sistine Chapel; and in the Man of Sorrows resting on the lap of the *Pietà.* He bore witness at the same time to a plan of redemption, a reformation in obedience of all the forms on which beauty depends. For this reformation the *Moses* is an amazing symbol, a sculp-

84. Philip Caraman notes that "from the time of his conversion [Ignatius] had regretted that he had not been born a Jew" (*Ignatius Loyola,* 133). Imprisoned by the Inquisition at Alcalá, Ignatius was asked "if he observed the Sabbath"—a question that gives some indication of his ongoing religious conversations with Jews. See the *Autobiography of St. Ignatius Loyola,* 63. Ignatius's vigorous efforts to secure legal protections for Jews were enlightened by sixteenth-century standards. Concerning his efforts see the *Autobiography,* 133–34, 129, 139, 186, 190, 197. See also James W. Reites, "St. Ignatius of Loyola and the Jews," *Studies in the Spirituality of Jesuits* 13.4 (1981): 1–48.

85. Vasari, *Lives,* 4:121.

ture that brings to life the very patriarch through whom was given the com-
mandment of anti-idolatry: "Thou shalt not make to thyself a graven thing, nor
the likeness of any thing that is in the heaven above, or in the earth beneath, nor
of those things that are in the waters. . . . Thou shalt not adore them, nor serve
them" (Exod. 20:4–5).

<div style="text-align: center;">

Reformata Conformare: Ignatius's
"Two Standards" and Michelangelo's
Eucharistic *Last Judgment*
</div>

Obedience for Michelangelo and Ignatius entails not merely moral conformity to
the Ten Commandments, and the fourth commandment in particular, but also
heroic configuration to the pattern of Christ's life in one's daily decision-making
concerning the "indifferent" matters that are neither good nor bad in themselves,
but which assume ethical value in vocational contexts: "What ought I to do for
Christ?"

Whereas the First Week of St. Ignatius's *Spiritual Exercises* aims at the detach-
ment from sin that makes true "indifference" and inner freedom possible, the Sec-
ond Week aims at the discovery and election of one's vocation in life or at making
some other important choice in the context of one's calling. Ignatius facilitates
this choice through a meditation on "Two Standards: The One of Christ, Our
Supreme Commander and Lord, the Other of Lucifer, the Mortal Enemy of Our
Human Nature" ([136–48], 65–67). Michelangelo vividly depicts this same divi-
sion of souls in the *Last Judgment* (1536–41), the somber masterpiece that he
painted during the first years of his friendship with Vittoria Colonna—a period
that coincides with the arrival in 1538 of Ignatius of Loyola in Rome. The eu-
charistic symbolism of the *Last Judgment* on the wall above the altar in the Sis-
tine Chapel is unmistakable. Its function as an altarpiece serves to clarify the
centrality of the Eucharist to the art of obedience practiced by the Catholic re-
formers studied here.

Even as the First Week of the *Spiritual Exercises* corresponds to Iñigo de Loy-
ola's purgation at Manresa, the Second Week takes its bearings from his arduous
pilgrimage to the Holy Land in 1523—a literal following in the footsteps of Christ
that prepared him to accept his vocation to the priesthood. The First Prelude to
the exercises of the Second Week takes the retreatant spiritually to the Holy Land:
"A composition by imagining the place. Here it will be to see with the eyes of the
imagination the synagogues, villages, and castles through which Christ our Lord
passed as he preached" ([91], 53). The Second Prelude is a petition for the desired

grace of a vocation: "That I may not be deaf to his call, but ready and diligent to accomplish his most holy will" ([91], 53). Imagining the call of Christ the King in this preparatory exercise, the exercitant is advised to be aware of what is at stake, since those who offer their total service to Christ "will not only offer their persons for labor, but go further still. They will work against their human sensitivities and against their carnal and worldly love, and they will make offerings of greater worth," as their discipleship requires ([97], 54).

Having set the vocational goal of the Second Week, Ignatius then prescribes a series of meditations on the early life of Christ, corresponding to His and Mary's initial, exemplary response to the Father's call: the Incarnation of the Second Person of the Trinity, the Nativity, the Presentation in the Temple, the Finding of the Twelve-year-old Jesus in the Temple. These meditations are to be conducted using the imagination and applying all five senses to a consideration of the evangelical scene, so as to involve the exercitant emotionally and reflectively. For example, in meditating on the Nativity, the retreatant resolves: "I will make myself a poor, little, and unworthy slave, gazing at [Our Lady, Joseph, and the Infant Jesus], contemplating them and serving them in their needs, just as if I were there. . . . Then I will reflect upon myself to draw some profit" ([114], 58–59).

The meditation on the Two Standards occurs on the fourth day of the Second Week: "Here it will be to consider how Christ calls and desires all persons to come under his standard, and how Lucifer in opposition calls them under his" ([137], 65). Continuing a long biblical and medieval tradition, Ignatius directs "a composition, by imagining the place," which is "a great plain" outside Jerusalem and "another plain in the region of Babylon" ([138], 65). The exercitant is first to overhear imaginatively the destructive plotting of Lucifer and his army against humanity; then he is to turn his attention to "an area which is lowly, beautiful, and attractive" ([144], 66), where Christ is gathering His disciples and sending them out to teach, heal, and help others. The colloquy that follows asks Mary "to obtain for me grace from her Son and Lord that I may be received under his standard" ([147], 67).

Although Ignatius does not explicitly compare the composition of place—in this case, the contrastive plains of Jerusalem and Babylon—to artistic composition, commentators on the *Spiritual Exercises* regularly do just that. Joseph Rickaby, S.J., for example, asserts: "Ignatian contemplation is what an artist would call a 'study' of a scene in our Lord's Life. We may call such contemplation a *mind-painting*. The best themes of this contemplation are those that would attract an artist. We make to ourselves a *tableau vivant*, say, of the Nativity, look hard at it, think, resolve, and pray."[86]

86. Rickaby, ed., *Spiritual Exercises of St. Ignatius Loyola*, 89.

As shown by the self-portrait it contains, Michelangelo's *Last Judgment* is the work of an artist who is also an exercitant, engaged in the making of an election. Conceived shortly before his first encounter with Ignatius, the colossal fresco, the largest in Rome, cannot be the direct result of Michelangelo's participation in an Ignatian retreat, but it demonstrates his spiritual closeness to the Spanish reformer. The full eucharistic and ecclesial meaning of the work becomes apparent when it is viewed in context as an altarpiece within the pope's Sistine Chapel. Charles De Tolnay rightly asserts, "The fresco is intended as a complement to the mensa-altar, located at the center below and before it, and as a spiritual preparation for the believer about to receive the sacrament."[87]

The famous fresco has three zones. Christ the Judge is at the center of the highest zone, with the Virgin Mary at His right side. His raised arms set into motion the ascent and descent of souls (more than four hundred figures) in the painting. The Lord in majesty is encircled by two groups of saints: the arch at Christ's left including St. Peter, the arch at His right featuring St. John the Baptist. These saints closest to Christ are flanked by Prophets, Confessors, and Martyrs. Lawrence and Bartholomew sit near Christ's feet on opposite sides, Bartholomew holding his flayed skin, Lawrence the grill iron on which he was roasted alive. Hosts of angels in two arches above the saints carry the cross and the pillar of scourging, respectively, as victorious tokens of Christ's Passion.

In the middle zone of the *Last Judgment* are depicted the souls who have just been judged, the righteous ascending at Christ's right, the damned falling at His left. Angels in the center sound trumpets to awaken the dead, calling them to judgment.

The lowest zone is similarly divided into three horizontal parts. At the center, directly above the altar where Mass is celebrated, is an open tomb, the cave of Limbo, decorated with a death's head. At the viewer's left the dead are arising from their graves in answer to the trumpet blasts. At the right Charon conducts the damned to hell, where Minos receives them into a Dantesque inferno at the far right.[88]

Like Ignatius's "Two Standards" meditation, Michelangelo's *Last Judgment* depicts Christ and Satan, figured here as Midas/Minos, and their opposed bands of followers.[89] More important, perhaps, the rising and falling motion represented within the painting (an effect heightened by the slanting of the wall on which it

87. Charles De Tolnay, *Michelangelo V: The Final Period* (Princeton: Princeton University Press, 1960), 28.

88. Michelangelo's intimate familiarity with Dante's *Commedia* is well attested. See *The Poetry of Michelangelo*, 421, 424.

89. Equipped with the ears of an ass, Minos, the king of Hell, becomes conflated with King Midas, lover of gold, and thus with the biblical Mammon, the demonic idol of covetousness.

is painted) insists on the necessity of a choice or election between two kinds of discipleship. One must follow either Christ or the Enemy. The spiritual insight is essentially the same as that to which René Girard gives forceful expression: "God and Satan are the two supreme models. . . . If we don't see that the choice is inevitable between the two supreme models, God and the devil, then we have already chosen the devil and his mimetic violence."[90] An election, therefore, must be made.

A lukewarm indecision—the Satanic parody of Ignatian "indifference"—is, in fact, impossible in Michelangelo's *Last Judgment,* where one either rises or falls. One cannot remain in the Cave of Limbo without actually being in the Mouth of Hell. Michelangelo's painting connects the Cave of Limbo with alternative entrances and exits: with the empty tomb of the risen Christ and the open graves of the saints, on the one hand, and with Hell's Mouth, on the other.

The Cave of Limbo appears, as mentioned earlier, at the center of the lowest zone, so that the priest who celebrates Mass stares directly into it. When he elevates the Host, Christ rises again, as it were, from the tomb—the altar itself being a kind of sepulcher. Michelangelo's original conception of the *Last Judgment* and the unusual quality of his altarpiece derives from his ecclesial interpretation of St. Paul's apocalyptic, eucharistic warning in 1 Corinthians 11:28–31: "Let a man examine himself. . . . For any one who eats and drinks without discerning the body eats and drinks judgment upon himself. That is why many of you are weak and ill, and some have died. But if we judged ourselves truly, we should not be judged."[91] The communicant who opens his mouth to receive the Host does so facing the Cave of Limbo, which images the necessity of a personal decision for Christ and His church. Michelangelo's artwork thus links the Host as the Body of Christ both to the doctrine of the resurrection of the body at the end of the world and to the church as a corporate body defined by obedience to the pope as Christ's representative and by a shared belief in the Real Presence of Christ in the Eucharist.

Not unlike Ignatius Loyola's exercitants, who often place themselves imaginatively in a biblical scene by identifying with one of the characters, Michelangelo makes and models the choice of obedient discipleship by painting his own face in the *Last Judgment* in that of St. Bartholomew, who was skinned alive for his refusal to worship false gods.[92] The self-portrait has evoked much scholarly re-

90. René Girard, *I See Satan Fall like Lightning,* trans. James G. Williams (Maryknoll, NY: Orbis, 2001), 40–42.

91. De Tolnay lists various biblical sources for Michelangelo's fresco, but he overlooks this key text. See his *Michelangelo V: The Final Period,* 33–34.

92. Although there were various traditions regarding Bartholomew's mode of martyrdom, "les hagiographes optèrent pour un martyre moins banal et firent de saint Barthélemy un *Marsyas*

flection, in part because the limp skin bearing his features is held by a resurrected Bartholomew, brandishing a knife, whose face is that of Pietro Aretino, Michelangelo's powerful critic. Michelangelo does not depict Aretino in hell, where he placed another critic, Biagio da Cesena, in the figure of Midas/Minos. Biagio had complained about the nudes in the *Last Judgment*, deeming the work more suited to a bathhouse than to a church; Aretino's complaint was similar, but Aretino voiced it publicly in an open letter only eight years after the completion of the fresco. Anticipating a possible attack from Aretino, who had written earlier to Michelangelo with suggestions that the painter rejected, Michelangelo honors Aretino's pious (albeit short-sighted) intentions, depicts him as a saint, and shows him (in a gesture reminiscent of Leonardo da Vinci's Peter at the Last Supper) raising up a knife,[93] as if to ask Christ whether or not it should be used. As a saint, therefore, Aretino/Bartholomew mirrors the pagan slayer of Michelangelo/Bartholomew and shows the potential for the mimetic violence that is revenge. Whether or not to use the knife—that is a question that requires a decision, an election, as an answer.

Michelangelo apparently hoped that Aretino would hear Christ's answer to Peter: "Put back thy sword into its place; for all those who take the sword will perish by the sword" (Matt. 26:52). At the same time, however, he seems to anticipate his own martyrdom as an artist, knowing that there were other critics who shared Aretino's views. The cloth-like skin of Bartholomew thus foreshadows the fate Michelangelo feared for his fresco: the painting over of all the nudes in Michelangelo's *Last Judgment* by Daniele da Volterra in 1565, by order of Pope Paul IV, after a period of heated polemic.[94]

The painting over, which occurred in the year after Michelangelo's death, in effect reverses the whole trajectory of Michelangelo's career. The nude as a figure no longer conveyed the same meaning to Reformation and Counter-Reformation viewers that it did to Michelangelo and to earlier generations. The nudity in the *Last Judgment*, George L. Hersey observes, "is hardly sensuous. It is the nudity of desolation, of renunciation, of Christ's own body during the Passion, of the desert saint who hates his own flesh."[95] The nude figures in the ceiling frescoes, by contrast, celebrate (in the words of John Dillenberger) a human "body that mirrors the divine in all its beauty and glory, the nakedness of creation."[96] For Michelan-

chrétien" (Louis Réau, *Iconographie de L'Art Chrétien* [Paris: Presses Universitaires de France, 1958], 1:181). The mythological Marsyas was the victim of Apollo's jealousy.

93. On the resemblance to Leonardo's Peter, see George L. Hersey, *High Renaissance Art in St. Peter's and the Vatican* (Chicago: University of Chicago Press, 1993), 221.

94. On the controversy over the *Last Judgment*, see especially Romeo De Maio, *Michelangelo e la Controriforma* (Rome: Laterza, 1978).

95. Hersey, *High Renaissance Art in St. Peter's and the Vatican*, 221.

96. John Dillenberger, *Images and Relics: Theological Perceptions and Visual Images in Sixteenth-Century Europe* (New York: Oxford University Press, 1999), 125–26.

gelo the human body was sacred, a Pauline "temple of the Holy Spirit," and therefore fitting to the art of churches, where the Eucharist was housed. Did not St. Paul write, "Glorify God and bear him in your body" (1 Cor. 6:20)? ⌐

⌐As Nagel has brilliantly demonstrated, Michelangelo the reformer sought to imbue his art with the same aura that attended medieval sacred images of devotion, such as the *St. Luke Madonnas,* the "true image" (*l'imagin vera*) of Christ in a relic like Veronica's Veil, the visionary *imago pietatis* in paintings; and Nicodemus's carving of the *Volto sancto.* For him and for Vittoria Colonna, all these images were genuine, albeit rough, artworks.[97] Possessed of new skills and anatomical knowledge, the Christian artist of a later time was bound, in the view of Michelangelo and some of his contemporaries, to build on these earlier works, not to replace them but to preserve and perfect them, presenting them anew in what Nagel calls "a rarefied and attenuated form, one that offered an introversion of the image's traditional public function and address."[98] As a sketch, as it were, the icon of old was to stand, barely visible, behind the perspectival, dimensional art of the new art masters.

⌐Incorporated into the *Last Judgment,* the skin of Bartholomew, which bears the blurred features of Michelangelo's face, resembles and thus evocatively enshrines the veil of Veronica, bearing the imprint of Christ's face—an artwork painted by Christ himself with His own blood and sweat.[99] In a contemporaneous madrigal composed for Vittoria Colonna, Michelangelo images himself being skinned, not by Aretino, but by time and death: "From what sharp, biting file / does your tired skin keep growing thin and failing, / O ailing soul? When will time release you from it, / so you'll return to heaven, where you were / pure and

97. Nagel makes this point forcefully and at length in *Michelangelo and the Reform of Art.* See especially 12–16, 51, 214. Nagel pays particular attention to the image of the Man of Sorrows, the *imago pietatis,* which according to legend corresponds to an apparition of Christ to St. Gregory the Great during Mass, in answer to his request for a sign of Christ's true presence in the Eucharist. See Belting, *Likeness and Presence,* for a discussion of the paintings attributed to St. Luke (47–77) and the legends of the "Holy Face" (208–24). See also Jean C. Wilson, "Reflections on St. Luke's Hand: Icons and the Nature of Aura in the Burgundian Low Countries during the Fifteenth Century," in *The Sacred Image East and West,* ed. Robert Ousterhout and Leslie Brubaker, Illinois Byzantine Studies 4 (Urbana: University of Illinois Press, 1995), 132–46.

98. Nagel, *Michelangelo and the Reform of Art,* 198. For a related discussion of artists other than Michelangelo, see Belting, *Likeness and Presence,* 481–88.

99. Belting, *Likeness and Presence,* 4. See also Roberto Fedi, "'L'imagin vera': Vittoria Colonna, Michelangelo, e un'idea di canzoniere," *Modern Language Notes* 107 (1992): 46–73. Vittoria refers to "l'imagin vera" in one of her sonnets about St. Francis of Assisi, and she describes the name of Christ *in cor dipinto* in her sonnet about St. Ignatius of Loyola (*Rime spirituali* 125). To Michelangelo she wrote that she has been praying to God "that I may find you on my return with His image so renewed and so alive by true faith in your soul as you have so well painted it in my woman of Samaria" (quoted and translated in Jerrold, *Vittoria Colonna,* 134). Michelangelo drew for Vittoria three sketches: a crucifixion, a *Pietà,* and a picture of Jesus speaking with the Samaritan woman.

joyful before, / your dangerous and mortal veil cast off?"[100] Welcoming his own death as a purification and release, Michelangelo does not fear the skinning of his critics. He acknowledges with them, however, the "dangerous" quality of the bodily "mortal veil." His answer to them is to anticipate their skinning of him with his own defacement—a "Christian and penitential gesture" that is (in Nagel's words) "paradoxically, an iconoclasm assuming figural force."[101] As a remedy for the idolatrous potential of his own art, Michelangelo disfigures the self he paints, leaving it behind and still vulnerable to the knife.

Conformata Confirmare: Ignatius's Passion Week and Michelangelo's Last *Pietàs*

The Third Week of the *Spiritual Exercises* strengthens or confirms the exercitants in their conformity to Christ, in their free choice to follow Him, by directing them through a series of meditations on the suffering and death of the Lord. The disciple who has joined the company of Jesus enters into his or her labors, imaginatively sharing in His Passion (Week Three), so as to be able to follow Him into His glory (Week Four). The eucharistic coloring of the meditations of the Third Week as a whole is evident from the First Contemplation, which focuses on the Last Supper, to the last, which considers "how the most holy body of Christ our Lord was separated from His soul and remained apart from it, and where and how it was buried" ([208], 86).

Even as the purgative period in Ignatius's own life is reflected in Week One, and his personal experience of pilgrimage and vocation in Week Two, so does the time of persecution during his studies for the priesthood correspond to Week Three. From the Lent of 1524 to June of 1527, according to his *Autobiography,* Ignatius studied in Barcelona and Alcalá, begging for alms, performing penance, serving the poor, "giving spiritual exercises and teaching Christian doctrine."[102] Three companions joined him. Ignatius's religious zeal and catechesis as a layman awakened the suspicions of the Inquisition, and Ignatius was imprisoned for "seventeen days without being examined or knowing the reason for it."[103] Continu-

100. "Per qual mordace lima / discrese e manca ognor tuo stanca spoglia, / anima inferma? Or quando fie ti scioglia / da quella il tempo, e torni ov' eri, in cielo, / candida e lieta prima, / deposto il periglioso e mortal velo?" (*Poetry of Michelangelo,* 317). De Tolnay suggests that the image of the hanging skin marks a line of descent into hell and symbolizes Michelangelo's own possible fall. See Charles De Tolnay, *Michelangelo V: The Final Period,* 44.

101. Nagel, *Michelangelo and the Reform of Art,* 197.

102. *Autobiography of St. Ignatius,* 61.

103. Ibid., 63.

ing his studies in Salamanca in 1527, Ignatius was again arrested, chained, and called before a panel of judges.[104] At the University of Paris from February 1528 to March 1535, Ignatius had to answer again to inquisitors.[105] After a brief time in Spain, during which he was reportedly burned in effigy because of his initiatives for social reform, Ignatius traveled to Venice, where he again stood trial.[106] Only at the end of these and other sufferings did he, a newly ordained priest, receive the vision at La Storta on his way to Rome. That vision confirmed him in his calling: "[He] saw so clearly that God the Father had placed him with His Son Christ that his mind could not doubt that God the Father had indeed placed him with His Son."[107]

Michelangelo's "Third Week" represents a similar period of persecution, personal loss, self-doubt, and sustained, eucharistic meditation on the Passion of Christ. The completion of the *Last Judgment* in 1541 placed him at the symbolic center of a sustained controversy over the relationship between artistic expression and religious worship. Michelangelo and the Marchessa of Pescara were both under suspicion of heresy.[108] Michelangelo absorbed the criticisms against his work into his own soul-searching, accusing himself of having made an idol of his art.[109] In 1547 Michelangelo stood at the deathbed of his good friend, Vittoria Colonna, whose virtue and religious vision had supported and inspired his own. Shortly thereafter he began work on the *Pietà* now housed in the Museo dell' Opera del Duomo in Florence (plate 11).[110] In 1552, at work on that sculpture, Michelangelo wrote three anguished lines of poetry describing his spiritual condition: "In such slavery, and with so much boredom, / and with false conceptions and great peril / to my soul, to be here sculpting divine things" ("Con tanta servitù, con tanto tedio / e con falsi concetti e gran periglio / dell' alma, a sculpir qui cose divine").[111] The Florentine *Pietà*, Antonio Paolucci asserts, "represents the dramatic peak of Michelangelo's career, because . . . it reflects his moment of greatest religious torment."[112]

104. Ibid., 69.

105. Ibid., 77–78, 81.

106. Ibid., 86–87.

107. Ibid., 89.

108. See Dermot Fenlon, *Heresy and Obedience in Tridentine Italy: Cardinal Pole and the Counter Reformation* (Cambridge: Cambridge University Press, 1972); De Tolnay, *Michelangelo V: The Final Period*, 68–69. My view of the relationship of Vittoria and Michelangelo with Ignatius Loyola is obviously very different from De Tolnay's.

109. *Poetry of Michelangelo*, 476.

110. I thank the curator of the Museo dell' Opera del Duomo for permission to reproduce this image.

111. *Poetry of Michelangelo*, 473.

112. Antonio Paolucci, *Michelangelo: The Pietàs* (Milan: Skira, 1999), 82.

Ignatius of Loyola counseled retreatants to consider, in conjunction with
Christ's death, "Our Lady's loneliness along with her deep grief and fatigue," as
well as "the fatigue of the disciples" ([208], 86). Similarly Michelangelo's Floren-
tine *Pietà* includes four interwoven figures carved from a single block of marble:
Christ's body, supported by the grieving Madonna, Mary Magdalene at Christ's
side, and Nicodemus standing at the back of the group. Nicodemus's face is that
of the eighty-year-old Michelangelo. Through the self-portrait, Loren Partridge
observes, "Michelangelo enacts his faith . . . by personal identification with the
sacred drama, much in the same way recommended by the founder of the Jesuit
order, Ignatius Loyola."[113]

The *Pietà* in Florence was originally intended, according to Condivi's witness,
as an altarpiece: "Michelangelo plans to donate this *Pietà* to some church and to
have himself buried at the foot of the altar where it is placed."[114] As Nagel and
Partridge argue, moreover, the design of the *Pietà* resembles that of deposition
scenes used as altarpieces: "[The] body of Christ is fully displayed and frontally,
as is the Host, and . . . it gives the impression of sinking downward, as if about to
be lowered onto the altar."[115] The sculpture thus renews the eucharistic petition
in an earlier poem of Michelangelo's: "O flesh, O blood, O wood, O ultimate pain!
/ through you may be justified all of my sin, / in which I was born, just as my fa-
ther was. / You alone are good; may your infinite mercy / relieve my predestined
state of wickedness, / So near to death and so far from God" ("O carne, o sangue,
o legno, o doglia strema, / giusto per vo' si facci el mie peccato, / di ch' i' pur nac-
qui, e tal fu 'l padre mio. / Tu sol sé buon; la tuo pietà suprema / soccorra al mie
prèditto iniquo stato, / sì presso a morte e sì lontan da Dio").[116] The poem plays
on the surname that Michelangelo inherited from his natural father, Buonarroti,
in order to appeal to God's merciful fatherhood in Christ: "You alone are good
[*buon*]." Seeking mercy [*pietà*] for his sins through prayer in poetry and sculp-
ture, Michelangelo presents to God the *imago pietatis,* the Man of Sorrows in the
arms of His pitifully grieving mother.

What sets Michelangelo's Florentine *Pietà* apart from other sculptures depict-
ing the Mother of Sorrows is Michelangelo's ambitious attempt to carve four fig-
ures out of a single marble block, a feat accomplished in antiquity (according to
Pliny the Younger) only in the *Laocöon.*[117] In Michelangelo's *concetto* of the sculp-
ture, the towering figure of Nicodemus bends forward to shelter the other figures
from behind and thus binds together the group as a whole, which centers on

113. Partridge, *Art of Renaissance Rome,* 106–7.
114. Condivi, *Life of Michelangelo,* 90.
115. Partridge, *Art of Renaissance Rome,* 104.
116. *Poetry of Michelangelo,* 162. For other poems in which Michelangelo invokes Christ's
blood, see 484, 501.
117. See Pliny's *Historia naturalis,* 36. 4.

Christ. Identifying himself with Nicodemus, the legendary sculptor of the *Volto santo* venerated in Lucca, in Michelangelo's native Tuscany, Michelangelo endeavors to imitate the privileged man of the Gospel (John 3:1–21; 19:38–42) in carving a "true image" of the crucified Lord.[118] Even as Nicodemus works "*in* the group" to hold it together, so too Michelangelo works "on the group" to create and preserve its multifigured unity, thus giving expression (in Nagel's words) to "a piety that belongs specifically to the sculptor."[119]

According to Vasari, flaws in the marble frustrated Michelangelo in realizing this ideal of artistic unity—four "larger than life-size" figures carved out of one stone—and, falling short of that perfection, Michelangelo turned in anger on the statue, which he had "come to hate"; damaged it, and would have completely smashed it, were he not stopped by his servant Antonio.[120] Michelangelo's rage gives some indication of his intense attachment to the original idea of the *Pietà*. What could it have meant to him? Perhaps the iconoclastic destruction of his own work was really aimed at his own sinful presumption, his self-worship, in attempting to surpass the legendary *Laocöon* in a monument to his own memory. Perhaps the failure of the work, which the sculptor had intended as a last, great, life-offering to God, seemed to Michelangelo to be a fearsome sign of God's displeasure with him. Internally divided between his urge toward artistic creation in God's praise and his fear of idolatry, Michelangelo had hoped to overcome that division within himself and in the church through the miraculous unity of the four figures, founded on a single stone.

As an altarpiece, the Florentine *Pietà*, like the *Last Judgment*, explores the ecclesial dimension of the Eucharist, linking the sacramental Body of Christ not only to the crucified body held frontally in the Virgin's arms and supported on her knees, but also to the mystical body of believers united in the scene by their common devotion to Christ. What is key to Michelangelo's *concetto* is the interrelationship of the figures as their limbs and bodies join in unusual postures reflecting the artist's anatomical virtuosity and the spiritual intensity of their sorrowful communion. The Magdalene and Nicodemus help to support Christ's sinking body, which is held by Mary, the archetype of the church. The physical contact between Christ's body and the Virgin's is maximized by his twisted position as he sits on her lap, leans against her breast, his head against her face, his right leg between her knees, his left leg (now missing) across her thigh.

118. See Belting, *Likeness and Presence*, 304–5. Vittoria Colonna spent months in Lucca in 1537.

119. Nagel, *Michelangelo and the Reform of Art*, 208. For the argument that Michelangelo chose to portray himself as Nicodemus because of the sect of the Nicodemites, see Dillenberger, *Images and Relics*, 141–43.

120. Vasari, *Lives of the Painters*, 4:145, 159. Vasari mentions a missing piece of the Virgin's elbow that Michelangelo had struck off in haste; a bothersome "vein"; and the left leg of Christ that Michelangelo had removed in an attempt to alter it (159, 177).

Scholars often remark on the gestural associations with birthing and erotic love as outward signs of Michelangelo's longing to see death (in Paolucci's words) "as a return to the origins of life and therefore to the mother."[121] Nicodemus, after all, had asked Jesus: "How can a man be born when he is old? Can he enter a second time into his mother's womb and be born again?" (John 3:4). More generally, however, the physical closeness of the three figures as they struggle together to support the weight of Christ's body and the unbearable grief it represents is emblematic of Communion. It suggests that the deepest meaning of the Eucharist entails a divine, mystical, and ecclesial love that is stronger than death (cf. Song of Sol. 8:6).

If in the case of the Florentine *Pietà* Michelangelo made his salvation too anxiously dependent on his own work and labor, in the last of his sculptures, the unfinished *Rondanini Pietà*, he yields instead to the working of grace. Wondrously simple in its design, the sculpture consists of two figures fused, seemingly without effort, into one. A standing Mary holds in front of her the body of her dead son, which leans backward into hers as if to be absorbed into it, the two heads touching in a symbolic kiss. Six days before his death, Michelangelo was still carving on this statue, his last testament and the culmination of his spiritual exercises. Left incomplete, it bespeaks in its rough beauty the sufficiency of human finitude, brokenness, and weakness when joined to God's mercy.

Whereas in the first and second of his sculpted *Pietàs* (as well as in the *Pietà* he drew for Vittoria Colonna), the Virgin's lap resembles an altar, in the *Rondanini Pietà* the standing Virgin can be likened to a translucent monstrance. As Mary carried Christ within her, so too the church is the great Christ-bearer. As Paolucci explains: "The Madonna is the image of the Church. The *Corpus Christi* lives forever in the body of the Church, which, through the mystery of the Eucharist preserves and renews the death and resurrection of Our Lord. This is perhaps the theology behind the iconography of the *Rondanini Pietà*."[122] Michelangelo's last testament, then, participates in Christ's own, spoken from the cross: "Woman, behold, thy son! . . . Behold, thy mother" (John 19:26–27).

Confirmata Transformare: Ignatius's Tears
and Michelangelo's Incorrupt Body

The exercitants who have meditated on Christ's passion and death turn their attention during the Fourth Week of the Ignatian *Spiritual Exercises* to Christ's res-

121. Paolucci, *Michelangelo: The Pietàs*, 136.
122. Ibid., 139.

urrected life: "Rising again, he appeared in body and soul to his Blessed Mother" ([219], 91). They meditate on a series of thirteen different apparitions of the Risen Lord and call to mind "things which bring pleasure, happiness, and spiritual joy" ([229], 93), asking through these exercises "for the grace to be glad and to rejoice intensely because of the great glory and joy of Christ the Lord" ([221], 91). During this week, too, the retreatants set aside penitential practices and avail themselves "of light or of the pleasant features of the seasons" ([229], 93). The final contemplation of the *Exercises* is the "Contemplation to Attain Love," which involves a grateful recognition of God's goodness and gifts and the exercitant's renewed self-surrender to the Creator and Lord: "Take, Lord, and receive my liberty, my memory, my understanding, and all my will—all that I have and possess. You, Lord, have given all that to me. I now give it back to you, O Lord." ([235], 95).

During the Fourth Week, the retreatant enters, as it were, into a share in the Lord's glory, anticipating the happiness of heaven and experiencing a paradisiacal renewal of the earth through his or her own recreation "as an image and likeness of the Divine Majesty" ([235], 95). This transformation involves a participation in the qualities of Christ's resurrected body—subtlety, agility, clarity, impassibility—made available to the exercitant through the Eucharist. These same qualities, I have argued, essentially define the Christian ideal of beauty and sanctity.

Caroline Walker Bynum has shown that late-medieval saints sought not only to anticipate the *visio beata* through their mystical union with God, but also to manifest in their own mortal bodies, as a result of that union, some of the qualities of Christ's resurrected body.[123] Bi-location, levitation, effluvia (or the lack thereof), long fasting, minimal sleep, glossolalia, luminosity, and the incorruption of corpses—all such phenomena were outward signs that pointed to a transfiguring, spiritual closeness to God. To Ignatius of Loyola God granted the gift of tears; to Michelangelo an incorrupt body.

Ignatius himself uses tears to measure the degrees of his transformation. In his *Autobiography* he recalls three occasions when he came near to death. At Manresa "a very great fever brought him to death's door," and his frightened response was to reject any thought of his own righteousness and instead "to cry out loudly, calling him[self] a sinner."[124] Later, in danger of shipwreck at sea, he "was greatly confused and sorrowful, as he believed he had not well used the gifts and graces which God had given him."[125] Finally, "in the year 1550, he was very ill with a very

123. See Caroline Walker Bynum, *Fragmentation and Redemption: Essays on Gender and the Human Body in Medieval Religion* (New York: Zone, 1991); *The Resurrection of the Body in Western Christianity, 200–1336* (New York: Columbia University Press, 1995).

124. *Autobiography of St. Ignatius,* 40.

125. Ibid.

severe illness," which everyone expected to be his last. "At this time, thinking about death, he felt *such happiness and such spiritual consolation at having to die that he dissolved entirely into tears.*"[126]

Ignatius's flowing tears—like the tears of St. Francis of Assisi, or the sweet odor of sanctity associated with other saints—were an outward sign to him and to others of the outpouring of the Spirit within him. They were also, as the episode of 1550 makes clear, defined as an anticipation of the afterlife, the soul's fluid crossing of the boundaries separating this life from the next, earth from heaven, humanity from God. Given this association with spiritual passage, it is not surprising that Ignatius experienced the *charismata* of tears at Mass, where the paschal mystery of Christ's passion, death, and resurrection is renewed sacramentally. The extraordinary entries in Ignatius's *Spiritual Diary* associate tears, as well as other charismata (especially the gift of tongues [*loquela*]), with the daily celebration of the Eucharist. Ignatius's abundant tears flow like the blood and water from Christ's side, like wine from the chalice. Ignatius's brief notation for Ascension is typical: "Thursday, May 29th—I had tears before, during, and after Mass."[127]

Whereas St. Francis always allowed his tears freely to flow, understanding them as a desired, constant cleansing of his spiritual vision,[128] Ignatius sometimes suppressed his tears, if he found himself taking too great a pleasure in the consolation they afforded, or if they distracted him from his surrender to God.[129] Ignatius consciously avoided idle and idolatrous tears, even as he rejoiced in the flowing tears that brought him into communication with God. For him, they were a means to an end, a way of knowing God's loving will for him, a sign of God's presence on a particular pathway that stretched before him. The Ignatian way of tears was, in short, a route of obedience.

St. Ignatius of Loyola was canonized, in company with two other saints of Spain, Teresa of Ávila (1515–1582) and Isidore the Farmer (ca. 1070–1130), on March 12, 1622, by Pope Gregory XV. Michelangelo was canonized (in the secular sense of that word) much earlier, when the Florentine Academy paid its homage to "the divine Michelangelo" in 1564. The assembled artists and aristocrats honored him not merely as the most gifted artist of the age, the master of four differ-

126. Ibid., 40–41. Emphasis added.

127. Ignatius Loyola, *The Spiritual Diary,* trans. Antonio De Nicolas, in his *Powers of Imagining,* 227.

128. See St. Bonaventure, *Life of St. Francis,* in *Bonaventure: The Soul's Journey into God, The Tree of Life, The Life of St. Francis,* trans. Ewert Cousins (New York: Paulist Press, 1978), 5.8, 224.

129. See, for example, the entries for March 14–16, 1544, in the *Spiritual Diary,* in De Nicolas, *Powers of Imagining,* 219–20.

ent arts (sculpture, painting, architecture, and poetry), but also as a *santo vecchio,* a saintly old man and a model of Christian virtue.[130]

Already during his lifetime, two published biographies—Vasari's (1550) and Condivi's (1553)—had related Michelangelo's history in hagiographic terms.[131] They presented him as a lay artist-saint, attesting to the common belief, firmly held by Michelangelo himself, that the goodness of an artist's life partially determines his ability to represent sacred subjects, since (as Savonarola had taught) every artistic work is to some extent a self-portrait, a revealing expression of the artist's very self.[132] As Barolsky observes, Michelangelo and his biographer Vasari participated in a long tradition that defined "aesthetic or artistic experience in theological terms."[133] According to their understanding and Michelangelo's actual practice, objects to be used in worship must first be conceived and crafted in prayer. The beauty of an artwork, Michelangelo maintained, finds its ultimate source in God, whose grace beautifies the soul, guides the sculptor's thought (*intelletto*), and directs his hammer blow.[134] Using the instruments of his profession, the artist is himself God's instrument, realizing "his divine art" (*sua divin'arte*).[135]

Vasari's *Life* introduces Michelangelo as one sent by God as a savior to redeem the human race from darkness and error. Endowed with exceptional gifts, Michelangelo was born under an auspicious star in the elect city of Florence, Vasari relates, after being conceived by his father "at Chiusi and Capresse near the Sasso della Vernia, where St. Francis received the stigmata."[136] Even as Michelangelo was sent from God, so too were his works of art. About the *Last Judgment,* for example, Vasari writes, "This great painting was sent by God to men as an example to show what can be done when supreme intellects descend upon the earth, infused with grace and divine knowledge."[137]

Vasari's concluding account of Michelangelo's personal virtue in the second

130. *The Divine Michelangelo,* 69. A statue portraying Christian Charity (*Pietà Christiana*) by Valerio Cioli (ca. 1529–1599) was unveiled at Michelangelo's obsequies, and other statues showed Michelangelo's virtues overcoming opposed vices, such as laziness and envy. See 97–101.

131. On the hagiographic and biblical quality of Vasari's *Life,* see Barolsky, *Michelangelo's Nose,* 54–67. Vasari's second edition of Michelangelo's *Life* was published in 1567; it follows Condivi's in important respects and includes the account of Michelangelo's incorrupt body.

132. For Savonarola's teaching that "every painter paints himself," see Steinberg, *Fra Girolamo Savonarola,* 48. Steinberg's chapters 8 and 9 are especially helpful in their presentation of Savonarola's view of the arts.

133. Barolsky, *Michelangelo's Nose,* 148.

134. Michelangelo expresses this thought in one of his poems. See *The Poetry of Michelangelo,* 128.

135. The phrase is Michelangelo's. See *The Poetry of Michelangelo,* 77.

136. Vasari, *Lives of the Artists* 4:109.

137. Ibid., 143.

edition of his biography of the artist largely elaborates on that in Condivi's ear-
lier *Life*. Condivi notes Michelangelo's practice of abstinence and fasting,[138] his
renunciation of sleep, his sexual continence, his generosity to others, his poverty
and simplicity, his love of solitude and study, his retentive memory, his associa-
tion with virtuous friends, his lack of jealousy and avarice, his obedient and de-
vout service to the church.[139]

Much more than these biographies, however, Michelangelo's "autobiography"
in his works of art revealed to his contemporaries the quality of his soul. The out-
ward signs pointing to his sanctity gained a powerful confirmation in the public
eye when his coffin was opened in the sacristy of Santa Croce in Florence. The
anonymous author of the *Esequie* writes:

> We all . . . believed that we would find the body putrified and disfigured because . . .
> from the day of his death 25 days had passed. But after opening it they found no bad
> smell whatsoever, and you would have sworn that he was resting in a sweet and quiet
> slumber. The same features of the face, . . . not one limb decayed or revolting. When
> touching his head and his cheeks, which everyone did, they found them to be soft
> and lifelike, as if he had died only a few hours before, and this filled everyone with
> amazement.[140]

The body of Michelangelo, who (as Convidi writes) "loved the beauty of the
human body" and "everything beautiful in general";[141] who depicted in nude
bodies the innocence of the soul and the power of the resurrection; who con-
templated with such ardor the body of Christ on Calvary and in the Eucharist
—the body of this same Michelangelo became itself a saint's relic to be touched
and venerated, its incorruption acclaimed as a "divine sign."[142] "Resting in a sweet
and quiet slumber," his "life" imitating his art, Michelangelo in death thus vali-
dated his artistic *concetto* of the crucified Christ, sleeping in Mary's arms, soon to
awake and rise. What better Ignatian "composition of place"?

138. Ascanio Condivi records, "Michelangelo has always been very abstemious in his way of
life, taking food more out of necessity than for pleasure, and especially while he had work in
progress, when he would most often content himself with a piece of bread which he would eat
while working" (*Life of Michelangelo*, 106).

139. See Condivi, *Life of Michelangelo*, 105–8.

140. *The Divine Michelangelo*, 74–77.

141. Condivi, *Life of Michelangelo*, 105.

142. See the letter of Giovanni di Simone to Lionardo Buonarotti, dated March 18, 1564, in
which he bears witness to the intactness of Michelangelo's body and calls it a "divine sign" (*The
Divine Michelangelo*, 16).

A Eucharistic "Ante-/Anti-Aesthetic" Aesthetics?

⏝The pure taste of the apple is as much a contact with the beauty
of the universe as the contemplation of a picture by Cézanne.
—Simone Weil

The Eucharist is outwardly only a fragment of matter,
yet it is at the center of the Catholic religion.
—Simone Weil

We believe in "Consumption." . . . It is a thoroughly vulgar metaphysic.
—Jean Baudrillard

T he Protestant challenges to Catholic eucharistic beliefs during the early modern period were implicitly tied to the covering of Michelangelo's nudes and explicitly connected to an often violent iconoclasm that resulted in the destruction of works of religious art—paintings, statues, books, buildings.[1] What, if anything, does this historical rift within Christianity have to do with modern, Hegelian reflections on the imminent "end of art"?

The extraordinary reflections on the Host by the modern, mystic philosopher Simone Weil (1909–1943) provide a key to her aesthetic theory and help to account for the manifest differences between her doctrinally Catholic (and therefore "medieval") aesthetics, and that of Georg Wilhelm Friedrich Hegel (1770–1831), whose dialectical history of art rests on a Protestant, eucharistic understanding. Like Hegel, Weil has sometimes been called a Gnostic,[2] but Thomas Werge rightly defends her against that charge, arguing that her "religious vision is neither wholly Jansenist nor Gnostic, . . . but oriented toward a sacramentalism marked by tensions and paradox."[3] Weil herself explicitly distinguished two types of

1. See the previously cited study of Lee Palmer Wandel, *Voracious Idols and Violent Hands: Iconoclasm in Reformation Zurich, Strasbourg, and Basel* (Cambridge: Cambridge University Press, 1995).

2. As Thomas Werge notes, Thomas Merton so designates her in *The Conjectures of a Guilty Bystander* (Garden City, NY: Doubleday, 1968), 142.

3. Thomas Werge, "Sacramental Tension: Divine Transcendence and Finite Images in Simone Weil's Literary Imagination," in *The Beauty That Saves: Essays on Aesthetics and Language in Simone Weil*, ed. John M. Dunaway and Eric O. Springsted (Macon, GA: Mercer University Press, 1996), 87.

philosophers—the fanciful system-builders and the Socratics—naming Hegel
as a representative of the type opposite her own, ever-questioning one.[4] In this
chapter I argue that the contrastive sacramental beliefs of Weil and Hegel gener-
ated opposed aesthetics.

For both Weil and the youthful Hegel, the Host was at the center of inquiry
and prompted critical questions about the eating of beauty. In answering these
questions, Weil also answered to Hegel. Her responses prove the contemporary
relevance of a "way of beauty" [*via pulchritudinis*] that his philosophy assigns to
a darkened past. Scattered references to Hegel in her notebooks and letters show
the depth of her response, a spirited response that proves the truth of Adorno's
dictum, "No reading of Hegel can do him justice without criticizing him."[5] In-
deed a comparison of their theological aesthetics shows Weil's critique of Hegel
to anticipate many of the themes found in the auratic, "anti-aesthetic" aesthetics
of Walter Benjamin (1892–1940) and Theodor W. Adorno (1903–1969).

In this chapter, which shows the continuing relevance of the medieval themes
sounded in the previous chapters, I present a three-part argument. First I describe
the divergent eucharistic understandings of Weil and Hegel, suggesting the im-
plications thereof for their aesthetics. Second I focus on Weil's response to Hegel's
practical art criticism. In the third and final section, "Endings and Beginnings," I
argue that Hegel's aesthetics inevitably proclaims the end of art, whereas Weil's
just as certainly announces its endless beginning anew.

The Host as Convention and Symbol

Reflecting on the paradox that places the small, plain Host at the very heart of the
cosmos and at the center of a whole world of burgeoning religious art and beauty,
Simone Weil observes: "At the very center, however, there is something utterly
stripped of beauty, . . . something depending wholly on convention. . . . This con-
vention, placed at the center point, is the Eucharist."[6]

Weil's use of the term *convention* is polyvalent and reinvigorates the lexicon of

4. See André A. Devaux, "On the Right Use of Contradiction according to Simone Weil," trans.
J. P. Little, in *Simone Weil's Philosophy of Culture: Readings toward a Divine Humanity,* ed. Richard
H. Bell (Cambridge: Cambridge University Press, 1993), 150–57.

5. Theodor W. Adorno, *Hegel: Three Studies,* trans. Shierry Weber Nicholsen (Cambridge, MA:
MIT Press, 1993), 145.

6. Simone Weil, *Waiting for God,* trans. Emma Craufurd (New York: Putnam's, 1951), 187; Si-
mone Weil, *Attente de Dieu* (Paris: Fayard, 1966): "Mais au centre même il y a quelque chose qui
est entièrement dépourvu de beauté, . . . quelque chose qui est uniquement convention. . . . Cette
convention placée au point central c'est l'Eucharistie" (182).

ancient and medieval aesthetics. The Host is a "convention" (from Latin *con-venire,* meaning "to come together"), first because it mediates between the extreme poles of the divine and the human. The disparity between what the Eucharist appears to be (a bread wafer) and what it actually is (Christ Himself) is, for Weil, moreover, a distance so great that it embodies to the highest degree the aesthetic distance necessary for the contemplation of beauty. Faith and love cross that distance. The proper reception of the Eucharist demands a discerning, a recognition, of an all-surpassing Beauty in its total hiddenness (Cf. 1 Cor. 11:27–29). Christ's presence in the Eucharist is, Weil observes, "more complete inasmuch as it is more secret."[7] The greater the sacramental hiddenness and distance, the greater the potential for an intimate closeness in Communion, when Christ in the Host is hidden again, this time within the person who receives and eats it, in order that he or she might embody Christ in an extension of Christ's own Incarnation and sacramentality. The human and artistic forms taken by Christ thus multiply in a veritable explosion of His beauty into the world through those who communicate with Him in the Host. Weil writes, "Christ . . . becomes in a sense each one of us, as he is completely in each Host."[8]

The Host is also a "convention," according to Weil, because the sacramental form of bread is utterly impersonal and therefore suited to a universal, a catholic, reception: "It is not the human person of Christ such as we picture him; it is not the divine person of the Father, likewise subject to all the errors of our imagination; it is outwardly only a fragment of matter, yet it is at the center of the Catholic religion."[9] Because the eucharistic rite—that is, its outward forms and signs, including the words of consecration—remains the same, no matter which priest presides, or where, or when, the Eucharist is manifestly a convention. Its formulaic blankness, independent of circumstances, is for Weil "the perfection of purity," humility, and truth. "Only a convention," Weil asserts, "can be the perfection of purity here below."[10] Here a "convention" is a formula, something completely traditional and oft-repeated, that "brings together" (*con-venire*) a community, causing its gathering and expressing its oneness. The Eucharist as a convention is

7. Weil, *Waiting for God,* 189; *Attente de Dieu,* 184: "plus complète pour autant qu'elle est plus secrete."

8. Weil, *Waiting for God,* 81; *Attente de Dieu,* 59: "Le Christ vit en nous; de sorte que par cet état le Christ dans son intégrité, dans son unité indivisible, devient en un sens chacun de nous comme il est tout entier dans chaque Hostie."

9. Weil, *Waiting for God,* 199–200; *Attente de Dieu,* 197: "Ce n'est pas la personne humaine du Christ telle que nous l'imaginons, ce n'est pas la personne divine du Père soumise elle aussi en nous à toutes les erreurs de notre imagination, c'est ce fragment de matière qui est au centre de la religion catholique."

10. Weil, *Waiting for God,* 188; *Attente de Dieu,* 183–84: "Seule une convention peut être ici-bas la perfection de la pureté."

thus "convenient"—that is, fitting—to Christ as personified *Convenientia,* an Augustinian name for Beauty that might be translated as the harmonious joining together, the communion of many parts.

Weil's insistence on the Host's beauty and conventionality clearly depends on a Catholic theological understanding of the Eucharist. According to the Catholic doctrine of transubstantiation, the consecrated Host is actually not bread, but only gives the appearance of bread, retaining its accidents. Because it gives a purely conventional and totally improper appearance to Christ, who is the actual substance of the sacrament, the Host (the *species* of bread) is for Weil a representation of Beauty itself (in Latin, *Species*), insofar as Beauty too is an appearance, an epiphany. "We want to get behind beauty, but it is only a surface," she writes. "It is like a mirror that sends us back to our own desire for goodness. . . . We would like to feed upon it, but it is merely something to look at; it appears only from a certain distance."[11]

Weil's use of the words *surface* and mirror (in French, *miroir;* in Latin, *speculum*) recalls Kant's discussion of beauty's "appearance" in the *Critique of Judgment* (1790), but it also plays distantly on the eucharistic term *species,* which is used to name bread and wine as the different outward forms or appearances of the sacrament. These *species* allow for the tangible presence of Christ, whom patristic and medieval theologians celebrated as the *Species,* the "Beauty" of God, because He is the perfect Image, Likeness, and Art of the Father.[12] For these theologians, as for Weil, the Eucharist derives its very meaning from a *caritas* that is graceful, pleasing, and seemly—in Greek, *charis*—and thus inseparable from the Beautiful.

Eucharistic *convenientia* is the expression of, and means and security for, conformity with Christ in obedience to God. The Host is beautiful, Weil reflects, because it is a material that offers no resistance to God's will and formation; it obediently lets its very substance be changed at the words of consecration: "Christ proposed the docility of matter to us as a model."[13] Writing to Fr. Perrin, her spiritual director, on May 15, 1942, the day of her departure from Marseilles as a Jewish fugitive from the Nazis,[14] Weil confesses, "The most beautiful life possible has

11. Weil, *Waiting for God,* 166; *Attente de Dieu,* 156: "Nous voudrions aller derrière la beauté, mais elle n'est que surface. Elle est comme un miroir qui nous renvoie notre propre désir du bien. . . . Nous voudrions nous en nourrir, mais elle n'est qu'objet de regard, elle n'apparaît qu'à une certaine distance."

12. See St. Augustine, *De Trinitate,* ed. W. J. Mountain and Fr. Glorie, CCSL 50 (Turnhout: Brepols, 1968), 6.10, 241–42.

13. Weil, *Waiting for God,* 130; *Attente de Dieu,* 113: "Le Christ nous a proposé comme modèle la docilité de la matière. . . ."

14. The standard biography is Simone Pétrement, *Simone Weil: A Life,* trans. Raymond Rosenthal (New York: Schocken, 1988). For studies that emphasize Weil's Jewish identity, see Thomas R. Nevis, *Simone Weil: Portrait of a Self-Exiled Jew* (Chapel Hill: University of North Carolina Press,

always seemed to me to be one where every thing is determined . . . and where there is never any room for choice."[15] Anticipating her own "probable death" [*une mort probable*], Weil wonders if "perhaps God likes to use castaway objects, waste, rejects. After all, should the bread of the Host be moldy, it would become the Body of Christ just the same after the priest had consecrated it. Only it cannot refuse, while we can disobey."[16] The eucharistic transubstantiation that makes bread no longer bread, changing its very substance, leaving only its appearance, is for Weil the perfect *decreation,* a model for her own longed-for, total conformity with Christ crucified and risen, in both "gravity" and "grace," affliction and beauty.

Weil's de-creative understanding of transubstantiation is a key to the causal relationship she perceives between the plainness of the little Host, on the one hand, and the auratic beauty and fecundity of nature and art, on the other. As J. P. Little explains, "At its most basic level, [decreation] is our response to our creation by God, a reflection of the act of creation itself" which, Weil believed, involved "'an act, not of expansion on God's part, but of abdication.'"[17] This doctrine of creation "brings out the immense importance of the physical and material for Simone Weil,"[18] because it means that God Himself withdrew in order to make space for it. "God permitted the existence of things distinct from himself and worth infinitely less than himself," Weil writes: "By this creative act he denied himself, as Christ has told us to deny ourselves."[19]

Viewing Christ's kenotic, redemptive, and sacramental activity as parallel to, consistent with, and continuous of God's creative act, Weil discovers in the consecrated Host the seedlike source of a new creation (Cf. 2 Cor. 5:17; 1 Cor. 15:42–47): "We must become nothing, we must go down to the vegetative level; it is then

1991) and Sylvie Courtine-Denamy, *Three Women in Dark Times: Edith Stein, Hannah Arendt, Simone Weil,* trans. G. M. Goshgarian (Ithaca: Cornell University Press, 2000).

15. Weil, *Waiting for God,* 63; *Attente de Dieu,* 38: "Le plus belle vie possible m'a toujours paru être celle où tout est déterminé, . . . et où il n'y a jamais place pour aucun choix."

16. Weil, *Waiting for God,* 72; *Attente de Dieu,* 49: "Mais peut-être que Dieu se plaît à utiliser les déchets, les pièces loupées, les objets de rebut. Après tout, le pain de l'Hostie serait-il moisi, il devient quand même le Corps du Christ, après que le prêtre l'a consacré. Seulement il ne peut pas le refuser, au lieu que nous, nous pouvons désobéir."

17. J. P. Little, "Simone Weil's Concept of Decreation," in *Simone Weil's Philosophy of Culture,* 27. On the topic of decreation, see Simone Weil, *Gravity and Grace,* trans. Emma Craufurd (Lincoln: University of Nebraska Press, 1997), 78–86. Little compares Weil's idea to that of the eighteenth-century Jesuit philosopher Jean-Paul de Caussade, as expressed in his *Sacrament of the Present Moment,* trans. Kitty Muggeridge (London: Collins, 1981). See Little, "Simone Weil's Concept of Decreation," 49–51.

18. Little, "Simone Weil's Concept of Decreation," 26.

19. Weil, *Waiting for God,* 145; *Attente de Dieu,* 131: "Dieu a permis d'exister à des choses autres que Lui et valant infiniment moins que Lui. Il s'est par l'acte créateur nié lui-même, comme le Christ nous a prescrit de nous nier nous-mêmes."

that God becomes bread."[20] By receiving Communion, we incorporate, as it were, Christ's own self-denial, His emptying of Himself to assume the descending forms, first of humanity; second of a condemned felon (cf. Phil. 2:6–8); and, third of bread: "Catholic communion. God did not only make himself flesh for us once, every day he makes himself matter in order to give himself to man and to be consumed by him. Reciprocally by fatigue, affliction, and death, man is made matter and is consumed by God. How can we refuse this reciprocity?"[21] This Communion with Christ enables us in turn to deny ourselves, so that, in the words of St. Paul, "It is now no longer I that live, but Christ lives in me" (Gal. 2:20).[22]

The self-denying Christ is and remains, however, the Logos of God. Taking the de-created, eucharistic bread as a model of obedience, and following the self-emptying Lord, a person's freely chosen "de-creation" thus becomes a way to participate instrumentally in God's own wonderful, creative power—a vital power that conquers even death and that gives rise to manifold works of beauty: "Except the seed die . . . [i]t has to die in order to liberate the energy it bears within it, so that with this energy new forms may be developed."[23]

Weil's understanding of the doctrine of transubstantiation—or, better put, of Christ's Real Presence—as being conducive to manifold aesthetic expressions finds a reluctant confirmation in Hegel's writings, where he admits the aesthetic superiority of medieval Catholicism, while yet maintaining Protestantism to be the higher, more spiritual form of Christianity.[24] Hegel's historical scheme is well known. What has received insufficient attention is the specific place of eucharistic theology within Hegel's aesthetics.

Hegel's early theological writings—*The Positivity of the Christian Religion* (written in Bern, 1795–96, and in Frankfurt, 1800), *The Spirit of Christianity* (Frankfurt, 1798–99), and the *Fragment of a System* (ca. 1800)—were first published in Germany in 1907; they were translated into English only in 1948, more

20. Weil, *Gravity and Grace*, 83; Simone Weil, *La Pesanteur et la Grace*, with an introduction by Georges Hourdin (Paris: Plon, 1962), 45: "Devenir rien jusqu'au niveau végétatif; c'est alors que Dieu devient du pain."

21. Weil, *Gravity and Grace*, 80; *La Pesanteur et la Grace*, 43: "Communion catholique. Dieu ne s'est pas seulement fait une fois chair, il se fait tous les jours matière pour se donner à l'homme et en être consommé. Réciproquement, par la fatigue, le malheur, la mort, l'homme est fait matière et consommé par Dieu. Comment refuser cette réciprocité?"

22. I use the Douay-Challoner version of the Holy Bible, ed. John P. O'Connell (Chicago: Catholic Press, 1950).

23. Weil, *Gravity and Grace*, 81; *La Pesanteur et la Grace*, 44: "Si le grain ne meurt. . . . [i]l doit mourir pour libérer l'energie qu'il porte en lui afin qu'il s'en forme d'autres combinaisons."

24. See Georg Wilhelm Friedrich Hegel, *Aesthetics: Lectures on Fine Art*, trans. T. M. Knox, 2 Vols. (Oxford: Clarendon Press, 1991) 1:103; For Hegel's response to Italian medieval art, see Hegel, *Hegel: The Letters*, trans. Clark Butler and Christine Seiler, with commentary by Clark Butler (Bloomington: Indiana University Press, 1984), 615.

than a hundred years after Hegel's death. The *Fragment of a System* (*Systemfragment*) contains the first, clear formulation of Hegel's famous dialectic as "the union of union and nonunion": "die Verbindung der Verbindung und der Nichtverbindung."[25] Taken together with his other writings from that same period, the *Systemfragment* shows (in the words of Richard Kroner) "that the deepest root of Hegel's system was a personal religious experience."[26] Hegel's *Logic* (1801–2) can rightly be understood in the context of his religious reflections as "the fulfillment of what the young Hegel had been groping for in his pantheism of love and his interpretation of the Eucharist."[27] Horst Althaus agrees: "The Eucharistic sacrament—the communion of bread and wine—is an immediate presence for Hegel, as it was for Hölderlin. It was impossible [for Hegel] to ignore the daily influence and significance of such things . . . , even though he is equally aware that the rational understanding cannot help resisting the sacramental idea of the Host."[28]

The early Hegelian writings concerning the Eucharist are characterized by aesthetic concerns, a dialectical habit of mind, and an incipient historiography. In *The Positivity of the Christian Religion* (*Die Positivität der christlichen Religion*), Hegel emphasizes the beauty of the Lord's Last Supper. "This sensuous symbol in which he imaginatively conjoined his memory with the serving of the meal they would enjoy in the future was very easily apprehended from the things present before them just then," namely, the bread and wine on the table, Hegel writes, "but if it is regarded purely aesthetically, it may seem something of a play on words."[29] What does Hegel mean by this "purely aesthetical" regard that sets a "symbol" against a "wordplay"? He refers to Christ's words of consecration: "This is my body" (Luke 22:19). To call bread his "body" is "more pleasing in itself," Hegel observes, "than the persistent use of the words 'blood and flesh,' 'food and drink' (John 6:47–55), in a metaphysical sense, which which even theologians have pronounced rather harsh."[30] Hegelian aesthetics finds a harmonious matching of

25. Georg Wilhelm Friedrich Hegel, *Early Theological Writings*, trans. T. M. Knox (Chicago: University of Chicago Press, 1948), 312; *Hegels theologische Jugendschriften*, ed. Herman Nohl (Frankfurt: Minerva, 1966), 348.

26. Richard Kroner, introduction, to Hegel, *Early Theological Writings*, 14.

27. Ibid., 32.

28. Horst Althaus, *Hegel: An Intellectual Biography*, trans. Michael Tarsh (Malden, MA: Polity, 2000), 50.

29. Hegel, *Early Theological Writings*, 90; *Hegels theologische Jugendschriften*, 169: "ein Sinnbild, wodurch er in der Vorstellung das Andenten an sich mich Teilen der Mahle, die sie genießen würden, selbst in Verbindung setze, das zwar aus Gegenständen, die gerade gegenwärtig waren, sehr natürlich gegriffen war, aber bloß von der ästhetischen Seite betrachtet, etwas spielend scheinen kann."

30. Hegel, *Early Theological Writings*, 90; *Hegels theologische Jugendschriften*, 169: "aber doch an sich gefälliger ist, als der so lange durchgeführte Gebrauch der Worte Blut und Fleisch, Speise

sensuous expression and artistic concept in the conjoining of meal and memory, but it recoils from the sacramental deictic that names "bread" as Christ's "body," finding it acceptable only as a wordplay. The literal interpretation was a historical development, according to Hegel, "when the whole thing became a mysterious act of worship and a substitute for the Jewish and Roman sacrificial feasts."[31]

The Spirit of Christianity (*Der Geist des Christentums*) was written two years later.[32] There he treats the topic of the Last Supper extensively and in a probing, dialectical fashion. Hegel struggles to name what took place in the cenacle. He calls it a love-feast at first, but adjudges that expression inadequate: "This eating hovers [*schwebt*] between a common table of friendship and a religious act, and this hovering makes difficult the clear expression of its spirit."[33] Hegel's use of the verb "to hover" [*schweben*] recalls the dovelike Spirit of the Lord, hovering over the waters in Genesis 1:2. It suggests some vaguely understood, but creative *tertium quid* that synthesizes the apparent opposites of table and altar.

Hegel continues his reflection, which is structured in a dialectical series, composed of alternating affirmations and denials. The meal, he writes, is "not a mere symbol of friendship, but an act, a feeling of friendship itself, of the spirit of love."[34] Christ's word of consecration "approximates the action to a religious one, but does not make it one."[35] The "bread is just bread, the wine just wine; yet both are something more."[36] The "something more" to which Hegel refers is metonymic, not metaphoric or allegorical, because "in this link [between bread and persons], difference disappears, and with it the possibility of comparison."[37] Christ is really united with those who receive Communion; His love permeates them. "The action of eating and drinking is not just a self-unification brought

und Trank . . . in metaphysischem Sinn, der selbst von Theologen für etwas hart erklärt worden ist."

31. Hegel, *Early Theological Writings*, 90; *Hegels theologische Jugendschriften*, 169: "und das Ganze in eine mysteriöse gottesdienstliche Handlung verwandelt, die an die Stelle der jüdischen und römischen Opfermahlzeiten trat."

32. Althaus chronicles Hegel's interest at this time in learning about Catholicism and his (possibly romantic) friendship with a young, Catholic lady, Nanette Endel (*Hegel: An Intellectual Biography*, 43–46).

33. Hegel, *Early Theological Writngs*, 248; *Hegels theologische Jugendschriften*, 297: "und darum schwebt dies Essen zwischen einem Zusammenessen der Freundschaft und einem religiösen Akt, und dieses Schweben macht es schwer, seinen Geist deutlich zu bezeichnen."

34. Hegel, *Early Theological Writings*, 248: *Hegels theologische Jugendschriften*, 297: "auch dies ist nicht ein bloßes Zeichen der Freundschaft, sondern ein Akt, eine Empfindung der Freundschaft selbst, des Geistes der Liebe."

35. Hegel, *Early Theological Writings*, 249; *Hegels theologische Jugendschriften*, 297: "nähert die Handlung einer religiösen, aber macht sie nicht dazu."

36. Hegel, *Early Theological Writings*, 249; *Hegels theologische Jugendschriften*, 298: "So ist, objektiv betrachtet, das Brot bloßes Brot, der Wein bloßer Wein; aber beide sind auch noch mehr."

37. Hegel, *Early Theological Writings*, 249; *Hegels theologische Jugendschriften*, 298: "denn in dieser Verbindung fällt die Verschiedenheit weg, also auch die Möglichkeit der Vergleichung."

about through the destruction of food and drink," Hegel observes, "nor is it just the sensation of merely tasting food and drink."[38]

Hegel struggles, because he cannot resolve the polarity of table and altar into a single image: "In the love-feast there is also something objective in evidence to which feeling is linked, but with which it is not yet united into an image."[39] It is an aesthetic problem of the nonidentical that cannot be resolved synchronically for Hegel, but only in an imperfect, diachronic fashion. First the spirit of Jesus objectifies itself in bread and wine. Then "the love made objective, this subjective element becomes a *thing,* reverts once more to its nature, becomes subjective again in the eating."[40] The movement is circular.

Unlike Weil, who believes the consecrated Host to be no longer bread, but Christ in the outward appearance of bread, Hegel sees the Host as really bread: "The bread is to be eaten, the wine to be drunk; therefore they cannot be something divine."[41] As a result the eucharistic action is prevented, finally, "from becoming a religious one."[42] "There is a sort of confusion between object and subject rather than a unification," Hegel writes, because "love here becomes visible and attached to something which is to be destroyed."[43] "There is no unification," moreover, between the spiritual and physical senses: "To faith it is the spirit which is present; to seeing and taste, the bread and wine."[44]

The result, for Hegel, is a palpable sadness in the communicants that is incompatible with a "genuinely religious action," which necessarily produces (he believes) "a complete peace of soul."[45] The apostles "began to be sorrowful [*entstand ein Kummer*]" after the Last Supper, and Christians today feel at best a

38. Hegel, *Early Theological Writings,* 250; *Hegels theologische Jugendschriften,* 299: "die Handlung des Essens und Trinkens nicht bloß eine durch Vernichtung derselben mit sich geschehene Vereinigung, noch die Empfindung ein bloßer Geschmack der Speise und des Tranks."

39. Hegel, *Early Theological Writings,* 248: *Hegels theologische Jugendschriften,* 297: "Uber bei dem Mahle der Liebe kommt doch auch Objektives vor, an welches die Empfindung geknüpft, aber nicht in ein Bild vereinigt ist."

40. Hegel, *Early Theological Writings,* 251; *Hegels theologische Jugendschriften,* 299: "Aber die objektiv gemachte Liebe, dies zur Sache gewordene Subjektive kehrt zu seiner Natur wieder zurück, wird in Essen wieder subjektiv."

41. Hegel, *Early Theological Writings,* 251; *Hegels theologische Jugendschriften,* 300: "Das Brot soll gegessen, der Wein getrunken werden; sie können darum nichts Göttliches sein."

42. Hegel, *Early Theological Writings,* 252; *Hegels theologische Jugendschriften,* 300: "ist es, was die Handlung nicht zu einer religiösen werden ließ."

43. Hegel, *Early Theological Writing,* 251; *Hegels theologische Jugendschriften,* 300: "Aber gerade diese Art ... mehr einer objektiven Vermischung als einer Vereinigung, daß die Liebe in etwas sichtbar, an etwas geheftet wird, das zernichtet werden soll."

44. Hegel, *Early Theological Writing,* 252; *Hegels theologische Jugendschriften,* 300: "dem Glauben ist der Geist gegenwärtig, dem Sehen und Schmecken das Brot und der Wein; es gibt keine Vereinigung für sie."

45. Hegel, *Early Theological Writings,* 252; *Hegels theologische Jugendschriften,* 301: "aber nach einer echt religiösen Handlung ist die ganze Seele befriedigt."

"melancholy serenity [*wehmütigen Heiterkeit*]," he writes, because "feeling's intensity was separate from the intellect and both were one-sided, because worship was incomplete, since something divine was promised, and it melted away in the mouth."[46] The Host was only bread after all.

Commenting on these haunting, eucharistic passages from the youthful Hegel, Kroner sees in the circular movement Hegel traces in the liturgy the first expression of what will become for him a general, hidden law of the spirit itself, whereby opposites are united, without ceasing to be opposites.[47] In the eucharistic sacrament, too, Hegel first confronts the double meaning of *appearance* (*Schein*) that later becomes so important to his epistemology and aesthetics. The Host makes visible in an objective, sensuous way Christ's love, but it also promises more than it gives. As Althaus puts it, "The feeling of elevation rests on a deception. . . . Form and matter fall apart."[48] As a result the value of the sacrament and its beauty are imperiled for Hegel, as is the whole fate of art.[49]

<hr />

Sacrament, Suffering, and Art

Hegel's and Weil's reflections on the Eucharist lead them to opposed conclusions that have enormous consequences for their aesthetics. The differences between Weil's self-forgetting subject, who is attentive to the world's beauty as an iconic "sacrament" of God in art and nature, and Hegel's self-conscious one, who turns toward art as a mirror of consciousness, come to the fore in their discussions of the form and content of Christian art.

Hegel distinguishes three successive periods of art: the Symbolic, the Classical, and the Romantic. Under the heading of the Romantic, Hegel deals specifically with the religious art of the Christian Middle Ages. According to Hegel

<hr />

46. Hegel, *Early Theological Writings*, 253; *Hegels theologische Jugendschriften*, 301: "denn die geteilte Spannung der Empfindung und der Verstand waren einseitig, die Andacht unvollständig, es war etwas Göttliches versprochen, und es ist im Munde zerronnen."

47. Kroner, introduction to Hegel, *Early Theological Writings*, 18.

48. Althaus, *Hegel: An Intellectual Biography*, 51.

49. Hegel's aesthetical writings, as we shall see, confirm this link in his thought between the Eucharist and art, as does a curious episode that took place in Berlin, where the philosopher lectured on aesthetics in the winter of 1820–21, in the summers of 1823 and 1826, and in the winter of 1828–29. Catholic students there, according to Althaus, "made an official complaint . . . that Hegel had impugned the Catholic religion in his lectures," by blaspheming the Eucharist, a complaint to which Hegel made a formal reply. Hegel's student, H. G. Hotho, confirms the report in a letter dated April 1, 1826. Hegel, he writes, "'had said that in the Catholic ceremony [of the Eucharist] God is conceived as existing as a material thing, and that if therefore a mouse should consume this thing [the Host], then God should exist in the mouse and even in its excrement.'" See Althaus, *Hegel: An Intellectual Biography*, 161.

Christian art, like the artwork of the preceding periods, is the expression of a religious spirituality, but one that has been taken to the highest degree. Symbolic art erected through its architecture the temple; Classical art supplied through its sculpture the god to be honored therein; and Romantic art filled the temple with the worshiping community through an all-pervasive, atmospheric anthropomorphism made possible by the Incarnation.[50]

What is immediately striking about Hegel's imaginative scheme is the absence of the Host and tabernacle, the invisibility in his Romantic art of the eucharistic Lord who has replaced the Classical idol as the object of worship. Hegel's (increasingly idiosyncratic) Protestantism bypasses the convention of the Host and the glorified body of the risen Lord present in the sacrament and focuses instead on Christ's mystical body, the church. In Hegel's eyes the Host disappears, while the medieval statues, icons, and stained-glass windows, which teemed with figures of praying angels and saints, easily metamorphose in his vision into a Protestant worshiping community gathered in a space stripped bare of idolatrous ornamentation. "Material for this," he writes, "is afforded by colour, musical sound, and finally sound as the mere indication of inner intuitions and ideas."[51] Whereas "the light of the eye is absent from the [Classical] sculptures," the figures of Romantic painting appear to Hegel as mirrors of an enlightened consciousness, "seeing," besouled, and radiant from within.[52]

Whereas Hegel has the Host disappear, to be replaced by the body of the community, Weil sees the plain little Host, which is Christ, as the generative center of all Christian art: "architecture, singing, language," and saints.[53] She feeds spiritually on this Host, the source of all beauty, but she, living in an age of brutal political movements and "social enthusiasms," also fears to be devoured by the ecclesiastical and political bodies to which Hegel had pointed with such optimism a century earlier: "Our true dignity," she writes to Fr. Perrin, "is not to be parts of a body. . . . The Hosts are not a *part* of Christ's body."[54]

Whereas Weil looks to the eucharistic body of Christ in the Host as the quintessence of beauty and art, Hegel celebrates the embodied forms of Greek sculpture as "the consummation of the realm of beauty. Nothing can be or become more beautiful."[55] Above all, Classical art possesses aesthetic *integritas:* "When the classical ideal figure is at its true zenith, it is complete in itself, independent,

50. Hegel, *Aesthetics,* 1:85; *Ästhetik,* 1:91.
51. Hegel, *Aesthetics,* 1:86; *Ästhetik,* 1:92.
52. Hegel, *Aesthetics,* 1:521; *Ästhetik,* 1:501–2.
53. Weil, *Waiting for God,* 187; *Attente de Dieu,* 182: "L'architecture, les chants, le langage."
54. Weil, *Waiting for God,* 80–81; *Attente de Dieu,* 59: "Car notre vraie dignité n'est pas d'être des parties d'un corps. . . . Les Hosties ne sont pas des parties de son corps."
55. Hegel, *Aesthetics,* 1:517; *Ästhetik,* 1:498.

reserved, unreceptive, a finished individual which rejects everything else. Its shape is its own."[56] Greek sculpture represents Hegel's idea of beauty (in William Desmond's words) as "*a sensuous image of being whole,* the spiritually significant materialization of a possible perfection."[57] Because the statue of a god realizes perfectly the Greek artist's anthropomorphic Idea of God, it constitutes an extraordinary, Hegelian synthesis of matter and spirit. "Art," Hegel writes, "has the task of presenting the Idea to immediate perception in a sensuous shape."[58] Thus understood, the work of art stands as a synthetic middle term in a dialectic. Desmond comments on this ideal, Hegelian synthesis: "Against any dualism of the sensuous and the spiritual, the [Greek] artwork invokes the sensuous presentation of spirit, a presentation which is concomitantly a spiritualization of the sensuous."[59]

The wholeness of a Greek statue, as Hegel sees it, resembles the easy, aesthetic harmony to be observed in the Eucharist, were it only the conjoining of a meal with a memory, and not also a religious act. Hegel's practical art criticism, here and elsewhere, depends on a close proximity, verging on identification, of concept and outward form; he finds it impossible to accommodate the greater distance, polarity, and implicit diachrony that characterizes the aura of individual objects belonging to a ritual tradition. Theodor Adorno's criticism rings true: "There is in [Hegel's] aesthetic a certain excess of materiality. . . . Hegel's dialectic of art is confined to genres and their history, whereas it does not seem to be present in the work of art itself, at least not radically enough."[60]

Weil loved Greek art as much as Hegel did, but for different reasons—not because of its autonomous wholeness, but because of its power to express divine and human suffering. In a notebook entry she refers cryptically to the "sad divinities of Hegel," remarking, "In Sophocles man retains the human form although shattered by a hostile destiny."[61] In sharp contrast to Hegel, moreover, Weil does not regard sculpture as an artform worthy of separate treatment: "It is not an art on its own."[62] She views it instead as a development out of architecture, which is "a means of exploring space."[63] For her, therefore, a work of sculp-

56. Hegel, *Aesthetics,* 1:532; *Ästhetik,* 1:511.

57. Desmond, *Art and the Absolute,* 137. Drawing upon Jacques Maritain's *Creative Intuition in Art and Poetry* (New York: Pantheon, 1953) and his *Art and Scholasticism,* trans. Joseph W. Evans (South Bend: Notre Dame University Press, 1974), Desmond compares St. Thomas Aquinas's aesthetic criteria of *integritas, consonantia,* and *splendor* to Hegel's on pp. 130–41.

58. Hegel, *Aesthetics,* 1:72; *Ästhetik,* 1:79.

59. Desmond, *Art and the Absolute,* 62.

60. Adorno, *Aesthetic Theory,* 385.

61. Weil, *First and Last Notebooks,* 385.

62. Weil, *Lectures on Philosophy,* 188.

63. Ibid.

ture is not an isolated whole, but a component of the larger space in which it appears. Within the over-arching "form of the cathedral," Weil taught her students, "one is aware of an infinite number of relationships."[64] In such an environment, nothing is autonomous.

Whereas Hegel imagines the perfection of art qua art to reflect the composure of a complete self-containment, Weil emphasizes the opposite: "The unity of a work of art must be ceaselessly in peril and still preserved at each instant."[65] In her *Lectures on Philosophy*, she surveys the various artforms to illustrate this point, concluding with thoughts on the beauty of the human body, whose "warm" harmony "is always at risk on account of movements, passions, and which, nevertheless, is preserved at each moment."[66]

Weil's definition of art as always inclusive of what imperils its unity suggests not only that her view of Classical art differs from Hegel's (as is evident in their divergent readings of Sophocles' *Antigone*),[67] but also that she discovered a paradigmatic beauty in the Christian art that was, for Hegel, symptomatic of aesthetic decline. In comparison to Classical art, the Romantic (i.e., Christian) is defective, fragmentary, and even ugly *as art*, according to Hegel, because it consciously aims at showing the incompletion and imperfection of merely natural objects and relationships per se, while using them nonetheless as indispensable, sacramental, metonymic vehicles of a higher, spiritual realm. Romantic art, in short, is anti-idolatrous, calling attention to its own physical limits and transcendent spirituality. It is art transcending art, always caught in the very act of leaving even its own earthly beauty behind in order to reach a purely spiritual beauty. In Hegel's words, "Romantic art is the self-transcendence of art [*Hinausgehen der Kunst*] but within its own sphere and in the form of art itself."[68]

Hegel finds Romantic art inherently flawed and inferior to Greek art, first and foremost, because it lacks self-sufficient, autonomous *integritas* and impassibility. This lack shows itself in its recurrent subject matters: the tales of the martyrs and above all "the story of the Passion, suffering on the cross, the Golgotha of the Spirit—this sphere of portrayal is separated *toto caelo* from the classical plastic ideal. . . . This cannot be portrayed in the forms of Greek beauty."[69] Even if the "infinite sanctity" of Christ, the central figure, is artistically represented, the larger

64. Ibid.
65. Ibid., 187.
66. Ibid., 189. She calls particular attention to the body of the athlete engaged in sports.
67. See Jay Geller, "Hegel's Self-Conscious Woman," *Modern Language Quarterly* 53.2 (1992): 173–99; Ann Loades, "Simone Weil and Antigone: Innocence and Affliction," in *Simone Weil's Philosophy of Culture*, 277–94.
68. Hegel, *Aesthetics*, 1:80; *Ästhetik*, 1:87.
69. Hegel, *Aesthetics*, 1:538; *Ästhetik*, 1:517.

scene of His trial unavoidably includes "what is unbeautiful in comparison with the beauty of Greek art."[70]

Even in the Resurrection, moreover, the wounds remain. Thus, even if a final integrity and harmony are achieved in the skillful portrayal of Christ and His saints in glory, that scene metonymically includes and presupposes an entire, preceding process of redemptive sanctification that is still ongoing and unfinished for the beholder. "For the reconciliation of the individual person with God does not enter as a harmony directly," Hegel points out, "but as a harmony proceeding only from the infinite grief, from surrender, sacrifice, and the death of what is finite."[71]

For Hegel, as Hans Urs von Balthasar notes: "the finite must literally perish if it is to become spiritual and infinite. But the resurrection of the flesh . . . allows us to possess the infinite within the finitude of form. . . . The decision, therefore, lies between the conflicting parties of myth and revelation."[72] "If there were no such thing as the resurrection of the flesh," Balthasar argues, "then the truth would lie with gnosticism and with every form of idealism down to Schopenhauer and Hegel."[73] Opposing Hegel, Balthasar insists: "In Jesus' finitude, and in everything that is given with and which pertains to this form, we hold the infinite. As we pass through Jesus' finitude and enter into its depths, we encounter and find the Infinite, or rather, we are transported and found by the Infinite."[74] Balthasar goes on to declare, "Only the one who loves finite form as the revelation of the infinite is both 'mystic' and 'aesthete.'"[75]

Hegel's practical art criticism consistently devalues both implicit diachrony and the auratic distance between the finite and the infinite, the human and the divine, in favor of a synchronic, static, self-contained wholeness, forgetful of process and suffering. As Hegel recognizes, what has been deformed through sin must first be reformed, then conformed, and finally transformed. To Hegel's mind, however, a truly beautiful artwork contains no evocative sign of its own coming-into-being, its previous imperfection. Hegel, in short, rejects as aesthetically inferior and ugly what Sandor Goodhart, drawing on the pattern of scrip-

70. Hegel, *Aesthetics*, 1:538; *Ästhetik*, 1:518.

71. Hegel, *Aesthetics*, 1:537; *Ästhetik*, 1:517.

72. Hans Urs von Balthasar, *The Glory of the Lord: A Theological Aesthetics*, trans. Erasmo Leiva-Merikakis and ed. Joseph Fessio S.J. and John Riches (New York: Crossroad; San Francisco: Ignatius Press, 1983–1991), 1:155.

73. Ibid.

74. Ibid. It is tempting to compare these declarations of Balthasar to the important writings of Jewish philosopher Emmanuel Levinas concerning the ethics and the discovery of the Transcendent in the immanent. See especially Emmanuel Levinas, *Of God Who Comes to Mind*, trans. Bettina Bergo (Stanford, CA: Stanford University Press, 1998). Balthasar argues that "the 'ethical' is realised precisely in the figure of the 'aesthetic'" in the case of Jesus (*Glory of the Lord*, 2:13).

75. Balthasar, *Glory of the Lord*, 2:114.

tural narrative, calls a "prophetic reading" of things, an interpretation that finds the end of a narrative already entailed in its beginning, and conversely the beginning in the end. "Suffering," Goodhart observes, "is not a synchronic phenomenon, but a diachronic perspective."[76]

The Hegelian devaluation of a biblical diachrony in depictions of Christ's death and resurrection, in favor of an ideal, philosophical synchrony as exhibited in Greek sculpture, has, of course, important eucharistic implications, because the mystic actions of the Catholic Mass represent the entire paschal mystery, in its historical sequence. The words of consecration recall not only the Last Supper, Christ's coming in the form of bread, but also Christ's Incarnation, the Son's becoming human. The elevation of the Host evokes the crucifixion, when Christ was raised on the cross. The lowering of the Host to the altar brings to mind the deposition from the cross. The reception of Communion, when the faithful receive the glorified body of Christ, is a new rising of the Lord in those who are His new creation. Finally the *Ita missa est,* with which the priest blesses and dismisses the congregation, evokes and renews Christ's commission of the disciples at His ascension into heaven.[77]

Hegel's aesthetics, founded on a different eucharistic theology, can accommodate the implicit diachrony in the Host neither in the Mass nor in medieval artworks depicting Christ's life. Art qua art should not lay bare any wounds, according to Hegel. Adorno argues the opposite: "By absorbing its opposite, ugliness, beauty expands and becomes that much stronger."[78] Hegel was right, according to Adorno, to see a greater spiritualization in Christian art, but he erred in adjudging its inclusion of ugliness an aesthetic deficiency: "Spiritualization incorporated something into art that had always been taboo because it was ugly and repulsive to the senses; the sensually unpleasant has an affinity for spirit."[79] That affinity results from the necessary involvement of suffering in work, striving, and change. To exclude ugliness and pain from art and its beauty, Adorno argues, is to deprive art of its power to lodge a protest against the status quo, to separate art from nature, and to undermine the universal appeal that springs from "specific impulses" and individual, human faces.[80] "Spiritualization," Adorno insists, "is a legitimate criticism of culture by art."[81]

76. Sandor Goodhart, *Sacrificing Commentary: Reading the End of Literature* (Baltimore: Johns Hopkins Press, 1996), 200.

77. Early and medieval Christians recognized a richly elaborate symbolism in the ritual actions of the Mass. See, for example, St. Thomas Aquinas, *Summa theologiae* (New York: Benziger, 1947), vol. 2, part 3, q. 83, art. 5, 2520–23.

78. Adorno, *Aesthetic Theory,* 384.

79. Ibid., 280–81.

80. Ibid., 293.

81. Ibid., 137.

Weil's answer to Hegel's accords with Adorno's, but it takes the form of a meditation on the perennial problem of the *Christus deformis.* In her important essay "The Love of God and Affliction," she meditates on the passion of Christ and the horrors of history. Her probing portrayal of mental and physical misery prompts the question, Is there any sense in which human affliction can be said to be beautiful? For Weil, as for Adorno, the aesthetical question is inseparable from ethical issues. If affliction is only an ugliness, how can it be possible for us to turn the eyes of our love, of our attention, toward those who bear the marks of slavery, toward the outcasts, the accursed, and the condemned? What gift of ourselves can we give to another if we see that person as ugly? Conversely, if one is afflicted, how can one endure that terrible condition without losing one's soul and the ability to see any beauty at all in the world?

For Weil it is not enough to set the beauty of the world beside the ugliness of acute suffering as two different means by which God captures our attention, opens us for the reception of grace, and frees us from our egocentrism. To Job, the bearer of unspeakable affliction, God eventually showed the beauty of the world.[82] But what did Job see in his vision? Weil answers, the obedience of the whole created order to God and the operation of the laws of necessity that Weil terms "gravity." That natural order is in itself beautiful. "What is more beautiful," Weil asks, "than the action of gravity on the fugitive folds of the sea waves, or on the almost eternal folds of the mountains? The sea is not less beautiful in our eyes because we know that sometimes ships are wrecked by it. . . . All the horrors produced in this world are like the folds imposed upon the waves by gravity. That is why they contain an element of beauty."[83] If grace so penetrates a person that he or she becomes "light" and "able to walk on the water," as Jesus did (Matt. 14:25–32), that agility occurs, she writes, "without violating any of the laws of nature."[84] Such a lightness accords with gravity and does not contradict it; both belong to the paradisiacal order of the world and are forms of its light-filled beauty.

82. Weil, *Waiting for God,* 121; *Attente de Dieu,* 103: "Alors un jour Dieu vient se montrer lui-même à elle et lui révéler la beauté du monde, comme ce fut le cas pour Job" (Then, one day, God will come to show himself to this soul and to reveal the beauty of the world to it, as in the case of Job).

83. Weil, *Waiting for God,* 128–29; *Attente de Dieu,* 112: "Rien n'est beau comme la pesanteur dans les plis fugitifs des ondulations de la mer ou les plis presque éternels des montagnes. La mer n'est pas moins belle à nos yeux parce que nous savons que parfois des bateaux sombrent. . . . Toutes les horreurs qui se produisent en ce monde sont comme les plis imprimés aux vagues par la pesanteur. C'est pourquoi elles enferment une beauté."

84. *Waiting for God,* 127; *Attente de Dieu,* 111: "Dieu a fait en sorte que sa grâce, quand elle pénètre au centre même d'un homme et de là illumine tout son être, lui permet, *sans violer les lois de la nature,* de marcher sur les eaux." Emphasis mine. This observation by Weil may be in direct response to Hegel, who argues the Deistic position that the miracles that are the subjects of medieval art are ugly, because in violation of natural law. See *Aesthetics,* 1:550; *Ästhetik,* 1:529.

What separates Christ in His human agony on the cross from His Father in Heaven is an infinite distance, Weil observes; but it is a separation that is simultaneously bridged by the infinite divine love that unites the Father with the Son. Weil describes this "distance" in aesthetic terms as a manifestation of the beauty of the Incarnate Logos. It is, she writes, the sounding in the silence of "two notes, separate yet melting into one, like pure and heart-rending harmony. This is the Word of God. The whole creation is nothing but its vibration."[85]

Weil's concept of an aesthetic distance joining the two Pauline forms of Christ—*forma Dei* and *forma servi* (Phil. 2:6–8)—is a fresh, modern reformulation of the Augustinian solution to the problem of Christ's beauty in His deformity on the cross, a solution (as we have seen) with great, artistic consequences for the Middle Ages. Weil finds the same distance present in Christ's eucharistic "form" of bread, in which the whole Christ is hidden. There, added to the Incarnational distance between divinity and humanity, and to the distance between Christ's death and resurrection, is the distance between appearance and substance, a sacramental distance that must be bridged by faith and love. Bridging it allows the "formless" Host to be the mysterious source of new, Incarnational, and artistic forms of beauty.

The relationality entailed in Weil's eucharistic "distance" is precisely what disturbs Hegel, who regards it as a lack of artistic autonomy. In Romantic art, Hegel writes, "infinite subjectivity is not lonely in itself like a Grecian god who lives in himself absolutely perfect in the blessedness of his isolation; on the contrary, it emerges from itself into a relationship with something else."[86] Hegel adjudges the relational distance adumbrated in the Christian art to be simply too great to be given adequate (and thus beautiful) representation in any artistic media. "The defect is just art itself," according to Hegel, "and the restrictedness of the sphere of art."[87] The truth that Romantic art presents is better expressed, according to Hegel, not by art, nor by religion, but by philosophy.[88]

85. Weil, *Waiting for God*, 124; *Attente de Dieu*, 106: "comme deux notes séparées et fondues, comme une harmonie pure et déchirante. C'est cela la Parole de Dieu. La création tout entière n'en est que la vibration."

86. Hegel, *Aesthetics*, 1:532–33; *Ästhetik*, 1:512.

87. Hegel, *Aesthetics*, 1:79; *Ästhetik*, 1:85.

88. Answering to Hegel, who went "beyond the form to attain an absolute knowledge," Hans Urs von Balthasar writes, "The Incarnation is the eschaton and, as such, is unsurpassable. Whoever strains to go beyond this, whoever deems that the Father is still not visible enough in the Son, has not given sufficient thought to the fact that the Father has revealed himself in the Son" (*Glory of the Lord*, 2:235, 302).

Art's Endings and Beginnings

Hegel's famous "end of art" thesis accords with his understanding of art's first origins. Asserting the uncertainty of sense-perception and of each one's necessarily perspectival view of things, Hegel maintains the illusory nature of the sensory world. Its appearance as illusion (*das Schein*) is, for him, the key to its truth. In *The Phenomenology of Spirit*, Hegel declares that those who are foolish enough to believe in the truth and reality of objects of sense "had better be sent back to the most elementary school of wisdom, the ancient Eleusinian mysteries of Ceres and Bacchus; they have not yet learnt *the inner secret of the eating of bread and the drinking of wine*."[89] Even animals have been "deeply initiated" into this mystery, for they "do not stand stock still before objects of sense," in reverence before their reality and beauty, but instead "in complete assurance of the nothingness of things they fall-to without much ado and eat them up."[90]

In this passage the equation of the quasi-eucharistic, Gnostic "eating of bread" and "drinking of wine," on the one hand, with bestial devouring, on the other, is striking. It signifies for Hegel the recognition that the boundary between inside and outside is completely permeable. Just as whatever is outside can be eaten and thus incorporated into oneness, so too the mind's projection effectively absorbs the world, which is nothing more than an appearance. The "initiated" possess this knowledge. Maggie Kilgour describes the process thus: "What is outside must be subsumed and drawn into the center until there is no category of alien outsideness left to threaten the inner stability. . . . The eater is not himself in turn eaten, but secures his own identity by absorbing the world outside 'himself.'"[91]

In the *Aesthetics* Hegel returns to these images of eating and cult in order to explain the emergence of art as a positive, instructive form of sensuous appearance. In the beginning, according to Hegel, the human being existed in an "appetitive relation to the external world"; the slave of his own desires, he remained close to nature and failed to distinguish himself from the other animals, which he used, consumed, and sacrificed for his own self-satisfaction.[92] In so doing, however, he was untrue to himself as a rational, spiritual being. When man first used art—"pictures of the wood that it might use, or of the animals that it might want to eat"—he emancipated himself from blind, uncontrolled desire for natural objects, because "this relation of desire is not the one in which man stands to the

89. Hegel, *Phenomenology of Mind*, 159; *Phänomenologie des Geistes*, 87. Emphasis added.
90. Hegel, *Phenomenology of Mind*, 159; *Phänomenologie des Geistes*, 87.
91. Maggie Kilgour, *From Communion to Cannibalism: An Anatomy of Metaphors of Incorporation* (Princeton: Princeton University Press, 1990), 5, 6–7. Kilgour is commenting on Mikhail Bakhtin's discussion of Rabelais, not on Hegel, but the passage is apt.
92. Hegel, *Aesthetics*, 1:36; *Ästhetik*, 1:46.

work of art. He leaves it free as an object to exist on its own account; he relates to it without desire, as to an object for the contemplative side of spirit alone."[93] Art "lets its object persist freely and on its own account, while desire converts it to its own use by destroying it."[94]

Hegel argues that since art in its origins represents what is eatable and derives "from the sensuous sphere," it retains by definition a fundamental, sensory appeal: "It is produced for man's *senses*."[95] Thus Hegel explains the semantic associations of aesthetic experience with "taste" and, at a further remove, with man as *Homo Sapiens*.[96] These are all traces of "the beginning of art," when "the urge of imagination consisted in striving out of nature into spirit."[97] Mankind used art in order to recognize himself as different from the other animals; "consequently, the sensuous aspect of art is related only to the two theoretical senses of sight and hearing, while smell, taste, and touch [*Geruch, Geschmack und Gefühl*] remain excluded from the enjoyment of art."[98]

In the act of representing in art what he previously only ate, early man created a distance between himself and the consumable world of nature that allowed him to assert at a higher level the illusory quality of nature and to make a claim for a fundamental perspectivalism. Stephen Bungay sums it up when he observes that art, for Hegel, "is an expression of self-awareness, and a means of expanding it."[99] Hegel takes Kant as his starting point, declaring, "The beautiful [*Schöne*] has its being in pure appearance [*Schein*]."[100] Whereas Weil emphasizes the relationship between the beautiful and the ethical, however, Hegel grounds his discussion of beauty's appearance in questions of epistemology. The *Schein* of all objects of sense perception, according to Hegel, stands as a middle term between human consciousness and the supersensible: "The inner world, or the supersensible beyond, has, however, *arisen*: it comes to us out of the sphere of appearance and the latter is its mediating agency [*Vermittlung*]. The truth of the sensible and the perceptual lies, however, in their very appearance. The supersensible is then *appearance qua appearance* [*Erscheinung als Erscheinung*]."[101] Thomas Ryba explains,

93. Hegel, *Aesthetics*, 1:36–37; *Ästhetik*, 1:46–47.

94. Hegel, *Aesthetics*, 1:38; *Ästhetik*, 1:48.

95. Hegel, *Aesthetics*, 1:32; *Ästhetik*, 1:42.

96. Ibid., 1:34. On the meanings of *sapere*, see Richard Broxton Onians, *The Origins of European Thought about the Body, the Mind, the Soul, the World, Time and Fate* (Cambridge: Cambridge University Press, 1988), 61–65; on "taste" see Raymond Williams, *Keywords: A Vocabulary of Culture and Society*, rev. ed. (New York: Oxford University Press, 1983), 313–15.

97. Hegel, *Aesthetics*, 1:517; *Ästheik*, 1:498.

98. Hegel, *Aesthetics*, 1:38; *Ästhetik*, 1:48.

99. Stephen Bungay, *Beauty and Truth: A Study of Hegel's Aesthetics* (Oxford: Oxford University Press, 1984), 33.

100. Hegel, *Aesthetics*, 1:4; *Ästhetik*, 1:16.

101. Georg Wilhelm Friedrich Hegel, *The Phenomenology of Mind*, trans. J. B. Baillie, 2nd ed.

"Appearance, for Hegel, thus functions like a partially silvered pane of glass. In mediating the outside view it also reflexively makes us aware that is it only a view *for someone*. Without the instrumentality of that pane (that is, appearance) we would have no awareness that the scene was positional, that is to say, that it had a subjective center. But in coming to this awareness we also look beyond the pane which—dissolving in its instrumentality—becomes transparent to us, the viewers."[102]

Weil answers directly and sharply to Hegel's perspectivism, albeit without naming him, in her essay, "Forms of the Implicit Love of God." There she acknowledges that Hegel is, for the most part, tragically correct about the realm of appearance: "Each man imagines he is situated at the center of the world. The illusion of perspective places him at the center of space; an illusion of the same kind falsifies his idea of time; and yet another kindred illusion arranges a whole hierarchy of values around him. . . . We live in a world of unreality and dreams."[103] The perception of the world in its real beauty requires nothing less than that we "empty ourselves of our false divinity, deny ourselves," and "give up being the center of our world in imagination."[104] The decentering of ourselves precipitates a profound transformation that "takes place at the very roots of our sensibility, in our immediate reception of sense impressions and psychological impressions," allowing us to awaken to "what is real and eternal."[105] It enables us to turn the "face of [our] love [*face de cet amour*]" toward other centers of attention: toward God, who is "the true center [*le véritable centre*]"; toward our neighbor; and toward the epiphanic beauty of the world, which appears before us, and which we truly see, perhaps for the first time.[106]

Whether in the rapt recognition of a beauty external to ourselves, or in the suffering of acute, physical pain, we are not likely to imagine ourselves godlike at the center of the universe. As avenues of actual grace, sensory impressions can be

(London: George Allen and Unwin, 1966), 193; *Phänomenologie des Geistes* (Hamburg: Felix Meiner, 1952), 87.

102. Thomas Ryba, "Postmodernism and the Spirituality of the Liberal Arts: A Neo-Hegelian *Diagnosis* and an Augustinian *Pharmakon*," in *Divine Representations: Postmodernism and Spirituality*, ed. Ann W. Astell (Mahwah, NJ: Paulist Press, 1994), 182.

103. Weil, *Waiting for God*, 158–59; *Attente de Dieu*, 147–48: "[C]haque homme a une situation imaginaire au centre du monde. L'illusion de la perspective le situe au centre de l'espace: une illusion pareille fausse en lui le sens du temps; et encore une autre illusion pareille dispose autour de lui toute la hiérarchie des valeurs. . . . Nous sommes dans l'irréalité, dans le rêve."

104. Weil, *Waiting for God*, 159–60; *Attente de Dieu*, 148: "Se vider de sa fausse divinité, se nier soi-même, renoncer à être en imagination le centre du monde."

105. Weil, *Waiting for God*, 159; *Attente de Dieu*, 148: "C'est s'éveiller au réel, à l'éternel. . . . Une transformation s'opère alors à la racine même de la sensibilité, dans la manière immédiate de recevoir les impressions sensibles et les impressions psychologiques."

106. Weil, *Waiting for God*, 160; *Attente de Dieu*, 148–49.

strong enough, Weil argues, to cut through self-protective illusions and societal deceptions, awaking the light of the soul, which in turn lightens the body, purifying its senses. Through the reforming and transforming work of grace, it is finally possible, Weil maintained, to see truly, if only we are attentive enough. "When one is attentive," she writes, "one's consciousness is open to illumination."[107] The last notebook entry before her death reads: "For living man here below, in this world, sensible matter . . . is like a filter or sieve; it is the universal test of what is real in thought, and this applies to the entire domain of thought without exception. Matter is our infallible judge."[108]

Antimimetic with respect to the perceptible, Hegel's art imitates instead the thought of the artist precisely in its freedom to depart from nature as the senses perceive it. In his *Aesthetics* Hegel explicitly rejects the ancient view that art imitates nature, by which standard, he argues, the best art would have to be a kind of virtual reality, like the fabled grapes of Zeuxis, at which "living doves are supposed to have pecked."[109] With Schiller, Hegel maintains instead that art departs from the factual and historical into the ideal and universal.[110] Indeed Hegel reverses Plato's evaluation of art in its mimetic relation to the world, arguing that the divinity's "appearance" in the *Schein* of art is actually purer than in the beauty of nature. The human spirit self-consciously represents its particular vision of things in the sensuous forms of art, which mirror in turn this subjectivity. The artwork is thus best understood in Hegelian terms not primarily as an imitation of the world, but rather as a free expression of the artist's world-altering imagination. The imperfection of imitation—that is, the lack of verisimilitude, of copy-realism—is for Hegel a paradoxical measure of the purity of subjective perception and self-expression.

Weil sees an idolatrous potential both in the copy-realism Hegel rejects and in the fanciful self-expression he advocates. True art, for Weil, is not a simulacrum, not a sacrilegious copying of something naturally beautiful, but rather a kind of consecration that allows the beauty of the cosmos to enter into and to transform a finite part of the whole. She defines art as "an attempt to transport into a limited quantity of matter, modeled by man, an image of the infinite beauty of the whole universe. If the attempt succeeds, this portion of matter should not hide the universe, but on the contrary, it should reveal its reality to all around."[111] The

107. Weil, *Lectures on Philosophy*, 92.

108. Weil, *First and Last Notebooks*, 364.

109. Hegel, *Aesthetics*, 1:42; *Ästhetik*, 1:52.

110. See Friedrich Schiller, "On the Art of Tragedy," trans. Daniel O. Dahlstrom, in Schiller, *Essays*, ed. Walter Hinderer and Daniel O. Dahlstrom, The German Library 17 (New York: Continuum, 1993), 1–21.

111. Weil, *Waiting for God*, 168; *Attente de Dieu*, 159: "L'art est une tentative pour transporter

artist can only accomplish this "transportation," this impression of an image of infinite beauty, if he himself "has had real, direct, and immediate contact with the beauty of the world, contact that is of the nature of a sacrament."[112] The real genius of an artist is his openness to inspiration, to grace. God himself, therefore, "has inspired every first-rate work of art, though its subject may be utterly and entirely secular; he has not inspired any of the others."[113]

Works of art that "are neither pure and true reflections of the beauty of the world nor openings onto this beauty are not, strictly speaking, beautiful," according to Weil; their apparent "luster" may indeed be "diabolical"—"un éclat diabolique"—for the devil is truly the ape of God, a liar, and the "father of lies" (John 8:44).[114] In her notebook she observes, "God is and does not appear. The devil appears and is not."[115] Citing Nero as a prime example of the many "perverted aesthetes," she wonders about what motivates their abuses of beauty: "Is it like the hunger of those who frequent black masses for the consecrated Hosts? Or is it, more probably, because these people do not devote themselves to what is genuinely beautiful, but to a bad imitation?"[116] She sees the artificial beauty of luxury as a misguided "desire for contact with universal beauty," a contact more easily given to the poor than to the rich, whose insulated, self-protective circle "is not the universe," but rather "hides it," like a theatrical screen.[117]

The "light" of true art produces an ecstatic "lightness" in the beholder, according to Weil, whereas the "luster" of a demoniacal artwork, however attractive, enhances one's self-centeredness. Adorno speaks similarly of a demonic "glow" that overcomes "aura": "If works of art take on a glow, they perish as a result of their own objectification" as commodities or status-symbols.[118] Adorno

dans une quantité finie de matière modelée par l'homme une image de la beauté infinie de l'univers entier. Si la tentative est réussie, cette portion de matière ne doit pas cacher l'univers, maus au contraire en révéler la réalité tout autour."

112. Weil, *Waiting for God,* 169; *Attente de Dieu,* 160: "Tout véritable artiste a eu un contact réel, direct, immédiat avec la beauté du monde, ce contact qui est quelque chose comme un sacrement."

113. Weil, *Waiting for God,* 169; *Attente de Dieu,* 160: "Dieu a inspiré toute oeuvre d'art de premier ordre, le sujet en fût-il mille fois profane; il n'a inspiré aucune des autres."

114. Weil, *Waiting for God,* 169; *Attente de Dieu,* 159–60: "Les oeuvres d'art qui ne sont pas des reflets justes et purs de la beauté du monde, des ouvertures directes pratiquées sur elle, ne sont pas à proprement parler belles."

115. *The Notebooks of Simone Weil* 1:227.

116. Weil, *Gravity and Grace,* 207; *La Pesanteur et la Grace,* 152: "Cela resemble-t-il à la faim des amateurs de messes noires pour les Hosties consacrées? Ou bien, plus probablement, ces gens ne s'attachent-ils pas au beau authentique, mais à une imitation mauvaise?"

117. Weil, *Waiting for God,* 168; *Attente de Dieu,* 159: "désire le contact de la beauté universelle, alors que le milieu qu'on organise n'est pas l'univers. Il n'est pas l'univers et il le cache. L'univers tout autour est comme un décor de théâtre."

118. Adorno, *Aesthetic Theory,* 126.

regards such a dialectical transformation as virtually inevitable: "Given the definition of art as appearance or apparition, we can say that art carries its negation in itself like a *telos*. The sudden emergence of appearance gives the lie to the aesthetic illusion [*Schein*]."[119] This explains the "explosive" and "apocalyptic" quality Adorno discerns in every work of art.[120] Mimesis for Adorno is always already antimimetic, because nonidentical, and thus potentially destructive of itself. Modern, nonfigurative art thematizes this antimimetic quality for Adorno—the almost desperate resistance of art to its own commodification.

The starting point for Hegel, Weil, and Adorno in their respective approaches to beauty's "appearance" is the first part of Kant's *Critique of Judgment* (1790), to which Weil explicitly refers. She agrees with Kant that beauty qua beauty "is a finality which involves no objective. . . . Beauty is not a means to anything else."[121] It is "only a surface" that "appears from a certain distance."[122] As Ann Pirruccello explains, for Weil the beauty of an object "yields nothing but its own existence, and it is attended to, and available, under no other conditions. . . . [It] provides an end or finality that is merely beauty itself, a good that appears only from a reverential distance and therefore offers us nothing that we can possess or appropriate without destroying."[123] In one of her notebooks, Weil writes: "Beauty is something that one desires without wanting to devour it. We simply desire that it should be."[124]

Adorno defends artistic beauty in a similar way, declaring: "Art's role in a totally functional world is precisely its afunctionality. . . . To instrumentalize art is to undercut the opposition art mounts against instrumentalism."[125] Art's beauty, for Adorno, is like the auratic, symbolic exchange of Jean Baudrillard, that is to say, a presentation that disrupts the forces of mass consumption, and which is best represented in a special gift—e.g., an engagement ring—given to a beloved friend. Such a gift qua gift cannot be bought or sold; it lacks use value and economic-exchange value; it is, moreover, entirely "unique" in that it seals a pact between particular persons at a given time and place.[126]

119. Ibid.

120. Ibid., 125.

121. Weil, *Waiting for God*, 165, 167; *Attente de Dieu*, 155, 157: "Comme Kant a très bien dit, c'est une finalité qui ne contient aucune fin. . . . La beauté seule n'est pas un moyen pour autre chose." Cf. Immanuel Kant, *Critique of Judgment*, trans. J. H. Bernard (New York: Hafner, 1951), 45.

122. Weil, *Waiting for God*, 166; *Attente de Dieu*, 156: "elle est comme un miroir. . . . [E]lle n'apparaît qu'à une certaine distance."

123. Ann Pirruccello, "Overcoming Self: Simone Weil on Beauty," in *Divine Representations: Postmodernism and Spirituality*, ed. Ann W. Astell (Mahwah, NJ: Paulist Press, 1994), 43, 40.

124. *The Notebooks of Simone Weil*, 2:335.

125. Adorno, *Aesthetic Theory*, 442.

126. Jean Baudrillard, *For a Critique of the Political Economy of the Sign*, trans. Charles Levin (St. Louis: Telos, 1981), 64.

In her notebooks Weil likens such a gift as Baudrillard describes to a relic or sacrament: "The sacraments . . . are like souvenirs of loved ones that have died. A letter from such an one, a ring, a book . . . constitute veritable contacts with him, contacts that are real, unique, irreplaceable. All genuine lovers and friends experience joy in exchanging souvenirs. So likewise it is doubtful whether there can be any genuine religion without sacraments. . . . Plato looked upon *the beautiful* as a souvenir of the beyond."[127] Weil describes the salvific function of beauty precisely in sacramental terms as a *metaxu* or "bridge" that mediates a real connection between God and humanity.[128]

"[Weil's] starting point," Patrick Sherry emphasizes, "is not the beauty of art, but that of the natural world," which is a "creation of God," and which serves as "an intermediary" between God and humanity, "reflect[ing] God's nature and attract[ing] the soul to Him."[129] The beauty of the world and its mediating power depend in Weil's understanding on Christ, the unique Mediator in whose mediation the world's beauty participates instrumentally. Weil identifies the Christ of the Incarnation and of the Eucharist with the Logos of God: "God created the universe, and his Son, our first-born brother, created the beauty of it for us. The beauty of the world is Christ's tender smile for us coming through matter. He is *really present* in the universal beauty. . . . It is also like a sacrament."[130] This theo-aesthetical understanding leads Weil to regard as sinful the ignoring, defacing, belittlement, and misuse of beauty in creatures.[131]

For Weil the beauty of the world is a sacramental, whose very "appearance" calls the creature away from ego-centrism toward the beauty of the world, the love of which is an implicit form of the love of God the Creator; by contrast Hegel's *Erscheinung,* whether in nature or art, is a medium for the recognition of an essential sameness or pantheism, the center of which is Spirit itself. The individual subject, according to Hegel, needs the *Schein* of the world and of art in order to see himself as yet another "appearance" of Spirit.

Hegel's aesthetics, therefore, begins with art as the mirror of mind. He explic-

127. *The Notebooks of Simone Weil,* 2:335.

128. See Simone Weil, *Gravity and Grace,* trans. Arthur Wills (Lincoln: University of Nebraska Press, 1997), 132–34. For an extended treatment of this topic, see Eric Springsted, *Christus Mediator: Platonic Mediation in the Thought of Simone Weil* (Chico, CA: Scholars Press, 1983).

129. Patrick Sherry, "Simone Weil on Beauty," in *Simone Weil's Philosophy of Culture: Readings toward a Divine Humanity,* ed. Richard H. Bell (Cambridge: Cambridge University Press, 1993), 262.

130. Weil, *Waiting for God,* 165; *Attente de Dieu,* 154: "Dieu a créé l'univers, et son Fils, notre frère premier-né, en a créé la beauté pour nous. La beauté du monde, c'est le sourire de tendresse du Christ pour nous à travers la matière. Il est *réellement présent* dans la beauté universelle. . . . C'est aussi quelque chose comme un sacrement." Emphasis mine.

131. See Sherry, "Simone Weil on Beauty," 263–64.

itly defines aesthetics as the "philosophy of fine art [*Philosophie der schönen Kunst*],"[132] choosing to exclude from its purview any consideration of natural beauty, whereas in her lectures on philosophy, delivered at Roanne in 1933–34, Weil emphatically includes nature as an "area of beauty," alongside the different arts, and she lists among those arts many that Hegel would not consider "fine": for example, public ceremony, dance, and sports.[133] In her later writings, her consciousness, transformed by mystical experience, is characterized by an ever-expanding, aesthetic sensibility that gives a new voice to what Umberto Eco calls the "integrated aesthetic" of the Middle Ages, within which "even ugliness found its place."[134]

In this initial, important divergence from Hegel in the very definition of aesthetics, Weil anticipates Adorno's complaint that Hegel erred in neglecting the beauty of nature, which inspires the genuine, auratic beauty of art. Hegel refused to consider nature's beauty as being "indifferent, not free and self-conscious in itself": "nicht in sich frei und selbstbewußt."[135] Against Hegel, Adorno insists, "It is precisely this moment [of 'indifference'] shared by natural and artistic beauty which must not be lost."[136] Adorno refers approvingly to a passage in an essay by Walter Benjamin, where he illustrated what he meant by the "aura" of premodern art by using an image from nature: "If, while resting on a summer afternoon, you follow with your eyes the mountain range on the horizon or a branch which casts its shadow over you, you experience the aura of those mountains, of that branch."[137] Offering his own definition of aura, Adorno insists: "We can say that perceiving nature's aura means to become conscious of that quality in nature which is the defining element of a work of art. Aura is an objective signification beyond all subjective intentions."[138]

For Adorno, Hegel's neglect of nature with respect to art is comparable to Karl Marx's relative lack of attention to the environment and natural resources as material means of production. Weil, who wrote so passionately about nature's beauty, necessity, human labor, and "the need for roots," would have agreed: There is something in nature that wordlessly protests against every manner of exploitation, something that is (in Adorno's words) "a kind of crying without

132. Hegel, *Aesthetics*, 1:1; *Ästhetik*, 1:23.

133. Weil, *Lectures on Philosophy*, 187–89.

134. Eco, *Art and Beauty in the Middle Ages*, trans. Hugh Bredin (New Haven: Yale University Press),35.

135. Hegel, *Aesthetics*, 1:2; *Ästhetik*, 1:14.

136. Theodor Adorno, *Aesthetic Theory*, trans. C. Lenhardt, ed. Gretel Adorno and Rolf Tiedemann (London: Routledge and Kegan Paul, 1983), 385.

137. Walter Benjamin, "The Work of Art in the Age of Its Mechanical Reproduction," in *Illuminations*, ed. Hannah Arendt, trans. Harry Zohn (New York: Schocken, 1969), 222–23.

138. Adorno, *Aesthetic Theory*, 386.

tears."[139] Complaining to her parents about the contemporary trend toward fad-
dish "adulterations" of food and "chemical mixtures" in drinks, Weil writes: "The
pure taste of the apple is as much a contact with the beauty of the universe as the
contemplation of a picture by Cézanne."[140]

In order really to behold nature's beauty, however, a distance is needed. Ben-
jamin famously correlates a loss of artistic aura, first with the separation of art
from the altar, and second with the mechanical reproduction that brings works
of art too close to their viewers. Admitting the historical truth of Benjamin's
scheme, but contesting the degree and irreversibility of aura's decline, Adorno
calls for an artistic "turning away from nature's immediacy," because "aesthetic
distance from nature is also a movement in the direction of nature."[141] Paul Ri-
coeur talks about the artwork's "retreat from and transfer back into the world":
"As the gap with reality grows wider [e.g., in the case of nonfigurative painting],
the biting force of the work on the world of our experience is reinforced, . . . the
more intense the return back upon the real."[142] For her part Weil argues for aes-
thetic distance and ascetic renunciation, the deliberate, methodological "turning
away" from that which gives an immediate gratification, the free choice of art for
the sake of reverencing nature's beauty. "It may be," she muses, "that vice, de-
pravity, and crime are nearly always, or perhaps always, in their essence, attempts
to eat beauty, to eat what we should only look at."[143]

For Weil the eucharistic convention of the Host is the wondrously antimimetic
mimesis, the pinnacle of an anti-aesthetic aesthetics, the exception that proves the
rule that beauty should not be eaten. It was, she thought, the proper food of saints
and the source of true works of art. Finding herself inadequate to its sacramen-
tal reception, she nonetheless feasted on the Host ardently with her eyes in ado-
ration. For Hegel, who did receive the Host, but with a diminished sacramental
faith, the Eucharist was primarily a memorial of the Lord's death, the bittersweet
sign of a loss of symbolic unity between content and expression, a cause of frus-
trated hope, a source of sadness, and a foreshadowing of the end of art. Conceived

139. Ibid., 170. See Simone Weil, *The Need for Roots: Prelude to a Declaration of Duties toward Mankind,* trans. Arthur Wills (New York: Octagon, 1979).

140. Weil, *Seventy Letters,* 189.

141. Adorno, *Aesthetic Theory,* 385, 390.

142. Paul Ricoeur, "Aesthetic Experience," trans. Kathleen Blamey, *Philosophy and Social Criticism* 24.2/3 (1998): 29.

143. Weil, *Waiting for God,* 166; *Attente de Dieu,* 156: "Peut-être les vices, les dépravations et les crimes sont-ils presque toujours ou même toujours dans leur essence des tentatives pour manger la beauté, manger ce qu'il faut seulement regarder." In his introduction to her *Lectures on Philosophy,* Peter Winch observes, "It is an important and striking feature of Simone Weil's account of methodological action that it emphasizes this 'turning away', the renunciation of immediate satisfaction in favor of doing something else which does not lead directly to what I seek" (13).

of as a substitute for food, Hegel's art does not escape being consumed itself in the end, albeit by the noblest of eaters, Philosophy.

Beside this Hegelian table stands that of Hegel's friend and onetime roommate, the poet Friedrich Hölderlin (1770–1843), whose lyric "Brod und Wein" (1800–1802) was composed during the same years when Hegel was writing his eucharistic meditations. On the poet's table the bread remains (at least temporarily) uneaten, still promising a nourishment that will (perhaps) come.

8 : TO (FAIL TO) CONCLUDE

Eucharists without End

To have divine love as its inner form, a woman's life must be a eucharistic life.
—Edith Stein

I loved above all the processions in honor of the Blessed Sacrament.
—St. Thérèse of Lisieux

To explain the Eucharist—a multiform, inevitable, and instructive naïveté.
—Jean-Luc Marion

When Simone Weil died in England in August 1943, Edith Stein (1891–1942) was already dead, a Jewish victim of the Nazis in Auschwitz. Stein, one of Edmund Husserl's most brilliant students, had become Catholic in 1922. For ten years she had lived a devout life as a teacher and scholar, practicing an intense, eucharistic piety. In 1933 she entered the Carmelite cloister in Cologne, choosing for herself a name, "Sister Teresa Benedicta of the Cross," that evoked the names of Carmel's two great sixteenth-century reformers, Saints John of the Cross (1542–1591) and Teresa of Ávila (1515–1582), whose autobiography had stirred Stein's conversion. Anticipating her eventual arrest, deportation, and martyr's death, Stein spent the last months of her life with her sister Rosa in the Carmelite convent in Echt, Holland.

There Stein completed a book-length study of St. John of the Cross, *The Science of the Cross* (1942). Like St. Bonaventure's Life of St. Francis, Stein's work approaches the life of her spiritual father as a masterpiece of divine and human art, tracing in it the theo-aesthetical themes she had begun to explore in a 1941 essay, "Ways to Know God." In that essay she analyzes the biblical "image-language" of Pseudo-Dionysius the Areopagite. In *Science of the Cross,* she explores St. John's life and thought from the phenomenological perspective of the emblem (the cross) and the poetic symbols (the night, the wedding, the feast) he used to express his way of holiness. Writing about his experience, she clarified her own.[1]

Faithful to her Jewish heritage, Stein was drawn to the Carmelite tradition as

1. Edith Stein's interest in aesthetics dates back to her youth. See Elizabeth A. Mitchell, "Artistic Creativity and Empathic Act in the Thought of Edith Stein" (Licentiate Thesis, Pontifical University of the Holy Cross, 2000).

the most "Judaic" of the Christian spiritualities. The Carmelites, after all, claim as their founder the Old Testament prophet Elijah, who prayed on Mount Carmel. A prototype of eucharistic devotion, Elijah was miraculously nourished in the wilderness by ravens (3 [1] Kings 17:2–6) and later by an angel (3 [1] Kings 19:4–8). He was a model for St. John of the Cross, according to Stein, and remains "the model of all who withdraw into solitude, renouncing sin and all sensory pleasures, indeed all earthly things."[2]

The great opponent of the priests of Baal (3 [1] Kings 18:19–40), Elijah is also for the Carmelites the great prophet of anti-idolatry, who atones for that sin—the first sin committed by Adam and Eve—by a life of constant worship of the one true God. Taking her cue from the first sentence spoken by Elijah in the scriptures (3 [1] Kings 17:1), Stein regards him as the exemplar of the Carmelite vocation: "We who live in Carmel and who daily call upon our Holy Father Elijah in prayer know that . . . [h]is spirit is active among us in a vital tradition and determines how we live. . . . To stand before the face of the living God [as Elijah did]—that is our vocation."[3] Stein explains that standing before the face of God means "to watch in prayer": "Prayer is looking up into the face of the Eternal."[4] More concretely prayer consists in meditation on the Law of the Lord, especially as that law is embodied in the life of Christ, who "is present to us in the most Blessed Sacrament. The hours of adoration before the Highest Good and listening for the voice of the Eucharistic God are simultaneously 'meditation on the Law of the Lord' and 'watching in prayer.'"[5]

In Stein's understanding, eucharistic adoration—the focused glance of the eyes to the consecrated Host and of the soul to Christ—is a means to "the highest level" of union with God, "when we are so united with the triune God, whose temple we are, that his Spirit rules all we do or omit."[6] In the 1934 preface to her short biography of St. Teresa, Stein vividly contrasts the night adoration of the sisters, who "take turns keeping watch in the choir before the Blessed Sacrament," with the carnivalesque disorder outside in the streets, which represents the "frantic tumult" of the time, when "people get drunk and delirious, while political battles separate them, and great need depresses them."[7] The Carmelite practice of

2. Edith Stein, *The Science of the Cross*, trans. Josephine Koeppel, O.C.D., ed. Lucy Gelber and Romaeus Leuven, O.C.D., The Collected Works of Edith Stein 6 (Washington, DC: ICS, 2002), 19.

3. Edith Stein, "Before the Face of God: On the History and Spirit of Carmel," in *The Hidden Life: Hagiographic Essays, Meditations, Spiritual Texts*, trans. Waltraut Stein, The Collected Works of Edith Stein 4 (Washington, DC: ICS, 1992), 1.

4. Ibid., 3.

5. Ibid., 4.

6. Ibid.

7. Edith Stein, "Love for Love: The Life and Works of St. Teresa of Jesus," in *The Hidden Life*, 29.

eucharistic adoration, Stein suggests, atones for the idolatry that worships the Führer and the Reich as a new "Golden Calf" (Exodus 32), a spectacular reflection of the ego's own will-to-power. "In place of the cold, the contempt, that [the Lord] receives out there," she writes, "[the sisters] offer him their warm love," drawing down through their supplications "God's grace and mercy on a humanity submerged in sin and need."[8]

The downward flow of grace corresponds to the upward gaze of the eucharistic adorer. In "Ways to Know God," Stein explains that God's "symbolic theology" includes "food and drink," which are "the shapes in which the God-Man presents himself in a veiled manner"—shapes possessing an anagogy, a gravitational "pull," which leads the faithful to ascend to an invisible, divine reality.[9] What impressed Stein was the role played by such symbols in conducting the soul back to its origin in God, who dwells alone in the soul's own innermost chamber.[10] The soul's path leads past all earthly images and through the soul's "dark night" to God Himself, but the way is nonetheless mediated through, and expressed by, the attractive force of natural and artistic symbols, found in nature and in the sacred scriptures, which fit to each one's personal calling and unique experience of God.

Distinctive of Carmelite spirituality is the extent to which the "formlessness" of night as a symbol is paradoxically constitutive of its theo-aesthetic life-form, which famously proceeds from the purgative night of the senses to the active and passive night of the spirit. "Night," observes Stein, "is invisible and formless. But still we perceive it. Indeed it is nearer to us than all things and forms; it is more closely bound to our being."[11] The creative tension that inheres in this "formless" form corresponds, in Carmelite thought, to the very structure of the soul, which centers on God. In that innermost region, the soul is "nothing" in itself and exists only in union with God, the creator and giver of forms. At this innermost depth, Stein writes, "primary life is formless," hidden "not only from other spirits but from the soul itself."[12]

Given this orientation toward a nocturnal formlessness and hiddenness, the very forms that express Carmelite spirituality radicalize the *Christus deformis* as an image of the self. One thinks, for example, of the many crosses St. John carved and sketched for himself (including the visionary drawing of the crucified Christ

8. Ibid.

9. Edith Stein, "Ways to Know God: The 'Symbolic Theology' of Dionysius the Areopagite and Its Objective Presuppositions," in *Knowledge and Faith*, trans. Walter Redmond, The Collected Works of Edith Stein 8 (Washington, DC: ICS, 2000), 95.

10. On this topic, see my "Biblical Images of God and the Reader's 'I' as *Imago Dei*: The Contribution of Edith Stein," *Interpretation* (October 2005): 382–91.

11. Stein, *Science of the Cross*, 39.

12. Ibid., 157.

that inspired the famous painting by Salvador Dalí); of the icon of the Holy Face, crowned with thorns, on which the dying St. Thérèse of Lisieux (1873–1897) fixed her gaze;[13] and of the haunting image of a Jewish "stranger" who makes her riddling appearance in a convent play by St. Teresa Benedicta of the Cross (Edith Stein), knocking suddenly "in the middle of the night" of the Holocaust to beg for shelter for her people.[14]

The Carmelite art of prayer answers to the first sin of idolatry, even as the Cistercian art of humility responds to a first sin of prideful *curiositas,* the Franciscan art of poverty to an avaricious concupiscence, the Dominican art of preaching to a gluttonous misuse of the mouth, and the Ignatian art of obedience to a primal disobedience. The Carmelite adores the Host exposed in the monstrance, unlike Adam and Eve, who ate the forbidden fruit in an act of self-worship. The Carmelite learns from eucharistic adoration the art of a blind contemplation that recognizes every image as always already a veil, a covering, and therefore a revelation of the God who remains hidden behind all things and at the center of one's soul. For the Carmelite, the constant facing of God in what is faceless, dark, "formless"—the Host on the altar, the invisible Trinity in the inmost chamber of the soul—directs the soul's way back to the original nothingness out of which God created all the world's beauty. To repeat the words of Edith Stein, "Primary life is formless." Its beauty consists in its pure potential, its absolute openness to the Giver of forms, its being nothing in itself but all things with God (cf. Phil. 4:13; Luke 1:37). Prayer defines this basic attitude of loving self-surrender, submission, and worship. The union it effects is an atonement for idolatry, a oneness with the God who is One.

This book lacks a chapter on Carmelite saints and their art of prayer due to my decision to focus on the spiritual arts of the Middle Ages, a period that preceded the great age of the Teresian reform. Regrettable as that lack is, given the remarkable beauty of the Carmelite way, it may nevertheless be accounted a *felix culpa,* a "happy fault," to the extent that it discloses the open-endedness of this study, which seeks its sequel in further work.

As a book about Christian spirituality, *Eating Beauty* advances a major thesis: namely, that every genuine spirituality, medieval or modern, is oriented toward a restoration (or better, "restauration," to play upon the beauteous "aura" in the "restaurant" of the eucharistic food) of the paradise originally created by God through the Word. That Christological paradise was lost through the first sin. Every spirituality therefore finds its way back to an original beauty through a pro-

13. On the spirituality of Thérèse, see my "Facing Each Other: Saint Thérèse of Lisieux and Emmanuel Levinas," *Spiritus* 4.1 (2004): 24–43.

14. See Stein, "Conversation at Night," in *The Hidden Life,* 128–33.

nounced virtue, which is eucharistically infused and nourished through ascetical practice, and which is fitting to a particular, diagnostic interpretation of the primal offense against God. This root virtue combines with others, which are joined to it through charity, the "bond of perfection" (Col. 3:14), to create a distinctive life-form, which is exemplified in the attractive lives of the saints, who each give the eucharistic Christ an iconic "face" by allowing Him to live, to exercise His virtues, in them.

Drawing from some of the same Dionysian and phenomenological sources that inspired Edith Stein, philosopher Jean-Luc Marion has written extensively about the Eucharist and the icon, distinguishing between the two as incarnational forms. "No face accompanies" the presence of "the divine nature . . . in the Eucharist," where only bread and wine appear as outward signs, Marion observes, whereas the icon offers "a perpetual visage of Christ waiting for His return."[15] The use of the Eucharist and the icon in combination thus creates a "distortion of the economy that prevents the danger of the idol," for the church "can never identify" the divine nature, facelessly present in the Eucharist, with the painted face of the icon "in a single liturgical performance."[16] Instead the icon "glorifies itself only by returning all glory to the invisible, . . . appearing at a distance from the invisible, precisely because the invisible marks it all the way through."[17] The icon, which is seen, points to what is unseen—to the God who sees—and thus renders Him present without representing Him, but not in the same way that the outward signs of bread and wine render Christ sacramentally present: "Hence the importance of not including the common icon under the title of 'sacrament.'"[18]

Similar to the liturgical "distortion" that combines the "faceless" Eucharist both with the icon and the imagistic word of the sacred scriptures, this book has joined the beauty of the sacrament, which is to be eaten, with the beauty of the saints, those distinctive "faces" of Christ that cannot represent Him mimetically, but which nevertheless make Him vitally present in the world. Because they have been "eaten" by Christ, consumed by the God they receive in Communion, and virtuously changed by Him, they glorify Him. They bear His mark in the conversion, the transformation, of their lives.

I have restricted myself, for the most part, to four spiritualities of the High Middle Ages, that period in the history of the church that saw the advent of new types of saints and witnessed an intensification of eucharistic cult. In these spiritualities and in modern ways of holiness that approximate their eucharistic at-

15. Jean-Luc Marion, *The Crossing of the Visible*, trans. James K. A. Smith (Stanford: Stanford University Press, 2004), 77.

16. Ibid.

17. Ibid.

18. Ibid.

tachment, one finds an understanding of the beautiful that is inseparable from the good and the true, but which is (for that very reason) dynamic and inclusive of a whole life-process of suffering, digestion, dying, and transformation. The medieval and early modern spiritualities that I have analyzed from the combined perspectives of their respective understandings of the first sin, their receptivity to remedial eucharistic virtues, and their actualization of the entire life-forms to which these virtues give rise—these are but a few of the "infinity of Eucharists" that are possible, a small indication (to echo Marion) of the "endless fecundity" of the Spirit at work in shaping the diversity of "Eucharistic attitudes."[19]

We end, then, as we began. Eating beauty.

19. Jean-Luc Marion, *God without Being: Hors-Texte,* trans. Thomas A. Carlson (Chicago: University of Chicago Press, 1991), 157.

APPENDIX

CLARE, SINGING OF FRANCIS

I.

And what shall "Sister Moon" now sing of him,
Of "Brother Sun," our Francis, whose bright smile
Has warmed us all, his cheerful voice a hymn
Of gladness, thankful praise, and laughter, while
The daylight lasts. And then our "Brother Fire"
Comes to gather us at dusk in time
For prayer of blessing, fueling our desire
To glow and burn like flaming sparks divine
Amidst the coals, the coldness, and the night.
Yes, Sister Moon and Brother Sun both shine
At twilight, forming but a single light
Of two reflections, joined in God's design—
For Clare and Francis, Mary-Joseph, there's
But One who pairs us, Light whom light declares—

II.

When Francis wanted to enact, to stage
The Christmas story, he enlisted all
The villagers to play the parts that, page
By page, the Gospels told. And at his call
They all assembled—shepherds, Romans, kings,
Innkeepers, innocents and soldiers, boys
And girls, white angels wearing colored wings,
And children running with their favorite toys
To give the Child a gift. And in the straw
Where Mary knelt, with Joseph at her side,
A wondrous sight that filled their hearts with awe—
A Truth that all the pageantry belied—
Jesus in the midst of them, his Light
Far brighter than the stars that pierced the night.

III.

The stars at night are nothing, be content,
But apertures for Heaven's light, each star
An opening within the firmament,
A portal that the angels left ajar,
Through which God's glory passes, shining down
Upon us from afar, a shining rain
Made visible by night and held to crown
The darkness at the height. For it is plain
That light and darkness form a star, a hole
That's nothing in itself, deriving all
Its splendor from its openness, extol-
ling God and praising him who's Lord of all.
If stars shed rays, what light his wounds must hold,
Pierced by an angel, stigmata of gold!

IV.

His body stigmatized, a bright domain
Of nothingness and offering, a space
Of pure thanksgiving, to which Love lays claim—
When children look to see the stars that grace
The sky at night, they lift their heads. So too
The chalice, elevated like a star,
Requires us to look above in due
Amazement at the miracle that's far
Beyond our understanding—bread and wine,
Christ's body and his blood, memorial
Sublime. But now his wounds become a sign
Of witness and a testimonial
To Love unending, for they radiate
The Lord's own light and mark the Master's fate.

MEDITATIONS ON MICHELANGELO

1. On the *Pietà* in Rome

O Michelangelo! Why did you carve
Such calm in her and leave her cheek so smooth?
Is she unaging then? Have grief and time
No power to affect her flesh, to prove
Her old? The fold of stone reveals her youth—
The untouched brow, the slender, open hand,
The firm light fingers, sheltering and still,
And on her lap the body of a man
Who's caught in all the silence of the stone—
Her Son, her Savior, and her God in stark
Repose, unclothed, and wrung into His rest.
Her countenance contemplative to mark
His wounds, this marble Mary moves to tears
For sorrow undiminished by the years.

2. On the *Pietà* in Florence

Madonna Florentine, the Son you hold
Is slipping through your arms, his heavy weight
So great that none can hold Him; even three
Must struggle hard to lift, to elevate
His falling form. His head against your face,
His naked limbs contorted at your side,
And still you hold Him—rough, unfinished stone,
Your grief in blindness falling short and wide
Of all the marks, the wounds, the welling tears.
The Magdalene turns eyes aside, but he
Looks down, his gaze upon the Son you bear,
His arms a cradle for your agony.
For Nicodemus, too, shall be reborn
Of this Maria, laboring and torn—

3. On the *Pietà* in Milan

Rondanini Pietà, the last
He carved, the work of dying days, a slim
Maria standing with the corpse of Christ
Upheld against her own, His every limb
In contact with her flesh, life touching death,
His death in her embrace. What gives her strength
To hold him so, presenting him to view?
His body faces out and stands full length
Before his mother's, leaning against hers,
A final pregnancy, a labor still
To last, to bring Him forth, out of her self,
Out of the stone. He stands, and rise He will—
Alive, but not alone. For two are one—
This priestly mother offering her Son.

BIBLIOGRAPHY

PRIMARY SOURCES

Albert the Great, Saint. *Opera omnia*. Edited by August and Émile Borgnet. 38 vols. Paris: Ludovicus Vivès, 1890–99.

Alger of Liège. *De sacramento corporis et sanguinis Dominici*. PL 180, cols. 739–854.

Ambrose, Saint. *In Lucam*. PL 15, cols. 1527–1850.

Andrews, Tom. *The Brother's Country*. New York: Persea, 1990.

——. *Random Symmetries: Collected Poems*. Oberlin: Oberlin College Press, 2002.

Angela of Foligno, Blessed. *Complete Works*. Translated by Paul LaChance, O.F.M. Classics of Western Spirituality. New York: Paulist Press, 1993.

Augustine, Saint. *Confessiones*. Edited by James J. O'Donnell. 3 vols. Oxford: Clarendon Press; New York: Oxford University Press, 1992.

——. *The Confessions of St. Augustine*. Translated by John K. Ryan. New York: Doubleday, 1960.

——. *De Genesi ad litteram*. PL 34, cols. 245–486.

——. *The Literal Meaning of Genesis*. Translated by John Hammond Taylor, S.J. Ancient Christian Writers 41–42. New York: Newman, 1982.

——. *De Musica*. PL 32, cols. 1081–1194.

——. *De Sermone Domini in Monte Libros Duos*. Edited by Almut Mutzenbecker. CCSL 34. Turnhout: Brepols, 1968.

——. *De Trinitate*. Edited by W. J. Mountain and Fr. Glorie. CCSL 50. Turnhout: Brepols, 1968.

——. *Enarrationes in Psalmos, 1–50*. Edited by D. Eligius Dekkers, O.S.B., and John Fraipont. CCSL 38. Turnhout: Brepols, 1956.

——. *In Johannis Evangelium*. Edited by D. Radbodus Willems. CCSL 36. Turnhout: Brepols, 1954.

——. *On Music*. Translated by Robert Catesby Taliaferro. In *The Writings of Saint Augustine*, 2:153–69. The Fathers of the Church 2. New York: CIMA, 1947.

——. *Sermones de scripturis*." PL 38, cols. 23–994.

——. *The Trinity*. Translated by Stephen McKenna, C.SS.R. The Fathers of the Church 45. Washington, DC: Catholic University of America Press, 1963.

Bernard of Clairvaux, Saint. *De diligendo Deo*. In *Sancti Bernardi pera*, vol. 3, *Tractatus et opuscula*, edited by J. Leclercq and H. M. Rochais, 119–54. Rome: Cistercian Editions, 1963.

——. *De gradibus humilitatis et superbiae*. In *Sancti Bernardi opera*, vol. 3, *Tractatus et opuscula*, edited by J. Leclercq and H. M. Rochais, 13–59. Rome: Cistercian Editions, 1963.

——. *On Loving God*. In *Bernard of Clairvaux: Selected Works*, translated by G. R. Evans, 173–205. New York: Paulist Press, 1987.

——. *On the Song of Songs, I*. Sermons 1–20. Translated by Kilian Walsh, O.C.S.O. In *The*

Works of Bernard of Clairvaux, vol. 2. Cistercian Fathers Series 4. Spencer, MA: Cistercian Publications, 1971.

——. *On the Song of Songs, II.* Sermons 21–46. Translated by Kilian Walsh, O.C.S.O. In *The Works of Bernard of Clairvaux,* vol. 3. Cistercian Fathers Series 7. Kalamazoo, MI: Cistercian Publications, 1976.

——. *On the Song of Songs, III.* Sermons 47–66. Translated by Kilian Walsh, O.C.S.O., and Irene M. Edmonds. In *The Works of Bernard of Clairvaux,* vol. 4. Cistercian Fathers Series 31. Kalamazoo, MI: Cistercian Publications, 1979.

——. *On the Song of Songs, IV.* Sermons 67–86. Translated by Irene Edmonds. In *The Works of Bernard of Clairvaux,* vol. 6. Cistercian Fathers Series 40. Kalamazoo, MI: Cistercian Publications, 1980.

——. *Sermones.* Vol. 4 of *Sancti Bernardi opera,* edited by J. Leclercq and H. Rochais. Rome: Cistercian Editions, 1966.

——. *Sermones super Cantica Canticorum, 1–35.* Vol. 1 of *Sancti Bernardi opera,* edited by J. Leclercq, C. H. Talbot, and H. M. Rochais. Rome: Cistercian Editions, 1957.

——. *Sermones super Cantica Canticorum, 36–86.* Vol. 2 of *Sancti Bernardi opera,* edited by J. Leclercq, C. H. Talbot, and H. M. Rochais. Cistercian Fathers Series Rome: Cistercian Editions, 1958.

——. *The Steps of Humility and Pride, with an introduction by M. Basil Pennington.* In *The Works of Bernard of Clairvaux,* vol. 5, *Treatises II,* translated by M. Ambrose Conway, O.C.S.O, 25–82. Cistercian Fathers Series 13. Washington, DC: Cistercian Publications, Consortium Press, 1974.

(Saint) Bernard of Clairvaux: The story of his life as recorded in the Vita Prima Bernardi by certain of his contemporaries, William of St. Thierry, Arnold of Bonnevaux, Geoffrey and Philip of Clairvaux, and Odo of Deuil. Translated by Geoffrey Webb and Adrian Walker. Westminster, MD: Newman Press, 1960.

Bonaventure, Saint. *Bonaventure: The Soul's Journey into God, The Tree of Life, The Life of St. Francis.* Translated by Ewert Cousins. New York: Paulist Press, 1978.

——. *Breviloquium.* Translated by Erwin Esser Nemmers. London: B. Herder, 1947.

——. *Collations on the Six Days.* Translated by José de Vinck. Vol. 5 of *The Works of Bonaventure.* Patterson, NJ: St. Anthony Guild, 1970.

——. *The Disciple and the Master: St. Bonaventure's Sermons on St. Francis of Assisi.* Translated and edited by Eric Doyle, O.F.M. Chicago: Franciscan Herald, 1983.

——. *Doctoris Seraphici S. Bonaventurae opera omnia.* 10 vols. Quaracchi: Collegium S. Bonaventurae, 1882–1902.

——. *St. Bonaventure's De reductione artium ad theologiam: A Commentary with an Introduction and Translation.* Translated by Sister Emma Thérèse Healy. Saint Bonaventure, NY: Saint Bonaventure College, 1939.

Bridges, Robert. *Hymns.* Oxford: Oxford University Press, 1899.

"The Canonization Process of St. Dominic, 1233." In *Early Dominicans: Selected Writings,* translated and edited by Simon Tugwell, O.P., 66–93. Classics of Western Spirituality. New York: Paulist Press, 1982.

Catherine of Genoa, Saint. *The Life and Sayings of Saint Catherine of Genoa.* Translated and edited by Paul Garvin. Staten Island, NY: Alba, 1964.

——. *Purgation and Purgatory, The Spiritual Dialogue.* Translated by Serge Hughes. Classics of Western Spirituality. Mahwah, NJ: Paulist Press, 1979.

Catherine of Siena, Saint. *The Dialogue.* Translated by Suzanne Noffke, O.P. Classics of Western Spirituality. New York: Paulist Press, 1980.

——. *Epistolario.* Vol. 1. Edited by Eugenio Dupré Theseider. Rome: Tipografia del Senato, 1940.

——. *The Letters of St. Catherine of Siena.* Vol. 1. Translated and edited by Suzanne Noffke, O.P. Medieval and Renaissance Texts and Studies. Binghamton: State University of New York, 1988.

——. *Libro della Divina Dottrina vulgarmente detto dialogo della Divina Providenza.* Edited by Matilda Fiorilli. Bari: Gius, Laterza, 1912.

——. *The Orcherd of Syon.* Edited by Phyllis Hodgson and Gabriel M. Liegey. EETS 258. London: Oxford University Press, 1966.

Chaucer, Geoffrey. *The Riverside Chaucer.* Edited by Larry D. Benson. 3rd ed. Boston: Houghton Mifflin, 1987.

Colonna, Vittoria. *Rime.* Edited by Alan Bullock. Gius: Laterza, 1982.

Condivi, Ascanio. *The Life of Michelangelo.* Translated by Alice Sedgwick Wohl. Edited by Hellmut Wohl. Baton Rouge: Louisiana State University Press, 1976.

Cursor Mundi. Edited by Richard Morris. EETS 57. London: N. Trübner, 1874.

De Caussade, Jean-Paul. *Sacrament of the Present Moment.* Translated by Kitty Muggeridge. London: Collins, 1981.

The Divine Michelangelo: The Florentine Academy's Homage on His Death in 1564: A Facsimile Edition of Esequie del Divino Michelangelo Buonarroti, Florence, 1564. Translated and edited by Rudolf and Margot Wittkower. London: Phaidon, 1964.

Enchiridion symbolorum: Definitionum et declarationum de rebus fidei et morum. 34th ed. Edited by Adolfus Schönmetzer. Barcelona: Herder, 1967.

Feuillet, Jean Baptist, O.P. *The Life of Saint Rose of Lima.* Translated by anonymous. Edited by F. W. Faber. New York: P. J. Kenedy, 1900. First published in 1617.

Francis and Clare: The Complete Works. Translated by Regis J. Armstrong, O.F.M. Cap, and Ignatius C. Brady, O.F.M. New York: Paulist Press, 1982.

Francis of Assisi, Saint. *The Writings of St. Francis.* Translated by Benen Fahy, O.F.M. Edited by Placid Hermann, O.F.M. Chicago: Franciscan Herald, 1964.

Francis of Assisi: Index. Edited by Regis J. Armstrong, William J. Short, and J. A. Wayne Hellman. New York: New City Press, 2002.

Francis of Assisi: The Founder. Edited by Regis J. Armstrong, William J. Short, and J. A. Wayne Hellman. New York: New City Press, 2000.

Francis of Assisi: The Prophet. Edited by Regis J. Armstrong, William J. Short, and J. A. Wayne Hellman. New York: New City Press, 2001.

Francis of Assisi: The Saint. Edited by Regis J. Armstrong, William J. Short, and J. A. Wayne Hellman. New York: New City Press, 1999.

Gertrude of Helfta, Saint. *The Herald of Divine Love.* Translated and edited by Margaret Winkworth. Classics of Western Spirituality. New York: Paulist Press, 1993.

——. *Le Héraut.* Books 1 and 2. In *Oeuvres spirituelles,* vol. 2, edited by Pierre Doyère. SC 139. Paris: Cerf, 1968.

——. *Le Héraut.* Book 3. In *Oeuvres spirituelles,* vol. 3, edited by Pierre Doyère. SC 143. Paris: Cerf, 1968.

——. *Le Héraut.* Book 4. In *Oeuvres spirituelles,* vol. 4, edited by Jean-Marie Clément and Bernard de Vregille, S.J. SC 255. Paris: Cerf, 1978.

Gezo of Tortona. *De corpore et sanguine Christi.* PL 137, cols. 371–406.

Gower, John. *Mirour de l'omme.* Translated by William Burton Wilson. Revised by Nancy Wilson Van Baak. East Lansing, MI: Colleagues, 1992.

Hansen, Leonhard, O.P. *De Sancta Rosa virgine ex tertio ordine S. Dominici Limae in Peruvia, Americae Provincia.* 3rd ed. AASS 39 (August 5), 892–1029. First published in 1688.

Hegel, Georg Wilhelm Friedrich. *Aesthetics: Lectures on Fine Art.* Translated by T. M. Knox. 2 vols. Oxford: Clarendon, 1991.

——. *Ästhetik.* 2 vols. Frankfurt: Europäische Verlagsanstalt, 1966.

——. *Early Theological Writings.* Translated by T. M. Knox. Chicago: University of Chicago Press, 1948.

——. *Hegels theologische Jugendschriften.* Ed. Herman Nohl. Frankfurt: Minerva, 1966.

——. *Hegel: The Letters.* Translated by Clark Butler and Christine Seiler, with commentary by Clark Butler. Bloomington: Indiana University Press, 1984.

——. *Phänomenologie des Geistes.* Hamburg: Felix Meiner, 1952.

——. *The Phenomenology of Mind.* Translated by J. B. Baillie. 2nd ed. London: George Allen and Unwin, 1966. First published in 1931.

Hildegard von Bingen. *Scivias.* PL 197, cols 383–738.

——. *Scivias.* Translated by Mother Columba Hart and Jane Bishop. New York: Paulist Press, 1990.

Hölderlin, Friedrich. *Poems of Hölderlin.* Translated by Michael Hamburger. Kingsway, England: Nicholson and Watson, 1943.

The Holy Bible. Douay-Challoner version. Edited by John P. O'Connell. Chicago: Catholic Press, 1950.

Hugh of Fouilloy. "De claustro animae." PL 176, cols. 1018–1182.

Hugh of St. Victor. "De fructibus carnis et spiritus." PL 176, cols. 997–1010.

——. "De sacramento corporis et sanguinis Christi." PL 176, cols. 461–72.

——. *Summa sententiarum, Tractatus tertius.* PL 176, cols. 89–118.

Humbert of Romans. *Treatise on the Formation of Preachers.* In *Early Dominicans: Selected Writings,* translated and edited by Simon Tugwell, O.P., 179–384. Classics of Western Spirituality. New York: Paulist Press, 1982.

The Hymns of the Breviary and Missal. Ed. Dom Matthew Britt, O.S.B. New York: Benziger, 1948.

Ignatius of Antioch. *The Letters.* In *The Apostolic Fathers,* translated by Gerald G. Walsh, S.J., 81–143. New York: Christian Heritage, 1948

Ignatius of Loyola, Saint. *The Autobiography of St. Ignatius Loyola.* Translated by Joseph F. O'Callaghan. Edited by John C. Olin. New York: Fordham University Press, 1992 .

——. *The Constitutions of the Society of Jesus.* Translated by George E. Ganss, S.J. St. Louis: Institute of Jesuit Sources, 1970.

——. *Letters of St. Ignatius of Loyola.* Translated and edited by William J. Young, S.J. Chicago: Loyola University Press, 1959.

——. *Saint Ignatius Loyola: Letters to Women.* Edited by Hugo Rahner, S.J. New York: Herder and Herder, 1960.

——. *The Spiritual Diary.* Translated by Antonio T. De Nicolás. In Antonio T. De Nicolás, *Powers of Imagining: Ignatius de Loyola: A Philosophical Hermeneutic of Imagining through the Collected Works of Igantius de Loyola, with a Translation of these Works,* 174–238. Albany, NY: State University Press of New York, 1986.

——. *The Spiritual Exercises of Saint Ignatius.* Translated and edited by George E. Ganns, S.J. St. Louis: Institute of Jesuit Studies, 1992.

——. *The Spiritual Exercises of St. Ignatius Loyola, Spanish and English.* Translated and edited by Joseph Rickaby, S. J. 2nd ed. New York: Benziger, 1923.

Isidore of Seville. *Etymologiae.* PL 82, cols. 73–728.

Jacob's Well, an English Treatise on the Cleansing of Man's Conscience. Edited by Arthur Brandeis. EETS 115. London: Kegan Paul, Trench, Trübner, 1900.

Jacobus de Voragine. *The Golden Legend of Jacobus de Voragine.* Translated by Granger Ryan and Helmut Ripperger. 2 vols. New York: Longmans, Green, 1941.

——. *The "Historia occidentalis" of Jacques de Vitry: A Critical Edition.* Edited by John Frederick Hinnebusch. Freiberg: University Press, 1972.

——. *Legenda Aurea.* Edited by Giovanni Paolo Maggioni. 2nd rev. ed. 2 vols. Tavarnuzze-Firenze: SISMEL-Edizioni del Galluzzo, 1998.

Jean de Mailly. "The Life of St. Dominic." In *Early Dominicans: Selected Writings,* translated and edited by Simon Tugwell, O.P., 53–60. Classics of Western Spirituality. New York: Paulist Press, 1982.

Jerome, Saint. *Commentarius in Ecclesiasten.* Edited by Marcus Adriaen. CCSL 72, 247–361. Turnhout: Brepols, 1959.

——. *Epistolae.* PL 22, cols. 325–1224.

John Chrysostom, Saint. *In Matthaeam.* PG 57.

Justin Martyr, Saint. *Dialogue with Trypho.* In *Writings of Saint Justin Martyr,* translated by Thomas B. Falls, 139–366. The Fathers of the Church 6. Washington, DC: Catholic University of America Press, 1948.

——. *The First Apology.* In *Writings of Saint Justin Martyr,* translated by Thomas B. Falls, 21–111. The Fathers of the Church 6. Washington, DC: Catholic University of America Press, 1948.

Kant, Immanuel. *Critique of Judgment.* Translated by J. H. Bernard. New York: Hafner, 1951.

Malory, Sir Thomas. *The Works of Sir Thomas Malory.* Edited by Eugène Vinaver. 2nd ed. Oxford: Clarendon Press, 1967.

Michelangelo. *The Letters of Michelangelo, Translated from the Original Tuscan.* Translated and edited by E. H. Ramsden. 2 vols. Stanford: Stanford University Press, 1963.

——. *The Poetry of Michelangelo.* Translated by James M. Saslow. New Haven: Yale University Press, 1991.

Neoplatonic Saints: The Lives of Plotinus and Proclus by Their Students. Translated by Mark Edwards. Translated Texts for Historians 35. Liverpool: Liverpool University Press, 2000.

Nicholas of Cusa. *Sermones I (1430–1441).* In *Opera omnia,* edited by Rudolf Haubst et al., 384–431. Hamburg: Felix Meiner, 1991.

——. "Tota pulchra es, amica mea, et macula non est in te" (Sermo 243). In *Sermones IV (1455–1463)*, 254–63. In *Opera omnia*, edited by Walter Andreas Euler and Harald Schwaetzer, vol. 19, fasc. 3. Hamburg: Felix Meiner, 2002.

"The Nine Ways of Prayer of St. Dominic." In *Early Dominicans: Selected Writings*, translated and edited by Simon Tugwell, O.P., 94–103. Classics of Western Spirituality. New York: Paulist Press, 1982.

Plotinus. *Enneads*. 7 vols. Translated by A. H. Armstrong. Loeb Classical Library. Cambridge, MA: Harvard University Press, 1989.

Raymond of Capua, O.P. *De S. Catharina Senensi, virgine; De poenitentia S. Dominici*, edited by Godefridus Henschcenius and Daniel van Papenbroeck. AASS 12 (April 3). Rev. ed. by Joanne Carnandet, 861–967. Paris: V. Parmé, 1866 .

——. *The Life of St. Catherine of Siena*. Translated by George Lamb. London: Harvill, 1960.

Richard Rolle. "The Form of Living." In *Richard Rolle: Prose and Verse*, edited by Sarah Ogilvie-Thomson, 1–25. EETS, o.s., 293. London: Oxford University Press, 1988.

Savonarola, Fra Girolamo. *Savonarola: Prediche e scritti commentati e collegati da un racconto biografico*. Edited by Mario Ferrara. Florence: Olschki, 1952.

Schiller, Friedrich. *Letters on the Aesthetic Education of Man*. Translated by Elizabeth M. Wilkinson and L. A. Willoughby. In *Essays*, edited by Walter Hinderer and Daniel O. Dahlstrom, 86–178. The German Library 17. New York: Continuum, 1993.

——. "On the Art of Tragedy." Translated by Daniel O. Dahlstrom. In *Essays*, edited by Walter Hinderer and Daniel O. Dahlstrom, 1–21. The German Library 17. New York: Continuum, 1993.

Smith, Joshua. *Divine Hymns or Spiritual Songs*. New Hampshire, 1784.

A Stanzaic Life of Christ: Compiled from Higden's "Polychronicon" and the "Legenda Aurea." Edited by Francis A. Foster. EETS 166. Oxford: Oxford University Press, 1971. First published in 1926 by Humphrey Milford, London.

Stein, Edith. "Before the Face of God: On the History and Spirit of Carmel." In Stein, *The Hidden Life*, 1–6.

——. "Conversation at Night." In *The Hidden Life*, 128–33.

——. *Essays on Woman*. Translated by Freda Mary Oben, edited by Lucy Gelber and Romaeus Leuven. 2nd ed. The Collected Works of Edith Stein 2. Washington, DC: ICS, 1996.

——. *The Hidden Life: Hagiographic Essays, Meditations, Spiritual Texts*. Translated by Waltraut Stein. Edited by Lucy Gelber and Michael Linssen, O.C.D. The Collected Works of Edith Stein 4. Washington, DC: ICS, 1992.

——. "Love for Love: The Life and Works of St. Teresa of Jesus." In Stein, *The Hidden Life*, 29–66.

——. *On the Problem of Empathy*. Translated by Waltraut Stein. 3rd rev. ed. The Collected Works of Edith Stein 3. Washington, DC: ICS, 1989.

——. *The Science of the Cross: A Study of St. John of the Cross*. Translated by Josephine Koeppel, O.C.D., edited by Lucy Gelber and Romaeus Leuven, O.C.D. The Collected Works of Edith Stein 6. Washington, DC: ICS, 2002.

——. "Ways to Know God: The 'Symbolic Theology' of Dionysius the Areopagite and Its Objective Presuppositions." In *Knowledge and Faith*, translated by Walter Redmond,

edited by Lucy Gelber and Michael Linssen, 83–134. The Collected Works of Edith Stein 8. Washington, DC: ICS , 2000.

Tauler, John. *Spiritual Conferences.* Translated by E. Colledge and Sr. M. Jane. St. Louis: Herder, 1961.

Teilhard de Chardin, Pierre. *The Divine Milieu.* New York: Harper, 1960.

——. *Hymn of the Universe.* New York: Harper, 1970.

Tertullian. *Adversos Judaeos.* PL 2, cols. 595–642.

——. *De carne Christi.* PL 2, cols. 751–92.

——. *De ieiunio adversus psychicos.* PL 2, cols. 953–78.

Thérèse of Lisieux, Saint. *Story of a Soul: The Autobiography of St. Thérèse of Lisieux.* Translated by John Clarke, O.C.D. Washington, DC: ICS, 1976.

Thomas Aquinas, Saint. *Expositio in Psalmos David. Opera omnia,* 14. New York: Musurgia, 1949. Originally published in 1852–73 by P. Fiaccadori.

——. *Quaestiones disputatae.* 2 vols. Edited by Raymond Spiazzi, O.P. 8th rev. ed. Rome: Taurini, 1949.

——. *Scriptum super libros sententiarum magistri Petri Lombardi.* Edited by R. P. Mandonnet, O.P. 4 vols. Paris: P. Lethielleux, 1929.

——. *Summa theologiae.* 3 vols. New York: Benziger, 1947.

——. *Summa theologiae.* Edited by the Institutio studiorum medievalium Ottaviensis. Ottawa, Canada: Garden City Press, 1941.

Thomas of Cantimpré. "Defense of the Mendicants." In *Early Dominicans: Selected Writings,* translated and edited by Simon Tugwell, O.P., 133–36. Classics of Western Spirituality. New York: Paulist Press, 1982.

Tommaso Caffarini da Siena. *Sanctae Catharinae Senensis legenda minor.* Edited by E. Franceschini. Fontes vitae S. Catharinae Senensis historici 10. Milan: Bocca, 1942.

Vargas Machuca, Juan de. *La rosa de el Peru, soror Isabel de Santa María, de el hábito de el glorioso patriarca Santo Domingo de Guzmán, credito de su Tercera Orden, luster y patrona de la alma ciudad Lima, su patria / escrita en panegýrica chronólogica oración.* Seville: Iuan Gomez de Blas, 1659.

Vasari, Giorgio. *The Lives of the Painters, Sculptors, and Architects.* Translated and edited by William Gaunt. 4 vols. London: Dent, 1963.

Vita prima sancti Bernardi. PL 185, cols. 225–466.

Weil, Simone. *Attente de Dieu.* Paris: Fayard, 1966.

——. *First and Last Notebooks.* Translated by Richard Rees. London: Oxford University Press, 1970.

——. *Gravity and Grace.* Translated by Arthur Wills. Lincoln: University of Nebraska Press, 1997.

——. *The Need for Roots: Prelude to a Declaration of Duties toward Mankind.* Translated by Arthur Wills. New York: Octagon, 1979.

——. *The Notebooks of Simone Weil.* Translated by Arthur Wills. 2 vols. London: Routledge and Kegan Paul, 1976.

——. *La Pesanteur et la Grace.* With an introduction by Georges Hourdin. Paris: Plon, 1962.

——. *On Science, Necessity, and the Love of God.* Translated and edited by Richard Rees. London: Oxford University Press, 1968.

———. *Seventy Letters.* Translated by Richard Rees. London: Oxford University Press, 1965.

———. *Simone Weil: Lectures on Philosophy.* Translated by Hugh Price. Cambridge: Cambridge University Press, 1990.

———. *Waiting for God.* Translated by Emma Craufurd. New York: Putnam's, 1951.

Woolf, Virginia. *Orlando: A Biography.* San Diego: Harcourt, 1928.

SECONDARY SOURCES

Adorno, Theodor W. *Aesthetic Theory.* Translated by C. Lenhardt. Edited by Gretel Adorno and Rolf Tiedermann. London: Routledge and Kegan Paul, 1983.

———. *Hegel: Three Studies.* Translated by Shierry Weber Nicholsen. Cambridge, MA: MIT Press, 1993.

Aers, David, and Lynn Staley. *The Powers of the Holy: Religion, Politics, and Gender in Late Medieval English Culture.* University Park: Pennsylvania State University Press, 1996.

Althaus, Horst. *Hegel: An Intellectual Biography.* Translated by Michael Tarsh. Malden, MA: Polity, 2000.

Andrien, Kenneth J. *Andean Worlds: Indigenous History, Culture, and Consciousness under Spanish Rule, 1532–1825.* Albuqurque, NM: University of New Mexico Press, 2001.

Arrupe, Pedro, S.J. "Art and the Spirit of the Society of Jesus." *Studies in the Spirituality of Jesuits* 5.3 (1973): 83–92.

Ashley, Benedict, O.P. *The Dominicans.* Collegeville, MN: Liturgical Press, 1990.

Astell, Ann W. "Biblical Images of God and the Reader's 'I' as *Imago Dei:* The Contribution of Edith Stein." *Interpretation* (October 2005): 382–91.

———. *Chaucer and the Universe of Learning.* Ithaca: Cornell University Press, 1996.

———. "Facing Each Other: Saint Thérèse of Lisieux and Emmanuel Levinas." *Spiritus* 4.1 (2004): 24–43.

———. *Joan of Arc and Sacrificial Authorship.* South Bend, IN: University of Notre Dame Press, 2003.

———. *Job, Boethius and Epic Truth.* Ithaca: Cornell University Press, 1994.

———. *Political Allegory in Late Medieval England.* Ithaca: Cornell University Press, 1999.

———. *The Song of Songs in the Middle Ages.* Ithaca: Cornell University Press, 1994.

———. "Telling Tales of Love: Julia Kristeva and Bernard of Clairvaux." *Christianity and Literature* 50.1 (2000): 125–48.

Auerbach, Erich. "*Sermo Humilis.*" In *Literary Language and Its Public in Late Latin Antiquity and in the Middle Ages,* translated by Ralph Manheim, 27–66. London: Routledge and Kegan Paul, 1965.

Balfour, Reginald. *The Seraphic Keepsake.* London: Burns and Oates, 1944.

Balthasar, Hans Urs von. *The Glory of the Lord: A Theological Aesthetics.* Translated by Erasmo Leiva-Merikakis. Edited by Joseph Fessio, S.J., and John Riches. 7 vols. New York: Crossroad; San Francisco: Ignatius, 1983–1991.

Bangert, William V., S.J., *A History of the Society of Jesus.* 2nd rev. ed. St. Louis: Institute of Jesuit Studies, 1986.

Barolsky, Paul. *Michelangelo's Nose: A Myth and Its Maker.* University Park: Pennsylvania State University Press, 1990.

Barth, Karl. *The Doctrine of God.* In *Church Dogmatics,* translated by T. H. L. Parker, W. B. Johnston, Harold Knight, and J. L. M. Haire; edited by G. W. Bromily and T. F. Torrance, vol. 2, part 1, 650–77. Edinburgh: T. and T. Clark, 1957.

Barthes, Roland. "Authors and Writers." In *A Barthes Reader,* edited by Susan Sontag, 185–93. New York: Wang and Hill, 1982.

———. *Sade, Fourier, Loyola.* Translated by Richard Miller. New York: Wang and Hill, 1976.

Bartlett, Anne Clark. *Male Authors, Female Readers: Representations and Subjectivity in Middle English Devotional Literature.* Ithaca: Cornell University Press, 1995.

Baudrillard, Jean. *For a Critique of the Political Economy of the Sign.* Translated by Charles Levin. St. Louis: Telos , 1981.

Bedero, Adriaan H. *Bernard of Clairvaux: Between Cult and History.* Edinburgh: T. and T. Clark, 1996.

Bell, Rudolph M. *Holy Anorexia.* Chicago: University of Chicago Press, 1985.

Belting, Hans. *Likeness and Presence: A History of the Image before the Era of Art.* Translated by Edmund Jephcott. Chicago: University of Chicago Press, 1994.

Bénichou, Paul. *The Consecration of the Writer, 1750–1830.* Translated by Mark K. Jensen. Lincoln: University of Nebraska Press, 1999.

Benjamin, Walter. "The Work of Art in the Age of Its Mechanical Reproduction." In *Illuminations,* translated by Harry Zohn; edited by Hannah Arendt, 217–51. New York: Schocken, 1969.

Bernstein, J. M. *The Fate of Art: Aesthetic Alienation from Kant to Derrida and Adorno.* University Park, PA: Pennsylvania State University Park, 1992.

Bestul, Thomas H. *Texts of the Passion: Latin Devotional Literature and Medieval Society.* Philadelphia: University of Pennsylvania Press, 1996.

Biddick, Kathleen. "Genders, Bodies, Borders: Technologies of the Visible." *Speculum* 68.2 (1993): 389–418.

Bishop, Jonathan. *Some Bodies: The Eucharist and Its Implications.* Macon, GA: Mercer University Press, 1992.

Bloomfield, Morton W. *The Seven Deadly Sins: An Introduction to the History of a Religious Concept, with Special Reference to Medieval English Literature.* Lansing: Michigan State University Press, 1967.

Boudreau, Gordon V. *The Roots of Walden and the Tree of Life.* Nashville: Vanderbilt University Press, 1990.

Browe, Peter, S.J. *Die häufige Kommunion im Mittelalter.* Münster: Regensbergsche Verlagsbuchhandlung, 1938.

———. *Die Verehrung der Eucharistie im Mittelalter.* Munich: Max Hueber, 1933.

Brown, Frank Burch. *Religious Aesthetics: A Theological Study of Making and Meaning.* London: Macmillan, 1990.

Bungay, Stephen. *Beauty and Truth: A Study of Hegel's Aesthetics.* Oxford: Oxford University Press, 1984.

Burr, David. *The Spiritual Franciscans: From Protest to Persecution in the Century after Saint Francis.* University Park: Pennsylvania State University Press, 2001.

Bynum, Caroline Walker. *Fragmentation and Redemption: Essays on Gender and the Human Body in Medieval Religion.* New York: Zone, 1991.

———. *Holy Feast and Holy Fast: The Religious Significance of Food to Medieval Women.* Berkeley: University of California Press, 1987.

———. *The Resurrection of the Body in Western Christianity, 200–1336.* New York: Columbia University Press, 1995.

Camporesi, Piero. *The Incorruptible Flesh: Bodily Mutation and Mortification in Religion*

and Folklore. Translated by Tania Croft-Murray and Helen Elsom. Cambridge: Cambridge University Press, 1988.

Caraman, Philip. *Ignatius Loyola: A Biography of the Founder of the Jesuits.* San Francisco: Harper and Row, 1990.

Carruthers, Mary J. *The Book of Memory: A Study of Memory in Medieval Culture.* Cambridge Studies in Medieval Literature. Cambridge: Cambridge University Press, 1990.

———. *The Craft of Thought: Meditation, Rhetoric, and the Making of Images, 400–1200.* Cambridge Studies in Medieval Literature 34. Cambridge: Cambridge University Press, 2000.

Caskey, Noelle. "Interpreting Anorexia Nervosa." In *The Female Body in Western Culture: Contemporary Perspectives,* edited by Susan Rubin Suleiman, 175–89. Cambridge: Harvard University Press, 1986.

Cavadini, John C. "The Sweetness of the Word: Salvation and Rhetoric in *De doctrina Christiana.*" In *De doctrina Christiana: A Classic of Western Culture,* edited by Duane W. H. Arnold and Pamela Bright, 164–81. Notre Dame, IN: Notre Dame University Press, 1995.

Chapman, Emmanuel. "The Perennial Theme of Beauty and Art." In *Essays in Thomism,* edited by Robert E. Brennan, O.P, 335–46. New York: Sheed and Ward, 1942.

Chidester, David. *Word and Light: Seeing, Hearing, and Religious Discourse.* Urbana: University of Illinois Press, 1992.

Clements, Robert J. *Michelangelo's Theory of Art.* New York: New York University Press, 1961.

Constantine, David. *Hölderlin.* Oxford: Clarendon Press, 1988.

Couet, P. Eugène. *Les miracles historiques du Saint Sacrement.* Brussels: Chaussée de Wavre, 1906.

Courtine-Denamy, Sylvie. *Three Women in Dark Times: Edith Stein, Hannah Arendt, Simone Weil.* Translated by G. M. Goshgarian. Ithaca: Cornell University Press, 2000.

Cousins, Ewert. *Bonaventure and the Coincidence of Opposites.* Chicago: Franciscan Herald Press, 1978.

———. Introduction to *Bonaventure: The Soul's Journey into God, The Tree of Life, The Life of St. Francis.* Translated by Ewert Cousins. New York: Paulist Press, 1978.

Cunningham, Lawrence. "Recent Franciscana: A Survey." *Spiritus* 3.2 (2003): 263–69.

Davis, Ellen F. *Swallowing the Scroll: Textuality and the Dynamics of Discourse in Ezechiel's Prophecy.* Sheffield, England: Almond, 1989.

Davis, William N. Epilogue to Rudolf Bell, *Holy Anorexia.* Chicago: University of Chicago Press, 1985.

De Bruyne, Edgar. *Études d'esthétique médiévale.* 3 vols. Brugge: "De Tempel" Tempelhof, 1946.

De Maio, Romeo. *Michelangelo e la Controriforma.* Rome: Laterza, 1978.

De Nicolas, Antonio T. *Powers of Imagining: Ignatius de Loyola: A Philosophical Hermeneutic of Imagining through the Collected Works of Ignatius Loyola, with a Translation of These Works.* Albany: State University Press of New York, 1986.

Descharmes, Robert, and Giles Néret. *Salvador Dalí, 1904–1989: The Paintings.* Cologne: Taschen, 2000.

Desmond, William. *Art and the Absolute: A Study of Hegel's Aesthetics.* SUNY Series in Hegelian Studies. Albany: State University of New York Press, 1986.

De Tolnay, Charles. *The Art and Thought of Michelangelo.* Translated by Nan Buranelli. New York: Pantheon, 1964.

——. *Michelangelo V: The Final Period.* Princeton, NJ: Princeton University Press, 1960.

Devaux, André A. "On the Right Use of Contradiction according to Simone Weil." Translated by J. P. Little. In *Simone Weil's Philosophy of Culture: Readings toward a Divine Humanity,* edited by Richard H. Bell, 150–57. Cambridge: Cambridge University Press, 1993.

Di Bari, Nicola. *Il culto di S. Maria Maddalena in Puglia: Fonti letterarie, monumentali e iconografiche.* Bari: Ecumenica Editrice, 1990.

Dillenberger, John. *Images and Relics: Theological Perceptions and Visual Images in Sixteenth-Century Europe.* New York: Oxford University Press, 1999.

Douglas, Mary. *Purity and Danger: An Analysis of the Concepts of Pollution and Taboo.* Boston: Ark Paperbacks, 1985.

Eco, Umberto. *The Aesthetics of Thomas Aquinas.* Translated by Hugh Bredin. 2nd ed. Cambridge, MA: Harvard University Press, 1988.

——. *Art and Beauty in the Middle Ages.* Translated by Hugh Bredin. New Haven: Yale University Press, 1986.

Egan, Harvey D., S.J. *Ignatius Loyola the Mystic.* The Way of the Christian Mystics 5. Wilmington, DE: Michael Glazier, 1987.

Emmerson, Richard K., and Ronald B. Herzman. "The *Legenda Maior:* Bonaventure's Apocalyptic Francis." *The Apocalyptic Imagination in Medieval Literature, chap.* 2, 36–75. Philadelphia: University of Pennsylvania Press, 1992.

Fedi, Roberto. "'L'imagin vera': Vittoria Colonna, Michelangelo, e un'idea di canzoniere." *Modern Language Notes* 107 (1992): 46–73.

Fenlon, Dermot. *Heresy and Obedience in Tridentine Italy: Cardinal Pole and the Counter Reformation.* Cambridge: Cambridge University Press, 1972.

Ferrara, Mario. "L'Influenza del Savonarola sulla Letteratura e l'arte del quattrocento." In *Savonarola: Prediche e scritti commentati e collegati da un racconto biografico,* edited by Mari Ferrara, part 2, 1–72. Florence: Olschki, 1952.

Finnegan, Mary Jeremy, O.P. *The Women of Helfta: Scholars and Mystics.* Athens: University of Georgia Press, 1991.

Fleming, John V. *From Bonaventure to Bellini: An Essay in Franciscan Exegesis.* Princeton: Princeton University Press, 1982.

Flores Galindo, Alberto. "In Search of an Inca." In *Resistance, Rebellion and Consciousness in the Andean Peasant World, 18th to 20th Centuries,* edited by Steve J. Stern, 193–210. Madison: University of Wisconsin Press, 1987.

Fontana, Paolo. *Celebrando Caterina: Santa Caterina Fieschi Adorno e il suo culto nella Genova barocca.* Geneva: Marietti, 1999.

Frank, Georgia. "'Taste and See': The Eucharist and the Eyes of Faith in the Fourth Century." *Church History* 70.4 (2001): 619–43.

Frese, Pamela R. "Flowers." In *Encyclopedia of Religion,* edited by Mircea Eliade, 358–61. New York: Macmillan, 1987.

Freud, Sigmund. "Civilization and Its Discontents." In *Civilization, War, and Death,* edited by John Rickman, 26–81. Psycho-Analytical Epitomes 4. London: Hogarth, 1968.

——. *Totem and Taboo: Resemblances between the Psychic Lives of Savages and Neurotics.* Translated by A. A. Brill. New York: Random, 1946.

Fulton, Rachel. *From Judgment to Passion: Devotion to Christ and the Virgin Mary, 800–1200.* New York: Columbia University Press, 2002.

Galilea, Segundo. *Cuando los santos son amigos.* 2nd ed. Bogotá, Columbia: Ediciones Paulinas, 1992.

García-Rivera, Alejandro [Alex]. *The Community of the Beautiful: A Theological Aesthetics.* Collegeville, MN: Michael Glazier/Liturgical Press, 1999.

——. *St. Martin de Porres: The "Little Stories" and the Semiotics of Culture.* Maryknoll, NY: Orbis, 1996.

Geller, Jay. "Hegel's Self-Conscious Woman." *Modern Language Quarterly* 53.2 (1992): 173–99.

Gilson, Étienne. *The Mystical Theology of Saint Bernard.* Translated by A. H. C. Downes. London: Sheed and Ward, 1955.

——. *The Philosophy of St. Bonaventure.* Translated by Dom Illtyd Trethowan and F. J. Sheed. London: Sheed and Ward, 1940.

Girard, René. *I See Satan Fall like Lightning.* Translated by James G. Williams. Maryknoll, NY: Orbis, 2001.

——. *Things Hidden since the Foundation of the World.* Translated by Stephen Bann and Michael Metteer. Stanford: Stanford University Press, 1987.

——. *Violence and the Sacred.* Translated by Patrick Gregory. Baltimore: Johns Hopkins Press, 1977.

Glave Testino, Luis Miguel. *De Rosa y espinas: Economia, sociedad y mentalidades andinas, siglo XVII.* Serie estudios históricos. Lima: Instituto de Estudios Peruanos: Banco Central de Reserva del Perú, Fondo Editorial, 1998.

Glucklich, Ariel. *Sacred Pain.* New York: Oxford University Press, 2001.

Goffen, Rona. *Spirituality in Conflict: Saint Francis and Giotto's Bardi Chapel.* University Park: Pennsylvania State University Press, 1988.

Goldscheider, Ludwig. *Michelangelo: Paintings, Sculpture, and Architecture.* 6th ed. London: Phaidon, 2000.

Goodhart, Sandor. *Sacrificing Commentary: Reading the End of Literature.* Baltimore: Johns Hopkins University Press, 1996.

Goody, Jack. *The Culture of Flowers.* Cambridge: Cambridge University Press, 1993.

Gössmann, Maria Elisabeth. *Die Verkündigung an Maria im dogmatischen Verständnis des Mittelalters.* Munich: Max Hueber, 1957.

Graziano, Frank. *Wounds of Love: The Mystical Marriage of Saint Rose of Lima.* Oxford: Oxford University Press, 2004.

Greenblatt, Stephen. *Renaissance Self-Fashioning: From More to Shakespeare.* Chicago: University of Chicago Press, 1980.

Habig, M. A., O.F.M. *Saints of the Americas.* Huntington, IN: Our Sunday Visitor, 1974.

Hamburger, Jeffrey F. *Nuns as Artists: The Visual Culture of a Medieval Convent.* Berkeley: University of California Press, 1997.

——. *The Rothschild Canticles: Art and Mysticism in Flanders and the Rhineland Circa 1300.* New Haven: Yale University Press, 1990.

——. *The Visual and the Visionary: Art and Female Spirituality in Late Medieval Germany.* New York: Zone, 1998.

Hampe Martínez, Teodoro. *Santidad e identidad criollo: Estudio del proceso de canonización*

de Santa Rosa. Cuzco, Peru: Centro de Estudios Regionales Andinos "Bartolomé de las Casas," 1998.

Hanssen, Beatrice. "'Dichtermut' and 'Blödigkeit': Two Poems by Hölderlin Interpreted by Walter Benjamin." *MLN* 112.5 (1997): 786–816.

Harpham, Geoffrey Galt. *The Ascetic Imperative in Culture and Criticism.* Chicago: University of Chicago Press, 1987.

——. "Asceticism and the Compensation of Art." In *Asceticism,* edited by Vincent L. Wimbush and Richard Valantasis, 357–68. New York: Oxford University Press, 1995.

Harries, Karsten. *The Ethical Function of Architecture.* Cambridge, MA: MIT Press, 1997.

Harrison, Carol. *Beauty and Revelation in the Thought of Saint Augustine.* Oxford Theological Momographs. Oxford: Clarendon Press, 1992.

Healy, Sister Emma Thérèse. *Saint Bonaventure's De reductione artium ad theologiam: A Commentary with an Introduction and Translation.* Saint Bonaventure, NY: Saint Bonaventure College, 1939.

Heidegger, Martin. *Elucidations of Hölderlin's Poetry.* Translated by Keith Hoeller. New York: Humanity Books, 2000.

Heng, Geraldine. *Empire of Magic: Medieval Romance and the Politics of Cultural Fantasy.* New York: Columbia University Press, 2003.

Henry, Avril. "The '*Pater Noster in a table ypeynted*' and Some Other Presentations of Doctrine in the Vernon Manuscript." In *Studies in the Vernon Manuscript,* edited by Derek Pearsall, 89–114. Cambridge: D. S. Brewer, 1990.

Hersey, George L. *High Renaissance Art in St. Peter's and the Vatican.* Chicago: University of Chicago Press, 1993.

Hinnebusch, William A., O.P. *Dominican Spirituality: Principles and Practices.* Washington, DC: Thomist Press, 1965.

Hollywood, Amy. *The Soul as Virgin Wife: Mechthild of Magdeburg, Marguerite Porete, and Meister Eckhart.* Studies in Spirituality and Theology 1. Notre Dame: University of Notre Dame Press, 1995.

Honée, Eugène. "Image and Imagination in the Medieval Culture of Prayer: A Historical Perspective." In Henk van Os, *The Art of Devotion in the Late Middle Ages in Europe, 1300–1500,* translated by Michael Hoyle, 157–74. Princeton: Princeton University Press, 1994.

Hufgard, M. Kilian, O.S.U. *Saint Bernard of Clairvaux: A Theory of Art Formulated from His Writings and Illustrated through Twelfth-century Works of Art.* Medieval Studies 2. Lewiston, NY: Mellen, 1989.

Illich, Ivan. *In the Vineyard of the Text: A Commentary to Hugh's Didascalicon.* Chicago: University of Chicago Press, 1993.

James, Edwin Oliver. *The Tree of Life.* Leiden: E. J. Brill, 1966.

Jerrold, Maud F. *Vittoria Colonna.* Freeport, NY: Books for Libraries, 1969. First published in 1906.

John Paul II, Pope. "Letter of His Holiness to Artists." 1999.

Kaftal, George. *St. Catherine in Tuscan Painting.* Oxford: Blackfriars, 1949.

Kandinsky, Wassily. *Concerning the Spiritual in Art.* Translated by Michael Sadlier, Rev. Francis Golffing, Michael Harrison, and Ferdinand Ostertag. New York: Wittenborn, Schultz, 1947. Originally published in 1912 as *Über das Geistige in der Kunst.*

Kass, Leon. *The Hungry Soul: Eating and the Perfecting of Our Nature.* New York: Free Press, 1994.

Kilgour, Maggie. *From Communion to Cannibalism: An Anatomy of Metaphors of Incorporation.* Princeton: Princeton University Press, 1990.

King, Archdale A. *Eucharistic Reservation in the Western Church.* London: A. R. Mowbray, 1965.

Köpf, Ulrich. "Bernhard von Clairvaux in der Frauenmystik." In *Frauenmystik im Mittelalter,* edited by Peter Dinzelbacher and Dieter R. Bauer, 48–77. Stuttgart: Schwabenverlag, 1985.

Kroner, Richard. Introduction to Hegel, *Early Theological Writings.* Translated by T. M. Knox. Chicago: University of Chicago Press, 1948.

Kubler, George. *Esthetic Recognition of Ancient Amerindian Art.* New Haven: Yale University Press, 1991.

Ladner, Gerhart B. *The Idea of Reform: Its Impact on Christian Thought and Action in the Age of the Fathers.* Cambridge, MA: Harvard University Press, 1959.

Leclercq, Jean. *The Love of Learning and the Desire for God: A Study of Monastic Culture.* Translated by Catharine Misrahi. New York: Fordham University Press, 1982.

——. "The Making of a Masterpiece." In Bernard of Clairvaux, *On the Song of Songs IV.* Translated by Irene Edmonds, ix–xxiv. Cistercian Fathers Series 40. Kalamazoo, MI: Cistercian Publications, 1980.

——. *Monks and Love in Twelfth-Century France: Psycho-Historical Essays.* Oxford: Clarendon Press, 1979.

Levinas, Emmanuel. *Of God Who Comes to Mind.* Translated by Bettina Bergo. Stanford: Stanford University Press, 1998.

Little, J. P. "Simone Weil's Concept of Decreation." In *Simone Weil's Philosophy of Culture.* edited by Richard H. Bell, 26–51. Cambridge: Cambridge University Press, 1993.

Loades, Ann. "Simone Weil and Antigone: Innocence and Affliction." In *Simone Weil's Philosophy of Culture,* edited by Richard H. Bell, 277–94. Cambridge: Cambridge University Press, 1993.

Lockhart, James. *Spanish Peru, 1532–1560: A Colonial Society.* Madison: University of Wisconsin Press, 1968.

MacCormack, Sabine. *Religion in the Andes: Vision and Imagination in Early Colonial Peru.* Princeton: Princeton University Press, 1991.

MacIntyre, Alasdair. *After Virtue: A Study in Moral Theory.* 2nd ed. Notre Dame: University of Notre Dame Press, 1984.

Magne, Jean. *From Christianity to Gnosis and from Gnosis to Christianity: An Itinerary through the Texts to and from the Tree of Paradise.* Translated by A. F. W. Armstrong. Brown Judaic Studies 286. Atlanta, GA: Scholars Press, 1993.

Malvern, Marjorie M. *Venus in Sackcloth: The Magdalen's Origins and Metamorphoses.* Carbondale: Southern Illinois University Press, 1975.

Marion, Jean-Luc. *The Crossing of the Visible.* Translated by James K. A. Smith. Stanford: Stanford University Press, 2004.

——. *God without Being: Hors-Texte.* Translated by Thomas A. Carlson. Chicago: University of Chicago Press, 1991.

Maritain, Jacques. *Art and Scholasticism.* Translated by Joseph W. Evans. South Bend, IN: Notre Dame University Press, 1974.

———. *Creative Intuition in Art and Poetry.* New York: Pantheon, 1953.

Martin, F. David. *Art and the Religious Experience: The "Language" of the Sacred.* Lewisburg, PA: Bucknell University, 1972.

Martin, James Alfred, Jr. *Beauty and Holiness: The Dialogue between Aesthetics and Religion.* Princeton: Princeton University Press, 1990.

Martz, Louis L. *The Poetry of Meditation: A Study in English Religious Literature of the Seventeenth Century.* Rev. ed. New Haven: Yale University Press, 1962.

Mary Alphonsus, Sr., O.SS.R. *St. Rose of Lima: Patroness of the Americas.* Cross and Crown Series of Spirituality 36. Rockford, IL: TAN Books, 1982.

Maurer, Armand A., C.S.B. *About Beauty: A Thomistic Perspective.* Houston, TX: Center for Thomistic Studies, University of St. Thomas, 1983.

Mazzetti, Mila. "La poesia come vocazione morale: Vittoria Colonna." *Rassagna della Letteratura Italiana* 77 (1973): 58–99.

McAvoy, Liz Herbert, and Teresa Walters, eds. *Consuming Narratives: Gender and Monstrous Appetites in the Middle Ages and Renaissance.* Cardiff: University of Wales Press, 2002.

McCall, Tom. "Plastic Time and Poetic Middles: Benjamin's Hölderlin." *Studies in Romanticism* 31.4 (1992): 481–99.

McDonald, A. J. *Berengar and the Reform of Sacramental Doctrine.* Merrick, NY: Richwood, 1977. First published in 1930 by Longmans, Green, London. .

McGinn, Bernard. *The Flowering of Mysticism: Men and Women in the New Mysticism— 1200–1350.* Vol. 3 of *The Presence of God: A History of Western Christian Mysticism.* New York: Crossroad, 1998.

McGuire, Brian Patrick. *The Difficult Saint: Bernard of Clairvaux and His Tradition.* Cistercian Studies Series 126. Kalamazoo, MI: Cistercian Publications, 1991.

McNaspy, Clement J., S.J., "Art in Jesuit Life." *Studies in the Spirituality of Jesuits* 5.3 (1973): 93–111.

Meany, Mary Walsh. "Angela of Foligno: A Eucharistic Model of Lay Sanctity." In *Lay Sanctity, Medieval and Modern.* Edited by Ann W. Astell, 61–75. Notre Dame, IN: University of Notre Dame Press, 2000.

Meehan, Aidan. *Celtic Design: The Tree of Life.* New York: Thames and Hudson, 1995.

Meiss, Millard. *Giovanni Bellini's St. Francis in the Frick Collection.* New York: Princeton University Press, 1964.

Meissner, W. W. *The Psychology of a Saint: Ignatius of Loyola.* New Haven: Yale University Press, 1992.

Merton, Thomas. *The Conjectures of a Guilty Bystander.* Garden City, NY: Doubleday, 1968.

Miles, Margaret R. "From Ascetics to Anorexics." Review of *Holy Feast and Holy Fast,* by Caroline Walker Bynum. *The Women's Review of Books* 5.2 (November 1987): 22–23.

———. *Image as Insight: Visual Understanding in Western Christianity and Secular Culture.* Boston: Beacon Press, 1985.

———. *Plotinus on Body and Beauty: Society, Philosophy, and Religion in Third-Century Rome.* Oxford: Blackwell, 1999.

———. "Vision: The Eye of the Body and the Eye of the Mind in Augustine's *De trinitate* and Other Works." *Journal of Religion* (April 1983): 125–42.

Mitchell, Elizabeth A. "Artistic Creativity and Empathic Act in the Thought of Edith Stein." Licentiate Thesis, Pontifical University of the Holy Cross, 2000.

Mooney, Catherine M., ed. *Gendered Voices: Medieval Saints and Their Interpreters.* Philadelphia: University of Pennsylvania Press, 1999.

——. "Voice, Gender, and the Portrayal of Sanctity." In *Gendered Voices: Medieval Saints and Their Interpreters,* edited by Catherine M. Mooney, 1–15. Philadelphia: University of Pennsylvania Press, 1999.

Morrison, Karl F. *"I Am You": The Hemeneutics of Empathy in Western Literature, Theology, and Art.* Princeton: Princeton University Press, 1988.

Nagel, Alexander. *Michelangelo and the Reform of Art.* Cambridge: Cambridge University Press, 2000.

Nevis, Thomas R. *Simone Weil: Portrait of a Self-Exiled Jew.* Chapel Hill: University of North Carolina Press, 1991.

Newhauser, Richard. *The Early History of Greed: The Sin of Avarice in Early Medieval Thought and Literature.* Cambridge Studies in Medieval Literature 41. Cambridge: Cambridge University Press, 2000.

Newman, Barbara. *God and the Goddesses: Vision, Poetry and Belief in the Middle Ages.* Philadelphia: University of Pennsylvania Press, 2003.

——. "What Did It Mean to Say 'I Saw'?: The Clash between Theory and Practice in Medieval Visionary Culture." *Speculum* 80.1 (2005): 1–43.

Novak, Michael Anthony. "Salvador Dalí's *Sacrament of the Last Supper:* A Theological Reassessment." Paper given at the conference Epiphanies of Beauty, Notre Dame University, Notre Dame, IN, November 2004.

Oben, Freda Mary. *The Life and Thought of St. Edith Stein.* New York: Alba, 2001.

O'Donnell, James. *Cassiodorus.* Berkeley: University of California Press, 1979.

Onians, Richard Broxton. *The Origins of European Thought about the Body, the Mind, the Soul, the World, Time and Fate.* Cambridge: Cambridge University Press, 1988.

O'Regan, Cyril. "The Religious and Theological Relevance of the French Revolution." In *Hegel on the Modern World,* edited by Ardis B. Collins, 29–52. Albany: State University of New York Press, 1995.

O'Reilly, Jennifer. *Studies in the Iconography of the Virtues and Vices in the Middle Ages.* New York: Garland, 1988.

Ostrow, Steven F. *Art and Spirituality in Counter-Reformation Rome.* Cambridge: Cambridge University Press, 1996.

Paolucci, Antonio. *Michelangelo: The Pietàs.* Milan: Skira, 1999.

Partridge, Loren. *The Art of Renaissance Rome, 1400–1600.* New York: Harry N. Adams, 1996.

Paternosto, César. *The Stone and the Thread: Andean Roots of Abstract Art.* Translated by Esther Allen. Austin, TX: University of Texas Press, 1989.

Pennington, M. Basil, O.C.S.O. Introduction to Saint Bernard of Clairvaux, *The Steps of Pride and Humility.* In *Treatises II, The Works of Bernard of Clairvaux,* translated by M. Ambrose Conway, O.C.S.O, 5:1–24. Cistercian Fathers Series 13. Washington, DC: Cistercian Publications, 1974.

Pétrement, Simone. *Simone Weil: A Life.* Translated by Raymond Rosenthal. New York: Schocken, 1988.

Pirrucello, Ann. "Overcoming Self: Simone Weil on Beauty." In *Divine Representations: Postmodernism and Spirituality,* edited by Ann W. Astell, 34–46. Mahwah, NJ: Paulist Press, 1994.

Polizzotto, Lorenzo. *The Elect Nation: The Savonarolan Movement in Florence, 1491–1545.* Oxford: Oxford University Press, 1994.

Price, Merral Llewelyn. *Consuming Passions: The Uses of Cannibalism in Late Medieval and Early Modern Europe.* New York: Routledge, 2003.

Radnóti, Sándor. "Benjamin's Dialectic of Art and Society." In *Benjamin: Philosophy, History, and Aesthetics,* edited by Gary Smith, 126–57. Chicago: University of Chicago Press, 1989.

Rahner, Hugo, S.J. *Ignatius the Theologian.* Translated by Michael Barry. New York: Herder and Herder, 1968.

Rahner, Karl, S.J. "Art against the Horizon of Theology and Piety." In *Theological Investigations,* vol. 23, *Final Writings,* translated by Joseph Donceel, S.J., and Hugh M. Riley, 162–68. London: Darton, Longman, and Todd, 1992.

——. "The Doctrine of the 'Spiritual Senses' in the Middle Ages." Translated by David Morland, O.S.B. In Rahner, *Theological Investigations,* 16:109–28. New York: Crossroad, 1979.

——. "The Ignatian Mysticism of Joy in the World." Translated by Karl-H. Kruger and Boniface Kruger. In Rahner, *Theological Investigations,* 3:277–93. Baltimore: Helicon, 1967.

——. "The Passion and Asceticism." Translated by Karl-H. and Boniface Kruger. In Rahner, *Theological Investigations,* 3:58–85. Baltimore: Helicon, 1967.

——. "The Resurrection of the Body." Translated by Karl-H. Kruger. In Rahner, *Theological Investigations,* 2:203–16. Baltimore: Helicon, 1964.

——. "The 'Spiritual Senses" according to Origen." Translated by David Morland, O.S.B. In Rahner, *Theological Investigations,* 16:81–103. New York: Crossroad, 1979.

——. "The Theological Concept of Concupiscence." Translated by Cornelius Ernst, O.P. In Rahner, *Theological Investigations,* 1:347–82. Baltimore: Helicon, 1961.

Ratzinger, Joseph. *The Theology of History in St. Bonaventure.* Translated by Zachary Hayes. Chicago: Franciscan Herald , 1971.

Réau, Louis. *Iconographie de L'Art Chrétien.* 3 vols. Paris: Presses Universitaires de France, 1958.

Redmond, R. P. *Berengar and the Development of Eucharistic Doctrine.* Newcastle upon Tyne: Doig, 1934.

Reineke, Martha J. "'This Is My Body': Reflections on Abjection, Anorexia, and Medieval Women Mystics." *Journal of the American Academy of Religion* 58.2 (1990): 245–65.

Reites, James W. "St. Ignatius of Loyola and the Jews." *Studies in the Spirituality of Jesuits* 13.4 (1981): 1–48.

Ricoeur, Paul. "Aesthetic Experience." Translated by Kathleen Blamey. *Philosophy and Social Criticism* 24.2/3 (1998): 25–39.

——. *Freud and Philosophy.* New Haven: Yale University Press, 1970.

——. *The Symbolism of Evil.* Translated by Emerson Buchanan. New York: Harper and Row, 1967.

Ritter, Joachim. *Hegel and the French Revolution.* Translated by Richard Dien Winfield. Cambridge, MA: MIT Press, 1982.

Rochlitz, Rainer. *The Disenchantment of Art: The Philosophy of Walter Benjamin.* Translated by Jane Marie Todd. New York: Guilford, 1996.

Rubin, Miri. *Corpus Christi: The Eucharist in Late Medieval Culture.* Cambridge: Cambridge University Press, 1991.

Rudolph, Conrad. *The 'Things of Greater Importance': Bernard of Clairvaux's Apologia and the Medieval Attitude toward Art.* Philadelphia: University of Pennsylvania Press, 1990.

Russell, Rinaldina. "The Mind's Pursuit of the Divine: A Survey of Secular and Religious Themes in Vittoria Colonna's Sonnets." *Forum Italicum* 26.1 (1992): 14–27.

Ryan, Thomas A. *Thomas Aquinas as Reader of the Psalms.* Studies in Spirituality and Theology 6. Notre Dame, IN: University of Notre Dame Press, 2001.

Ryba, Thomas. "Postmodernism and the Spirituality of the Liberal Arts: A Neo-Hegelian *Diagnôsis* and an Augustinian *Pharmakon.*" In *Divine Representations: Postmodernism and Spirituality,* edited by Ann W. Astell, 177–2001. Mahwah, NJ: Paulist Press, 1994.

———. "Truth and the Sensuous in Theology: Newman, Milbank, and Pickstock on the Perception of God." Forthcoming in a collection of essays on John Henry Cardinal Newman, edited by Ian Ker and Terrence Merrigan.

Sabatier, Paul. *Life of St. Francis of Assisi.* Translated by Louise Seymour Houghton. New York: Scribner's, 1894.

Salles-Reese, Verónica. *From Viracocha to the Virgin of Copacabana: Representation of the Sacred at Lake Titicaca.* Austin: University of Texas Press, 1997.

Sanday, Peggy Reeves. *Divine Hunger: Cannibalism as a Cultural System.* Cambridge: Cambridge University Press, 1986.

Saward, John. *The Beauty of Holiness and the Holiness of Beauty.* San Francisco: Ignatius, 1996.

———. "The Fresh Flowers Again: St. Bonaventure and the Aesthetics of the Resurrection." *The Downside Review* 110 (1992): 1–29.

Scarry, Elaine. *The Body in Pain: The Making and Unmaking of the World.* New York: Oxford University Press, 1985.

———. *On Beauty and Being Just.* Princeton: Princeton University Press, 1999.

Schöne, Wolfgang. *Über das Licht in der Malerei.* Berlin: Mann, 1954.

Scott, Karen. "Catherine of Siena and Lay Sanctity in Fourteenth-Century Italy." In *Lay Sanctity, Medieval and Modern: A Search for Models,* edited by Ann W. Astell, 77–90. Notre Dame, IN: University of Notre Dame Press, 2000.

———. "'Io Catarina': Ecclesiastical Politics and Oral Culture in the Letters of Catherine of Siena." In *Dear Sister: Medieval Women and the Epistolary Genre,* edited by Karen Cherewatuk and Ulrike Wiethaus, 87–121. Philadelphia: University of Pennsylvania Press, 1993.

———. "Mystical Death, Bodily Death: Catherine of Siena and Raymond of Capua on the Mystic's Encounter with God." In *Gendered Voices: Medieval Saints and Their Interpreters,* edited by Catherine M. Mooney, 136–67. Philadelphia: University of Pennsylvania Press, 1999.

———. "St. Catherine of Siena, 'Apostola.'" *Church History* 61 (April 1992): 34–46.

Sherratt, Yvonne. "Aura: The Aesthetic of Redemption?" *Philosophy and Social Criticism* 24.1 (1998): 25–41.

Sherry, Patrick. "Simone Weil on Beauty." In *Simone Weil's Philosophy of Culture: Readings toward a Divine Humanity,* edited by Richard H. Bell, 260–76. Cambridge: Cambridge University Press, 1993.

Slavin, Robert J., O.P. "The Thomistic Concept of Education." In *Essays on Thomism*, edited by Robert E. Brennan, O.P., 313–31. New York: Sheed and Ward, 1942.

Snoek, G. J. C. *Medieval Piety from Relics to the Eucharist: A Process of Mutual Interaction.* Leiden: Brill, 1995.

Snyder, Joel. "Benjamin on Reproducibility and Aura: A Reading of 'The Work of Art in the Age of Its Technical Reproducibility.'" In *Benjamin: Philosophy, History, and Aesthetics,* edited by Gary Smith, 158–74. Chicago: University of Chicago Press, 1989.

Sommerfeldt, John R. *The Spiritual Teachings of Bernard of Clairvaux: An Intellectual History of the Early Cistercian Order.* Cistercian Studies Series 125. Kalamazoo, MI: Cistercian Publications, 1991.

Spargo, Sr. Emma Jane Marie. *The Category of the Aesthetic in the Philosophy of Saint Bonaventure.* Franciscan Institute Publications 11. Saint Bonaventure, NY: Franciscan Institute, 1953.

Springsted, Eric. *Christus Mediator: Platonic Mediation in the Thought of Simone Weil.* Chico, CA: Scholars Press, 1983.

Stavig, Ward. *The World of Túpac Amaru: Conflict, Community, and Identity in Colonial Peru.* Lincoln: University of Nebraska Press, 1999.

Steinberg, Leo. *The Sexuality of Christ in Renaissance Art and in Modern Oblivion.* 2nd ed. Chicago: University of Chicago Press, 1997.

Steinberg, Ronald M. *Fra Girolamo Savonarola, Florentine Art, and Renaissance Historiography.* Athens: University of Ohio Press, 1977.

Stern, Steve J. *Peru's Indian Peoples and the Challenge of Spanish Conquest, Huamanga to 1640.* Madison: University of Wisconsin Press, 1982.

Sullivan, Lawrence E. *Icanchu's Drum: An Orientation to Meaning in South American Religions.* New York: Macmillan, 1988.

Summers, David. *Michelangelo and the Language of Art.* Princeton: Princeton University Press, 1981.

Szemiński, Jan. "Why Kill the Spaniard? New Perspectives on Andean Insurrectionary Ideology in the 18th Century." In *Resistance, Rebellion, and Consciousness in the Peasant World, 18th to 20th Centuries,* edited by Steve J. Stern, 166–92. Madison: University of Wisconsin Press, 1987.

Tanck, D. E. "Catechisms in Colonial Spanish America." *New Catholic Encyclopedia,* 3:232–34. New York: McGraw-Hill, 1967.

Tannahill, Reay. *Flesh and Blood: A History of the Cannibal Complex.* London: Abacus, 1996.

Thurston, Herbert. *Familiar Prayers.* Westminster, MD: Newman, 1953.

Tobin, Frank. Introduction to Mechthild of Magdeburg, *The Flowing Light of the Godhead.* Translated by Frank Tobin. Classics of Western Spirituality. New York: Paulist Press, 1998.

The Treasury of Saint Francis of Assisi. Ed. Giovanni Morello and Laurence B. Kanter. Milan: Electa, 1999.

Trexler, Richard C. "Lorenzo de' Medici and Savonarola, Martyrs for Florence." *Renaissance Quarterly* 3 (1978): 293–308.

Tugwell, Simon, O.P. Introduction to *Early Dominicans: Selected Writings.* Edited by Simon Tugwell. Classics of Western Spirituality. New York: Paulist Press, 1982.

Van de Goorbergh, Edith, and Theodore Zweerman. *Respectfully Yours: Signed and Sealed, Francis of Assisi.* Saint Bonaventure, NY: Franciscan Institute, 2001.

Van der Leeuw, Gerardus. *Sacred and Profane Beauty: The Holy in Art.* Translated by David E. Green. New York: Holt, Rinehart, and Winston, 1963.

Van Dijk, S. J. P., and J. Hazelden Walker. *The Myth of the Aumbry: Notes on Medieval Reservation Practice and Eucharistic Devotion.* London: Burns and Oates, 1957.

Van Os, Henk. *The Art of Devotion in the Late Middle Ages in Europe, 1300–1500.* Translated by Michael Hoyle. Princeton: Princeton University Press, 1994.

Vargas Ugarte, Rubén, S.J. *Santa Rosa in the Arts [Santa Rosa en el Arte].* Lima: Los Talleres Gráficos de Sanmartí S. A., 1967.

Viladesau, Richard. *Theological Aesthetics: God in Imagination, Beauty, and Art.* New York: Oxford University Press, 1999.

Von Hügel, Friedrich. *The Mystical Element of Religion As Studied in Saint Catherine of Genoa and Her Friends.* 2 vols. Milestones in the Study of Mysticism and Spirituality. New York: Herder and Herder, 1999.

Wakefield, Gordon S., ed. *The Westminster Dictionary of Christian Spirituality.* Philadelphia: Westminster Press, 1983.

Walker, Charles F. *Smoldering Ashes: Cuzco and the Creation of Republican Peru, 1780–1840.* Durham: Duke University Press, 1999.

Wandel, Lee Palmer. *Voracious Idols and Violent Hands: Iconoclasm in Reformation Zurich, Strasbourg, and Basel.* Cambridge: Cambridge University Press, 1995.

Watson, Arthur. *The Early Iconography of the Tree of Jesse.* London: Oxford University Press, H. Milford, 1934.

——. "The *Speculum Virginum* with Special Reference to the Tree of Jesse." *Speculum* 3 (1928): 445–69.

Way, Karen. *Anorexia Nervosa and Recovery: A Hunger for Meaning.* Haworth Women's Studies. New York: Haworth Press, 1993.

Webb, Heather. "Catherine of Siena's Heart." *Speculum* 80.3 (2005): 802–17.

Weiner, Herbert. "On the Mystery of Eating: Thoughts Suggested by the Writings of Rav Abraham Isaac Kuk." In *Standing before God: Studies on Prayer in Scriptures and in Tradition, with Essays in Honor of John M. Oesterreicher,* edited by Asher Finkel and Lawrence Frizzell, 329–38. New York: Ktav, 1981.

Werge, Thomas. "Sacramental Tension: Divine Transcendence and Finite Images in Simone Weil's Literary Imagination." In *The Beauty That Saves: Essays on Aesthetics and Language in Simone Weil,* edited by John M. Dunaway and Eric O. Springsted, 85–97. Macon, GA: Mercer University Press, 1996.

Wiethaus, Ulrike. *Ecstatic Transformations: Transpersonal Psychology in the Work of Mechthild of Magdeburg.* Syracuse, NY: Syracuse University Press, 1996.

Williams, Raymond. *Keywords: A Vocabulary of Culture and Society.* Rev. ed. New York: Oxford University Press, 1983.

Williamson, Beth. "Altarpieces, Liturgy, and Devotion." *Speculum* 79.2 (2004): 341–406.

Wilson, Jean C. "Reflections on St. Luke's Hand: Icons and the Nature of Aura in the Burgundian Low Countries during the Fifteenth Century." In *The Sacred Image East and West,* edited by Robert Ousterhout and Leslie Brubaker, 132–46. Illinois Byzantine Studies 4. Urbana: University of Illinois Press, 1995.

Winch, Peter. Introduction to *Simone Weil: Lectures on Philosophy.* Translated by Hugh Price. Cambridge: Cambridge University Press, 1990.

Woods, Richard, O.P. *Mysticism and Prophecy: The Dominican Tradition.* Maryknoll, MD: Orbis, 1998.

Wyschogrod, Edith. *Saints and Postmodernism: Revisioning Moral Philosophy.* Chicago: University of Chicago Press, 1990.

Zeigler, Joanna E. *Sculpture of Compassion: The Pietà and the Beguines in the Southern Low Countries, c. 1300–c. 1600.* Brussels: Belgian Historical Institute of Rome, 1992.

Zerries, Otto. "Lord of the Animals." Translated by John Maressa. In *Encyclopedia of Religion,* edited by Mircea Eliade, 22–26. New York: Macmillan, 1987.

ILLUSTRATION CREDITS

Plate 1. Lucas Cranach the Elder, *Madonna and Child,* ca. 1535. Gift of Adolph Caspar Miller. Image © Board of Trustees, National Gallery of Art, Washington, DC. Used with permission.

Plate 2. Berthold Furtmeyr, *Eva und Maria,* ca. 1481. Clm. 15710. Fol. 60v. Bayerische StaatsBibliothek, Munich, Germany. Used with permission.

Plate 3. Salvador Dalí, *The Sacrament of the Last Supper,* 1955. Chester Dale Collection. Image © National Gallery of Art, Washington, DC. Used with permission.

Plate 4. Mary A. Zore, *Bread of Angels Mandala,* 2002. Courtesy of the artist.

Plate 5. *Vision of Saint Bernard during Mass,* late fifteenth century. MS. Douce 264, Fol. 37. Bodleian Library, Oxford, England. Used with permission.

Plate 6. *Pater Noster Table,* ca. 1400. Vernon MS. MS. Eng. Poet.a.1. Fol. 231v. Bodleian Library, Oxford, England. Used with permission.

Plate 7. Domenico Veneziano, *Saint Francis Receiving the Stigmata,* ca. 1445. Samuel H. Kress Collection. Image © Board of Trustees, National Gallery of Art, Washington, DC. Used with permission.

Plate 8. Domenico Veneziano, *Saint John in the Desert,* ca. 1445. Samuel H. Kress Collection. Image © Board of Trustees, National Gallery of Art, Washington, DC. Used with permission.

Plate 9. Lázara Bladi, *People of Peru Paying Reverence to Saint Rose,* 1668. Church of Saint Mary sopra Minerva, Rome, Italy. Courtesy of Teodoro Hampe Martínez.

Plate 10. Angelino Medoro, *Santa Rosa,* 1617. Santuario de Santa Rosa de Lima. Lima, Peru. Courtesy of Señora María Luisa Ugarte.

Plate 11. Michelangelo, Florentine *Pietà,* ca. 1552. Opera di S. Maria del Fiore di Firenze/ Nicolò Orsi Battaglini. Florence, Italy. Used with permission.